THE FOREST

Alexander Nemerov

THE FOREST

A Fable of America in the 1830s

PRINCETON UNIVERSITY PRESS
Princeton and Oxford

THE A. W. MELLON LECTURES IN THE FINE ARTS

NATIONAL GALLERY OF ART, WASHINGTON
Center for Advanced Study in the Visual Arts
Bollingen Series XXXV: 66

For Jeremi Szaniawski

Shakespeare's plays are not in the rigorous and critical
sense either tragedies or comedies, but compositions
of a distinct kind; exhibiting the real state of sublunary
nature, which partakes of good and evil, joy and
sorrow, mingled with endless variety of proportion
and innumerable modes of combination; and expressing
the course of the world, in which the loss of one is the
gain of another; in which, at the same time, the revel-
ler is hasting to his wine, and the mourner burying his
friend; in which the malignity of one is sometimes
defeated by the frolick of another; and many mischiefs
and many benefits are done and hindered without design.

—SAMUEL JOHNSON, *Preface to Shakespeare*, 1765

Contents

Author's Note

This book tells the story of many people. Sometimes they know one another, sometimes they do not. Often they go their separate ways, this person striving for one thing, that one for something else. Together they make a pattern of life at a given time in the history of the United States.

The forest is a backdrop—if not always an actual setting—for what follows. Trees play an important role, but this is not a book of ecology. It portrays the dense and discontinuous woods of nation, a forest of people destroying and saving the woods and, in some way, themselves.

These people are all artists in one way or another. Some are painters and poets. Others have no artistic intention. But all are creators of private and grand designs, makers of worlds in the way that this book, in telling their stories, makes the world they lived in. My artists—my characters—are mystics traveling paths of realization, lost in thought.

The action unfolds in brief stories. Each is an episode, an impression, not an argument or claim. The reader searching for conclusive meanings will be disappointed. The book is a fable, not a history. For authoritative histories of the period, I recommend, among other books, Sean Wilentz's *The Rise of American Democracy: Jefferson to Lincoln*, Daniel Walker Howe's *What Hath God Wrought: The Transformation of America, 1815–1848*, and Charles Sellers's *The Market Revolution, 1815–1846*. Much of what follows is based on the historical record, though only some of it is true. Yet I hope that something real is revealed: a lost world of intricate relation, of human beings going about their ways, living the dream of themselves in shade and sun.

—ALEXANDER NEMEROV

Herodotus among the Trees

A Lone Pine in Maine

The axe struck the pine tree a first blow. The sound bounced from the hillside, echoing back to the woodman. The phlegm of the cut and the scratch in his throat made no common language. The blue sky, passing clouds, and pine needles on the ground were only sun and shade and softness beneath his boots. He chopped and the tree fell, splitting and cracking and thumping to the earth. Sawyers sheared the branches and stripped the gray bark. This was in Maine, north of Augusta, near the Kennebec River.

The tree was a white pine, more than a hundred feet tall. It grew in a stand of pines in deep, cool, black sand. The rest of the trees in the swampy ground still stood, remarkably straight and without limbs until two-thirds of the way up, their summits crowned by a few upright branches that seemed from a distance to float in air. The one now on the ground, wet with moss, would become part of a house, or the beams of a church, shelves for a shop or barrels for salted fish. A piece might become the frame of a mirror before which a young woman, a candle at her side, fastened a locket around her neck. Gone were the days when the Royal Navy had scouted the forests for white pines and stamped them for future use as masts. Now Yankees turned them into floors, shingles, clapboards, pails, packing crates, the cornices and friezes of front doors, the moldings of fireplaces and the frames of paintings. At Philadelphia a bridge of white pine crossed the Schuylkill. Another pine bridge crossed the Delaware at Trenton. White pine trestles fifteen hundred and three thousand feet long connected Boston to Cambridge and Charleston. The clip-clop of horses on the spans made a hymn of praise. The Greeks had the Shield of Achilles; the Americans made their daily round of pine.

Back in the swamp, the pine now felled, the lumbermen cut it into sections about fifteen feet long, stamping each log with a mark of ownership, then used teams of oxen to drag the pieces to a clearing where the logs sat until winter, when they were trundled onto the frozen Kennebec to await the spring thaw. When the ice broke up, the timber floated down to Winslow, where representatives of different companies sorted through it. Identifying the logs with the stamp of their own firms, they assembled the wood into rafts to sell to the sawmills between Winslow and the sea.

The largest town in those miles to the ocean was Augusta. There one day in July 1837 an observer in a riverside house spied a lone pine log rolling and shining in the stream. He imagined that the log had traveled "hundreds of miles from the wild upper sources of the river, passing down, down, between lines of forest, and sometimes a rough clearing" before it floated past this cultivated spot. In his imagination, the log still carried freezing winds and summer stars stuck in the sheared boughs, whose bending and waving the sodden trunk still remembered. He watched as the log slowed with the current, where a milldam under construction impeded the river, eyeing it still as a raft of planed boards floated past, piloted by a man whose voice mingled with the broken words of the Canadians and Irishmen at work on the dam. The wind blowing through the trees on the bank made another voice, as did the flowing river, though he noticed how all the sounds diffused "a sort of quiet" across the scene.

The observer, Nathaniel Hawthorne, saw trees as secrets. With the "knotty fingers" of their roots, they held on to the mystery of themselves. From summits they gazed down, curiously aware, staring at their fellows who had fallen in some mudslide, "anticipating a like fate," but it was no use

personifying them. He knew that the language of moral foreboding and damnation was an imperfect medium for disclosing the enigma of these strange presences. Allegory was only another planed board, a rhetorical carpentry that turned wildness into moral furniture. Anthropomorphism— the kind he used when he described the "barkless arms" of a pine that stood in death as "its own ghost"—was no better: only an approximation for the disquieting seriousness of these wooden beings.

Somewhere beyond emblems and fantasies was a secluded pool, a lonely place at which trees stared at themselves, redoubling their silence to repel the words of the writer as much as the blade of the axe. The writer, after all, was just a lumberman of a different kind—splitting the world into lengths of meaning, shaving it in the milldam of his story-works—though unlike the lumberman, he recognized that his aim was to harvest the riches of the trees before, not after, they were killed. Hawthorne envisioned writing a story of "some treasure or other thing to be buried, and a tree planted directly over the spot, so as to embrace it with its roots."

For him, trees were brains, arbors of thought, much like his own.

The Town the Axes Made

About twelve miles northwest of Hartford, Connecticut, in a new stone building, a nameless blacksmith held the glowing iron on the anvil, using tongs to shift and turn the metal beneath the rhythmic blows of a heavy trip-hammer. Around him dozens of other smiths worked at their own anvils, the din making a continuous sound, like piano keys depressed all at once, that rebounded off the darkened walls

of the factory on the banks of the Farmington River, where a waterwheel powered the hammers that shaped the axes.

Other men at grinding wheels honed the blades that had cooled. They wore leather aprons and pumped foot treadles, sharpening the edges before windows revealing hillsides of pine, oak, and maple. Down the street, in the fast-growing company town of Collinsville, Connecticut, elms lined the new green, making a vista toward the workers' houses and the new Congregational Church, the wooden spire of God in the town the axes made. Started by the brothers Samuel and David Collins in 1827 as a modest concern—eight men forging and tempering eight axes each a day—the company had grown vastly in a few years. By 1831 the Collins Company employed 200 men producing 200,000 axes a year, and it did the briskest trade of any company in the state.

A village blacksmith had been his own boss, employee, and purveyor, but Collinsville was changing that. Charles Morgan of Somers, Connecticut, had stamped his name on the axes he crafted, but when he came to Collinsville in 1827, lured by the higher pay, his work was claimed by the firm. Before, he had made his axes every step of the way; now, the company's division of labor meant that he did only the forging and tempering, one among several men devoted to these tasks, while grinders and polishers finished each axe. In 1830 Morgan complained of feeling sick and temporarily returned to Somers. Two years later he left Collinsville for good.

Out in the woods, a man wielding a Collins axe was likewise no longer economically independent. Back in the first decade of the nineteenth century, the settlers outside Augusta fiercely protected their liberty, disguising themselves as "white Indians" to scare off the local capitalists bent on morally improving them and turning their labor to economic

advantage. Calling themselves Liberty Men, a group of these white Indians strapped on masks "of bearskin, some sheepskin, some stuck over with hog's bristles, etc.," to greet a company representative, intimidating him by firing a deafening musket volley into the air. But by the 1830s improved roads had reduced the isolation that fueled their defiance. Now town and country were more connected, even as settlers continued to face the harsh conditions and extreme poverty of their remote existence. Desperate to secure a living, they relied increasingly on the "Great Proprietors" they had once opposed. By the end of the 1830s Maine was shipping more than forty million feet of lumber from the mouth of the Kennebec alone. The axe that sounded in the forest was made by many men, and the man who wielded that axe did so for lumber interests who claimed his work for their own.

What then of the solitary cut made by a man with an axe in a great wood? The splintering established only a local radius of sound. The sound seemed intent on its own vanishing, at one with the woodman's expenditure of energy, as if some of his body, his very muscles, had traveled into the split in the tree, subsumed there like the noise itself in the woody deafness. The changing country brought a new obscurity of individual actions, a novel lexicon of the forgotten, a ritual of cutting oneself down every day—clearing oneself away, it might be said, with a full day's work, a pact of erasure with the things you destroyed. The pounding of the trip-hammers became the same as the forest silence that swallowed all sound: no one heard a thing. At Collinsville, the grinders ingested tiny particles of stone and over time became sick and died. And the blade of each day, whetted to an edge, split the dusk from the sun.

Hat and Tornado

In 1830 the painter Thomas Cole purchased a top hat from a shop at 128 Fulton Street in Manhattan. Cole was no gentleman born, and his artist's profession was no great sign of social prestige, but the hat gave him a certain dignity and elevation. Made of cardboard covered in brown felt with silk trim around the base, it implied the delicacy and refinement of the head it housed.

Inside that hat was his childhood in Lancashire, England, where he grew up the seventh of eight children, the only boy, of Sarah and James Cole, a woolen manufacturer. Inside it was the harsh treatment he received at school when he was little, the memories of poor food and illness, his resistance to becoming a lawyer or ironmonger, and his fondness for colors and designs; his experience, too, of coming to the United States with his whole family in 1819, when he was eighteen years old. Inside the hat were his travels on foot from Philadelphia to Steubenville, Ohio, where he went to join the rest of the Coles after he had stayed in Philadelphia to earn money as a printmaker and novice self-taught painter while they tried establishing themselves on the frontier. Inside that hat, now that a few years later he had affected the style of a gentleman, he stored his ideas for paintings to attract wealthy patrons, his plans for advancement in the world, and for improving his adopted country. He held it all there, the vision of a series of pictures warning of a country moving "from barbarism to civilization—to luxury—to the vicious state, or state of destruction—and to the state of ruin and desolation." The hat helped make the man who dreamed the dignity of his own occupation, the man of pieties and pronouncements.

But the hat also concealed the man's eccentric mystery. It hid all that lay close amid the outward trappings of his morality, hiding it even from himself. An odd idea for a painting, for example, was forming in his brain: a massive chalice brimming with a mountain lake on which tiny sailboats floated, a Brobdingnagian cup vegetally fringed at the lip and base, ever so slightly obscene, that resembled the hat housing the brain that conceived the fantastical scheme.

That brain was a font of visions more frankly erotic, like the one he described of a spring evening outside the Colosseum in Rome in 1832, on a trip to Italy a wealthy patron had funded, on which he looked up to see ivy and wildflowers festooning the moonlit ruin, making it seem "more like a work of nature than of man," and beheld there, too, not far away, a young woman. Sitting there in a reverie, the bachelor artist ignored his customary repression and spoke unprompted to this stranger, telling her in the moonlight how the Colosseum reminded him of a spent volcano whose fires had once "blazed forth with desolating power," so that "the thunder of the eruption shook the skies," but that now, "long extinguished," had left only a "crater of human passions," disturbed by birdsong in the morning and the chanting of monks at night.

The year before he returned to New York in November 1832, Cole painted a large picture of a tornado. *Tornado in an American Forest*, he called it. Gray wind snaps one tree off at the trunk and blows others almost horizontally. Two massive trees lean in the foreground, one a birch blown back by the gale, the other extending a black and bony branch into the storm, defying the putrid darkness while a bareheaded Cole struggles to stay upright at its foot. What unholy energy, what resinous storm of turpentine, blew the hat from

his head? Cole cribbed the sideways-blowing trees on their
hillside from Paolo Uccello's *Deluge*, which he had seen at
Santa Maria Novella in Florence, but no scripture, moral, or
message underwrites his screed of passions spending them-
selves in pointless eruption and ravaging darkness.

rush, *rush*, RUSH

The preacher poured forth his words. They went into the
night. This was at a camp meeting, held in the "burned-over
district," the swath of Western New York State swept by
revivalist religion in the 1830s. The meeting took place in
the woods, in a clearing made for the purpose, and it had
been going on for several days and nights continuously. On
benches made of felled tree trunks set before the preacher's
crude wooden platform, hundreds of men, women, and chil-
dren looked toward him, their faces shining in the reflected
light of twin pyres burning to either side of the rostrum.

The preacher, Jedediah Burchard, told his listeners that
they were all sinners, that they should "be lifting up [their]
eyes and unavailing prayers in eternal hell." But they could
still find Jesus and be saved. With dark, searching eyes
Burchard peered at his psalmbook, bringing his nose nearly
down to the pages to read in the flickering light. During his
sermon, from Acts 10:29, "I ask therefore, for what intent
ye have sent for me?," he struck his hands together often
and occasionally smote the desk on which his Bible lay or
slammed down the Bible itself. A former circus acrobat, he
came out from behind the desk and tiptoed about the narrow
stage like a man on a tightrope. If only he had been speaking
in a church, he could have stepped out into the crowd and
walked across the back of the pews, as he liked to do.

His language was direct, physical. The Holy Ghost would pour down on his listeners like mountain streams in spring. It would come upon them, "rush, *rush*, RUSH," strip them of "all the corruptions and pollutions, which they naturally possessed." Gesturing to the "anxious seats," the front benches seating those most in need of salvation, Burchard told them "the water—the Holy Spirit—is troubled, *troubled*, TROUBLED" and that sinners "come right forward to the *anxious seats*—they *step right into the water* and"—he slapped his hands together—"salvation comes right into their souls." He kept speaking in these vocal trinities: "The water must be TROUBLED worse, and *worse*, and WORSE. . . . The worse the water is troubled, the better, and the higher the waves rise, *rise*, RISE."

Many of the women rose, only to swoon and stay on the ground. A careful observer saw one of them wink, but even this girl remained down like her sisters, all drowned in the preacher's words. Their bodies lay on the forest floor like the victims of some flood until eventually they stood up, awakened as if at the Last Judgment. Few could remember which psalm struck them down or which commanded them to rise. Salvation required no labor of thought; words came naturally. Language was as immediate as the trees looming over the fiery proceedings, as instinct with elevation as the upper boughs, as lofty yet curiously kindred as the underside of the leaves seventy feet from the ground. Little came between these souls and the clouds and the stars. Burchard made the miracles he foretold.

Around the open space where Burchard spoke were many tents, each with its own revival meeting going on. In one of those tents, a long structure separated by a foot-high bench laid lengthwise, men knelt and swooned on one side, women on the other. The air was close, filled with the smell of dust,

the smoke of whale-oil lamps, the odor of stale straw on the floor. Some "men were taking the hands of women between their hands, and patting and striking them, exhorting them." Others were "quiet, half faint, exclaiming, groaning or weeping." Outside, Burchard's figures of speech kept rising, turning in the air and blending into the leafy canopy, where the illumined branches and leaves became twisting serpents and tongues and the forest seemed to speak itself.

The next day, after the meeting had concluded and the congregants had departed, the quiet clearing gave the sense of city streets the morning after an election, a place where the "walls and corners are yet covered with flaming hand-bills, witnesses and documents of the high-running excitement, which but yesterday seemed to roll like an agitated sea." In those election places the rain washes most of the handbills away. The remaining slogans are then ripped from the walls, macerated in vats, and turned into new posters for parties unknown. Where the camp meeting had been, the trees likewise began a renewal. But they also harbored the memory of sounds that, properly speaking, left no record. Human voices echoed in their canopies until it seemed that the trees themselves had become the congregants of their own sylvan religion, taking a cue from the brimstone language of malady and affliction to sing, in counterpoint, a tune of their own.

History without a Sound

Alexis de Tocqueville and Gustave de Beaumont rode slowly on horseback through the Michigan woods. To them, the fifty miles from Flint to Saginaw were trackless, but their two Ojibwe guides, both teenage boys, led the way. The Frenchmen wanted to see the untouched American forest and had

gone to great trouble to do so. That summer of 1831 they had crossed New York State, sailed a hundred miles on Lake Erie, and kept pressing on without finding the wilderness they sought. At the small frontier settlement of Detroit and then farther on at Flint, they encountered another obstacle: no settler understood their wish to see trees without economic gain in mind. "An American thinks nothing of hacking his way through a nearly impenetrable forest, crossing a swift river, braving a pestilential swamp, or sleeping in the damp forest if there is a chance of making a dollar," Tocqueville wrote in his journal. "But the urge to gaze upon huge trees and commune in solitude with nature utterly surpasses his understanding." Only when the two Frenchmen invented a story about being financial speculators did the Americans help.

In company with their guides, Tocqueville and Beaumont entered the gloomy woods en route to Saginaw. The trees were so thick that they formed "a single whole, an immense and indestructible edifice, under whose vaults reigns an eternal obscurity." Dead trees hung suspended in air, prevented from falling to the ground by the density of the forest. No sounds—a church bell, a farmer's axe, a barking dog—penetrated the deep silence. Tocqueville thought the forest emptier than even the ocean, since at least on the ocean a person can see the horizon. At night the party kept going, the Frenchmen having prevailed on their guides not to stop. Looking round in the cool dampness, they no longer saw trees but "forms bizarre and disproportioned, incoherent scenes, fantastic images which seemed borrowed from the sick imagination of a man in fever." An occasional firefly was the only light.

Traveling from Detroit to Pontiac earlier that month, Tocqueville and Beaumont heard axes striking trees. They saw

trunks scorched by fire and shivered by axes all along the route. The occasional settler's cabin was an "ark of a lost civilization in an ocean of foliage"—only a hundred feet from one of these cabins the dark forest resumed. Yet the settler and his family were undaunted. The settler had started by cutting down the trees to make the cabin. Then he girdled others—making a deep cut to stop the flow of sap—which soon killed the trees and bared their branches, letting the sunlight fall to the ground where crops could be planted. While waiting for the girdled trees to die, he planted corn at their roots, since this crop did better in forest shade than in open sun. Meanwhile the settler made furniture—pieces so new that Tocqueville noticed leaves sprouting from the legs of a table. But now farther north, the travelers found no settlers and no cabins.

The woods on the way to Saginaw were so quiet and still that "a kind of religious terror grips the soul." The travelers talked less and spoke in ever-more hushed tones. Eventually they spoke only in whispers, then not at all. Pondering the relation of silence to history, Tocqueville recalled in his journal how in Sicily in 1827 he had gotten lost in a vast swamp near the ancient city of Himera. Now in Michigan four years later, he realized that the forest itself was the ancient civilization, its perennial selfsameness the way it had been for millennia. The woods marked time in so many ways—the life of an individual tree, manifest in concentric circles of growth; the couplings of skeletal pines entwined like Esmeralda and Quasimodo at the end of Victor Hugo's *Notre Dame*. The woods even foretold the future of their own past—in this up-and-coming country, they soon would vanish, "so great is the impetus that drives the white race to conquer the whole of the New World." Trying to be true to what he felt, Tocqueville needed a language that would reproduce the threatened

silence that made the leaf and root of his thought: an ety-
mology of nature, a hush of original sensations, back in the
Rousseauian midst of things.

He found the silence at a muddy hole swarming with
mosquitoes at which the Ojibwe guides told him and
Beaumont to slake their thirsts. A pale and darkened self-
reflection, a pocket of rainwater filling the pit left by the
roots of a toppled tree, the picture emerged from the ground
itself, an unlikely source as silent as it sounds, with no one to
sustain but the person who, bending down, drank from it on
his quest. Succor to the traveler absorbed in his own being,
the water gave balm to the soul at the root of things, while
the Ojibwe guides sat indifferently on the fallen tree, the face
of the older one painted a symmetrical red and black.

That winter near Cincinnati, Tocqueville and Beaumont's
boat got caught in river ice. With no thaw in sight, they
loaded their baggage onto a cart and walked through woods
in half a foot of snow to Louisville, where they found the
rivers still frozen. There they took a stagecoach for two days
and two nights to Nashville, traveling on a road that was
"nothing but a passage cut through the forest." They boarded
a ferry to cross the Tennessee River amid huge chunks of
ice, with Tocqueville frozen and shivering, unable to eat, and
growing faint. They stopped.

They came to a one-room inn where the innkeeper kept
slaves. One slave poked the fire; another dried the travelers'
clothes and brought them food. Commenting on the scene,
Beaumont decried the inhumanity of slavery, its effects on
enslaved and enslavers alike. At this point his journal is
so damaged it becomes illegible, just a mud of words. The
swampy pool, the mire of mirror ice—the historian's reflec-
tion speaks the silence of what toppled and what stood, in
the wood of solitude.

The Sacred Woods of Francis Parkman

In 1831, when he was eight years old, Francis Parkman went to live at the farm of his maternal grandfather in Medford, Massachusetts. The boy was sickly and glum, and his parents thought the country air would do him some good. In Medford, six miles from the family's mansion on Bowdoin Square in Boston, he began exploring the Five-Mile Woods, also known as Middlesex Fells, a forest surrounding a large pond and surmounted by a 325-foot rise called Bear Hill. The young Parkman collected eggs and captured lizards, trapped squirrels and woodchucks, tried shooting birds with a bow and arrow. When he returned to Boston in 1835, somewhat restored in health, he switched focus and began conducting scientific experiments, but did little except poison his room with noxious fumes and occasionally scorch himself in an explosion. Returning to his initial love, he became "enamored of the woods," his "thoughts always on the forests," as he wrote many years later, describing himself in the third person. They were the stuff of "his waking and sleeping dramas, filled with vague cravings impossible to satisfy." Still a teenager, he decided he would tell the history of the American forest—not the history of the trees but of the prolonged conflict they had witnessed.

That conflict was the French and Indian War, which raged in the American Northeast for more than a hundred years and culminated in the Seven Years' War of 1756–63. To get back to that time, Parkman told his Harvard classmates in his undergraduate commencement speech of 1844, he walked through a woodland portal, a "narrow gap in the woods," "a small square space hewn out of the forest." It was true that by then not much of that old forest remained. Around him he saw "the black and smoking carcasses of the murdered

trees," but in the woods that were left he made lost time reappear. His mind activated by the wet, dense, physical spaces he walked through—by dark woodland streams "fed by a decoction of forest leaves that oozed from the marshy shores"; by tall thin trees straining toward the light, "their rough, gaunt stems trickling with perpetual damps"; by dead trees crowding a riverbank, others partly submerged in mudbanks and shallows—he envisioned a great drama of historical actors and places. Writing in the darkness of his Boston study, where he kept the blinds closed to block the headachy sunlight that forced him to wear tinted glasses outdoors, he tried to write a few lines a day. Concluding with his most famous work, *Montcalm and Wolfe*, published in 1884, Parkman wrote history in a secluded space of dreams, an oneiric location that conjured the past in fragmentary visions. "In glimpses only, through jagged boughs and flickering leaves, did this wild primeval world reveal itself."

Back when he was an undergraduate, Parkman spent time in Italy in hopes of bettering his delicate health. Staying at a monastery in Rome for a few days in 1844, he endured the monks who prayed for his Unitarian soul. He ridiculed a mass at St. Peter's in which Veronica's veil hung above ten thousand worshipful congregants—the "handkerchief on which Christ wiped his face, and which contains the impressions of his features," he wrote to his parents, was only "one of the fooleries of Holy Week." But Parkman's woods were themselves a holy face, a hallucination of the real, and the physical ardors of his camping excursions deep into the American forests were the same as the ecstatically punishing rituals of the Passionist monks, whose hair shirts and simple diet afforded the young man a worthy model for his own discipline. In an era when he found that even the settlers in the woods did nothing but read the newspapers, think of

presidential politics, attend their sawmills, and hoe their potatoes—this is what he told his Harvard classmates at commencement—Parkman envisioned himself as an apostle of woodland directness. Drenching the world in its own immediacy, conjuring the forest in a stream of words, he made scenes appear in writerly visions, as if without human hands.

He described Father Isaac Jogues, a Jesuit priest captured and tortured by the Mohawks in 1642–43, who cut out a cross of bark and knelt beneath the wintry pines. Clad in furs, left to roam the inescapable woods by his captors, Jogues told his beads and read scripture. His right thumb had been cut off by a razor-sharp clamshell. His body was a welter of bruises from running the captive's gauntlet. But he walked on the shores of a remote lake and carved the name of Jesus on trees "as a terror to the demons of the wilderness." Parkman disdained Jesuit superstition, but the priest's pain-wracked writings on trees were like his own. The original manuscript sources before him—Jogues's accounts, those of other Jesuits—were at once legalistic documents and mysterious emanations from a remote place, apparitions of the dead.

As Parkman sat in his study one day, he examined the photograph of a bust of another Jesuit martyr, Jean de Brébeuf. Commissioned by the dead man's family, the bust was made of silver with a cavity inside, a recess for his skull. Likewise, Parkman created symbols incarnate with actuality, writerly crucibles of silver and bone. He was like those first Jesuits at Montreal, the ones who carved a large cross of wood, embedded it with the relics of saints, and carried it up a steep and rugged mountain. He, too, labored on signs and wonders. He trusted his eyes, went to the sites, and found himself back in the woods, where the light was slight.

A Shallow Pool of Amber

The trees could be seen, but they were a dream. "The solemn evergreen woods," Margaret Fuller called them in a letter of March 4, 1839, to her friend Charles Newcomb. The silence of those trees, "colder, if not deeper than that of summer noon, gave verge enough for reverie." She told Newcomb of the "tales the Spirits of the trees told me by the glimpses of the moon." She was twenty-eight years old, a disciplined intellectual and an aspiring writer living in Groton, Massachusetts, who faced an unpleasant task. Her father had died of cholera in 1835 and she was finally sorting through forty years of his papers. Timothy Fuller had been a lawyer and member of the Massachusetts and US House of Representatives, and he had kept copious documents: journal themes from his college days at Harvard, law minutes, minutes of legislature debates, a vast correspondence. When suddenly stricken, he had just finished overseeing the construction of a study at the end of the family's garden in Groton where he intended to sort through all these documents. Now the duty fell to Margaret, who was moved by what she read. "I know him hourly better and respect him more," she wrote to a friend, thanks to "those secrets of his life which the sudden event left open in a way he never foresaw." But the task was tedious. She had to look at each sheet separately and decide which ones to burn. The trees made an escape—into the mind, into language of another kind.

Three years earlier, she had been walking across a dull-brown field in early spring. Her stroll was languid, her mood bored. Nothing caught her fancy, nothing had a "life-like tint," not even the trees. A few withered leaves from last year blew on the oaks. Nothing made her happy and alive. Nothing penetrated the pores of her skin. Then she saw

"a shallow pool of the clearest amber," broken by the wind into tiny waves so that it flashed "a myriad of diamonds up at each instant." In it she saw the redemptive power of art: "a mixture of the most *subtle force* combined with the most *winning gentleness* . . . the most *impetuous force* with the most *irresistible subtlety*." It was dangerous, it drew her in; it invited her to drown, this respiring water that took her breath away. Yet the shallow pool was a sparkling redemption, an ecstatic solitude, revealing the world without prejudice, without morality. Fuller came to call places like the pool her "elemental manifestations," phenomena untinged by human likeness that "seemed to press themselves into the brain." Art was the lone gem in the empty field, coldly beckoning, a rival to love.

Grand Central

Red sash and belt bright, a tuft of white feathers flaring from a wrap around his head, the Onondaga chief Ut-ha-wah was lost in his own world. Staring into space, posing for his picture, he bided different times: uncertain future, distant past, the duration of posing, a climate of times, a meteorology of days, stuck in sequence, held in steady gaze. This man of such political importance for so many years, who had brought the Iroquois into the War of 1812 on the side of the Americans, held no center now. The same year he posed for his portrait, the Onondaga and the other tribes of the Haudenosaunee (or Six Nations of the Iroquois) had signed a treaty agreeing to cede their ancestral lands in Upstate New York to the American government and were heading west to the Kansas Territory, part of the US government's Indian Removal Policy. Rescinded by another

one four years later, the treaty still made the change in Ut-ha-wah's power clear enough. Art comes along when all is lost.

William John Wilgus, the painter of Ut-ha-wah, was a type of magician. A friend likened his brush to a wand. Just nineteen when he painted the portrait, he was renowned for his power to make painted figures look alive. In his studio in Buffalo, New York, on the second floor of a building above the Erie County Savings Bank, he made art of durable value, far more trustworthy, so it seemed to its early viewers, than the arbitrary coinage of ordinary portraits. When Wilgus later sold the painting of Ut-ha-wah in exchange for a farm in Lewis County, New York—a farm that he later sold for $1,600 in gold—he demonstrated that his art was a kind of real estate that magically kept its value. In a time of financial uncertainty—the Erie County Savings Bank had been created in response to the Panic of 1837—true likeness was a gold standard, portable across time and space.

Back in 1833, when Wilgus was fourteen, he was sent to New York by his father to study painting with Samuel F. B. Morse. Morse, an ambitious painter, was growing disenchanted with his profession, which had brought him insufficient fame and fortune. Soon he would turn to the invention of the telegraph and the Morse Code that would make him famous—though not without acknowledging a debt to painting as the basis for his new science. Using a picture frame as part of his first telegraph apparatus, he understood that paintings were message-sending devices: that lightweight canvases could be transported, as Jennifer Roberts notes, from one place to the next, their content intact. A portrait was a temporal telegraph: retaining a likeness over the years, the message of a person perpetually legible. "Keep, then, this portrait," a Seneca chief reputedly

told Wilgus. "Lose it not; give it not away; but put it in some safe place where it may remain forever."

It did not matter that the times themselves were speeding up, that the railroad age just beginning when Ut-ha-wah posed for his portrait was gathering force. Nor did it matter that Wilgus, dying of tuberculosis at age thirty-four in 1853, did not live to see much of the new age. The new mobilities carried his name onward even as he remained stuck in time. In 1865, twelve years after his death, a second William John Wilgus was born, a nephew named after his uncle the painter. And this nephew, watching a surveyor map the family's farm in 1876, fell in love with engineering's "mathematical exactitude," its "aesthetic charm," and later became an engineer, a railroad man, and eventually the architect of the new Grand Central Terminal in New York. It was this second William John Wilgus who devised the two-level tiers of tracks still in use today, who conceived the plan of extracting "wealth from the air," in the form of a twelve-story office building above the terminal that would eventually pay for its construction. An artist in his own right, an architect of far-flung space and time, the second William John Wilgus displayed one of his namesake's Indian paintings in his Manhattan home. As one of the trains of the New York Central railroad line was called the Iroquois, the portrait that hung in the new William John Wilgus's home—of a Seneca chief named Tommy Jemmy—sped through time and space.

Terminal and train, goal and journey: Wilgus's *Ut-ha-wah*—also called *Captain Cold*, after the name the chief's white allies gave him—projects a melancholy fixity in an unfixed world. With its subject radically still—the man posed, frozen in contemplation—the portrait seems to gird itself for a new era of thrumming speed, a time with few constants

except changing points of view. Call it a new era of artistic portability, an era of *displacement*: a time not just of Indian Removal but of objects themselves anticipating their own departure from different shores—their banishment manifest in heroically sorrowful looks of loss. The white feathers atop Ut-ha-wah's head make a crown of transport, a plume of flight and height, less markers of a cloud come down to lift and bathe the man in puffs of deity than to suggest that his true apotheosis—the wreath he must wear—consisted in the signs of vast distance, the bird's-eye views, that made him remote.

Back in the Onondaga lands, the woods themselves refused to stay put. In the great deforestations that began in the 1830s, planked and planed trees began traveling far and wide. The very words for the trees likewise began to change, get lost, become obscured. Among the words that faded, thanks to federal assimilationist policies that prohibited the Onondaga and other Iroquois tribes from speaking their own tongue, was the one for chestnut. As actual chestnut trees started disappearing early in the twentieth century because of an insect-induced blight, stories about the tree likewise began vanishing. So did instructions for using the properties of chestnut trees as medicine. Several Iroquois languages eventually had no words for these trees. And if there were no words to speak of the chestnut, there eventually would be none to speak *to* it. Of a new genetically modified chestnut tree, brought in by scientists as a form of restitution, an Onondaga elder recently asked: "Would you really trust that this new being will have the ability to hear it when it's spoken to and understand that you're speaking to it?" In the spiny burrs enclosing each chestnut, the tree held a secret about propagation and doom, about a language spread to the winds and dying on the ground.

Portraits themselves carried a natural genetic code that spread the likeness of a person like seed. Again like trees, portraits sheltered an unspoken dialect, a far-traveling muteness, a funerary retirement within themselves. If trees had become so accustomed to becoming boards that they had forgotten the meaning of their own rustling leaves, then portraits as they went forth also lost their origins, forgot their purpose, kept their peace. One of Wilgus's subjects "placed himself in the attitude of an orator," but Ut-ha-wah has nothing to say: nothing except that he will silently assist his viewers in forgetting who he was.

Only the feathers make a kind of sound, a note of sovereign brightness. Nearly weightless, and for that reason flying, they make a crown of lightness and soft abandon. They sanction being lost on the horizon. Call it historical consciousness: the flutter of things from afar, gathered roundabout the head, struck down and raised up. The crown and the aim, the spoil and the game, some memory remains.

The Tavern
to the Traveler

The Sleep of John Quidor

He slept on a long bench in his shop. You could not really call it a studio. This was in Manhattan about 1830, near the corner of Pearl and Center Streets.

Ancient dust carpeted the windowsills. It coated the few chairs, the mantelpiece, and even (it seemed) the man himself. When awake, he worked on his paintings, a commercial banner or a big wooden picture for the back of a fire engine. He ignored his students, two young men who milled about with nothing to do. Sometimes he would leave the shop for days or even weeks. Then he would come back and lie down again on the bench. Only a few years earlier, during his own student days, he had successfully sued his own teacher for having neglected to teach him properly, but now he himself was the neglectful teacher. Maybe it was neglect itself that his art portrayed.

In a corner of the dusty shop, one of his paintings rested on a crude easel. It showed Ichabod Crane fleeing on the white horse Gunpowder through a spectral forest of twisted trees. The artist had been adding some crusty bright white to the scene, and the results showed. Moonlight stuck like sugar to rocks and roots. Gunpowder appeared as glazed as a cookie. Near the shop where the painting sat on the easel, the brothers Robert and Alexander Stuart had just built a sugar refinery at the corner of Greenwich and Chambers Streets, producing "the highest quality sugar the city had ever seen . . . eliciting the 'wonder and admiration' of their fellow refiners," but the painting on the easel was not sweet, and it was not refined, and it elicited little wonder or admiration, though it was admirable and wonderful.

Washington Irving's tale was the painting's source, but the artist had made the story his own. It was as if he had

dreamed it into being, painted it in his slumber, as if he needed comatose retirement to arrive at this dark and comic self-conception: the inept schoolmaster, mocked by all and teacher of none, fleeing from imaginary fears so desperately that he becomes an even greater object of contempt. With his pointed witch's chin, the schoolmaster races alone in the darkened wood, fleeing from one aimless point to the next, the lunar brightness spotlighting him so remorselessly that he might be victim and criminal alike. The artist's two students, in awe of their teacher despite his desultory instruction, thought the steed was "a high-mettled courser, rivaling in naturalness and beauty the best on the Elgin marbles." Yet a reviewer noted that the horse was not like "anything in the heavens above, the earth beneath, or the waters under the earth."

The artist's only light was inward—a mental projection, the mind's moonbeams, the phrenology of a sleepwalking brain. Woods and painting converged as the labyrinth of an absurd and solitary freedom, a lawless place of singular visionary experience. And if that experience was terrifying—a matter of fleeing from oneself—the journey was strangely mixed with solace. The painting of Ichabod on his horse, barely reputable as a work of fine art, resembled the signs the artist sometimes painted—for example, the sign of an inn. *Here*, the sign said, eschewing all images of comfort by showing the unnerved traveler his own terrifying journey—as if the way to reassure people were to show them their own fears—*Here you are welcome*. Leave your learning at the door; bring only your delusions, the self-deceptions that alone make you memorable. After a night of terrors, enjoy some of my own.

The Dancing Figures of the Mountain Pass

There was talk in the barroom of making a new road over the mountain. Countrymen assembled in shirtsleeves, their legs crossed over one another, whips in hands, ready to bid on the job. Later that day, as the sun set, a stranger stopped and stood before the barroom door. This was in North Adams, Massachusetts, in late summer 1838.

The stranger carried a hand organ with an attached row of painted figurines. He bore this composite object on his shoulder, fastened to a staff, which he now anchored on the ground. As he began to play, the little figures began to move, and a group at the barroom door strained to get a look. The figurines—"dancers, pirouetting and turning, a lady playing on a piano, soldiers, a negro wench dancing, and opening and shutting a huge red mouth"—kept time to the music. The assembled crowd declared his entertainment "the masterpiece of sights" and paid the man a few coins.

An observer imagined the stranger's long and silent journey over nearby Saddle Mountain to get to the tavern. It must have been a great contrast—the gap between those elevated miles and the coarse frivolity of the public house, not just for the man but for his synchronized figurines. Up on the mountain there was no audience to watch the show; the man was alone, his entertainment dormant. But perhaps like all such things the mechanical dolls retained their uncanny life even while inactive, even with no one to see them, perhaps even especially then, when they were alone with their operator.

Perhaps for this reason, as they pirouetted and played before the yokels of North Adams, the figurines seemed to know more than they let on—even to display, if it may be put this way, a proper contempt for their audience. That contempt, if that is what it was, was maybe more that of

the player of the hand organ himself than his puppets, but it was funny how the grimacing little figures sported their own attitudes. What exactly those attitudes were, however, was anyone's guess. No sleuthing could discover their secret, and this impossibility of solution seemed to contribute to their confidence, adding to their poise as they twirled and marched and went through their cocksure motions.

High above the town, Saddle Mountain looked huge. Its trees and granite outcroppings made a black-green, blue-black mass. Clouds obscured the top of the mountain, some of them forming into swells like huge ocean waves, others making fantastic shapes that made the mountain seem to dream itself, aswirl in its own thoughts, while down below the cloudy-brained observer, in a summit of his own mind, could not be sure if he, too, had not wreathed reality with his own fantasy. The mountain mixed truth and delusion: "Cloud-land is one and the same thing with the substantial earth."

That mountain is what the dancing figures knew best. From the puppet master's tread across the blue-black height, they felt the thud of the ground in their delicate mechanisms. They were proud that even at such a height they maintained their own miniature elevation, there at the top of the staff through which the shocks of the earth administered pulses of jangling life. Up in that doubled altitude—top of the staff, top of the mountain—they knew filtered silence and violent storms, and they carried that rarefied experience down to the valley town. The summit of their skill lay in channeling the silent ramparts of the wooded mountains into barroom entertainments. There was nothing rude in their comic grimaces, their mastery of tempos fast and slow, but they portrayed what no polite art could show: the secret springs, the obscure truths, the lost wisdom before the new road.

The Dutchman's Diorama

A small tavern stood on a ridge atop Hoosic Mountain. In the unpainted barroom a gray-bearded man was holding forth. He called everyone "Captain," and they called him "the Old Dutchman," though he was German. He traveled the country with a wagon containing his "Diorama," which he invited them to inspect. Viewers looked through a glass lens and saw inside an unfurling succession of crude and wrinkled paintings showing the battles of Napoleon and Nelson. Into these scenes the Old Dutchman's big hairy hand occasionally descended to point out salient points of the action. He took pride in his show though he readily laughed alongside his audience when the "ludicrous miserability" of his art became too much to ignore.

Leaving the tavern, a traveler walked a mile to the bleak brow of the mountain and looked down on a world in miniature. Far-off Mount Monadnock glowed in the sun, the valleys sparkled around it, and the Deerfield River turned in its course. The vista was delightful after the Dutchman's stale entertainment. The ever-unfolding scene extended some sixty miles, a fresh and immediate vision, nothing like the vagabond's pathetic entertainments, the ridiculous deus ex machina of his didactic hand. Yet the opposite was true too. The man on the edge of the mountain felt that all he saw in those sixty miles emanated from the Dutchman, though the grizzled artist was still back at the tavern. He seemed the roaming spirit of the place, good-humored and grave, the wrinkled genius of the hairy fist, cranking now a much larger lever to reveal, one by one, the splendors of a vast valley world. Reflecting further, the traveler thought that all he saw—the immediacy of the scene below—was an imposture, the forfeiture of a god, a nameless stranger keeping folk busy

with visions of glory and peace so they might disregard his foul little pictures, his cracked and predestined pageant.

Menagerie

One day a caravan of wild animals came to the next town over from North Adams. Under a makeshift tent with a floor of grass, the showmen drew forth their animals before a large crowd. One of the men brought out four anacondas, the sluggish snakes draped around his body eventually livening up and sticking out their tongues as he described them in historical, poetic, and fanciful terms. Meanwhile, in the main amphitheater of the makeshift show, another animal trainer put his arm and whole head in a lion's mouth in front of a breathless audience of factory girls.

That night at the tavern, the anaconda man and the lion man talked of their troubles. A cage containing a leopard, panther, and hyena had overturned as the caravan came over the mountain. It had taken awhile to restore order. Now, just beyond the tavern's doors, all the animals were safe inside their cages, the lion looking disdainfully at the country boors gathered around it, the hyena snarling, and a lank white bear eagerly drinking water. The elephant, a mountainous mass, slept in a barn.

The creatures came from afar. They lost their origins. They paced in solemn circuits. It was difficult for them to remember what they were, or else too easy: for each creature of birth there was nowhere else on earth. No idol, no purpose, none that they could glean, held them and their masters to any plan, save the chance that they might inspire a long look, might see an onlooker's face frozen into a mask, and one day become a broken memory of the time they prowled this little town.

The Man with the Amputated Arm

A man with an amputated arm sat down next to some other men on a stoop. His arm was missing two or three inches below the elbow, and they saw that one of his bare feet had no toes. His clothes were soiled; his beard was grisly with a week's growth. They all looked away, knowing that he was drunk and about to start talking. He told how he lost the toes to the glancing blow of an axe, and how well he handled the pain. He said he lost the arm to a steam engine possessed by an evil spirit. Setting his teeth, sucking his breath, he described how bravely he endured the pain—the cutting of the muscles, the sawing of the bone—and how, flexing his stump, he still felt his missing hand: "There is the thumb, there the forefinger." Formerly a lawyer, he was now a foul-smelling soapmaker. He said his study was man.

He was up on phrenology. Proudly he noted how well he discerned the true character of many people by feeling the bumps on their skulls. Naturally, he felt people's heads with his remaining hand, but perhaps he also waved the stump of his other arm over the heads of those he examined. If he did, then the missing fingers would have felt for those inmost zones of the brain—Amativeness, Concentrativeness, Combativeness—secret centers yielding to invisible hands, revealing only to a kindred phantom what no touch could divine.

A few miles away from where he spoke—his discourse always rational yet also "wild and desperate and ruined"—a curious double of the man, perhaps an earlier version of himself or just who he was at that moment as he sat on the steps, spilled through the deep woods. It was a stream "talking to itself, with babbling din, of its own wild thoughts and fantasies." It was "the voice of solitude and the wilderness—loud

and continual," talking "along its storm-strewn path," issuing from a waterfall crashing down marble cliffs.

Down in the valley, dams blocked this stream and canals channeled it, concentrating its force to turn millwheels. The wheels ground the marble cliffs of the waterfall into tombstones and doorsteps, even the very ones on which the man with the missing arm sat. At journey's end, down in the town, he was still a voice in the wilderness, turned to village use, but frothing to the last, recalling the wildness of the stream that no longer ran free to the place he was. What kept him going was a distinct picture of a scene no one saw so clearly as him. Out in the woods, at the base of the waterfall cliff, on the walls of a deep pool where the stream gathered before speeding onward in its yet unbroken wildness, he saw a gallery of initials and names shining on the marble walls, the chiseled graffiti of lovers and wayfarers, a record of life, a writing of invisible hands.

A Land of One's Own

The sun hurt her eyes as she lay in her cradle. The light stung like a wasp. Looking down, she felt the brightness rise, reflected off the floor, and believed that the sun was located under her mother's kitchen. Laura Bridgman, three years old, was recovering from the scarlet fever that left her blind, deaf, and unable to speak in 1832.

In Hanover, New Hampshire, her rural home, her parents raised her to touch as much as she could. Eventually she came to understand what these things were: a grandfather clock in the south sitting room; a chest for holding cheeses; a log with a deep hollow hewn in it, filled with water; a dead baby in a coffin. She was curious about baking, the making of

candles and soap, the boiling of potatoes for pigs, her mother's spinning and weaving on a loom. She was fascinated by the hearth fire and loved to eat burned crusts mushed in milk. She spent time in the attic with her dolls, sitting and sleeping there amid barrels of grain and rye and bags of flour. Lifted up by her best friend, the farmhand Asa Tenny, she loved to pick sour and sweet apples during summer and fall. Then, soon after her seventh birthday, she went away to Boston, to the school of Dr. Samuel Gridley Howe, to learn how to read and write.

Some seventy miles from Hanover, a young woman named Frances Henshaw sat down at her desk. She was a pupil at the Middlebury Female Academy, a school emerging from the pioneering efforts of Ida Strong and Emma Willard to educate young women. Henshaw was fourteen, the daughter of a merchant, and it was 1828, the year before Laura Bridgman's birth. That day Henshaw worked on her *Book of Penmanship*, a homemade encyclopedia in which (like all the other pupils, each at work on their own equivalent) she not only practiced her hand but also wrote a paean to Christopher Columbus, noted the distance of each planet from the sun, and executed in ink and watercolor a series of nineteen beautiful maps of different states in the Union.

Each map was a corneal vibration, a delicate touch. Henshaw's Vermont is a quilt of counties, lined in pale borders of blue, yellow, and green. The words "Lake Champlain" descend one side. "Lake George" is written upside down, and "Vermont" appears above a legend of leaves and pendant buds. Her New Hampshire is a phrenology of hills—the Connecticut River, bounding one side, makes a profile of bumps, a slender face of subtleties, crisscrossed in towns and minutely divided streams. The student's wrist shaped the rivers, until the rivers became the veins of her hand, a cartography of self

and country, "a catechism to the nation state," as Noah Webster put it, a country learned by heart.

In Boston in 1837 Laura Bridgman began learning the sign of everything. Her teacher pasted labels of raised letters on knives, forks, and spoons. Soon she spelled *s p o o n*. Then the labels were given to her without the objects, and "now the truth began to flash upon her," that she could "make up a sign of any thing that was in her own mind, and show it to another mind." Eventually she learned the manual alphabet, drawing each letter drily with her finger. Given a pencil, she began writing these signs on paper, her left hand touching and guiding her right, which held the pen. Years later she wrote a few poems:

> Yield the beam of sun to those around thee.
> A Candle cannot be overblown which is hid in
> the midst of the pure heart.

Here was a map of the eclipse, a tracery of self-reflecting lines, the mind turning upon itself, head bent, intent. It was a speechless sight, a country of words indrawn, the guttural dialect of hidden things, remembered only by themselves: rivers reversed in their courses, the sun burning in leafless trees.

Down the Well

The procession moved slowly to the burial ground among the low Ohio hills. The spring day was damp and cool, and the mourners were glad of their overcoats. They made their way to bury fifteen-year-old Jedediah Williams, beloved son and boy of the village, killed when a wagon of cordwood ran over him in the dusk. At the grave they lowered the coffin

into the ground with ropes, then raised it when it did not
sit true in the hole, the mourners interrupting their grieving
and opening their eyes for a moment to wonder why the
casket had reemerged. When the coffin went back into the
ground, this time set right, a sexton threw straw on the lid
to damp the ugly sound of dirt striking the wood.

A few years before, the boy's father had a scheme to get
rich. He had been digging a salt well on his property—the
land between Marietta and Zanesville abounded in saline
deposits—and he had made an enticing discovery. Mr.
Williams and his men had bored a shaft through layers of
graywacke, sandstone, and shale until about one hundred and
twenty feet down they got to a layer of gray flint, a layer so
hard that the bore descended only about an inch a day. When
the drill came back up, they noticed that it dropped not just
gray stone but tiny bits of shiny metal on the ground. Taking
this metal up, they found they could flatten it with a ham-
mer and that it would not melt when held with an iron ladle
over a fire. Soon they gathered as many of the shiny pieces as
they could find, took them to town, and watched in wonder
as a silversmith fashioned a single silver button of marvelous
purity.

Mr. Williams formed a company, invited investors, and,
amid rampant speculation, began operations. Drilling another
hole about forty feet from the salt well, he and his men bore
down until they got to the fateful layer of gray flint. But
examining the bit after each day of hard cutting, they did
not find any traces of silver, let alone evidence of a lode.
Cutting across between the new hole and the salt well, they
still found nothing. And then one day, with Mr. Williams
and his men working in the salt well, all having been low-
ered there in a large basket, an errant hammer blow or some
other accident let loose a torrent of water that quickly began

filling the shaft. Frantically climbing into the basket and call-
ing above for it to be raised, the men narrowly escaped being
drowned as the water rose like a living thing after them, up
and up, until it finally crested forty feet from the surface,
leaving them alone as they rose the rest of the way to safety.
There the dream ended. There was no silver. The salt well was
filled with dirt and old timber and sealed.

Fifteen-year-old Jedediah Williams in his grave had not
been a dreamer in life. Pragmatic, muscular, a farm boy, he
did not stare at the clouds and conceive fanciful shapes and
odd designs. The wagon of wood that ended his life was as
hard and forthright as its victim. Exhausted from a long day
of stacking and hauling this wood, not paying much atten-
tion in the twilight, the driver hardly saw the boy (himself
weary) before hooves and wheels knocked him down as he
trudged home. Now in death Jedediah did not dream of the
ground above him, the wood of his casket, or anything else.
His simple graveclothes likewise pictured no visions. But the
world dreamed of him. The stars rolled, the moon glowed,
and the tops of the oaks tossed as if in sleep. The seed-corn
sat in the earth and ancient ammonites imprinted themselves
on the shale. The world wove around the boy a habit of great
beauty. True, no one saw this telling theater of care, of cem-
etery stone, little hill, and dew in the grass. But the next day
the shrouded sun rose, awakened in the memory of what was
gone—a world bereft, lifted in visions of what was left.

The Song of Cold Spring

Two men on horseback turned off the beaten path onto a
wooded lane. One told the other, explaining the detour, that
he would like to show his friend an old oak. The oak stood

next to the cottage where he had grown up—it had over-
seen all his youthful happiness—and though his mother had
recently sold the property, he still liked to come by and look
at the old tree, "a familiar and well-remembered friend."

When they came in sight of the tree, however, the man
sprang from his saddle in alarm. The new occupant of the
cottage was about to cut down the oak, and the traveler ran
up to him.

"What are you doing?"

"What's that to you?"

"You're not going to cut down that tree surely?"

"Yes, but I am though."

"What for?"

The woodman said the tree cast a shadow on his cot-
tage. It made his home damp and made him and his young
daughter susceptible to "fever and ague." He said also that
as he got older, he did not feel like walking to the woods
(in those deforested days they were already a long ways off)
to cut down trees to sell firewood to make a living. The oak
was right there next to the cottage, a ready source of money,
easy to chop down, no journey required. Appalled, the trav-
eler bargained with the man, agreeing to pay him ten dollars
not to cut down the oak and making him sign a document
attesting that the tree would stand as long as the woodman's
daughter lived.

The genteel author George Pope Morris wrote the tale
as the backstory for one of his poems—a poem that, set to
music, became a famous nineteenth-century song that took
its name from the song's first line:

> Woodman, spare that tree!
> Touch not a single bough!
> In youth it sheltered me,
> And I'll protect it now. . . .

So much about the song was clear. The old lands were sold. A new generation, lazy and seeking easy profit, had to be paid off to keep from destroying the last vestiges of a gentler way of life. The emotional tone was serenely sad, accessible. Morris, in company with Henry Russell, who wrote the music, knew exactly how to avoid "the foam of excited passions," how to express a sentiment without becoming grave and unpleasant. The song floated like a flower on the stream; it never sank into murky emotional depths. And Morris knew as well how to split the difference between nostalgia and progress—he had included the poem, originally called "The Oak," in the same issue of his journal, the *New York Mirror*, along with an engraving of Columbus, herald of all the tree-hacking settlers there ever would be.

But something about the song defied description. It was *indefinite*. Edgar Allan Poe, the man who used this term of praise, felt that the real power of music was to create an indescribable mood, and that Morris, the nation's best songwriter, was a master of *indefinitiveness*, as Poe called it. A person got lost in the plaintive lyrics and melancholy tune; the song cast a spell. It bewildered and enthralled; it made a feeling of its own. Perhaps its design could be charted, but try to figure it out—whether as musician or auditor—and you deprived it of its "dreamlike luxury," its "mystic atmosphere."

Writers' houses give off dreams. Morris, making a handsome living, purchased a country estate in Cold Spring, New York, from the eldest son of Alexander Hamilton for the munificent sum of $6,000, christened the place "Undercliff," and spent summers with his family in the white stone and plaster manor overlooking grounds of oak, maple, and chestnut trees down to the Hudson River. Poe, much poorer, moved to a modest cottage in Fordham, New York, in 1846, a sylvan setting thirteen miles north of Wall Street that

eventually became part of the Bronx but was then still a ver-
dant land of country lanes, peach and cherry orchards, and
stately trees near the writer's small wooden abode, where he
resided with his consumptive young wife Virginia Clemm
and her mother until Virginia died, in 1847, and Poe himself
in 1849.

A grove of trees stood near the cottage. One summer
day, an adolescent girl came with her mother to visit, and
Poe, taking an interest, sat with the girl in the grove. To her,
sitting with the famous author of "The Raven," noting his
blue-black eyes, his melancholy expression, and his military
bearing, the place seemed "a grove of romance" such as he
might have described in one of his tales. "Look up over your
head into the trees," he directed her. "See how beautiful is the
play of sunlight among the leaves—how the shadow of one
leaf falls on another." His voice was so distinctive that, years
later, she recalled she "could listen to his speech simply for
the pleasure of the sound." That voice and the play of sun and
shade made an indefinite moment, a prolonged one without
meaning that she never forgot.

The Bronx River purled near Poe's cottage. Once on
a summer picnic in the wood overlooking the stream, Poe
sat beneath the biggest oak and recited to the assembled
company his poem "The Bells." His voice mixing with the
birdsong coming from the treetops, he spoke the lines

> To the rolling of the bells—
> Of the bells, bells, bells—
> To the tolling of the bells,
> Of the bells, bells, bells, bells—
> Bells, bells, bells—

The words rang until the river spoke, until the oak's shade
became the song Poe made. His listeners, their faces dark and

bright, lost their way, forgot the time. For a moment life became unknown, the reflections of the trees drowned. And somewhere a woodman, axe in hand, did as planned.

The Branches Played the Man

The music flowed across the landscape. A man played his flute at the base of an old tree, surrounded by a small party of men and women, picnickers who had finished their meal. As the musician played, couples flirted. One pair made eyes at each other. Another attended separately to the song—the man reclined and listened raptly while the woman stood and looked down at him as he listened. Two young women stared avidly at the musician, the nearest looking on him in admiration, while some distance away another couple strolled down a path. The musician was the center of the scene, not only of the genteel cadre of listeners but of the distant lake, fields, and mountains, which all seemed made by his song.

Then there was the tree rising above him. It was old but still flowering with new leaves. Straight out of the flutist's back this tree rose, an expression of his song. As many as six branches spread in different directions, all but one adorned with fresh growth, as if the music itself had caused the half-dead thing to spring to life. Preoccupied at ground level, the absorbed listeners did not notice this tree, and the musician himself feigned that he, too, gave it no thought. But the tree portrayed not just his song but the man himself.

Some twenty feet tall, it loomed above the group. The musician may have been low—he sat on the ground, a mere entertainer—but his song spread above the party, an otherness rooted in his being (his legs, matching the branches

above, were the tree's roots). The song was something greater
than himself, an organic serenade of new growth and with-
ered branch. Pointing up and down, anchored to the earth
and fingering the sky, the notes seemed almost to swirl,
broadcast like seed, spun or flung as though from a magician's
and not a musician's fingers. Like a looming genie sprung
from a bottle, the tree turned the vapor of music into bark
and branch, even as the listeners stared only at the musician
himself, at one another, or into thin air.

But the flutist knew of this arboreal power. Kissing the
wooden stem of his pipe and fingering the holes, he was
the priest of a sacred rite, presiding over a pantheistic ritual
before an unsuspecting audience. Where they experienced
only their own beautiful interiority, the depth and tender-
ness of their separate solitudes, he piped with a sylvan force.
Made of rushes, made of reeds, the thin syringes of Syrinx,
his flute was a nymph held to his lips, a sister to the tree, an
expressor of the same fantasy. Trees and reeds were parts of
some primitive cult, the crude instruments of fearsome dei-
ties and pagans sleeping on the ground.

Had the listeners actually looked up and seen this tree as
a manifestation of the song, they would have fled in terror.
But the lone maestro kept them from recognizing this source
of fear. He knew how to regulate the wildness of his art, to
let it flow so that a drowsy calm spread among his listeners,
without them remembering, or caring, or even knowing that
he spun for them the music of a far deeper sleep. In this mys-
tery—a pleasant tune concealing something elemental—he
relied on the tree as accomplice, on it masquerading as noth-
ing more than a nice place of shade.

But he knew that it was he who really served the tree, not
the other way around. The branches played the man, finger-
ing him like he held his flute. Down to the roots it clasped

him, overseeing his woody notes. His listeners kept mistaking his art for something polite, but he did as the tree said, this priest of Pan, his pointed ears hidden in tufts of hair.

And a good thing, too, that they were hidden. Had one of the group brushed back that hair, the sunny day would instantly have closed. Not with cloud or night would it have grown dark but with trees, a whole forest of them instead of just this one, roofing the party in gloom. Without a sky to see, without a God to acknowledge, their world—the forest world of the pointed ears—would have become immediate, carnal, a howling of baleful sounds. Rituals of courtship would have descended into one frequent and brutish copulation, the blind groping told in fairy tales of young lovers lost in the woods.

But as it was, all remained sedate, just barely, passions held in check. Romance had come to tame the forest, to clear spaces and expose the light of day. A woodland man was chosen, an appointed representative, to preserve the original bewilderment by channeling breath into mellifluous sounds, piping it in controlled doses, so that creaturely passions became a delicate dance, lustful desire an amorous glance. But above it all, a pagan lord wrote the score.

An Oak Bent Sideways

Ahyokeh was six years old when her father Sequoyah taught her to read. For some time Sequoyah had been devising a written language, a syllabary that would enable his fellow Cherokee to exchange thoughts and information remotely, just like white people did with the scraps of paper he called their "talking leaves." As Sequoyah worked, he realized that he would need a student who could learn the written signs

and prove their worth. He understood that adults were too skeptical for this role, so he turned to Ahyokeh.

She proved not only a willing student but an able assistant in the creation of the language, helping him reduce the number of characters in his syllabary from two hundred to eighty-five. She helped him see that not every syllable needed to have its own sign, that the hissing sound at the start of many could be reduced to a single character, equivalent to the letter "S." When it came time for her to read the written language in company, Ahyokeh did so easily, astounding the assembled chiefs and persuading them to adopt Sequoyah's system.

As a little boy, Sequoyah had roamed the woods and fields around his family's home, studying plant and animal life. An Enlightenment prodigy, he devised farm improvements (including a method to refrigerate milk) for his mother's dairy herd. Written language was only a more exalted invention. Sequoyah ridiculed the idea that writing made the whites gods; it was only a matter of plain logic. It was a political matter, too, with Christian missionaries busy teaching Cherokee children the Roman alphabet, a question of protecting the tribe's sovereignty while demonstrating—in threatening times—the Cherokee's capacity for intellectual achievement. Yet when Ahyokeh stood at a window and read from afar the name of a man Sequoyah had written down, it still seemed a miracle.

A secular prophet, Sequoyah stares from Henry Inman's portrait of ca. 1830, a copy after Charles Bird King's original. Like Moses with one of the tablets, or Doubting Thomas fingering Christ's wound, Sequoyah gestures to a slate—perhaps a canvas—displaying the wonder of his alphabet. Perhaps in collaboration with his learned sitter, Inman makes the miracle scientific. The alphabet is nothing that cannot be

explained, taught, disseminated. The tablet is no mirage but a real thing: the square fingers of Sequoyah's left hand emerge from the back, holding the legend firmly in place. His pipe, a smokeless stimulant, is only another prop in a sober lesson of the practical world. Yet the darkened background—darker now with time—suggests the unfathomable origins of his language. To his white beholders in Washington, Inman's painted Sequoyah was the saint of an unknown legibility.

The original painting hung on the second floor of the War Office Building in Washington, next to the White House, in a gallery of like portraits commissioned by the Indian agent Thomas McKenney. Together the portraits made a pantheon, an alphabet of native figures, a political syllabary of signs, a silent speech of uneasy truce, transmitted from afar, emerging from the doubled darkness of the gloomy hall. But then the newest president, Andrew Jackson, ordered Sequoyah's tribe, the Cherokee, to march from their homes in Georgia to Oklahoma.

The language of their forced march can be read in the landscape today—a language of trees. In Monterey, Tennessee, an oak bends over sideways only a few feet off the ground, swerving like a backflipping diver for about eight feet before suddenly rising straight up, the bole displaced far from the roots. Near Fayette, Missouri, off County Road 208, another oak bends in similar fashion. These are "culturally modified trees," or trail trees, as they are also called, that can be found in numerous examples across the eastern United States and other places. In the southeast many of these trees apparently date from the 1830s and 1840s, the time of the Cherokee Trail of Tears. The Cherokee made them by bending a tree when it was a sapling and then securing it in its new position with a vine, weighted rock, or strips of rawhide. The bent tree over time became a pointer in the woods, a directional indicator

designating a place of water, caves, or shelter, or simply the
way forward. The trees were so striking—sometimes with
doubled trunks, sometimes (when they bent and touched
the ground) with two systems of roots—that they could
not be missed. Like the artifacts discovered recently in the
Tennessee woods—at a site where Cherokee camped for sev-
eral months in 1838 on their forced trek west—the trees mark
a moment of time. But when the campsite was discovered in
2012, it was covered by generations of leaves, moss, straw,
and other forest litter, whereas the trail trees are themselves
a kind of nature.

They make a scattered alphabet, distributed along a
straggling trace where some four thousand people died
of dehydration, tuberculosis, and whooping cough. Dia-
grammed on a page, a trail tree in its evolution from sapling
to deflected age resembles a set of characters, the legend of
itself, told in mysterious script. Spread on the track between
Georgia and Oklahoma, they make a moving memorial, a
set of road signs, whose once-helpful guidance has become,
after the fact, a cenotaph for the suffering. As lone swerving
things in columns of wood, they once held sway as map and
legend, readable from afar, bending at the height of a person
on horseback, legible at the level of the eye. But now the
single sign has become a stranger vocalization, down which
the sliding snake of the S might hiss, marking trails that have
disappeared. The direction has become lost in the woods,
mumbling its own utterance, decrying its own silence—the
chalk slate, the writing board, the legibilities of honesty, now
forlorn, unencompassing, no path but the one that alters
course.

So it is that the young tree—taught to turn, trained
in a different art—charts the path art denies. No lon-
ger the philosopher in the hallway, minion and maker

of nation, semisecure in his portraiture, but another art, wrested from the world, a phonetics of wood so intermittent that a person expecting to string words together might venture a hundred miles before discovering the next syllable, and—so slow the progress—perhaps a hundred years will pass before a period commutes the sentence. But well before the end, in the middle of nowhere, the wanderer divines the erratic word of truth.

Come, Thick Night

Smoke and Burnt Pine

Nat Turner saw hieroglyphic characters on the leaves. Written in blood, they portrayed men in different poses, the same he had seen in the sky when the Holy Ghost had said to him, "Behold me as I stand in the heavens." The spirit revealed itself in a stretch of lights spanning east to west—the Savior's hands extended on the cross. Now amid signs closer by—the dew on the corn, the blood-men on the leaves—he understood that Jesus had risen to heaven and come back to earth. "As the leaves on the trees bore the impression of the figures I had seen in the heavens, it was plain to me that the Saviour was about to lay down the yoke he had borne for the sins of men, and the great day of judgment was at hand."

Turner owned a Bible, a pocket-size volume about five by three and a half inches, densely printed on thin paper. Tattered and rounded at the corners, its front and back covers torn off along with its opening and closing chapters—Genesis, Exodus, Revelation—it is now a contact item, a holy relic: not only Turner's personal book but the one he is said to have held when captured on October 30, 1831, some two months after he led the rebellion on August 21 of that year. As Turner saw the signs, now this Bible is the sign of him.

History in that Bible is dense and thin, portable and hidden, an illegal literacy of self-begotten truths. It speaks the words of heaven but it was also down in the hole where Turner hid, in a pit he dug with his sword beneath the crown of a fallen tree, its toppled peak lying in a clump of fence rails. The truth resided in unlikely places, concealed in plain sight, not far from the events it ordained, where sky and earth rose and resided. After the rebellion, Turner was as before: "wrapped . . . in mystery." No martyr but the man, no deed or

doctrine but by his own hands, cupped in palms of the Lord
unseen.

He had cogitated his plans at a self-secluded place in the
woods. William Styron imagined it as "a mossy knoll encir-
cled by soughing pine trees and cathedral oaks." In that place
not far from the home of his master, Joseph Travis, Turner
"built a shelter out of pine boughs," using it as his "secret
tabernacle," where he would stay for days at a time, fasting to
hear better the voices of prophets. "The crashing of deer far
off in the woods became an apocalyptic booming in my ears,"
reflects Styron's Turner. "The bubbling stream was the River
Jordan, and the leaves of the trees seemed to tremble upon
some whispering, secret, many-tongued revelation."

The strokes of the axe that killed the master Travis and
his wife on the night of August 21, 1831, made another order
of time. They split the moments not just into before and after
but into ever-finer divisions and subdivisions, a whole real
estate of life and death, bordered suddenly, it seemed, by
nothing finite at all. Towns and counties took flight; maps
lost their legends. The Travis bedroom became a laboratory in
which moments, shaved by an axe, revealed an eternal hue,
a rainbow glossolalia, spoken in tongues of smoke and burnt
pine, a drought and parchment of terrific thirst. In that loss
of speech, clouds severed from the sky and stains fell like
rain, revealing no dream but of the end of time, no way of
effecting that dream but in the time the dream annulled, and
no wonder but the blade, in a shiver infinitesimally fine. All
that remained were ordinations of territory unclaimed: no
rule but abandon, no order but the one unbound, a country
of the spotted leaves.

Sculpting Thomas Jefferson's Face

Down the paths of Monticello the New York sculptor rode. John Henri Isaac Browere was arriving to make a plaster life mask of Thomas Jefferson, then eighty-two years old, using his secret process. The elderly Jefferson had recently broken his arm falling into a stream when his horse stumbled on the muddy bank, and he was in declining health generally. The business of slathering his features with plaster to achieve a remarkable "face"—indeed so lifelike as to seem less like a sculpture than a type of protophotograph—seemed too arduous for him to endure. But James Madison had provided Browere a letter of reference, Jefferson's family wanted the mask made, and the former president felt he could hardly deny a person who had come so far.

There was a reason to consent. A Browere sculpture made the man, preserving him for all time. It made him so exactly that there seemed no art at all, just a pure transcription of his features. It was "so simple and direct that, next to the living man, he has preserved for us the best we can have—a perfect *facsimile*." Other mold makers could not rid their masks of the somnolence of the sitter—the subject needed to be nearly comatose, a mass of slackened features, beneath the plaster— but Browere and Browere alone had figured out how to keep those features animate, perky. This was his miracle, his secret.

But at Monticello it did not go well. Jefferson lay on his back on a sofa, grasping a chair with his good hand. His family did not want to see him with the plaster coating his face, so they left the room, leaving him and the sculptor alone with Jefferson's trusted slave Burwell, who stayed to look after his master. After Browere laid on the plaster, Jefferson began having trouble breathing. He tipped the chair he held in one hand up and down, knocking the legs on the

floor, signaling his distress. Burwell came to the rescue and
Browere began breaking the cast with a hammer and chisel,
jarring the old man's head with the knocks. Once the mask
was broken off the face, some plaster still clung tenaciously
to the neck, requiring the sculptor to take a knife in his pow-
erful hands and run it between the skin and mold. The cast
having fallen in pieces to the floor, Browere picked them up
with satisfaction, seeing that the likeness once glued together
would be good. He disregarded the stare of Burwell, who held
the president in his arms and cast the plasterer a fierce look.

Nine years later, when Browere was dying in New York,
a victim of the cholera outbreak of 1834, he asked that the
heads of his most important plaster busts be sawed off and
placed in crates for forty years. Only then would his work be
revealed to a more enlightened future generation as a great
achievement. He raved on his deathbed as he did even in
better days, vilifying the academic art establishment that
had jealously dismissed him, envious of his extraordinarily
lifelike art. He hated the rumor about how he had nearly
killed Thomas Jefferson, the legend that went first to the
newspapers in Richmond and then to other rags across the
nation. It was all a lie—the man's life was never in danger.
His enemies hated his work because it was too true.

The refined artists scorned him as not really an artist at
all, just a man who coated people's faces in goo and peeled
back a perfect copy: he was a mechanic, a laborer. His studio
was a "plaster factory," as Browere himself called it, there
at the corner of Center and Pearl Streets in Manhattan, not
far from the home of John Quidor, his friend. They made a
perfect pair, those two—Quidor with too much imagination,
Browere with none—united in their pursuit of the uncouth.

But there was something off-putting about his work.
Even on the best of days a whiff of death attended Browere's

art. When he rode up to a notable person's house, it was as though the undertaker himself had arrived. With his plaster and chisel, he might as well have been measuring coffins; his presence was a sure sign that his subject was not long for this world. His first bust, back in 1817, had been of John Paulding, a dying hero of the Revolutionary War, one of three colonial soldiers who captured the British spy John André and sent him to the gallows. Now Browere was the executioner, the likeness-man, first taking Paulding then eventually his two colonial comrades, David Williams and Isaac Van Wert, before turning to other elderly worthies, transiting them on plaster-caked journeys to the beyond. No wonder a famous person might take fright on Browere's approach. He would freeze you in time, turn you to tendon and bone, and suck all moral value from your speechless head. Jefferson, barely alive and almost killed in the act of commemoration, died the year after Browere's visit. And pity the destined subject that gained the grave before Browere could arrive. He was not above exhumation.

When his busts were uncrated forty-two years after his death, displayed at the Centennial Exposition of 1876, the wrinkly replicas were less a national gallery than a sideshow, a carnival, and not a terribly beguiling one at that. They attracted only a few gawkers. In life the man had been an evil wizard, a weird force, who routinely cast "terrible imprecations upon the heads" of his enemies—curses strangely like the creepy terms of his plastered praise. The late sculptor's son, himself an artist, bestowed the remembered sitters with posthumous togas, hoping to dignify their strangely naked shoulders, but it was no use. The pantheon was a crypt.

Strange then that Browere and Nat Turner both came within a hair's breadth of taking the same life. Turner originally fixed the date of his insurrection as July 4, 1831,

choosing it because Jefferson had died on that day five years earlier, fifty years after the signing of the Declaration of Independence. The deed accomplished, Turner might become a new Jefferson, author of a new declaration. By a black art he would be free, his Bible a new national creed. Jefferson would symbolically die a second time, falling in the name of the scripture he had taken to reading in his last years, when he expressed "his contempt for all moral systems compared with that of Christ." When Turner moved back the date of the rebellion, he might still have taken solace, had he known that Browere had already scared the life out of the president, nearly suffocating him and holding a knife to his throat.

In the way of things, however, the symmetries were not so neat. Turner himself sat for a macabre and lifelike portrait, the interview of Thomas Gray, who took a "faithful record" of the prisoner's words while he awaited death in his Virginia cell. History for Gray, no less than for Browere, was a perfect replica on the eve of death. Did anything escape this mortuary craft? Art palls, it obscures—but in that night, that tone of smoke, we hear a voice otherwise withdrawn and gone.

Reading the Leaves

Three women gather around a table in a darkened room, staring at the dregs in a teacup. The eldest woman, a fortune-teller, tilts the cup in her right hand and points into it with her left, a look of recognition spreading on her face. A young woman seated across the table smiles and tugs her bonnet to hide a happy blush—her fortune is revealed. A chaperone, perhaps an older sister, stands above the young woman and stares down at the cup while resting her left hand on her ward's shoulder. The tidings are glad, the fortune is

good—a betrothal?—but something is off. The fortune-teller looks slightly crone-like, with her pointing finger, upturned nose, and pointy chin, her frilly bonnet of zigzag lace, her keen and wide-eyed vision. The two young women, cloak-wrapped outsiders to the darkness, appear sweeter—only half believing the omen, tittering at the augury—but together against the blackness, the trio reminds us that witches come in threes. The tablecloth is their charmed circle, a cauldron swirling with leaves that fantastically enlarge and spill what the older woman must see in the hidden cup.

The scene of the fortune-teller, a painting called *Dregs in the Cup* made by William Sidney Mount in 1838, reveals the traces of older pictures—much more venerable ones such as Caravaggio's *Incredulity of Thomas*. Caravaggio originated the kind of painting Mount made: a large canvas foregrounding life-size figures in dramatic actions. The tracing, however, reveals a stuttering of tongues, an incoherence, a gravitas lost. In Caravaggio's picture the risen Jesus invites Doubting Thomas to place his finger in the wound in his side, while two other apostles look intently upon the mystery. In Mount's painting the doubter's finger has become the fortune-teller's, the spear wound in Jesus's side turns into the teacup, and the staring apostles morph into the two young women. As though in a great game of rumor, Mount is the last person to hear a secret whispered from ear to ear across the centuries, and thinking he has it straight, ends up painting a garbled and slurred version of scripture, the dregs of tradition, the Resurrection of Jesus as a tableau vivant.

But maybe in this play there is a truth: the kind revealed in necromancy, indirection, the weird ritual of hocus-pocus that nobody buys. In *The Narrative of Arthur Gordon Pym of Nantucket*, published in book form the same year Mount made his painting, Edgar Allan Poe describes Pym's ordeal as a

stowaway on the whaling ship *Grampus*. Left with a supply of food and matches until his friend Augustus can liberate him, Pym sits in a cramped and dark six-by-four-foot box below decks and waits. Hours pass, then days. Supplies dwindle and Pym's courage starts to fail. Finally, a piece of paper is thrust into the darkness. Like the cup in the fortune-teller's hand, it promises to divulge the true nature of things. But Pym cannot read it in the dark. After groping around for a stray match, he glimpses a few marks in the sputtering flame, seven words written in red ink before the light goes out: *"blood—your life depends upon lying close."*

This is the sacrament, the sign—the red ink, the blood—the message on which a person's life depends: an omen, an obscure truth, a mystic star. Written in Richmond, Virginia, where Poe was editor of the *Southern Literary Messenger*, and published in the *Messenger* itself, the double-written line—Poe writing on a piece of paper about a piece of paper with the line *"blood—your life depends upon lying close"*—comes from the world Nat Turner made.

It is all about reading the signs. Pym, now a castaway taken up by another ship, eventually sails so far south he approaches Antarctica. He lands on the wooded isle of Tsalal. The Tsalians are "jet black, with thick and long woolly hair," clad in the skins of an "unknown black animal." They profess friendship but lay a trap and kill the ship's entire crew except for Pym and a companion, who, wandering dazed, encounter strange carvings on a marl wall. The carvings seem like an alphabet—"Ethiopian characters"—though it turns out that the marl itself has simply broken away in spots to create the illusion of writing. Pym makes a drawing of the apparent hieroglyphs and other pictures of the winding chasms where he found this natural language. Call it a kind of underwriting, shifting in the mud, scattered from the stars, a portentous language of revelation.

The cup drained to the dregs in Mount's painting contains its own kind of truth. Below the delightful premonition, the forecast of love, lay the literal remains of a past, not only the steeping of the tea but a pictorial memory: Jesus exposing his wound, Thomas inserting his finger; the admonition to believe without vulgar proof, to accept a miracle on faith alone. The parable took place below decks, beneath the visible artifice of the painted scene, the contraband philosophy of the catacombs, a stowaway's faith in the dark. Through a portal—the portal of the cup—the blood and dark bubble up. The witches, called Truth and Proof and Faith, giggle at the wound and lift the cup, their world of semblances and falsities requiring just this eucharistic draught if it is to endure: *"blood—your life depends upon lying close."*

A Meeting in the Great Dismal Swamp

When Nat Turner contemplated how to evade capture following the insurrection, he thought of the Great Dismal Swamp, a vast area of land on the southeastern border of Virginia and North Carolina. He may have hoped to gather there with other escaped slaves and start a larger revolt against the white people of Virginia. Journalists fixated on the swamp during the weeks that Turner was a fugitive, speculating that he would join the runaways rumored to be living there.

The swamp was a geological freak. Most swamps develop when rivers flow into land basins, but the Great Dismal was higher than the surrounding ground and seven rivers flowed out of it. It abounded with evergreen shrub bogs, loblolly pine barrens, cypress swamps, brier thickets, and stands of red maple, pond pine, sweet gum, mulberry, and other

trees. Copperheads, cottonmouths, and rattlesnakes writhed in the wet shadows. The slimy ground sucked each footstep and immediately filled it with water. Surveyors saw trees of a "great Bigness" barely standing in the boggy soil, which allowed little hold for the roots. High winds blew many of these big trees down, making thick barriers hazardous to travelers, who, trying to hack their way through, suffered accidental self-inflicted knife injuries when their raised machetes deflected off overhanging vines and cut into their own bodies. Old-timers said that bathing the wounds in the swamp's deep brown water—infused with juniper, cypress, maple, and gum—prevented infection. A strange place it was, inflicting harm and curing the wounds it caused.

But the soil of the Dismal never sucked Nat Turner's footsteps. No swamp tree slashed by his sword delivered in return an injury to him who hacked it. He hid some sixty miles from the swamp, close to the site of his rebellion. But together the man and the swamp made a curious symmetry, alike in their commitment to obscurity and refuge. The swamp hid him even though he was not there. So perfectly did it express the idea of concealment that, in effect, it secreted him. Suffocating the sky and one another, the pines and toppled cypresses created a verdant gloom of solitude, a rank wetness of pocketed black, that "envisioned"—if trees can be said to perceive anything at all—the figure they would never see. And because they themselves could not be seen— not in that grim vastness—these trees in all that brown water made a perfect image in the minds of those picturing the man they believed was there. To the white person blowing out a candle in Norfolk or Richmond before sleep, the place took on a gothic luster.

By then, barges, sloops, and even steamboats were plying the turgid water, bringing the swampland timber to

market while bypassing the hazardous ocean passage between Albemarle Sound and Chesapeake Bay. Yet the long-standing wish to develop the swamp—begun by William Byrd II, expanded upon by the young Virginia planter George Washington in 1760, and ultimately brought to fruition with the opening of a canal system in 1829—did not reduce the place's self-secluding mystery. It remained a nightmare location, a psychological phantom that truly existed. In that cloaked darkness, so often unpenetrated by "the Genial Beams of the sun," what overwhelmed most were not the sinister clusters of pine cones, the curtains of reeds ten feet high, the wildflowers blooming and spraying in the choked air. For white Virginians following the rebellion, the whole twisting mass was like the intricacy of one brain.

Or was it two? Poe also thought of the swamp. Maybe he thought of it enough that—by envisioning it, by calling it into his mind as a true place of the imagination—he succeeded in meeting Turner there, meeting a man who likewise in envisioning the place came to be a kind of resident there. By a mutual investment, a common power of mind, they each came to where they never went, and, in so doing, met each other in that location of the intellect. Turner as a boy found "many things that the fertility of my own imagination had depicted to me before." Poe saw quite clearly the swamp he never visited, picturing it as "a forest of tall eastern trees," where the shadows of these trees "sunk slowly and steadily down and commingled with the waves," where "the waters of this lake grow blacker with age, and more melancholy as the hours run on." He pictured a place where "each shadow . . . became absorbed by the stream," where "Darkness fell over all things."

In that darkness Turner and Poe convened. For them, tree, shadow, and reflection constantly changed places, so

that nothing and everything was real, fantasy and actuality sinking and surfacing in a play of fiction and truth. They named something about the swamp itself, the way it generated blackened visions, trees pooling in the brackish infusion of water, steeped in self-regard, with no one to see them seeing themselves, so that the keen imaginer, the person wrapped in himself, the man such as Turner who could reflect "on many things that would present themselves to my imagination," or a man such as Poe, found a still keener envisioner in the swamp itself, a kind of million-acre mind, drowsy, pure, and brown.

Perhaps in shadowy imaginings Turner and Poe met on the swamp's Lake Drummond, at the cypress called "the deer tree," which rises out of the lake, a tree so named after a witch who turned herself into a deer in a self-cast spell. Or maybe they clasped hands on the grounds of the Halfway House, the hostel opened on the canals in the 1830s that billed itself as available to weddings, assignations, and duels. Maybe they sat down there in imagination to a meal of wild honey on corn bread, of squirrel or venison, a filet of speckled perch. Swatting yellow flies and slapping mosquitoes, they eventually began their main business, talking not of duels or assignations but the interpenetration of plots, the tellers of tales, of lords, logos, and sacred signs; of holy wars, statutes, and chains; anarchies of the imagination and scriptures of the sane.

PART FOUR

Panic

Ere You Drive Me to Madness

Dorcas Doyen was born in 1813 in the tiny backwoods settlement of Temple, Maine. The place was just a few crude dwellings and farms deep in the forest. Dorcas's father was a shoemaker, one of many poor immigrants to the state at the end of the eighteenth century. Several years after her birth, seeking greater opportunity, he moved his wife and three children some forty miles southeast to the village of Hallowell, two miles from the state capital of Augusta. Dorcas found employment as a servant girl in Augusta and eventually, in 1826, at age thirteen, began working as a maidservant for Maine Supreme Court judge Nathan Weston and his wife Paulina at their beautiful new home on Summer Street.

The Westons regarded Dorcas as a protégé and opened their library for her use. She attended the nearby Cony Female Academy, becoming a favorite student among her teachers. At the Westons', she learned the social graces: a visitor to the home in 1827, met at the door by the young servant girl, was impressed by her manners and intelligence. On Thanksgivings the Westons would cross the Kennebec River to visit the home of the wealthiest man in Augusta, Judge Reuel Williams, taking Dorcas with them as help for the multifamily celebrations that Williams hosted each year on that holiday. The Williams mansion, the grandest in town, contained fourteen rooms, including an octagonal parlor decorated with expensive French wallpaper showing South Seas natives preparing to greet Captain James Cook on his voyages. Produced by the firm of Joseph Dufour, the beautifully colored wallpaper showed men playing pipes and women in stolae, their forms based on Roman frescoes found during the excavation of Pompeii and Herculaneum in 1748. Against

the cold sky outside, the paper was the warmest fantasy. In one scene three island women pirouette before a seated chief, their bare feet hardly touching the ground.

Sometime around 1830, rumors began spreading about seventeen-year-old Dorcas Doyen. Men noticed her and gossip about her romantic life began. She protested her innocence and the Westons took her side. But the innuendoes came from so many quarters that the judge and his wife eventually dismissed her. As for what happened next, it is difficult to say if the moralists of Augusta did not end up causing the fall they accused Dorcas of. She left the Westons in 1830 without many options and became a prostitute, first in Portland under the name of Maria Stanley, then in Boston as Helen Mar, and then—as Helen Jewett—in New York, where she moved in 1832.

The New York of that time was undergoing a boom. Concentrated in Lower Manhattan, the population had grown 35 percent between 1830 and 1835, rising to 270,000 people. Moral pamphleteers warned that the place was a "monstrous tide of depravity and dissipation," but young people like Helen Jewett enjoyed the sensual freedom of the great metropolis. She lived and worked in different brothels, attracted a small but attentive clientele, and soon became known around town for her dark-eyed, full-chested beauty, her wit and confidence. Wearing fine clothes and elaborate jewelry—sometimes she wore rings on all her fingers—she liked to walk unescorted to the post office, where she kept up a vigorous correspondence with admirers. Using different personae—the wounded bird, the sexual adventuress—she complimented and cajoled each client, making him think he was her only love.

Soon, however, she came under the sway of one man. Richard P. Robinson, a little younger than her, had grown

up in Durham, Connecticut, and moved to Manhattan in 1833 when he was sixteen. He lived in a boardinghouse on Dey Street and worked as a clerk in Joseph Hoxie's store on Maiden Lane, not far from the brothel on Thomas Street where Helen worked. Like many other young men newly arrived in New York, Robinson lived a life of aggressive bachelorhood, exploring the growing city and its attractions. Slightly built and suave, narcissistic and amoral, he believed half of the women in Manhattan were in love with him.

Like other young men in the city, Robinson read of Davy Crockett, the frontiersman whose legendary exploits on the page did not end with his death at the Alamo in March 1836. From 1835 into the 1850s, a fictional Crockett narrated his wild frontier adventures in numerous *Crockett Almanacks* aimed at the randy men newly liberated in the cities. No longer overseen by stern patriarchs and a "shadow cast" of women (mother, aunts, sisters) on their home farms, they explored their sexuality at will in the environs of the boardinghouse and beyond. The Crockett of the *Crockett Almanacks* offered page after finely printed page of wilderness libido, unchecked by rule or inhibition. "I'm the savagest creature you ever *did* see," Crockett says. "I can outlook a panther and outstare a flash of lightning; tote a steamboat on my back and play at rough and tumble with a lion. . . . To sum up all in one word, *I'm a horse.*" Crockett was unharnessed, Crockett was free. He fell asleep in the woods and awoke to find his head caught in the crotch of a tree. He got caught in the forest on a winter night and kept from freezing by shimmying up and down a thirty-foot length of tree trunk to make his arms and legs "feel mighty warm and good." "Along the Crockett frontier," cultural historian Carroll Smith-Rosenberg observes, "male sexuality was violent, nonreproductive, usually nongenital, and frequently homosexual."

Helen kept her distance from the men she slept with, but Robinson seduced her and she became emotionally dependent. Calling him by his nickname, she pleaded in April 1836: "Pause, Frank, pause, ere you drive me to madness. Come to see me to-night or tomorrow night. . . . Come and see me and tell me how we may renew the sweetness of our earlier acquaintance, and forget all our past unhappiness in future joy." Robinson's response was chilling. "I have read your note with pain, I ought to say displeasure; nay, anger. Women are never so foolish as when they threaten. You are never so foolish as when you threaten me. Keep quiet until I come on Saturday night, and then we will see if we cannot be better friends hereafter. Do not tell any person I shall come."

Arriving at the brothel on Thomas Street on that Saturday night, April 9, 1836, Robinson carried a hatchet beneath his cloak. At some point that night he struck Helen in the head with the hatchet while she slept, then set fire to the room. When two other prostitutes rushed into the room during the early hours of April 10, they found her dead in her bed, blood pooling around her pillow, her nightclothes turned to ashes, and one side of her body burned "a crusty brown." Robinson was soon apprehended—identified as the most recent visitor to Helen's room that night—but in a sensational trial covered by the era's new penny press, notably, the *New York Sun*, which proclaimed his innocence, he was found not guilty. A reporter who sought out Robinson later that year back in Durham, where he had returned, found him in "good spirits" and without guilt—a lack, the writer opined, resulting from his "total want of moral perception, and the untimely death of his conscience." Four months later he moved to Texas, ready to start a new life, saying in true Crockett fashion, "I can dance the tiger waltz, as well as the bloodiest."

Back at the brothel, a reporter noticed a painting of fron-
tier violence hanging in the front parlor. "It represented a
beautiful female, in disorder and on her knees, before two
savages, one of them lifting up a tomahawk to give her a
blow on the head." The painting was John Vanderlyn's *Death of
Jane McCrea*, painted in 1804 and part of the New York Acad-
emy of Art's collections. On view in the academy's exhibition
rooms on Chambers Street in the 1810s and 1820s, it had
arrived in the front parlor on Thomas Street likely because
John R. Livingston, one of the founding members of the
academy, was also "the largest owner of brothels in the city,"
according to Patricia Cline Cohen, author of the definitive
book on the Jewett murder. In the front parlor, where the
prostitutes and their potential clients gathered to chat and
eventually pair off, where large mirrors hung on the walls to
reflect the pretty gestures and seductive laughter, Vanderlyn's
painting offered a discordant and, as it turned out, prescient
note.

Jane McCrea was a seventeen-year-old girl who in 1777,
during the American Revolution, fell in love with an Amer-
ican Tory. Going to meet her lover near the town of Fort
Edward, New York, she was attacked and killed by Mohawk
warriors fighting for the British. A few decades later, her
grave had become a shrine; tourists chipped pieces from her
tombstone as mementos. As her legend grew, her love for a
Tory having been conveniently forgotten, Vanderlyn made
the painting as an illustration for an epic of America called
the *Columbiad*. By the late 1830s New York City schoolchil-
dren were reading of Jane McCrea's death in a textbook. At
the brothel on Thomas Street, Vanderlyn's painting was a
racy and perhaps patriotic prop. But following Helen Jewett's
murder, it took on an uncanny relevance.

McCrea was alleged to have died beneath a lone pine. Scouting out the tree in the 1840s, the historian Benson Lossing found it in dire condition: a recent storm had blown off the tree's top, and now any strong breeze blew down a scatter of twigs. The trunk was not much better off, "intaglioed" with the names of patriotic pilgrims, with McCrea's name, too, carved in bold letters. When the tree was cut down in 1849, an entrepreneur fashioned canes and boxes from the wood and hawked them at his Manhattan store, each with a certificate of authenticity as a true relic of Jane McCrea's tree.

The Manhattan Helen Jewett knew was the last one made mostly of wood. Four months before her murder, on the bitterly cold night of December 16, 1835, the wooden city had gone up in flames. Gas from a broken pipe ignited coals on the stove at the five-story dry-goods store Comstock & Andrews on Merchant Street, and all the buildings on the narrow block soon were ablaze. The sparks jumped from street to street until the firemen, water frozen in their hoses, looked on "with the apathy of despair." By the time the fire was extinguished at midnight the next evening, more than five hundred buildings had burned, including the newly built Merchants' Exchange, where a marble sculpture of Alexander Hamilton installed eight months before "cast a mournful glance" at the flames licking its base before the building crashed down on it. When the fire finally went out, looters from the Five Points ghetto pillaged champagne and liquor from abandoned stores. In milder weather scroungers dug through the rubble for cloths, silks, laces, indigo, and tea—all, however, damaged beyond repair. Never again would the city be so heavily made of timber. Dorcas Doyen—Helen Jewett—lived and died in this wooden world. She burned like

it until she became the fire itself, extinguished by the men who fought the flames.

She died in a sleigh bed. A sleigh was a sign of Maine, of the hard winters, the wealth of Augusta's first families, the Westons and the Williamses, of prestige and pace and, emulated in the boudoir, of dreams. Perhaps Dorcas Doyen was dreaming of Maine when she died. Temple, where she was born, was a forest: the hard woods—oak, maple, beech—plus all that pine. To a young woman in Manhattan with an engraving of Lord Byron in her room, who had invented herself as a fashionable queen, that wilderness home was just a blur, a background, compared to the city's excitement. But Dorcas first named herself "Helen" after the heroine of a novel, Jane Porter's *The Scottish Chiefs*, in which Helen Mar (the name Dorcas chose while in Boston) hails from the rugged medieval countryside. As she slept in the sleigh, Helen Jewett was still Helen Mar who was still Dorcas Doyen, from Temple, Maine.

The woods there made a wild seclusion, but that did not mean the place was invisible. In that remote place the trees kept a kind of watch, a gallery surrounding every action. Some of the actions were grim: the farmer eyeing his faithful old horse, deciding not to let it rest for its long service but literally to work it to death, to get every last bit of value from the creature, to extract "one last pull" before it died; the father commanding his daughter to sit on his knee; the stupefied man who fell on a frozen night and was not found until the next afternoon. Other scenes were beautiful: two ponies chasing each other around a field every summer evening at dusk; a girl and a boy picking red apples under a pale blue sky.

The forest enclosed each act, each being, in a halo of the unseen. The seclusion of the place made everything that

happened there, everything that *existed* there, seem as if it had never been. In that age just before the invention of photography—Dorcas Doyen died a few years before the first daguerreotype—the trees oversaw an unrecorded world. Call it a land of visibility: a world in which each moment, the spreading of the trees' own shadows on the snow, lived and died in a plenitude and vanishing; in which such moments rose and retreated like waves, in gradations so fine the breaking and the fading were the same. Dorcas Doyen grew up in that world, and a bit of that world died with her.

It was an artless land, to be sure. Crafts such as John Doyen's—the making of shoes—or those of other residents practicing their own forms of subsistence living, were the only cultural techniques around. But art and artifice of another kind—fictions and fantasies, portraits and tales, the steady mix of deceit and truth—arose in the minds of a few souls, Dorcas among them, as a transformative compensation. The dreams that filled her mind once she moved to Augusta—all the heroines and adventures and finally her pseudonymous selves—let her achieve a grander presence than the one the trees saw.

Yet beneath her make-believe the trees kept a truth about Dorcas. It was not a truth of her origins, of "reality" before the ruses of art took over. It was an art unto itself: the art of the trees in casting their shadows on the snow; of the stream overflowing its banks; of the simple moment unseen—the sleigh sliding on its runners, the water dripping from the boughs, the ice shining in the winter sun. Dorcas herself was seen by a world that kept the secret of herself. If fame vanishes, and only the unknown remains, it is fitting that the trees do not know her name.

Lifesaver

A man found Sam Patch's body in March 1830 at the junction of the Genesee River and Lake Ontario, seven miles from his last leap four months before. Still clad in the white spinner's shirt and black scarf he wore that day as he jumped from the summit of Genesee Falls, Patch's body had been submerged throughout the winter. Preserved in the icy water, he was still recognizable as himself as he rose to the surface at the feet of the startled laborer kicking through the spring ice to let his horses drink.

Patch's last dive on November 13, 1829, had been his second that week in Rochester—one of many during a spectacular two-year career. He had leapt from the falls at Passaic and even at Niagara itself, but on the second jump at Genesee, something had gone terribly wrong. In mid-leap he tilted. The crowd of ten thousand grew silent. And he never bobbed up, until now.

Some said the last dive was a trick. They claimed that Patch had disappeared behind the torrent's veil of mist and secreted himself in the rocky caverns concealed from view, that he would return another day. Others acknowledged his death but fixated on the boastful speech the inebriated jumper gave before he dove, the words barely audible amid the pounding noise of the cascade. "Napoleon was a great man and a great general," Patch yelled, according to a bystander who thought he heard the words. "He conquered armies and he conquered nations. But he couldn't jump the Genesee Falls. Wellington was a great man and a great soldier. He conquered armies and he conquered Napoleon, but he couldn't jump the Genesee Falls. That was left for me to do, and I can do it and will!" Defeat and victory, Napoleon and Wellington: the Genesee was Patch's Waterloo.

His first jump, back at Passaic in 1827, had upstaged the ceremonial opening of a bridge connecting the town to a new middle-class pleasure ground called Forest Garden. Patch, a textile spinner in town, resented the banishment of working-class people from the new resort, a land that prior to gentrification had been theirs to roam. At the grand unveiling he turned all eyes from the toll bridge and stole the show. The jumps that followed did the same, transforming the genteel taste for landscape scenery into a workingman's sublime. The treatment of Patch after his death—Whigs mocked him as a drunken fool, Jacksonians celebrated his Crockett-like exploits—split on party lines.

Yet a still more sublime purpose drove him. Call it the idiocy of his art. Sam Patch was determined to make the most of his unhappiness, to investigate the cause and purpose of melancholy, both his own and that of the universe, with the aim of turning his rage and sorrow into a perishable creation that no marble statue could rival. The sadness in question— the one his art would show—was that of unrequited love. Not love for a girl but love for what is called Nature. Since his youth in Pawtucket, Rhode Island, where he grew up as the child of an abusive, criminal, and alcoholic farmer, Sam found that life did not love him. "Life," in this sense, was not only his own, the one given him by his family, and not only the one a turbulent economy had dealt him and other workingmen, spitting and spinning them around without hope of profit and happiness—the precarious existence that led Patch to move from Pawtucket to Passaic seeking a job.

Foremost it was Nature itself that never loved Sam Patch, never gave him a life, never made him feel at home. Yes, for a person who felt secure, who had means, who had taste, the opposite was true. For that person, the natural world

beckoned everywhere, bestowing the bounty of God's good-
ness in the smile of a flower, the brush of a frond, the stars
twinkling above the trees at night. But Nature was alien to
Patch. It never gave fulfillment, order, belief—the sprouting
cosmos in the seed, the decaying leaf's friable edge. It never
sent a message and a cue, an ordination of natural laws, a
purpose and a path, germination to death, in which he could
feel his life as one allotted, bestowed by a power in whose
arms he could rest. He had none of that. So he forced a con-
summation, mastering the force that disowned him, taking
Nature by storm, piercing it in the arrow of his dives.

Every place has a spirit, a genius loci. But Sam Patch
never encountered these welcoming guardians. Faced with
the lack, he resolved to turn himself into the genius of the
places where he jumped. He would sacrifice himself so that,
forever more, the spirit of these places would be his own
and he could feel at home. Small matter that he risked death
and even had to die for a place to become full of his genius.
Nature had let him down. It had given him no answering
angel, not even in the most diaphanous of mists. So he made
his own angel in the form of himself.

The politer folk avoided this poetry of self-destruction.
The angel hovering over the waterfall in Thomas Cole's 1833
landscape is a far more genteel spirit. In a scene based on Lord
Byron's play *Manfred*, she floats in a great froth of spume, but
she never falls. Byron's autobiographical play about a noble-
man's incest and suicidal guilt, about his shattering power of
summoning spirits, including that of his dead half sister, the
love of whom had led to his banishment from England, gets
scrubbed clean in Cole's adaptation. The artist ignores Man-
fred's imperious demand that the spirits make him forget;
ignores, too, the spirits' maddening powerlessness to grant
him amnesia. Cole omits even Manfred himself, who should

be standing on the pulpit of rock that fronts the witch who might as well be the half sister herself. Instead, the painter shows no one there, leaving only the genius, the water witch, reigning over a turbulent location in which no fence protects a nature lover from a precipitous fall of amorous grace because no nature lover exists: the ledge is empty. All we get is a spirit that floats at no cost, with no damage, no damnation. But Patch, bursting with Byronic resentments and passions, went over the edge.

Sublimity in time, a perpetual memory, the genius of a place—alas, for Patch it was not to be. The places he jumped no longer exist. The placard noting the spot of his last leap has faded, soaked to illegibility by the waterfall it describes. Genesee Falls itself is no longer really the one he jumped—it has imperceptibly slipped backward, the rock face having eroded bit by bit in the perpetual rain. Inconstant to the last, untrue to the man who sought to make it his own, Nature has shifted its position. Patch's spirit floats in the way spirits do—down the vagrant stream, back in time, in memories mixed with places that forget he ever lived.

Sayings of the Piasa Bird

On November 7, 1837, the night he was shot dead, Elijah Lovejoy had holed up in the warehouse of Godfrey, Gilman & Company, a three-story stone building on the banks of the Mississippi, in the Illinois town of Alton, twenty miles north of St. Louis. Together with a small group of supporters, Lovejoy was guarding a printing press that had arrived early that morning and been stored for safety in the fortress-like warehouse. Thirty-four years old, he was an abolitionist minister and newspaper editor, and three of his presses had

already been destroyed, two in St. Louis and one in Alton. He was prepared to defend this one with his life.

Outside, a mob brandished guns and torches. Inside, so a later Alton preacher imagined, Lovejoy was thinking of the forest in his home state of Maine. This later preacher, John Gill, was a New Englander like Lovejoy who had come to Illinois and, like his predecessor, spoken out for the rights of black people. While living in Alton in the 1940s and 1950s, Gill completed his Harvard doctoral dissertation, which became a book, *Tide without Turning*, published in 1958. The book is poetic, dreamy, beautiful, full of visceral detail, the minister imagining Lovejoy's life with strong fellow feeling. Envisioning that last night in the warehouse, Gill pictured the abolitionist recalling Maine's winter woods. There, as a boy, Lovejoy had carried tools and water for the men who felled trees and split logs and stacked them in piles for spring sawing. In those woods the boy's father, a minister, visited outlying homes, accompanied by Elijah, the eldest of nine children. As he made his house calls, the minister left Elijah alone in the buggy for hours at a time, "under the shadows of the branches," with all the time in the world to think. Then his father would come out, and the minister and his son would continue their rounds, the family's sleigh moving on runners sleekly through the pines. All this came back to Lovejoy on November 7, 1837, in Gill's imagination. A little later that night, as one of the mob outside climbed a ladder to set fire to the warehouse's wooden roof, Lovejoy emerged holding a gun and was shot dead.

His killers saw him silhouetted against the Mississippi River. That was how Gill envisioned it. After shooting Lovejoy five times, the mob went into the warehouse and pushed the heavy printing press out an upper-story window. After it splintered on the ground, after they had lifted and tossed the

big and small pieces into the water, Gill imagines that some of the mob took the tiniest parts of the press and flipped them into the current as if they were skipping stones. Like Lovejoy himself, the press was gone forever, there at the junction at Alton where the Missouri flowed down from the Far Northwest and briefly turned the Mississippi a golden yellow color before it changed back to dark brown.

The press was not just Lovejoy's symbol; it was his voice. Back on July 4, 1837, he had used one of his earlier presses to exhort whites to "assemble to thank God for our own freedom" but to realize that "our feet are upon the necks of nearly three millions of our fellow men!" "Not all our shouts of self-congratulation can drown their groans." Kill the man and kill the press; the man and his editorials were synonymous. The two ceased speaking on the same night. Lovejoy drowned on dry land. His words sank without a trace.

And all the words he ever spoke, not just those in the newspapers, ebbed away. Back at Waterville College, in his valedictorian speech of 1826, he had told students and professors that "nations and individuals all embark upon the same mighty current which moves onward and still onward with irresistible force." This was the current of the time, and "he that will not go with it must sink beneath it." "Knowledge," he said then, "is triumphing gloriously over time and space, and over prejudice." Lovejoy had no notion then of calling for the emancipation of slaves—that would come later—and his notions of sweetness and light had other limits besides. He heartily despised Catholics, who not surprisingly would be among his chief persecutors in Alton. But his youthful speech was among the words that sunk in the churning muddy water moving at six miles an hour beneath the moon.

Those words drifted past St. Louis, where, a year and a half earlier, a black man named Francis McIntosh had alighted on

the cobblestone levee. McIntosh was a porter and cook on the steamboat *Flora*, which had docked at St. Louis the day before. With his work completed he left the boat to look around the city. Suddenly a man ran past him. Two other men chasing the first one called on McIntosh to stop the running man. When he did not, they identified themselves as policemen and arrested him for not assisting them. On the way to the jail, when one of the officers told him that he would spend the rest of his life in prison for his crime, McIntosh pulled a knife and killed one of the policemen and wounded the other. Hunted down by a mob and captured, he was taken to the outskirts of the city, then only seven blocks from the river, and tied to an old locust tree. While some of the vigilantes strung him up several feet above the ground, others piled wood at the base and set it on fire. "When the flames seized upon him he uttered an awful howl," recounted a newspaper. He "attempted to sing and pray, and then hung his head and suffered in silence." As the flames engulfed McIntosh, someone in the crowd said they should shoot him to put him out of his misery, but another said he was beyond feeling any pain, at which point McIntosh, burning alive, said, "No, no, I am suffering as much as ever: shoot me, shoot me." But no one did. The next morning only a part of his head and body remained. Someone stole his bones.

Lovejoy was not then an abolitionist, but the fate of McIntosh pushed him in that direction. In the newspaper he ran then, the *St. Louis Observer*, he did not dispute that McIntosh should be executed for his crime, but he denounced how he had been killed. That sealed his fate: he was singled out as friendly to abolition. In the trial acquitting the mob of any wrongdoing, the St. Louis judge Luke Lawless, an Irish Catholic, accused Lovejoy of fanning the flames of hatred

with his divisive rhetoric. Lovejoy then moved to Alton, but he could not get away, least of all from his own feelings, which grew more resolute against slavery, and in November 1837 the fires that torched the top of the Alton warehouse brought him out into the open, where he was incinerated by the gunshot McIntosh did not get.

Fire is what a person thinks of looking at the large pictograph of a bird—a kind of phoenix—painted on the bluffs at Alton above where Lovejoy was killed. As Gill puts it, describing the last night of the editor's life, "Behind the gunmen on a wind-scarred cliff above the water stood a strange, weird picture of a monster bird." It was the Piasa Bird—the Jesuit missionary and explorer Jacques Marquette recorded seeing it in his journal while traveling the Mississippi back in 1673. It had horns on its head like a deer, red eyes, a tiger's beard, a man's face, a body covered in scales, and a dragon's tail. Marquette said that no native person could stand to look at it for long. It was said to commemorate Chief Ouatoga's long-ago killing of a giant man-eating bird that lived on the limestone cliffs. Appearing some eighty feet from the ground up on the bluffs above the river's edge, the result of the river having gradually eroded the earth on which the original artist or artists stood, by the 1830s the bird seemed to have been painted by someone standing on thin air. A traveler who inspected the Piasa Bird in June 1838 claimed to have found ten thousand bullet holes in the cliff face, the result of Sac and Fox tribesmen ritually shooting it as they passed by. Yet the unkillable bird still rose, just like Lovejoy's press, which in 1915 was hauled from the river by men who found it while dredging to make a new concrete pier.

Oratory—a flow of long-lived fire: On January 27, 1838, Abraham Lincoln noted the events in St. Louis and Alton.

Less than three months after Lovejoy's murder, he spoke at
the Young Men's Lyceum in Springfield, Illinois, some hun-
dred miles from the crimes, saying that mob law threatened
American democracy in a way that no foreign power could.
The twenty-eight-year-old speaker told his listeners how "a
mulatto man, by the name of McIntosh, was seized in the
street, dragged to the suburbs of the city, chained to a tree,
and actually burned to death; and all within a single hour
from the time he had been a freeman, attending to his own
business, and at peace with the world." There was only mob
law, said Lincoln, because the nation's founders had grown
old and died, and now no one was really in charge. Jefferson,
Adams, and the others had been "a forest of giant oaks," but
they had all blown down in the storm of time, and dangerous
mobs like the ones in Alton and St. Louis filled the vacuum.
Like Lovejoy, Lincoln spoke the language of the current.

Back in Alton, Lovejoy's press had no way to take up
the words that Lincoln spoke. By then it was gulping mud,
eating its words, beginning its slow settlement in rust. Up
above, on a plateau commanding the river, stood the home
of one of Lovejoy's persecutors, the Catholic doctor Thomas
Hope. Hope was "a large, tall, portly, active, impetuous man,"
a friend recalled, "a gentleman of elegant manners." He was
a leading citizen; his words ruled the day. But on its own
bluff nearby, the Piasa Bird told punctually each morning a
different story, a tale of wing and scale and claw. Tirelessly, it
proclaimed news of the world as an indecipherable monster,
a glyph of stone. And down in the mud, well below the pla-
teau, a guttural speech took on the color of the stream.

The Death of David Douglas

David Douglas, after whom the Douglas fir is named, died at age thirty-five at Kaluakauka in Hawaii in 1834. On a botanist's mission, the third he took to the United States and the Pacific from his native Scotland, Douglas was found dead in a pit dug to trap wild cattle. His clothes were torn; his head and body gashed. A living bull was in the pit with his body. Although some thought an ex-convict had killed Douglas—murdering him and tossing his body into the pit after the naturalist had incautiously shown him a purse of money that morning when asking for directions—others believed that Douglas had simply fallen into the pit by accident and been killed by a bull already trapped there. Since Europeans had introduced a few cattle to Hawaii in the 1790s, the animals had propagated so widely that by Douglas's time thousands roamed wild and settlers began digging steep-sided pits, six to eight feet in length, deep enough that an animal that fell in could not get out again. Douglas—blind in one eye, his vision failing in the other, his body weighted by a pack of scientific gear—perhaps did not see the trap, despite being warned about the hazards all over the island. His was a literal "pitfall," the name of the cattle-hunting trap that led to his demise.

A way of mind died with Douglas that day. For him, as for other Romantics, the mind flowed with a spontaneous fusing power like nature's own: seeds of thought, germs of ideas, emerged in elaborate growths. Flower, petal, spore, and stalk made an organization, a natural emanation: so did a treatise, a poem, a painting, a stream of consciousness. The jungle world was a forest of mind. For Douglas, walking the trail on a knoll at the top of Laupāhoehoe, surrounded by lush vegetation, as he did on his last day on earth, was to

be lost in thought. Careless of the way, indifferent to his health, he might have been recalling one of the many plants he had discovered, or envisioning the further ones he sought. The intense soil of his mind was a hothouse for these finds. Spread with koa and ohia trees, with red and yellow flowers and roots in midair, the trail was a fertility of creation, and Douglas, in death, had all this on his tongue. He never lived to see his Romantic conceptions become antiquities. With his death Douglas's mind went underground, becoming only a clue to what it had been.

Scientists and artists are said to stumble on truths. They fall, they trip, they strike their heads; sudden stars and realizations appear. Who knows if Douglas's fall was such a eureka moment. Instead of skipping a stone and happening to see the universe's concentric circles, he skipped the stone of himself and sunk to the bottom of the radiant world he made, leaving it without a word except whatever tripped on his tongue. The Romantic painters of the time made lightning zap from the sky; they crushed the castle's battlements and made the trees cry; but in such a moment—struck down by heaven—Douglas did not live to see the painting his death made.

His fate was not sealed, however; the case remained open, and suspicion fell on the ex-convict Edward "Ned" Gurney, a man of roughly Douglas's age, who might have killed the naturalist with an axe, robbed him, then made it look like the victim had fallen into the cattle pit. Convicted of larceny at the Old Bailey in London, Gurney had been transported to New South Wales, arriving there at age nineteen in September 1819, then sailed two years later as a common seaman on board a ship bound for Hawaii, where he fled and took up residence on the slopes of Mauna Kea. A diminutive man, five foot two inches, with gray eyes, flaxen hair, and a florid

complexion, Gurney said he was in his hut on the morning of July 12 when Douglas greeted him at ten minutes before six in the morning, saying that his guide had gone ahead and asking to be shown the trail. Gurney said he walked with Douglas for a way, leaving him only after warning of several cattle pits near a watering hole two and a half miles farther on. When islanders came running later that day to tell Gurney that the European was dead, he went to investigate.

He found Douglas trampled on one side of the pit, the bull standing on the corpse. He shot the bull dead, clambered into the pit, and with the help of local people lifted the body out. He observed that Douglas's cane was at the lip of the pit, but not the bundle he had seen him with that morning. Also absent apparently was Douglas's faithful terrier, Billy, who just then, however, started barking from a short distance away. Drawn by the sound, Gurney found the dog and the bundle on a hillside about a hundred feet from the pit. He speculated that the naturalist had noted the trapped bull, continued on his way, then decided to take a closer look at the animal, dropping his pack and retracing his steps back to the pit, at which point "a false step, or some other fatal accident," caused him to fall in and the infuriated animal killed him. Gurney, who was never charged or absolved, admitted that he took the dead man's watch and damaged chronometer, his pocket compass, keys, and money. He said that he hired several Hawaiians to carry the body the twenty-seven miles to shore for transport and burial.

A cairn erected in the vicinity of the pit, raised on the centennial of Douglas's death, now speaks on behalf of the dead man. "In memory of Dr. David Douglas, killed near this spot in a wild bullock pit July 12, 1834 A.D." Nearby is a stand of Douglas firs planted on the centenary. But back of this official perpetuity, beneath the ground, there is a truth

lower down. Down there, the soil still grows with thoughts. Even when alive the thinker had departed the world with each act of mind. He had dreamed with each reflection, until looking down one day he saw his last. What is there now is only a continuation of his consciousness. Raise a glass to what remains. To paths and falls and fascinations: a toast, my friends, to the absent mind.

Animals Are Where They Are

Lord of the Sod

At the museum the raccoon is suspended in midair. Raccoons do not fly, but for a long time now, well before it came to the museum, this animal has not been what it was in life. With brass buttons for eyes, bird claws for horns, and bells tied to its tail, it has become a spirit animal, a ceremonial tobacco bag made by a member of a Plains tribe, perhaps an Ojibwe, sometime around 1840. The claw horns denote its magic; the brass eyes see inward; the bells are a tinkling voice.

Yet the creature is not too proud a god. Though a flying deity of horns, it lets us see the ordinary elements of what it was. We sense the padding of the scuttering feet, the scavenging of the nocturnal prowls, the evenings that made the mortal habitat—the lantern-moon, the carrion, the refuse tossed outside a hut. We cannot turn a blind eye to what it saw, its privileged inspection of the ground, the mulch of leaves where it peed. Dirt, pest, pestilence: without rancor the animal owned the terms because words were all the same. Lacking the name of itself, it dreamed its plenitude, preening in fur and filth, discovering the starlight in the frozen stream. Now a self-referential god, the beast displays its own art, the magic by which it was made anew, turned from one thing into another—a magic inhering in how it holds the past within itself. For that is its own sacred art, the bells and beads of this mummy of the woods and plains. Of all those who lived back then, none could speak better than this creature of what was without speech: to life-as-lived, to creaturely existence, the ever-replenished here and now of there and then.

Night Vision

Two barn owls perch on the upper reaches of a dead tree in the middle of the night. The female clasps a dead chipmunk in its talons, spreading a white wing to fend off her male counterpart as he climbs a lower branch in pursuit of a bite. The birds are life-size, in keeping with the aim of their maker, the artist John James Audubon, to portray ornithological specimens true to life, to make them "near-living doubles" for the actual birds, as Jennifer Roberts writes. The birds are right in front of us, at eye level, defying the boundary between art and life, in a plumage of graphite and colored ink. Far below their perch a river wends through a landscape of woods and fields. How did we get up this high? We could never be where we are, and in fact it appears we are not, since the owls pay us no mind. The one-for-one world—where art becomes life—requires that we not be there, or only invisibly there. To believe in a representation we must be lifted up and lose ourselves. Faith in an image is a kind of flight.

The elevation creates a frozen moment. Audubon's taxidermy—pinning specimens on a gridded board, the fresh-killed creature's eyes still gleaming—makes an architecture of suddenness, a burst of wing against sky, that says what we see is *Now*. Yet that Now is not so immediate that we do not also feel the swooping up that has led us to this singular, impossible moment. The heraldic instant—the indelible image fluttering on the page—carries with it a sense of the viewer's journey from below, the valley world, the river of earthly time out of which viewer and picture alike lift to some clarity beyond mortal reach.

That elevation is also a falling away, a drifting back to earth. Up on their perch, the owls reach a crescendo of their

being, an ascent of all that they are, never more fully them-
selves than in this composite of nearness, suddenness, and
height. But implicit in their presence is the drifting away
of this moment from itself, scattered to the world below,
where it will be as if our miraculous encounter with these
beings never took place. To say that this lower world *sleeps*
is no defiance to the way it looks in Audubon's picture. The
emptiness of the fields, the lazy bend of the river, implies
a landscape at rest. The people down there, wherever they
are, must be oblivious to the drama of the treetop. Likewise
even for us. We, too, must sleep—must forget—as the price
of our encounter with the owls, with the otherworldliness of
the real. Our experience reaches a height, then we descend,
resuming our place in the slumbering valley.

But for a moment art and creatures come together in a
world apart. Unbeknown to those below, some other activ-
ity goes on above, always at night. That other world unfolds
while the valley dreams, though it is not the dream of anyone
below. It is a world of actuality taking place independently of
the sleepers, separate from their stories, a night apart from
their rest, emerging boldly only when there is no one to con-
ceive it. The artist, in a trance, unconscious of his ordinary
being, sees—like a saint experiencing a vision—something
that neither sleeper nor wakeful person could. He feels him-
self lifted to behold what is not for his eyes. And if it is not
for any mortal to see the world so unconcealed, to find it laid
open in some ravishing spotlit moment, then the dangers of
that vision—dangers that prey on the trespasser—are ones he
likewise cannot see. He awakes on the ground, a picture in
hand, no wiser.

Audubon received the two owls in July 1832 as a gift from
his friend Dr. Richard Harlan of Philadelphia. The month
before, Harlan had been called with two other Philadelphia

doctors to travel to Canada to study the cholera epidemic breaking out in Montreal and Quebec City. They discovered that the outbreak had occurred nearly simultaneously in both places, traced to the transatlantic steamer *Voyageur*, which had stopped at Quebec and Montreal. The epidemic spread fast: from the *Voyageur*'s landing on June 8 to the morning of June 12, seventy people had already died in Quebec from all parts of the city. The disease began ravishing Montreal the day the ship landed there. By June 28, it had spread up and down the St. Lawrence River, a distance of 600 to 700 miles, and down into Vermont and New York State. Describing the stages of the illness, studying the effect of climate and human crowding on its spread, the three-person commission of Philadelphia doctors urged "every individual to discipline the mind so as to look on the disease with self-possession and resolution," calling upon medical men in particular "to avoid all exaggerations."

Audubon did not exaggerate the owls Harlan gave him. His scientific method was as lucid and dry-eyed as that of his friend. But his art was more in league with illness, with the spread of something in one body to another. His art of direct observation operated by contagion. The owls Harlan gave him were right there in front of him, so near he could smell them. When one died soon after arrival, nothing changed in his aim. Proximity—or what the epidemiological team called "vicinity"—ruled all. The actual creature passed invisibly into the drawing. The image became infected with the real. It did not matter if what the drawing showed was a full blast of owl from tail feathers to beak, or just a glancing fleck, a single furry piece of scat. The artist's close working quarters were a contagion zone, and on purpose. Close observation was required so that the creature would spread into the picture, transmitting itself through the artist, whose mind and

hand were the carrier. Jennifer Roberts describes Audubon's aim: "The image is not an immaterial copy that goes out into the world, but the original referent itself, transmitted to the page, with its old organic body left to decompose."

The picture then spread outward, like the wings of the owls. It went to Audubon's far-flung subscribers, who in places around Europe and North America opened the next installment of *The Birds of America*, receiving full-on the contagion of the artist's original contact. Birds gathered in Audubon's books like the passengers of the *Voyageur*, destined for distant ports. Just as the cholera epidemic provoked "terror and panic," in the words of Harlan and his fellow doctors, just as its invisible causes were seemingly impossible to trace, the artist worked in mysterious ways. There was no telling how that owl over there, an actual living (or recently living) creature, had gotten into the image, but so it had. It was a scientific puzzle. No matter how conventionally the artist might be understood—even as, indeed, the culture of taxonomy spread to artists themselves in those years (William Dunlap's *History of the Rise and Progress of the Arts of Design in the United States* of 1834 is a kind of ornithology of painters, sculptors, and printmakers)—the artist was an uncanny figure, presiding over the passage from the real into representation.

But it was the owls, not Audubon, who oversaw their migration. Creatures of the gothic, they commanded the artist to do as he did: to pose them, observe them, then send them on their way through the nocturnal ether of slumbering pinpricks that made, each dot on the page, a convincing illusion of the scheme of things. That is how Audubon imagined it—that he was there to execute the creatures' wish. Some instinct in the owls—in all the birds he painted—sought to be propagated, not only in the form of owlets in dull-gray little shells, six to a brood, but in flattened life-size pictures. To

be immortal, they required a host, and Audubon believed he was the best to be found. It was a question of transmission: of likeness penetrating him, becoming him; and of that likeness, in his art, spreading to others.

The Cup of Life

Richard Harlan, who gave the owls to Audubon, liked to distinguish himself from charlatans. In February 1832 he wrote of a Frenchman named Chabert who was then dazzling crowds in New York and Philadelphia by swallowing lethal doses of poison. Chabert would consume between twenty and forty grains of phosphorus "with perfect indifference." An antidote that Chabert had discovered but kept secret was the apparent reason he was able to survive. Coupled with his ability to eat fire, Chabert's impervious constitution made him a sensation. Years later Harry Houdini called Chabert "the most notable, and certainly the most interesting, character in the history of fire-eating, fire-resistance, and poison-eating." Of course, Chabert was frequently called out as a fraud. One writer thought he achieved the phosphorus miracle by a sleight of hand, "by having a hidden pouch into which the poison fell when he seemed to place it in his mouth." Others assailed his whole practice—including a cure for cholera—as so much "arrant" deceit. But no one could tell exactly how the miracle was worked, or what the sleight of hand was.

Trying to discover Chabert's fraud, Harlan secured an adult female cat and gave it several grains of phosphorus in a bowl of milk and water. After experiencing no ill effects for eighteen hours, the cat began suffering convulsions and died in horrible pain three days later. Harlan eagerly dissected

it, studying the grotesque effects of the phosphorus on the internal organs. But even turning life inside out, digging into its secrets, he could do little more than confirm the cause of death. The dead animal was the sign of an ongoing mystery, the secret of Chabert's survival.

The stuffed specimen dusted in arsenic, posed on a twig, a branch, in a naturalist's parlor—insect-repellent toxins helped keep a creature apparently alive after it had died. But in his pictures—a two-dimensional taxidermy—Audubon had created a preservation without poison. The rough-legged falcon grasped the tree, preparing to eat the blackbird pinioned in its claws, surviving on the page by a miracle. A viewer knew it should be dead, that it was dead, but that it went on living right there in his art. Some antidote in the very brush itself had licked the feathers to everlasting life, made the bones and tendons supple and stark. The bird was no longer ingesting some creaturely food but an elixir of life, like eagle-Jupiter in Thorvaldsen's sculpture of Ganymede, slaking his thirst in a cup of immortal wine.

The artist, too, must have drunk from this cup. Chabert-like, he had mysteriously defeated death, as if the power of imbibing some lethal concoction—imbibing and surviving—were what he had imparted to his creatures. What he tasted and what he drew were one: an incarnation, holy wine and blood, some substance lethal to the rest but indifferent to him. Whatever it was, it flowed through his veins and impregnated his brush. His birds spread their wings like angels, holy visitants on some earthly errand, refugees from stormy destructions of the church, the crashing of cathedrals, until all that remained were these gargoyles enjoying a sacred life of their own. Imposter, fraud, fake: it was all in how he crawled the wall, how he spouted the truth, what instead of vomit came from his mouth.

Calamity at New Garden

One day in New Garden, Pennsylvania, near a Quaker meet-
inghouse, the naturalist John Kirk Townsend observed an
unknown bird sitting on a fence rail. Even at the age of twenty-
three, Townsend was already an expert ornithologist, and
he was sure he had never seen anything quite like this bird.
Black, brown, and gray, with a white throat and brownish-
white belly, it was like a bunting or dickcissel but did not
resemble any he had ever seen. Its song was slightly different
too. As Townsend and his friend John Richards approached,
the bird flew off with short jerks of its wings to the top of
a nearby cedar tree, where it emitted a loud and varied set
of notes before moving quickly to other trees while the two
men tracked it below. Only with difficulty did Townsend get
in position for a shot. Eventually he was successful, and his
prize dropped to the ground. To this day, the bird is the only
specimen of "Townsend's Bunting" ever recorded. The date of
its death, still inscribed on a paper tag attached to its feet at
the Smithsonian Institution, was May 11, 1833.

Did the world stop on that day? Not really. People went
about their business. Yet if not a single sparrow falls to the
ground without God's awareness, then the fate of this unique
and unknown bird registered in the cosmic scheme. But to
what end? What if the bird dropping from its perch shared
some mysterious correspondence with other events of that
day, and what if the correspondence itself, unspoken, indi-
cated a rhyme and reason to the world, at least as people
believed in such schemes then: a network of happenings,
manifest in singular yet related fates, that drew together ran-
dom events in a grand and mysterious plan? On May 11, 1833,
the young Edgar Allan Poe published his poem "To _ _ _" in
the *Baltimore Saturday Visiter*:

To _ _ _

Sleep on, sleep on, another hour—
I would not break so calm a sleep,
To wake to sunshine and to show'r,
To smile and weep.

Sleep on, sleep on, like sculptured thing,
Majestic, beautiful art thou;
Sure seraph shields thee with his wing
And fans thy brow—

So Townsend's bird slept, slept on, a sculptured thing, that very day. And on that day, too, newspaper reports disclosed the first-ever attack on a US president, when the disgraced Navy lieutenant Robert Randolph, dismissed by Andrew Jackson for embezzlement, punched the president in the face. Then this: On May 11, out in the Atlantic, not far from where the *Titanic* would sink seventy-nine years later, the packet ship *Lady of the Lake*, bound from Belfast for Quebec with Irish immigrants, struck an iceberg and sank with a loss of 265 lives. Only fifteen crew and passengers survived. A partial list of those on board:

Name	Age	Status
Thomas Eagleson	22	lost
Jane Fegart	24	lost
Eliza Ferguson	18	lost
Sarah Ferguson	16	lost
James Ferguson	19	lost
Pat Ferguson	20	lost
Mary Ferguson	2	lost
John Filson	23	lost
Eliza Filson	23	lost
James Fitzsimmons	n/a	survived
John Flood	23	lost
Michael Forbes	20	lost
James Foster	25	survived
James Frizel	18	lost

For us now, only fantasy draws together the fates of these passengers with the little bird of New Garden, Pennsylvania. Dismissible dream, fata morgana, maybe so. But on the day itself, the world was perhaps more fluent with unspoken connections. The bird preserved at the Smithsonian is a talisman not just of the day but of belief itself, of whatever it was that kept meaninglessness at bay. And if that belief was enigmatic at its core—a mixed blessing—then who is to doubt its force? Preserved in the arsenic that would kill Townsend at the age of forty-one, still incarnating the day it died, the bird is not only unique but a mistake, an error, likely just a variant of another kind of bird and therefore, as "Townsend's Bunting," the singular representative of its kind. There will never be another like it. And if the day it died will never come again, and if every person who died on that day was also unique, unrepeatable, then someone—something—must have been sought as the day's avatar, a saint slaughtered for the renown of the unknown. Shipwreck, sorrow, the tongue of ice beneath the waves: the bird sings of unseen things.

Spiders at the Altar

Sometimes the spiders were beneath his writing desk or in a dark corner of his study. Other times he found them when he flipped up a pile of trash in the yard, or in the bark of a decaying tree, or at the top of a remote hill. He looked for them everywhere, there in northern Alabama, and when he found them, he scooped them into glass jars or lanced them with needles and affixed them on pasteboard cards. Back at his desk, he used a magnifying glass to make detailed drawings, his pen not shying from any aspect of their minute existence, even their private-most parts.

The arachnologist, the first true such person in the United States, was a jealous man. A native Frenchman, he had come to America as a teenager in 1816; eight years later, he married a woman from Massachusetts. An erudite couple, Nicholas Marcellus Hentz and his new bride, Caroline Lee Whiting Hentz, set out to become teachers. Nicholas taught first at Transylvania University in Kentucky, then at the University of North Carolina, then at a girls' school he founded in Cincinnati, where his wife helped with the instruction as they started a family. There, in addition to their duties as schoolmaster and schoolmistress, they belonged to a salon called the Semi-Colon Club. The conversation was erudite, the company lovely. But Nicholas found an admiring note that one of the salon's men had written to Caroline, and the Hentzes left town, moving to Florence, Alabama, to start a new school there in 1834.

Caroline Hentz was a writer, and her fiction sometimes alludes to her husband's jealous control. In *Ernest Linwood*, a novel published in 1856, the year both Hentzes passed away— she from pneumonia, he from complications of an illness that had left her his principal caregiver during the last years of his life—Linwood's wife, narrating the tale, tells how she feared displeasing him when they had guests, how she "repressed the natural frankness and social warmth" of her nature, and how, in her imagination, the guests left their house "chilled and disappointed." In the mirrors lining the Linwoods' parlor, "I could not turn without seeing myself reflected on every side, and not only myself, but an eye that watched my every movement, and an ear that drank in my every word."

In Florence—named by the town's urban planner, an Italian—the Hentzes established a school for the sons and daughters of local planters. Called Locust Dell, the school

was built by slaves on loan from neighboring plantations. Ensconced in the community, the schoolmaster and his wife went to barbecues at students' homes. Massachusetts-born Caroline Hentz, a descendant of one of the state's first emigrants, developed a fondness for Southern life. She vigorously defended chattel slavery in the decade leading up to the Civil War, partly as a riposte to *Uncle Tom's Cabin*, written by one of her fellow Semi-Colon Club members back in Cincinnati, Harriet Beecher Stowe. But Caroline Hentz was herself a person tasked with unremitting hard labor. The diary she kept of her time at Locust Dell reveals the daily round of the schoolmaster's wife: preparing lessons, disciplining students and servants, caring for boarders as well as her own young children (by then the Hentzes had three, excluding one who had died as an infant), even as she dealt with her moody husband and helped him in "his endless search for spiders."

In Nicholas Hentz's study these spiders battled. One day he watched as a *Mimetus interfector* devoured the eggs of a *Theridion vulgare* after having eaten the egg layer herself. Another time, the tables turned, a *Mimetus* hung dead in the web of a *Theridion*, no mean feat for the underdog *Theridion*, much smaller than its adversary, but crafty and patient. But *Mimetus interfector* was always a powerful enemy: triangular pointed lip, small but fierce fangs, eight eyes, a battery of long and short legs, an insatiable cannibal. The day Hentz put a *Mimetus* in a jar with a *Theridion* to see what would happen, the *Theridion* cowered as far as possible from its adversary, then engaged in "seeming reflections on fortitude and necessity," as Hentz put it, before rallying heroically to a combat that, alas, it lost, whereupon it was eaten by its foe.

Battles of a different kind took place in Caroline Hentz's popular fiction. A frequent contributor to *Godey's Lady's Book*, a new periodical full of poems, short stories, and fashion

illustrations, she published a tale called "The Fatal Cosmetic" in the June 1839 issue. A virtuous young woman named Margaret volunteers to paint a transparency for the window of a fine art gallery in a wealthy lady's home. Setting up her easel in the gallery, Margaret depicts the allegorical maidens Faith, Hope, and Charity before adding the overarching figure of Truth at the encouragement of a gentleman admirer looking over her shoulder. But a silly companion named Mary, believing the painting had been perfect before the introduction of Truth, pretends to erase all four figures with a sweep of her arm and accidentally knocks over the easel, which crashes into the wealthy patron's prized pier-glass mirror, which shatters into a million pieces. Mary tearfully pleads with virtuous Margaret not to confess who broke the mirror. The two agree to blame a black house slave named Dinah, who denies everything to her mistress but to no avail. When thoughtless Mary later leaves grains of skin-whitening arsenic indiscriminately among other cosmetic remedies in the medicine chest, a visiting lady who feels faint is accidentally given this very arsenic and dies, whereupon Dinah is again blamed and this time sent to "a damp, dreary prison-house, where seated on a pallet of straw, she was left to brood day after day." Transparent Truth spanning Faith, Hope, and Charity is erased, knocked over, before it can be lit from a light from without, so that it becomes a sorrow and a stain, the colors blending to one, the venal lie leaving everyone wounded, broken, except the artist Margaret, still free to live the life her damaged picture had spoken of.

Alone in his small world of spiders, Nicholas Hentz lived his own truth. Life among the arachnids was peaceful, absorbing, a kind of neutral love: the magnifying glass, the brushes and pencils, the many studies of individual legs, mandibles, and other body parts: the lips of the spider; the

vulva, nipples, and anus, the spider's cocoons, its hairs and
habitats; its different webs, horizontal and vertical, radial and
sac; the individual colors—pale yellow, metallic green, brown,
white, red, bluish black. Once the papers were graded, the
accounts settled, the spiders gave him enough to last a day
and a candlelit night—the *maxillae*, the *chelicerae*, all the lit-
tle nobs and tips and frozen legs, stuck upon their papers
but still instinct with the activity of scurrying. Their world
went on, if that is the right phrase, it *took place*, independently
of human actions, the politics of bedroom, schoolhouse, and
nation. Suspended in a world of human failings, the spiders
spun their separate fates.

But one fatal strand drew Hentz's arachnology back to his
jealous life at large. Holding his magnifying glass to a desic-
cated but still roseate specimen, careful to avoid embellishing
the creature's colors by burnishing it too much with the arti-
ficial brightness of the candlelight, he studied it to within
an inch of its life; he invaded its very being. The man was
a *describer*. He could not help but *see*—as if he himself had
eight eyes. He gave to the ostensibly neutral act of scientific
observation a manic, obsessive cast. With him it was all about
fading eyesight and round-the-clock surveillance. Unlike
Audubon, who contented himself with the large outlines of
his birds, not deigning to peer too closely into their crev-
ices and other mysteries, Hentz looked everywhere. Unlike
Audubon, who showed his birds only on their best days,
bright and shining, and who recognized that what remained
hidden was not just narratively unnecessary—a needless hin-
drance to the "plot" of each bird, its essential story—but a
violation of God's secrets, Hentz went straight to sacrilege.

In fairness to him, he was only following what his subjects
already were. What about a spider, after all, did *not* require
scrutiny? Even considered in their crab-like wholeness, the

creatures were a collection of tiny parts, each as strange as a lunar range. Blown up in the magnifying glass, the little fragments had a way of staying large in the mind, as if a spider's legs really were the size of fingers. They remained so even when, putting down the glass and looking back at the miniscule specimen without magnification, Hentz was struck anew by the near-invisibility of what he studied. Little things were big! They were monstrous! No wonder amid his work he was continuously out of breath, as if living in an oxygen-deprived land, for having delved so far into this realm of secrets: of discrete things made vast, then shrunk back down to a scale resembling silence and innuendo. Hanging from rotting planks, spinning their secret designs, spiders spoke a language the mere tracing of which felt like a violation, a compulsive act of stealth and prying.

Here is how it all came to an end. Hentz was all too aware of his spiders even when they were not in plain sight—at the church on Sabbath, for example. The Gospel sung by the planters and by the Hentzes at Sunday services was a needful deflection of a truth too true: that hiding beneath the pews, emerging under cover of night, different divinities busily sewed their scripture, with no faith but the one they spun. It was hard not to envision the spiders roaming the altar after hours, sniffing the incense, investigating a splayed-open Bible, reciting their spittle-psalms.

It all came to a head one evening. The Hentzes were entertaining some parishioners at their home. In a postprandial moment the arachnologist studied his guests in the many mirrors of his parlor. He tried to keep his composure, but it was no use—he saw it all. The crust of cake, the sliver of sauce, the morsel on the plate; the lip and smile and flickering eyelash, the dull shine of metal buttons on lace. Life, he reflected, was a tiny affair. A good thing that all of it would

soon be lost, the customs and the claims, leaving only the very largest remains. All would be forgotten, sifted away, the dirt and dandruff of the day. No one would know or, if they did, be able to portray the minutiae of these lives.

Moose and Stencil

The moose descended into the lake. Stepping gingerly for a thing so bulky, it waded into the water until submerged to the shoulders and dewlap. In that nearly immersed position it liked to cool itself and avoid the mosquitoes and flies. But on this day it did not stop there. It kept going until its head disappeared, and then it did not come up. Not for hours, not for days. So says a tale from *Davy Crockett's Almanack* of 1837. What happened as the moose went down? Circles widened above its head, marking where the antlers had been. The circles reached toward the edge of the lake that portrayed the bowl of forested hills looking down on the rippled water. Center and circumference, sinking and spreading, the moose disappeared in the world it made.

At a town nearby, in a tidy and small home, a child made drawings. Well, they were not exactly drawings. They were stencils—made by tracing the interior edge of a form cut out of pasteboard. They were left there at the girl's house by an itinerant artisan named Stephen Clark who was hired to decorate the wooden walls in lieu of the expensive wallpaper the family could not afford. The stencils the child drew from, however, were not those for the ferns and urns and crawling vines Clark had painted on the downstairs walls. They were small separate ones Clark had made from spare pasteboard to amuse the child, who watched him fascinated while he worked and wanted to create her own. So at the end

of one day he made her a stencil for a candlestick, then for a rooster, then for a pine tree. Once Clark completed his work and set off for the next town, the child kept the stencils and would sit on the floor of her bedroom in the family's small two-story home, tracing the lines of candlestick, rooster, and pine. She made a stencil of her own, too, using a spare bit of pasteboard Clark had left for the purpose—a cutout of an oak leaf. Taking it up, she followed the stencil's delicate grooves and a leaf took shape on the floor. Light falling through a mottled blown glass window made it seem for a moment like the leaf had even fallen into the house through the solid glass. Lifted from the floor, the outline on the boards completed, the stencil held the absent shape of the leaf like the lake held the invisible moose.

Both the leaf and the moose were silent. The child's stenciling and the animal's disappearance took place without notice. Each occurrence made a delicate noise, it is true—a rasp of graphite around the stencil track, a hissing of water around the moose—but these soft sounds only deepened the silence. In the parlor downstairs as the girl drew, her mother and father were talking with guests. "In one minute, in this talkative age, there is breath enough expended . . . to compose two or three whirlwinds, and perhaps a moderate hurricane," says the *Crockett Almanack* of 1838. But the moose was quiet and the girl was too.

The moose's tracks led down to the lake. An expert hunter had followed the animal there. The stronger impression of the front hooves told the hunter that the moose was a big bull, its rack of antlers weighing down the front of its body. The hunter carefully looked for wallowing pits, scented the urine in the soggy leaves (faint or pungently strong), and noted incisor marks on red maple and mountain ash trees. From these signs he could tell a whole story of this moose,

his loves and life, his battle scars and disposition. Back at the house, the adults in the parlor told the story of the child up above, pointing to the patterns on the walls and saying that she was upstairs with several of her own stencils now. But the words hardly reached the child's ears. And out in the woods, although the hunter could draw a complete picture of the moose without ever having seen it, he could not complete his story because there was no moose to be found.

The child's home was in a place called Columbus, New York. The town was established in the early nineteenth century and named after the man who sailed across the Atlantic Ocean and began European colonization of the Americas. But the child was making a different kind of discovery. The stencil portrayed an absence. When no one was using it, it made a gap in the shape of the desired image. In use, it created the positive impression—the picture came into view—but when on its own the stencil's empty center remained beguiling, always picturing the very shape of the thing one wished for: a world undiscovered, in potential. Such were the stencil's powers that it even created the wish itself—the desire for the pine tree or candlestick or oak leaf manifest in these enticing previews of their stenciled forms. But foremost the stencils always portrayed the secret shape of an invisible center, a mystery at the heart of things, before any picturing ever took place. At the lake, the moose went undiscovered.

The child did not know of the moose's existence. But something in her intuited the animal was there. What was the nature of that intuition? It was the belief, born of her craft, in solitary unknown things. The child guessed that for an animal the only place in the world that exists is the place where it is. She had heard of how a porcupine that drew close to a stream and began eating food extended to it on the blade of a paddle had not even noticed the man holding

out the paddle. Even the more alert and sociable animals, the ones not as stupid and sluggish as the porcupine, effectively lived in the same magical self-seclusion. When a local farmer brought a dead wolf back to her town to collect a bounty, the girl noted how the creature still exuded the aura of its remote forest existence. Back in her room, the stencil in the girl's hands greeted the unknown solitudes out there somewhere: *halo, hollow, hello.*

She sensed she was supposed to graduate from these reveries. But if that were so, it was confusing that the pictures made by adults were themselves so childlike. From a *Crockett Almanack* her older brother had smuggled into the house (a family of such country respectability was not supposed to read such things), she could see that the woodcut illustrator portrayed everything with the sadistic glee of a grown-up child. He tortured the page into liveliness, bestowing the whole world with bristling skin. Armadillos and alligators sported the segmented hide of pineapples. So did the bark of trees, the current of the Mississippi River, and the jointed pantaloons of frontier matrons. Even when the illustrator's lines quieted, when they distilled into flat calms and the curlicue fronds of barbered trees, the woodcutter's restless knife appeared to be only biding its time, catching its breath, before proceeding on another rampage of jagged scales. The visual peaks and valleys were a crude language, a phlegmatic oratorio like Crockett's before he addressed Congress: "Who—Who—Whoop—Bow—Wow—Wow—Yough." How baffling this adult childishness was, how different from the silence of the stencil.

Baffling as a sign of the life to come. The picture called *The Peaceable Kingdom*, which she saw in a Quaker neighbor's house, painted a few years before by a Pennsylvania artist named Edward Hicks, showed the wolf laying down with

the lamb, the leopard with the kid, the lion with the fatling, while a child stroked the mane of the affectionate lion, true to the legend on the painting's border: "a little child shall lead them." All was peace, all was goodness—so different from Crockett's frontier. But the child in the painting reminded the girl of the frontier hero—Crockett and Christ alike were prodigies of lion taming. The Christian menagerie seemed allied to the beasts raging on the *Almanack*'s thin pages. In some secret place of unknowable adulthood, peace and war were both versions of the same script.

But the stencils remained self-contained, secure in the content of their forms. They seemed to know they would keep delivering images of themselves and only themselves. Even when the stencils slept (that is how she thought of them when she put them away and she herself went to bed), they remembered what they were. Call it the awareness of the slumbering lake, the shallows and rocks and silted mud, the sky and trees reflected on the surface, those glimmering pictures out of which, just then, the moose emerged.

Encounter in a Black Locust Grove

Constantine Rafinesque was an oddity at Transylvania University. He was strange anywhere, but at this new frontier institution in Lexington, Kentucky, he stood out especially. With his large bald head and corpulent, stooping figure, he was "physically shrewlike to a degree that fascinates." His ill-fitting clothes seemed assigned to him at random; his ignorance of basic domestic economy—rituals of cleanliness, for example—was complete. His logical but antiquated mind was like the ruins of the old frontier station upon which modernizing Lexington was built: an archaic fortress fac-

ing all directions at once, bristling with defenses, a fantastic design of obsolete purpose in a new age.

At Transylvania, Rafinesque was a double stranger. He was a native Turk and the only naturalist in a school devoted to training Presbyterian ministers. The university president, a Unitarian, was a friend, but the board of trustees thought so little of Rafinesque that they paid him no salary except room and board and candles and wood for his fireplace, and even then they complained that his candle usage was too high. Maybe they had it against him because he was always submitting lists of demands and requests. Querulous and high-strung, the man was an outpost unto himself.

To subsist, he needed to attract paying students to his lectures, which fortunately he was able to do. He spoke about everything. A former student fondly recalled his lectures on ants, on their culture and history and society, their "lawyers, doctors, generals, and privates," how after their great battles they have "physicians and nurses" to care for the wounded. A fair specimen of his teaching, his papers in the short-lived *Western Review and Miscellaneous Magazine* addressed the salivation of the horse, the oil of the pumpkin seed, and the Milky Way. At a time when universities were developing specializations and departments of expertise, Rafinesque arrived in Lexington as a know-it-all, among the last human beings aspiring to understand the entire universe. A short list of the fields to which he contributed includes botany, horticulture, ornithology, ichthyology, mammalogy, entomology, conchology, paleontology, geology, minerology, meteorology, pharmacology, archaeology, astronomy, and herpetology.

A shipwreck off the coast of New London, Connecticut, was what unhinged him. That was back in summer 1815, near the end of a perilous three-month voyage from Palermo to New York. Rafinesque, who grew up in France, had spent

a few years as a young man in Pennsylvania and Delaware developing his botanical knowledge, and now en route from Palermo, he was returning to the United States at age thirty-one. But as the ship approached Montauk, it was caught in contrary winds, could not make land, and struck an underwater glacial boulder. Picked up in a rowboat, Rafinesque watched the ship sink and with it his life's work: 20,000 herbal specimens, 2,000 maps and drawings, 600,000 specimens of shells. "I had lost everything, my fortune, my cargo, my collections and labors for 20 years past, my books, my manuscripts, my drawings, even my clothes."

But at that moment something marvelous happened. Call it the birth of Rafinesque the fabulist. Even as he swam from the wreck, he was busy identifying new species of plants and fishes in the water around him—so he claimed. From there it was but a small step to becoming the eccentric naturalist of Kentucky, the one at odds with the trustees and his fellow naturalists. Audubon, on a stay with his eccentric peer, awoke one night to find a naked Rafinesque swinging his guest's cherished violin at bats that had infested his rooms.

The world for Rafinesque was a kind of plasma, a rolling and shifting of "endless shapes, mutations quick or slow." As he wrote in his epic twenty-part poem *The World; or, Instability*, published in 1836, "The great universal law" was the "perpetual mutability in every thing." Nothing endured and all evolved. Apparently distinct things—trees, rocks, rivers—were all related, reciprocally changing in a great swirl (today we would call it an ecosystem). God, the "Lord and Leader," directed it all, but lurking in the shadows, the deity Pan also oversaw Rafinesque's universe. No ordinary lord, Pan was everything, was everywhere, and not in a terribly pleasant way. The slimy interior of grace, the underbelly and backstory, he made a vast and morphing body: leaves were

his shaggy hair; tree bark was his skin. The forest made up his fingers and toes. He burbled in the streams and flowed in the sap, hanging from the trees that comprised his own roots: everything circulated through him, as him, in a vast and mutable fount of creative destruction.

Ralph Waldo Emerson, the era's most famous pantheist, said it well. "We see the world piece by piece, as the sun, the moon, the animal, the tree," he wrote in 1841, "but the whole, of which these are the shining parts, is the soul." So did Tocqueville when he noted that Americans regard individual things "only as the several parts of an immense Being." Pantheism, wrote an American in 1840, is "the admission of everything and the denial of nothing. He has the most accurate knowledge of God who has the most comprehensive knowledge of Nature. . . . God is Nature: Nature is God. . . . My books . . . are studies to reach the One Thing."

Yet who among Pan's believers could truly reach the One? Maybe only Rafinesque was right for the job. Only he had the patience and audacity to think the world stick by stick. Studying the frond of herb, holding it to the candlelight, writing his notes in an English that was his fourth or fifth language, he saw an entire forest in a sprig of lichen. The bug that crawled on his filthy cravat, that sizzled in the fire, flamed out as a tiny emissary of the cosmos.

Once he thought he saw Pan. A party of acquaintances had set off for a summer picnic in the woods surrounding Lexington. Forest novices, they carried books, drawing albums, pencils, and sandwiches, planning to make a day of it. Eventually, dripping sweat and not enjoying the trek, they looked for a place to sit down and eat. Finding a fallen tree across their path, they all sat down at once, and the tree, which proved to be rotten, collapsed beneath them. Out from the hollow emerged frogs, lizards, locusts, katydids, beetles,

hornets—every creature in the universe, it seemed. Fleeing, the party lost its way, and only by luck emerged a mile from Lexington a few hours later.

Hearing about the adventure from one of the travelers, Rafinesque recognized the place where they had entered the woods. It was near a stand of ancient oaks, their branches covered in vines, about two miles from a small limestone cave that only hunters and the naturalist himself knew of. He felt that the ruckus of insects swarming and fleeing the picnickers must have happened somewhere near that cave. Why, he could not say exactly. But the comedy of the crushed log, nothing unto itself, seemed to him a *sign*, a warning, to these idlers to back off a secret place they had come perilously near; and an invitation to him, knower of the All, to proceed.

Following a stream a few hundred yards to one side of the picnickers' entry point (in their amateur confusion, they had not noticed it), Rafinesque set out for the cave. Before long, he was standing in a grove of black locust trees that he recognized. The trees were blooming, their white drooping flowers exuding a lovely fragrance in the June heat. He looked up, observing how the leaves sprouted in fractal patterns, each one comprising a dozen or so oval segmented leaflets, making a kind of trilobite design. He placed a hand on the nearest tree, stroking its furrowed gray bark, then prepared to venture through the grove to the cave he knew the grove obscured. From his childhood reading—back in Marseilles, where he had taught himself Greek and Latin as a boy—he knew that Pan supposedly lived in a cave, and he now fancied (maybe it was just a whim of that day) that *this* cave, which he had visited before without noticing anything strange, was the one where the god lived.

Before Rafinesque could move farther, however, he became aware that the locust trees around him were shimmering.

They swayed, not in a wind, and not in the shifting light filtering from above, or even from the bees moving busily about the flowers. The trees seemed to emanate an aura— that was how he thought of it afterward—a kind of radiance. A buzzing sound accompanied the light, not the buzz of the bees but more like a sizzling or crackling noise, like a cymbal struck once so that it vibrated with a metallic timbre. Pan was everywhere, Pan was an "immense Being," shifting his toe roots and flexing his branch arms—Pan was the whole forest—but he could also conform his shape to any object, make his vastness intimate, and he seemed to be localizing himself just then. After a moment, the vibration and shimmer stopped and Rafinesque left, no longer wishing to look into the cave.

On his way back from the grove to the edge of the woods, he followed the stream. The sound it made on its gentle downhill run was nothing like the ringing noise of the black locust trees. Fragments of the sky appeared sometimes in the pools made by the stream's pebbles and stones, its lobes of accumulated leaves and mud. Beside one of those pools as he stopped to rest, his round belly heaving as he wiped perspiration from his brow, Rafinesque chanced to look down and thought he saw something. It was not his own reflection, blurred in a passing gurgle of light, but another picture, different from the stream's intermittent portrayal of the sky. Embedded an inch or two in the silted mud, angled upward against a small stone, a triangular chunk of glass portrayed the overhanging branch of a willow tree. Maybe it was part of some mirror a settler had dropped, or the make-do glass of a more solitary wayfarer, lost on his journey. But there it was, blocking one rivulet of the stream, a glass awaiting its Narcissus. He looked around, then looked back at the broken

mirror. He thought about stooping to pick the fragment up, but left it where it was and continued on his way.

It was a shame that Rafinesque was not a good artist (though he imagined his talents differently). His small drawing of the stand of locust trees, now much damaged and barely legible in places because of the foxing of the paper, poorly conveys the otherworldly drama of his experience. Maybe the encounter before the forest cave, let alone the attempt to draw it, made him too agitated to convey what he saw. But for that reason the drawing is inadvertently effective. Quivering in nervous graphite lines, Rafinesque's trees show the transfiguration in the draftsman, not in what he drew. "An earnest, articulate advocate of nonsense," a man whose "manic disorder fed on his immense erudition"—it made sense, what a biographer wrote of him. In that drawing titled *The Grove of Pan*, known to only a few, he created as true a picture of what could not be seen as ever was made.

The Clocks
of Forestville

The Time the Peddler Fell

The man walked to a window of his tower room and raised a spyglass to his eye. Through the bare woods of early November, he observed a solitary pedestrian on the dirt road at the edge of his estate. The stranger was walking steadily under the weight of two trunks hanging at each hip. A leather strap strung across his shoulders and attached to each trunk balanced the burden. "A peddler," said the man in the tower scornfully, still looking through the glass, "likely a peddler of clocks." On this last point he was not sure, since he could not read the stamped writing on the closed trunks, but clock peddlers were all over the place. The local people had been buying the new shelf clocks right and left, and the towerman assumed the peddler was delivering more of the same.

Time, he said to himself. *Time is money. Arrange the hours.* He almost spat the phrases out, mouthing the sayings of the thrifty merchants he hated. Their detestable proverbs sketched a democratic universe summed up in the dirty word *while.* While one person did this, another did that. It sounded innocuous, a version of the daily round, but what that simple word *while* really said was that all people were potentially equals, that life was a fair fight, that everyone got the same measure of hours and minutes to make their way; that the industrious man profited while the idle man slept, that the difference between the two was only a matter of merit, not right of birth. Absurd! For the man in the tower, the world was permanently divided between the great and the small, the high and the low. There was no *while* about it—as he lived his life, everyone else faded into nonentity.

In his turret—his private retreat—he had no clock. It was the last place for such a thing. In that study, full of folios and rare objects, he escaped from the plebeian world of minutes

and hours. Let his managers run his Hudson River estate: let them see that the tenant farmers paid their annual rent, apportioned crops to him, and did their annual work on the roads. The man in the tower—the patroon, they called him—had far more exalted things in mind. In that elevated and rounded room, windows facing west, he liked to see the dumbing down of day, the evening blaze of purple and pink rippling atop the Catskill Mountains, a hashish vision on the turret's bubbled glass. And he liked to look at his art. Putting down the spyglass, still muttering about peddlers, he turned from the window and walked in his padded slippers to a large table. Lighting a candle to aid the gray November light, he opened a folio of Old Master drawings, tokens of a honeymoon trip to Rome he inspected alone, his wife having long since left him (he was a tyrant).

Ah, look at this picture—who knows who drew it?—a little scrap of rag paper showing Joachim and Anna meeting at the golden gate. How ecstatic the elderly husband and wife look, trembling in angular lines: Anna's right hand on her husband's shoulder, her left in his right, the couple embracing to celebrate Anna's miraculous pregnancy. At their meeting there was no time at all, only a perpetual moment, dissolving and re-forming, cresting and residing, a wave of swiveling hips and swirling robes, outflung fingers and opened mouths. Or another drawing: St. Catherine of Alexandria and Maxentius—the Christian noblewoman standing before the enthroned emperor, the saint demurely gazing, Maxentius in a shadowy rage, his philosophers milling around the saint in a perplexity of robes and startled gestures. Here was another impactful *now*, a vision consecrated on no town square, in no liturgical lore, but just there on the page in the dimming Catskill light: blue gray wash on rag paper, alive to the touch of his hand, pulsing beneath the candle's flame.

Or this drawing: Hercules throttling the monster Cacus, the monster on his back, his right leg lifted to show the sole, a spigot of water shooting from his screaming mouth while Hercules straddles him and grips his throat. A sketch for some vomitous fountain perhaps? But who cared what the intent was? The point was the *now*. And all these drawings were so sudden, so instantaneous, that the man wondered if the artists had in mind orgasms as the ideal for the "ah" they hoped to elicit in their viewers. Sometimes he even tested this idea out, propping a drawing in front of him, to see if his own bodily experience corresponded to the shaking energies of the art. In an age when it seemed no shelf lacked a clock, his self-satisfaction was eternal.

His favorite word was *station*. The very sound of it—*station*—was pleasurable on his tongue: the serpentine *s*, the clucking sound made by the first *t* as the tongue struck the roof of the mouth, the "sh" sound of the second *t* as it emerged near the throat. He liked writing the word as well, never failing to give it a certain flourish in his correspondence, feeling like a king issuing a decree. Yet in the country at large he saw how stations were turning out to be false, fake, chimeras of different kinds. He knew firsthand what a French visitor discerned, that the imposing white marble palaces he saw arriving in Manhattan proved to be, on closer inspection, made of brick and wood painted white. He knew that the Hudson River painter Cole showed a great castle rising before a callow youth on a voyage of life, but that the castle—a magnificent station, if it had existed—was only a phantom, a dream. He had heard of a German prince—an explorer of the Far West—who thought that the towers of sandstone along the Upper Missouri looked from a distance like castles on the Rhine, only to discover, as his keelboat got near, that the rock formations lost all resemblance to bastions

of feudal power. But the towerman's castle was solid stone, and his power very real. He felt his station was secure.

Down on the road, hundreds of yards away, the peddler kept walking. He had long since vanished from in front of the giant estate, and was now some way into an adjacent wood through which the dirt road passed. He was in fact a peddler of clocks, delivering two models to customers in the nearby town of Kingston. In the damp November warmth, simultaneously cool and humid, he experienced time just as the towerman had suspected: as his own. As far as he was concerned, the universe emanated from him as if his own humble plodding marked the agitated rumble of the earth's creation. A moving mass of smell, of itching wool and coarse stubble, of perspiration, slick brow, and strong hands, he still tasted the buttered bread and coffee of his morning repast and reflected that his path in life belonged to him as much as the meal that lay in his belly. Of course, he knew that this was not really true. He was only the unsung end of a long supply chain: financiers, factory managers, clockmakers, and mercantile agents all preceded him in getting the clocks into the world. He was only one of many strung-out salesmen drumming up business, taking payments, delivering goods. But the illusion of independence was heady all the same, as substantial as the ground under his feet, and his mind wandered into certain dreams.

He pictured himself visiting a simple farmhouse. A family gathered around him as he demonstrated the intricate workings of the clock's mechanisms. They drew closer as he expounded on the practical importance of the correct time and even spoke of the philosophical mystery embodied in the clock in his hands. This extraordinary object, he told them, gathered the stuff of the universe, the celestial time of days and nights, showing it routinely and correctly. It was a

practical miracle, and he was a magician. He allowed scoffers and doubters to appear in his reverie—only so he could delight in rebutting them. *Reason*, he pictured himself saying, as if he were a reasonable person (which he was not); reason makes a man wise, that and the irrefutable ticking of the clock. No matter (he said in an aside to himself) if the damned things often became bloated and damaged en route, if their delicate wooden machinery required him to whittle and pare the cogs to make them work properly before delivery. He left that inglorious business out. What he saw as he walked on the dirt road through the forest were his admirers: the edified father, the bright-eyed son, the rosy-cheeked daughter at the window. He had his share of spite—sometimes he heard people dismissing him as a fool, not because of his clocks but because of his sales sermons, which, yes, sounded sometimes both too rapturous and too desperate. But he was certain he was his own man.

Just as he was feeling sure, however, he stumbled. He fell down hard to the ground. A tree root sticking up from the road sent him sprawling. Although his goods also struck the earth hard, he was relieved to find that the two clocks, one in each trunk, had not broken. He could not tell for sure since neither one was wound up, but gently shaking them he heard no disturbing noise. He was just feeling good about this, getting to his knees, steadying himself before trying to stand upright under the shoulder-strapped load, when his gaze happened to alight on a tree on one side of the road. It was not a special tree, just the tree he happened to see. It was a red maple, almost entirely leafless in the November day, then just starting to rain. The tree confronted him, if that is the right word for a tree, with its uprightness, as if it had remained standing while he had fallen, even as if the tree itself had knocked him down, which perhaps it had, if

one of its roots were to blame. But the tree was silent: crisp and sharp and wetly gleaming, flaring in rhythm with his vision; a curious solemn presence, inquisitive about this man kneeling before it.

The peddler shook his head, looked away from the tree, and tried to rise. But as he did so, he happened to look at one of his knees, where a patch of slimy magenta leaves—leaves of the red maple itself, it seemed—had stuck themselves. They made a kind of poultice, as if to cover and heal a wound below, though they were themselves a red shiny mass coagulating on his clothes. Peeling off one leaf and holding it before his eyes, he steadied himself under the shouldered weight and examined this thing that like him had fallen. It was a map of veins, bruises, and delicate edges, a land he had never seen: pungent and dripping in the rain. For a moment he was a connoisseur and priest, a celebrant at some rite of the heart. Then he laid the leaf down, staggered to his feet, and hastened on his way.

Daybreak on Monks Mound

Out in Illinois, a man named Amos Hill was busy on his farm. That morning, he had watched the sunrise and asked himself—yet again—if there was anything special to seeing it where he stood. His home was a hundred feet above the plains—as high as a ten-story building would be, once such structures existed. Just a few years before, Amos Hill had built his farmhouse atop this great flat mound of earth, choosing for the site an eminence on the mound's summit. He did not know it, but his home sat on the tallest human-made structure in North America—a vast earthwork extending a thousand feet from one end to the other of its

flat top. The elevation of his farm made him feel closer to the sun, in league with its rising, and that was what Amos Hill wondered about again that morning. He could not figure it out. He knew only that the sun shone differently up there than on the prairie below. Down on the ground, where cattle rested under the cottonwoods, where redwing blackbirds sang beside the deeply carved Cahokia Creek, the light was a little different. But beyond these basic facts his mind did not venture, and he turned to his hogs.

On that same eminence seven hundred years earlier, a priest wearing a cape of shell heads and a high crown of feathers had looked down on a populace of thousands on the plains below. The people staring up at the priest were more numerous than the citizens of medieval London, more powerful too. A coherent cosmology, a stable ideology, all centered on the mound atop which the priest stood. As the sun rose on that day seven hundred years earlier, lifting above the horizon just as it would for Amos Hill in 1834, a warrior appeared next to the priest. His face painted red, the warrior held a bowl of glowing embers taken from a chamber on the summit—the only fire burning that ceremonial day in the entire ten-thousand-person settlement of Cahokia. The warrior bent down and poured the embers onto a pile of leaves and branches. To the people below, watching the flames ignite, the sun itself had lit the torch, bestowing its blessings on the city for another season. They bowed down before both a cosmic and political power, the greatest in North America.

About who had been there before, Amos Hill had theories, suppositions, viewpoints. Ideas struck him at odd times, when he was squeezing the teats of his cow or working to build a path up one of the mound's sloping sides, when he was talking with his wife at supper or daydreaming about his native state of Massachusetts. What *Mayflower* had he built

on? It was the remains of an ancient civilization—that much was clear. This place of the mounds (for there were many smaller ones around the largest mound) was the domain of Indian kings, princes, and lords. Digging the basement for his house, he had found remnants of their rites and of their very beings: stone axes, tomahawks, and human bones. But who were these people? Likely they had no technology—he did not think they knew what a wheel was. So they made this heap with what—baskets of earth? If so, how many baskets for how many years had they needed to erect just the mound on which he built his farm? The rich black soil in which his crops of pumpkins, corn, and tomatoes grew so prolifically was the same loam of the Mississippi valley below, lifted into the sky. These ancients had cut down thousands of trees, too, judging by evidence of a massive palisade that once encircled the mounds as far as three miles from where he stood. It all made him scratch his head. Were the mounds a way to escape the spring floods of the Mississippi River, six miles to the west? Were they a military salient, making approaching enemies visible from miles away? He approached these existential questions like an amateur antiquary, undisturbed. The summit made him feel like a lord.

There was one respect, however, in which the great mound made him uneasy. It often shifted beneath his feet, especially after days of rain. One morning he found a slump about eight feet deep, like a huge dent in the dough of one of his wife's kitchen loaves. This was not the first time that he realized the solid-looking mound held a lot of water. He had already sunk a well, trying to take a positive view of the matter, but the unstable ground bothered him. Would his home slide off the edge one day, or snap in two as it sunk in a slough? And what else besides water would he keep finding? There had been a small earthen tumulus rising beyond a

grove of oak trees on the plateau, and one day he had swung a broadaxe in its side. Working with his sons over the next few mornings, he broke the dirt down and studied the splintered trove: arrowheads, beads, broken potsherds, a skull without the lower jaw, femurs, pelvises, a whole jumble of bone. The well water began mixing in his mind with this flotilla of remains.

Slowly Amos Hill began to think about time. He saw that his pretty wooden house painted yellow-white sat like a prairie lark on the back of a great bull. He gathered that the past on which he had built was far greater than his own achievement, both in extent and duration. It was also a graveyard, though even this gothic conception, which made Mrs. Hill dream in one of her malarial fevers of ghosts rising through the floorboards, could be seen positively, the parable of a democratic schoolbook: an old kingdom of superstition dying out, replaced by a new race of plain, ingenious, unstoppable people—white like Amos Hill himself—whose eagle scoffed at bones and drank the liquor of dawn.

Seemingly there was no cause for concern. The whole state of Illinois was setting up great, filled with settlers undeterred by cholera and Indian wars. Awaiting only the onset of cooler weather to be relieved of their bilious fevers, these hardy souls would then resume their prolific chopping of trees. They would return to their blacksmith experiments, looking for just the right temper of steel to break the fertile but plow-shattering land, sensing the advent of some new invention that, in fact, a New England settler named John Deere would conceive in 1837. They shot the game that was everywhere—deer, turkeys, geese, squirrel, the occasional wildcat. They stood in the brown creeks and killed turtles while butterflies danced in the tall grass like sprinkled signs of favor. Yet Amos Hill remained unnerved by the shifting

loam on which he had built. He envisioned time heaped up, built patiently layer by layer, rising up to hold within its amassed depths an ever-greater record of debris, on which, yes, he stood as king, the latest and greatest. But he also felt the heap sinking, imploding and sucking, a great hourglass of mud.

He reflected that the Trappist monks who lived among the mounds two decades earlier had made watches. It was a strange occupation for such a place. Advertising in the St. Louis papers, they made an exception to their vows of silence by doing business with the locals in this rare trade. But how many citizens in that grimy frontier town of river slime and maggoty animal pelts wanted a watch? And how diffi-cult it must have been—even in that town of many French people—to know exactly what to do with these speechless brothers of God who had emigrated from France to New Orleans, then eventually to Cahokia, to establish their rural retreat—only to have their enterprise cut short when disease killed most of them and forced the survivors back East.

Now, two decades later, when only fading imprints remained of the monks' lodgings, Amos Hill had a hard time squaring their watchmaking commerce with their gloomi-ness, with the papist rites that required each to dig a handful of earth daily for his own grave. He kept thinking of a story he had heard, that a benevolent lady from St. Louis had pitied the brethren and come to their door offering aid only to be greeted in profound silence. Turning away from this uncanny rebuff, she had heard a sound and looked back to see one of the monks kneeling in the doorway with a swab and pail of water, scrubbing the place where she had stood.

Musing on these gloomy ascetics and their strange rites, all too aware that the place where he lived was called Monks Mound, Hill hit upon an idea, though not necessarily a clear

one. In structure his idea was like the mound itself, with a plateau above and many hidden layers beneath—layers that Hill himself, though he lived upon them, could not fathom. He sensed a relation between the Trappists' ticking watches and their daily digging of the dirt for their graves. He naturally related these practices to the epic excavations of ancient Cahokia, to the thousands of citizens and their basketfuls of loam. It was all a bony rite of time—history not as progress but elevated inundation, a burial, a cave-in taking place aboveground.

Walking inside his farmhouse, Hill stood before the family's new shelf clock. He had purchased it from one of the traveling peddlers crisscrossing the state, a man he recalled well. The peddler, visible for miles from atop the mound, had ridden slowly across the prairie, heading west, straddling two trunks over his saddle, as if impersonating the pendulum inside one of his machines. He had approached the foot of the mound, wiped his brow, and hailed the man looking down on him from above, speaking to Hill in cheerful and frank tones. He asked to come up the path if only to have a glass of water, though Hill well knew that the man, once insinuated in his home, would make a hard pitch to sell one of his wares. So it had passed: the man tethered his horse to a nearby tree and ascended the path.

And now, looking at the shelf clock he had bought that day, Hill thought how admirable the device was, how elegant the numbers, how pretty the picture of George Washington's Mount Vernon painted below the dial. The portable commodity of a nation on the move, time had come to his home, a wholesome and reliable friend.

He stepped toward the clock and lifted it in both his hands, listening to the fragile mechanisms within. Steady the beat, lovely even, as if ticking the rhythms of the celestial

sphere, the infinities of space scooped into a box, the splendid work of the aproned sun at his anvil, forging the bright metal hours. What priest was Amos Hill? What incantation was his? A sky brought down, a sun raised up, he listened to a small sound.

The Clocks of Forestville

On a summer evening in the town of Forestville in the late 1830s, a young man approached a tree, knife in hand. The Connecticut town got its name from the dense woods that entrepreneurs had cut down a few years before to make way for a promising trade, the making of clocks. Soon the saws whirred and production increased all between Forestville and the nearby town of Plymouth, the fabled American System of Manufactures fully under way. Some 280 clock-making firms would exist in the adjacent town of Bristol alone, and by 1850 the state was making five hundred thousand clocks a year, specializing in the affordable shelf models that had shrunk the stature of grandfather time and put the hours within reach of everyman.

The tree the young man approached was an ancient red oak, still in leaf though bruised by time. The town's entrepreneurs had chosen to let it stand as a sign of the woods they had razed. Like other solitaries in New England towns, the Forestville oak was a living record, a dignified memory, speaking to ages past and the destruction that progress required. *The Solitary Oak*, Asher Durand called one of his paintings, doing justice to the general theme: a big oak, sole survivor of a once-vast woods, shading cattle and sheep and facing elegiacally to the west. But Durand got it wrong. The lone trees that stood ceremonially in New England towns—like the

one confronting the young man in Forestville—were scarier than the painter let on. Bending and torquing with the years, they blew ominously in storms. They scattered flurries of dry sticks in just moderate breezes, and sometimes they dropped a whole limb on an unsuspecting pedestrian. Gnarled and knotty, honeycombed with deterioration and fungus, they gave a disagreeably geriatric appearance, like warty creatures who had outlived their era. The iron railings placed around them seemed more like fences to keep them imprisoned than lattices for the trees' protection. If not evil, these wooden ogres seemed at least resentful amid the daily progress: the mills, the forges, the newsboys' shouts.

Something else rankled about these trees. The old elms and oaks were sixty and eighty feet tall, the sycamores still higher—a fact of no great note in a forest or grove. But when such a tree stood alone in a town or environs it became menacing and freakish, like a giant looming over the tiny citizens who had slain its kin. Maybe that is why the townsmen who carved their initials on the trunks of these monads did so less from love than defiance, chiseling the bark to show these towering lords who was boss. The carved initials made human presence the sign of all significance, the plaintive *I was here* supplanting the trees' own effortless clock—the mysterious inner growth of their annual circles of wood.

Standing before Forestville's old oak that summer evening, the young man raised his knife. He, too, would make his name. Like the men at the clockmaking factories, whose ranks he had recently joined, he would stand tall in proud self-assertion, closing ranks with these work brothers here on the tree just as he hoped to do within the factory's brick walls. But it was not easy to find a place on the old oak. At eye level and down almost to the roots, graffiti wrapped the bark in registers as dense as the whittled names on a child's

school desk. The scrimshaw of so many landlocked sailors left barely an open spot within reach. As he searched for an opening, however, the young man began to feel a graver concern. In imagination or not, he sensed the tree had become aware of him, that it searched for him with its blind knotty eyes. The full moon lighting the branches was a lunar watchtower blazing to spy him out, bidding by sheer luminosity to make the blind oak see the boy below. He lowered his blade, frozen to the spot. In the tree's sway he felt a vacancy of thought, an interlude of mind, the oak spreading over him velvet and sweet, the shelter of an unloved monster seeking a friend.

Nothing could end this sylvan moment, so it seemed, but then something did. The tree's remaining leaves began soughing above him, stirred by a sudden wind. Whether from senility, wisdom, or plain habit, the oak was speaking the language of the woods, sending signals to the other oaks deeper in a forest that no longer existed. In that unanswered sound, blown from the crown, the young man became more alone, more fully grown. He left no name we can call his own.

Longleaf Pine and a Length of Time

The boy stayed up late, reading by a lamp lit with oil rendered from the fat of raccoons. Dissatisfied with candles, he had hunted the creatures for this very purpose. Now, by the hissing flame, he observed not only the words on the page but, in imagination, the great woods outside his house. The part of East Texas where he lived was the westernmost edge of a 230,000-square-mile forest of longleaf pine. Hard and strong, nearly impervious to fire, the pines stretched unbroken for hundreds of miles, towering over a ground empty of

other vegetation. Lightning strikes routinely burned away the underbrush without setting the tough trees aflame. Reading by a glow made of nocturnal animals, the boy pictured the vast darkness the trees made.

He envisioned the forest in time as well as space. That was because he conjured the scene of himself reading as a boy when he was no longer young. Far from it, he was nearing the end of his life, aged ninety, recalling in 1910 what it had been like to grow up in Texas back in the 1830s. By those late years, William Physick Zuber had seen the destruction of the great woods he remembered envisioning while reading by his homemade light. Some forty years after his boyhood, vast commercial lumber companies had turned away from the heavily exploited Great Lakes regions to focus on the huge tracts of valuable longleaf pine in the South. At Zuber's death in 1913, Texas mills were planing billions of feet of pine boards every year, and some 262,000 men worked in the state's lumber industry. In the mills, boys as young as he had been back in the 1830s helped out, taking slabs of wood tumbling out of chutes and handing them to men at the circular saws.

Back in 1831, when young Zuber spent his nights reading, men were already cutting down the pines within two hundred yards of a place called Bray's Bayou, hauling the logs to the water, floating them to a mill, sawing them into timber, and transporting the boards on a schooner to Tampico, Mexico, for sale. But the primitive machinery of those days, such as the mill's waterpowered sash saw, hardly made a dent in the woods. It was not until steam engines began replacing water mills that the devastation began, a change marked by loud noise as much as anything else. By the early 1900s the racket had become deafening, with heavy-duty locomotives called Shay engines (five times more powerful and five times as loud as regular locomotives, so it was said) pulling lumber

on special rail-line spurs from the deep woods to mills and depots. In operation the Shay engine emitted a Tyrannosaurus growl that drowned out the continuous whining and whirring of the hungry gas- and steam-powered saws, silencing the noise of their predatory metal fangs eating bark and spitting sawdust. In that din, the lumbermen shouted barely audible oaths in one another's ears, while backwoods fishermen and hunters, bundling fatty pine to feed the engines and earn a few cents, yelled a dialect unheard of. Over it all, the mournful brass whistles of the Shay engines shrieked across the birdless woods.

Writing of the forest when he was a boy, the ancient Zuber had trouble distinguishing between his recollection of the silence and the deafness that had overcome him. Was it that the woods themselves had lost one of their senses? He got confused when he tried to recall how quiet they had been in 1831. He worried that his memory deceived him, that a lifetime of pounding sounds had destroyed the delicate hush so completely that, in its place, the racket had made a deafness that became the specter of the silence lost.

Gothic writers called the quiet of forests "eerie." Given what followed, it seemed that an atmosphere of foreboding had all along hung about such places, an expectancy of disaster. In their vast emptiness of long ago, as much as Zuber could recall it, the woods seemed prestocked with ghosts, ambitious ghouls who had no need to live and die before haunting a place but seemed drawn to the woods' silence as a climate welcoming their nonentity. The strange visual clarity of the understory—the way you could see a deer a half mile off because of the absent underbrush—was itself a version of this ominous peace, a kind of visual silence. The woods were, in short, unbelievable: not only in their extent, in their resistance to fire, but in the way they seemed to *know*

something, not least the secret of their own fate. They hardly needed the hum of a first waterpowered saw as an omen of their demise. The omen was already in them, in the steady chewing of parasitical insects at work in their bark, in the hammering of woodpeckers for the grubs infesting a dead trunk, a tapping that must have resounded inside the hollow like the tremors of doomsday. An imperceptible chewing of time, a symphony in concert with silence, the woods offered a towering knowledge, no more graspable than a pine's first limbs were to a person looking up at them from far below. The tall wisdom was no doubt the projection of the person whom the trees awed, but it was also more than a projection. By might, extent, and amplified quiet, the woods knew more than he did.

What they knew is that they would fall. The trees took a person's destructive thought and modeled it for him, showed him what it looked like in all its branching forms. The avaricious man, eyeing all the would-be lumber, sprouting with thoughts of profit, saw his ideas portrayed in the tracery of these beings tutoring him in design, educating him in all the economic and political machinery required to bring them to the ground. By their extent and imposing otherness, they prompted the machinations that brought them down: the repeal of the Homestead Act of 1866; the squashing of the tiny "peckerwood" sawmills, allowing big lumber companies to buy vast tracts of woods at $1.25 an acre and start clear-cutting; the thousands of black men fleeing the limits of sharecropping to work in the forests, serving as the indispensable cheap labor force that made the lumber companies' profits. The trees "knew" all this, in some way, portraying in their tracery of limbs the crossed arms of an exploiter's concentration; foretelling, in sheer mass, the hard labor required to bring them down, the missing-finger screams of

slipped blades and the shuddering weights of falling wood. The planed boards that went to build houses carried the trees' silence abroad into thousands of corners and stairs and floors. The men who did the deed, the quarter-million choppers, sawyers, and millworkers, black and white, who raised the racket of the crashing trees, did something strange. Little by little, over the decades to either side of the year 1900, they sculpted clearings that became the visual equivalents of the gothic hush they were paid to kill off. A language of large and loud destruction, responding to the woods' provocative quiet, led on by it, like a hunter tracking an animal, ended up instilling a more final form of this intolerable silence by vanquishing it, just as by shooting the animal the hunter creates the true nonexistence of the hidden beast that, moments before, had done all it could to blend in, fade away, be as if not there. Sympathetically, too, the lumbermen did away with their own lives as they cut down the trees, wasting, expending themselves in the destruction that, when complete, raised to new heights the great ethos of the Not There.

No wonder the creature that most haunted those woods became extinct. The ivory-billed woodpecker—the "Lord God Bird," nicknamed after the exclamations of people seeing the pterodactyl-like creature for the first time—disappeared with the trees that gave it life. Within a generation or so after Zuber's death in 1913, the last of these birds was gone. A genius of place when it lived, the ivory-billed woodpecker became more so in extinction: an angel lingering spectrally in woods that no longer existed, pluming in the slurry and waste. So reciprocal was it with its habitat, so reliant on the hardwood pines, that in retrospect it seemed a manifestation of those trees, as if a part of the wood had been granted the faculty of movement and been allowed to fly, not as a

matter of germination or any other purpose, but as a flour-
ish of useless and terrifying otherworldliness: a nameless
monster hastening the destruction of everything, including
itself.

The void left an uneasy feeling, a nausea akin to the inha-
lation of sawdust and gin. It hardly mattered that the guilt
did not originate in any person or thing. It was there all the
same. Even the indifferent person, casually laughing, inhaled
great breaths of it. Yet there was no consequence to this guilt,
no retribution, no judgment. The days of Deep Ecology were
far in the future—the era when, in the early 1970s, attorneys
representing a forest argued the case by saying a corporation
had no right to cut their clients down. The Deep Ecology days
were far in the past too: back in the sixteenth-century court-
rooms where an attorney representing weevils infesting the
vineyards at Saint-Julien had argued that the insects did not
deserve to be punished because they, too, were "creatures of
God"; where another attorney successfully argued that his cli-
ents, the rats plaguing Autun, had been unable to attend their
trial and were thus not in contempt of court because "they
had not been given enough time, that it was necessary to take
into account not only the distances to be traveled, but the dif-
ficulty of the journey, a difficulty made all the greater by the
fact that the cats were on the alert, present in every alleyway."
All this made no sense in nineteenth-century America.

By then the forests and the creatures within them had
long since lost the divine force of soul, and the rights attend-
ing thereto, that earlier and later societies would grant. Trees
and oceans and icecaps would have to wait for their legal
rights. Yet an occult force still played out over the destroyed
American forests. In East Texas, the night kept falling on the
woods no longer there. And in the mind of the young boy
now an old man, the darkness still sought the place where

the trees had been, the frilly canopies of needles just right for evening itself to bed down. Alight in a sputtering flame, these trees that did not burn grew radiant in the mind of the boy envisioning what had been, the man caught between past and future in a span of years, fourscore and ten, whose attenuations suggested a vaster spreading of time, stretched to a wingspan of colossal thinness: the ancient chronicler's note to himself, unable to lift his head, as he lay down to sleep.

And what did he dream? He no longer experienced the world but had the sensation of the world experiencing him—of it *tasting* him, he felt, as if he were the wafer and wine of some religion intent upon substantiating the myth of his existence. The pines were there, regarding him from tubs of bubbling sap and tar: waving to him, perhaps even ogling him, as they might a fine lady or gentleman, with all the bigendered sexuality of their ambidextrous arms, their male and female pine cones vibrating with excitement.

But the real subject of his dream was—for the thousandth time?—the occasion when Zuber had crossed the Brazos River as a teenager, part of a small group of volunteers marching to relieve the doomed garrison at the Alamo in 1836. The volunteers ferried to the west side of the river, climbed a hill, and saw the village of Washington a half mile away across a gentle, sloping plain. Three buildings stood there: two hotels and a store. They approached and stayed at one of the hotels. Zuber bought some stationery there, intending to record the history he was witnessing, but on the march a few days later he spilled his ink and then moths ate the pages. He remembered everything he had written, but even so—this was what was clear to him in the dream—the world he recorded had been blotted out, consumed, and become manifest in the moths' wings, which beat with the words that escaped him, swarming in the light he had made.

Shades of Noon

The four-man crew entered the dense hemlock forest, ready for the day's work on the northern slopes of the Catskills. The tops of the tallest trees were more than a hundred feet overhead, seeking the little light the shade-tolerant giants needed. It had taken decades and even centuries for the tallest of the hemlocks to reach the sun, and as they grew and grew, followed by younger hemlocks crowding upward, the light below got so dim that the plants and trees needing more sun had long since withered and died. On this warm and clear June day, the ground on which the men stood was wet and dark.

In that shadow the first man, the chopper, dropped a tree the crew had settled on—a colossus 150 feet tall and five feet in diameter. As it fell, the tree broke the branches of neighboring hemlocks, then hit the earth with a thud. The second man, the knotter, pruned the branches before the ringer divided the bark into four-foot lengths by cutting around the fallen trunk. The spudder began stripping the bark with a blade attached to a spud bar. All around this one crew, other groups of four labored on the same grimy, nasty tasks. The sticky and odd-smelling hemlock sap, called "slime" by the bark strippers, covered them as they worked; eventually it hardened until their clothes stood on their own. Mosquitoes, black flies, and no-see-ums swarmed around the men, who countered by slathering their bodies in pine tar and bacon grease.

The trees they cut down were nearly worthless—a shame, from an economic point of view, since thick forests of hemlocks covered the northern United States from Maine to Minnesota. The problem was that the wood was "shaky": it tended to split into concentric rings instead of smoothly into

planes. When it could be cut straight, it warped crazily while drying. It splintered when you drove a nail into it, and yet it grabbed the nails so intensely when they did go in that it was difficult to pull them out again. Few people would want to build a house—or anything—out of hemlock wood, though technically it could be done.

But the bark was another matter. It contained a good amount of tannic acid, perfect for tanning leather. As the demands for shoes, boots, and other leather products grew amid a dramatically increasing population, the need for hemlock increased, and since it took one whole hemlock tree to create enough tannic acid to tan only one or perhaps two hides, the northern forests were razed. With more than eight thousand tanneries in the United States by 1840, many of them centered in the hemlock-rich region of the Catskills, there would be leather-tanning in the area for as long as the stock of trees held out. Then the industry would move farther west. On this June day, their work completed, the men left cords of hemlock bark to cure until fall, when they would return to drive wagonloads of it, stacked like shingles, down the mountains and into the valley town of Hudson, right on the river.

Hudson was home to the ocean. It had been founded as a whaling port in 1783, placed there by Nantucket businessmen intent on establishing an inland harbor shielding American whalers from the destructive power of the British navy along the Atlantic coast. The American Revolution had amply demonstrated the Royal Navy's power, and in the likely event of a future war, these New England businessmen wanted a more defensible base for their lucrative operations. Within a few years, Hudson was a thriving center of wharves, warehouses, and more than a hundred dwellings—both an inland rural center and an entrepôt for ocean commerce. The scents

of whale oil and cow dung mixed in the air; the ships at anchor smelled of salt breezes.

On a fall day, not long after the latest loads of cured hemlock bark had arrived, a ship docked in Hudson's South Bay. The *Martha* was back from the Falkland Islands, bearing a cargo of seal hides. The great seal herds had been mostly destroyed a few decades before, during intensive hunting that saw ships from Hudson and other world ports land men on the creatures' nesting islands, called rookeries, where they beat the animals to death using clubs and oars, skinned the hides, salted them down, and stretched them to dry on pegs during the journey home. The work was wet, cold, and dangerous, even apart from the nasty slaughter of the doglike creatures, whose fierce resistance and valiant attempts to protect their young from being clubbed to death stayed in the minds of even hardened assailants. It took a rational and cold intelligence not to ponder the region's Jehovah-like signs of disapproval—the towering icebergs that would suddenly break off in five-hundred-ton flakes and hit the water with an explosion as loud as cannon fire, or the floes of shattered ice, blown by the wind, that like intelligent beings seemed to pursue the sealing ships, intent on their wreck. No wonder the *Martha* was glad to spot two other Yankee merchant ships amid the rookeries, one from New Haven and the other from Stonington, Connecticut. Even with the competition, there was safety and security in not being alone in such a desolate place. But the effort was worth it, and the *Martha* returned to Hudson with several thousand hides.

At the dock, the skipper met the owner and oversaw the transfer of the hides to the town's Tannery Lane. The lane was already stacked with the pelts of newly killed cows, deer, and other creatures arriving hourly on wagons swarming with flies. The seal skins, by contrast, were relatively well cured,

though still pungent with brine and seal oil, and flecked with blubber and dried blood. The latest load of hemlock bark had recently been manhandled off the wagons, then ground up and cooked into a slush the tanners called "ooze," which they stirred in foul-smelling vats. In the days that followed, laborers soaked the hides of the cows, seals, and other creatures in water to remove the salt and soften them. Then they fleshed the inside of the skins by scraping away the fat and blood before turning to the hard work of loosening and removing the hair on the hides' outsides, which usually meant soaking the skins for four to six days in a lime solution. Then they soaked the hides in still another solution, this time to neutralize the lime: a mixture of lukewarm water and pigeon or chicken shit, purchased from neighboring farms expressly for its de-liming qualities, until finally after eight or ten days of soaking, the hides were considered ripe and ready. The mess was astounding. Toxic tanning liquors, lime, flesh, and hair sat in stagnant pools or flowed into the Hudson, all part of the process that united hemlocks and seals in products of durable, pliable red-brown leather.

Did the hemlocks in their ancient groves understand that this was the way of the world? Travelers remarked on the trees' gloom: the lack of sunlight in the glades, the silence beneath the great heights, the shaggy leaves, downward-trending, that made the hemlock such a good choice for cemeteries—no wonder the trees took their name from a poison. Wanderers saw how dead limbs—the remains of branches broken off by heavy weights of snow—protruded from even the most robustly healthy of these trees. They saw the great number of fallen hemlocks, slowly rotting over decades—even centuries—lingering on the forest floor as for love of corruption. They saw how the hemlock seedlings liked these caved-in logs as places to grow, though the growth was

strangely slow: two or three decades for a hemlock to reach chest height, with few ever reaching that far, since deer ate most of the stalks. With a shadowy intelligence, the young hemlocks that survived could suspend their growth for a century or more, biding their time until an opening in the canopy let them resume their sunward search of growth. All this fecundity and decay, in an atmosphere of permanent shade, made it seem that the trees had minds tending to gloom and slime and delay.

Once upon a time, in the now-vanished obscurity of these trees, even the light had been different. What little of it that had filtered to the forest floor did so in twisting beams and pale streams. The light that did not penetrate, that instead hung above and around the hemlock groves, was likewise different: a bright weight, a sober gleam rubbed in fragrant darkness. But once those densities were gone, the light became rampant, commonplace, the utilitarian stuff of almanacs and art. In destroying the gloom—and with it the gravity of the light—the foresters did away with the insights of the unseen, the blindness of slow time, the magnitude of brightness itself. The soundless height of the trees, the plummeting of the roots, were one with the seal in the sun.

A Trip to Bloomingdale Asylum

The art historian and the recent mayoral candidate stopped before the asylum. From their homes in Lower Manhattan, they had taken a carriage all the way to Harlem, to the Bloomingdale Asylum for the Insane, a large building of smooth reddish-brown stone overlooking the Hudson River and shining in the June sun.

Both visitors were busy and preoccupied. The art historian, William Dunlap, was putting the finishing touches on his *History of the Rise and Progress of the Arts of Design in the United States*, a monumental work he would publish later that year of 1834. Researching and writing the book was complex enough—he was still gathering information from far-flung and local correspondents—but Dunlap's poor health made matters worse. In his late sixties, suffering terrible pains from kidney stones, he had recently undergone an operation that injured his bladder. He had a swollen gouty foot that made walking painful and had lately given up porter and ale, then brandy and wine, while restricting himself to bread, milk, and strawberries in hopes of making himself feel better. In the meantime, he found some relief in the laudanum prescribed by his doctor.

Dunlap's friend Gulian Crommelin Verplanck was equally busy though in stronger health. Just two months before, running as the Whig nominee, he had narrowly lost the election for mayor of New York City—an election so hotly contested that armed supporters of the rival candidates had fought with knives and clubs in the streets, then broke into gun shops and arsenals in preparation for open warfare, before the outgoing mayor called in troops to restore order. Still smarting from the loss—the outraged cries from thousands of his followers in front of City Hall kept ringing in his ears—Verplanck was perhaps also relieved. He had a range of literary and philanthropic interests that he could now turn to with greater leisure. So he traveled with his friend Dunlap to inspect Bloomingdale, a sanatorium that did not punish and torture the mentally ill but treated them with kindness and thoughtfulness, that gave them as much freedom as seemed prudent, and all in a beautiful setting that promised to speed the cure.

The resident physician greeted the two distinguished visitors cordially. He showed them the portrait of the institution's Quaker founder that Dunlap, a painter as well as an art historian, had made several years before. He showed them the supply rooms and kitchens in the basement, the stores of hearty provisions—flour, rice, crackers, cheese, salt, pepper, spices, fresh beef, mutton, and veal. In response to a question, he said the asylum had admitted slightly more than one hundred patients each month so far that year, an increase over the admissions in the same months the previous year. He spoke of the time he had spent in Paris studying how best to run the institution according to the latest humanitarian principles. Then he unlocked the door leading to a long wing housing male patients.

The corridor down which the guests and physician walked was ten feet wide, with living quarters on either side. Notwithstanding the asylum's aims to grant as much liberty as possible, some patients required restraint. One was strapped into a "camisole," a pair of long leather sleeves constraining his arms, because he liked to tear off his clothes. But other inmates were plainspoken and relaxed, as cordial as friendly strangers met on the street—their reasons for being institutionalized only gradually becoming clear. A tall young man invited the resident physician to a small wager based on a coin flip, tossed the coin, and while it was still in the air called both "heads and tails," announcing himself the winner. A man with a long gray beard and close-cropped hair, asked by the director if he knew one of the guests, required that of course he did not, never having seen the man a day before in his life. He gave lucid answers to other questions. But his replies hinged on compulsive analogies to violence: "If I say shoot that man, it is done. . . . I say it & they are dead."

The doctor conducted his guests outside, to the asylum's gardens. In neat courtyards beneath full-grown shade trees, patients were pitching quoits. Others strolled along paths, and one man sat on a bench, enjoying the airs off the river. Greeting the visitors cordially as they approached, he looked up from beneath dirty bangs. Mud crusted his britches and his cracked leather shoes, his swallowtail coat was frayed and worn, but he did not rise in salutation before the well-dressed visitors in their hats and cravats. Smiling, he pointed at the oak tree above his bench and then at a wreath of oak leaves they now noticed encircled his head. He asked the guests if they knew how leaves "got on" trees. They said they were confused by the question, that leaves grew on the trees, they did not "get on" there, that they sprouted each spring, that the very leaves of the oak above them had done so only two months earlier, and that they were beautiful, in the rustled shade and warm breeze of the June afternoon.

The man smiled and replied that this was not so—that the leaves did not sprout each spring but that God placed them there, one by one, not only on this tree but on all the deciduous trees of the earth. Asked to elaborate, he said that God's patience was infinite, that he had a store of all the leaves kept away from men's sight, and that while no one was looking the leaves went up, festooning the trees, attached there, in the thousands, the millions, beyond number, in truth. Then in the fall God took the leaves down, snatching them in withered clumps and clusters so that the process could begin again in spring. He said that some mistook the wind that blew the leaves for a divinity—the wind that was blowing through them right now—but the truth was that God was in the trees themselves, in their very leaves, in the miracle of how they came to be.

The guests kept silent. So did the smiling physician, as did the man, who now spoke of the philosophers studying the miracle. He said that some men devoted all their thought to how God handles the leaves, to what combination of thumb and fingers he uses to grab and attach them, to whether or not, having "stuck them on" each tree—that was the phrase he used—God gives each leaf a flourishing little tap. He said other scholars focused on the fact that not all leaves were alike, that although you could identify a leaf as coming from a certain kind of oak, for example, you could not say that all the leaves on that tree, or even any two of those leaves, were exactly alike, and that this, too, was a sign of mysterious matters beyond human comprehension. Truly it was a marvel, all of it: how the very leaves blowing above their heads at this moment did so as an homage to an unknown hand.

When the man tapped the wreath at his forehead, his guests asked if God had placed those leaves there too. He chuckled softly, smiling at the ignorance of his questioners. Of course God had not placed it there. The man had made the wreath himself, stringing leaves an attendant had pulled for him at his request, sewing them into this "garland of thought," as he called it. The garland of thought was only a human sign of the divine mind, he said, just the barest token of faith in something beyond knowledge—akin to an early Christian's sign of the cross. Of course the leaves themselves had been touched by God, pinched between his thumb and finger, and in that sense the ones he wore on his head came from on high. But the arranging of a human being's "outer mind," as he termed it, was the man's own. He tamped one of the leaves against his temple, as if to make it stick.

Later that afternoon the visitors climbed into their carriage, returning downtown with thoughts of their own. The

doctor had said the man was a painter poisoned by lead, though some said it was more than the brain poison that had crossed his mind. They claimed that painting all those leaves, daubing the brush repeatedly in shades of green, became for him such a strange and slurping endeavor, such a rote repetition—all that flicking and flecking of walnut oil studded in pigment—that gradually these little green dabs had usurped the place of distant mountain and cloud as his sign of God. What more could a person know of the unknown than to experience it, in throes of futility, in the repetitive effort to comprehend, by one's very actions themselves, the infiniteness of divine creation? Only by wearing a wreath, by resorting to signs, could a person align with the vastness that made him small, cracking his skull on the problem that outdid them all.

The art historian, who completed his tome that October, wrote that "every artist wishes, and ought to wish, that public attention should be called to him." He hoped his book would publicize as many artists as he could. Artists, he said, are impeccable men, worthy of our esteem, charting the progress and improvement of the United States. But what of the forest man in his cell, alone on his bunk, hands clasped behind his head? He was no artist, not by common grasp. But he strangely saw what no one else did. Just then, for example, he was looking up, studying a heavy wooden joist above his head, a welter of splits and seams, a lofty weight-bearing beam. What kept the sky suspended, what truth never ended? An infinite matter, a termite art, this piecing together of untold parts.

The Lost Child

At noon one day in August 1837 five-year-old William Filley set out for a nearby swamp in company with Mary Mount, a neighbor girl. William wore a cluster of pink flowers that his mother had placed in a buttonhole of his little coat, and he carried a piece of paper with writing on it. As the children prepared to depart from the Mount home, Mary's mother thought William should not go. Mary knew how to be cautious, but William was too young and the snakes infesting the swamp were deadly. But William put up such a fuss that Mary's mother relented and sent the children on their way.

In the swamp William soon became bored and wanted to go home. Mary Mount, busy picking berries, simply pointed him on the trodden path back toward her home and then turned back to filling her basket. When she got home a few hours later, she was astonished to find that William was not there.

Jackson, Michigan, where William disappeared, had been founded only eight years earlier. Named after the president whose two terms in office would soon conclude, the place had grown to some three or four hundred settlers, and by nightfall of that August day most of the men were out searching. They set fire to the brush and log heaps around the swamp to give them light and to make a beacon for the boy if he was lost nearby. But he did not come.

The next day a family two miles away reported that, the previous evening, they had heard a noise that sounded like the stifled cry of a child. The next day while exploring around the oak openings—the settler term for the spaces around burr oaks—they found a piece of paper that his parents identified as the one William had been carrying. Expanding wide around the spot where the paper was found, the settlers formed a vast circle, each man within arm's length of the

next one in the sphere, and slowly converged. They let bear and deer squeezed in the circle escape because the predetermined sign for finding the boy was a gunshot and they did not want to fire at the animals and give false hope to searchers farther away. But when the circle narrowed to a point and they found nothing, they turned to Mary Mount.

They said she must know something about the boy's disappearance. Possibly she had caused it, killed him even. She denied it. Her mother Lydia denied it. But the settlers descended on the Mount farm. One went into the house and broke into chests and tills looking for evidence. Others turned over the ash heap in the fireplace, looking for a child's bones. All around the Mount place hundreds of settlers searched the grounds, many more searchers than lived in Jackson itself, for word had spread. Next they went to the lake by the farm, Fitch's Lake it was called, dragging it during the day and searching it by torchlight and small raft at night. They found nothing, but by then all had convicted Mary Mount in their minds. For days, then weeks, then years, no word of the boy ever having come, the accusations followed her: "There is the girl that murdered Filley's boy"; "That is Mary Mount, the murderess."

But there was something the townspeople did not know. As William walked back down the path that August day, he had been abducted by Pottawatomie warriors. This became clear only in 1866, twenty-nine years later, when a man arriving in Jackson identified himself as "William Tilley," mistakenly substituting a T for the F, and telling the astonished townsfolk that he in fact was the lost boy. He said that he had no memories of the abduction but had lived with the Pottawatomie for several years when he was young and then had gone west with the tribe on its move from Michigan to the Great Plains. He had been given over to the Sioux, then

to the Crows, and finally to the Comanche. He had traveled all over the American West, in particular the Rocky Mountains and the Far Northwest, to "New Oregon," as he called it. He had hunted bears and mountain lions and been hunted by them in turn. He had witnessed acts of horrific cruelty among the Indian tribes, varying with each tribe's customs, but was always treated well and considered fully an Indian by his keepers. He spoke eleven different tribal dialects. To the good question of how he learned English, he said that he picked up the language when his Crow captors sent him to San Francisco in 1849 for that very purpose. He had found his way back to Michigan when an old Comanche chief, in his dying words, had told him that he was white, that his name was "William Tilley," and that he had come from Jackson, Michigan.

The tale was outlandish, absurd, impossible for many to believe. But William's father Ammi felt it was true and accepted the stranger as his son (William's mother had died in the meantime). The proof was a nasty scar at the base of the man's left thumb. The scar matched exactly the wound that Ammi's brother Grandison had caused when he accidentally sliced the left thumb nearly clean off William's hand when the boy was only two years old—a wound that occurred as Grandison tried to cut away a long coat sleeve interfering with the boy's efforts to grab apples off the ground one fall day in 1833 in Bloomfield, Connecticut, where the Filleys then lived. The scar having resolved the case, William Filley settled in Jackson, never worked, rode the railroad gratis (he got a free pass), and regaled the local children with Indian lore.

Meanwhile, Mary Mount had never left. Her decades-long torture made a reverse picture, a backward tattoo, of Filley's harrowing stories of life among the Indian tribes. For every frontier hardship he had endured, she had experienced

an unstoried one at home. When he descended into a cave and discovered a gruesome Comanche burial site, his encounter with the dead recalled the gothic search parties for his own corpse—and soon the suspicion of Mary Mount as the culprit—that had previously occupied the town. When Filley told of hearing how a Sioux woman had scalded a baby to death and then, as punishment, been scalded to death herself, the execution resembled Mary's psychological punishment at the hands of the townsfolk. When Filley fell some twenty or thirty feet through a hole and down into a mineral spring on one of his exploits, the temporary blindness caused by the stinging mineral steam—and his painstaking efforts to climb out of his blind grave—made him a figure of Mary's years of punishment and endurance. The two berry pickers of a single day in August 1837 had become sides of the same coin. He was shown in uncouth deerskin; she was the animal flayed.

Truth and fiction tethered together, lost to life, left to rot, they spoke to each other in those later days or did not. Which was which—true or false—went unsaid. The white paper of long ago was a blank note, a silent statement, a secret oath between them both. The wide circle of searchers had come together for a forest rite, a camp meeting to close the gap. Slowly they converged in solemn dance, found nothing, then reversed course to lay a different snare. The bears and deer they let flee were the sacred gods of their witch hunt. The guns they did not shoot were the militancy of their peace. By day and by night they stabbed the broad sheet of Fitch's Lake with poles, cracking the clouds and stars and stirring the sky in the smoke and spit of citizenship. But through it all, Mary and William remained the same, smote together in all but name, a couple to defy the days and trade the pain.

The swamp of that one day consumed them, swallowed them up. The buzzing half silence seemed made for the

purpose. The drowsy hum from the white oaks was bright and fertile, made of sunlight and a fetid smell—the almost audible germination of sweet acorns, the rough bark pumping loam to leaf. The canopy diminished outside sounds, intensifying those within. Heavy berries on the bushes gorged themselves with outer noise and became toxic with all they sucked up. The historian cannot contend with such a historyless place, the spot where the path retraced is the one first taken, where all directions lead two ways beneath the silvery leaves, becoming the mush of punishments and decays, indecipherable to those on hands and knees.

In the cheaply printed book of 1867 describing his abduction and exploits, William appears on the cover, Mary in one of the first interior pages. Uncouth William sports long hair, thick beard, a stone face that would be at home on Mount Rushmore. Mary is prim and tight-lipped, hair pulled back, brooch at her neck. Two different people, yet they share the same half smile, the same stern and hooded eyes behind which life lies. With time—the journeyman artist who made the engravings might have sensed—the two children had become more and more alike, blended in their common fate, until it became possible to mix and match. Filley was a version of Mary Mount, come back to the place where she had always been but now reborn as the grown man she was accused of killing when he was a child. And she was the living ghost of the man whose absence had turned her life into a living death.

That day in 1837 the children had ventured into a forbiddingly sacred site—an Indian burial ground was not far away—where some magic wand had cursed them into the legends they never wanted to be. In that alchemical place, made of new growth and yesterday's mulch, what was true, and what was not, were buried in one spot.

Supernatural

The Actress at the Waterfall

The young woman and man sat on a narrow ridge of stone, looking down at the plunge of the waterfall. Upstream, a few minutes before, they had tossed little branches and flowers into the rapids and watched the current plunge them over the falls. Now a rainbow appeared in front of them, in the mist. She was the English actress Fanny Kemble, twenty-three years old, newly arrived in America the previous September, part of a famous acting family that for years had run a popular theater at Covent Garden whose financial insolvency had led Fanny and her father, the actor-manager Charles Kemble, to recoup the losses on an American acting tour. Fanny's companion that day was Pierce Butler, one year younger than her, a handsome and wealthy Philadelphian, the most persistent of all her American admirers (her acting had taken the cities of the Northeast by storm). Butler had gone from fumbling nervousness around the intelligent, pretty, and shrewd actress—whose Manhattan hotel room he often had bedecked with flowers—to this intimate position by her side.

The plunging water began making Fanny dizzy. She and Butler crawled back across the ledge and returned to the stone path, slippery with spray. They reached a fallen tree and Butler lifted Fanny onto the trunk. There they dipped their pale hands in a nearby pool of black water as their guide came bearing a wild strawberry and a bluebell that he gave to Fanny. She ate the strawberry and dipped the flower into the pool, using it as a cup to drink the icy water. The couple's traveling party now rejoined them—Fanny's chaperone, her father, and her father's friend, all of whom had been careful to give the courting pair some time alone—and Fanny dipped the bluebell back into the pool to give her father Charles his

own taste of the cold water that looked like ink in the basin but that shimmered transparently on her lips. Something Shakespearean hung over the slightest actions of this father and daughter, a courtliness of gesture, a way of making the whole falls compress into the flower's bell, the noise made still and solemn as a syllable. True, the great array of Pierce Butler's amorous bouquets, themselves a waterfall of affection and passion, were even then working their charm on a woman who had vowed never to marry and give up her income and independence. But his wealth of flowers was nothing compared to the singular stem, the delicate drink, whereby the word spoken was a silence consumed; and no bell but the little flower, cousin to the ones flung over the falls, more perfectly consecrated the July day.

The terraces of rock rose above them, shaped in regular slabs, and the secluded place resembled an amphitheater. The party was at Trenton Falls, fifteen miles from Utica, New York, on their way to Niagara Falls, part of a summer sojourn Butler had organized to show Fanny the wonders of the American landscape. There in that remote place near Utica, Fanny experienced the mixture of solitude and performance she always felt on the stage. On the one hand, there were the explosions of applause and her sensitivity when they did not come—her initial pain, for example, when staid Philadelphia audiences did not clap at the conclusion of her balcony scene as Juliet. On the other hand, there was her deep conviction that simply reading Shakespeare alone in her room was always more pleasurable than acting one of his plays; her bemusement, for that matter, when during a performance one of her American Romeos would lose track not only of his lines but of his vial of poison and dagger, requiring her to locate the props while prompting his next speech, all while staying in character. Acting was too absurd, she confessed

to a friend. The impressions it made were so impermanent and, if looked at truly, were not even an art at all—since art required, in her word, "creation," whereas an actor was only "the filler up of the outline designed by another." Yet there she was at the amphitheater of the falls, where the waters roaring in a great curtain made an acclaim at one with her seclusion.

The feeling of being *terraced*, of being surrounded, on three sides at least, by great slopes of stone was more, for her, than evidence of the world's innate theatricality. It was no commentary on the performance of life, the role of manners and playacting in the enactment of living, nothing like Jaques's famous lines in *As You Like It*. It was a spell in the air, a sense that one's life was not one's own, that life in the round was compassed by an intelligence far greater than her own, however wise she was. Naturally, this intelligence was that of the Creator. Had it not been on an earlier excursion into American nature, another one Butler had persuaded her to take, this time to Bear Mountain above West Point on the Hudson, that she had felt that "she had been carried into the immediate presence of God"? There she had felt dizzy, her swoon like that of an old-time saint. At Trenton Falls the feeling was the same—she felt hollowed out, sculpted, for lack of a better term, by the invisible force that seemed to have shaped the terraces themselves. It felt like her actions were a pinpoint—the nub of the quill, the prick of the pen—in the midst of a large drawing whose very blankness, in those places the lines did not delimit, suggested a cosmic infinity. She acted, she drew breath, she walked perilously on the slippery stones, but in each case she was surrounded as in an auditorium with no one in attendance. In those moments nature felt like an empty house, such as the one at Covent Garden only four years earlier when her parents had brought her one night

to the stage to test whether or not her Juliet would carry, would play, before the crowds that might save the theater by paying to see her perform. The summa of her art was to feel this experience of being the tip of another's pen, the graceful line and arc of her own movements, smoothed and shaped neither by thousands of years of water crashing down in the same place, nor by the grace and manners of the private French boarding school her parents had sent her to when she was a teenager, nor even by the quill of Shakespeare himself, but by some invisible force in which she moved. Fanny Kemble's art was to delineate a line that she herself did not draw.

It would be easy to call this inspiration. The portrait that Pierce Butler's friend Thomas Sully made of Fanny back in Philadelphia implied as much. Fanny looks out, charming and rosy, as she might at a dinner party to which she brought a special grace. For this actress whose aunt was the famous tragic muse Sarah Siddons, the idea of adorning a party, of inspiring others, whether onstage or in a drawing room, was so much second nature that she could be forgiven for thinking that she simply *was* a muse, an incarnate god from some other world or, rather, a person here on earth who drew the graceful line of herself—indeed, who *spoke* these lines, as if draftsmanship were a kind of locution—in such a way that her admirers believed an angel was channeling itself through her. Sully, the painter, smudged the lower part of his picture in a swirl of gray, leaving the portrait deliberately unfinished while suggesting that Fanny herself was beyond capture, a rosy phantom, as full of life as a ghost is full of death, who had magically made her ringleted way to the chair at the artist's side.

Fame did not create the space around Fanny Kemble, or if it did, it was only a false and superficial form of space. From 1832 to 1834, when she was acting on American stages, she

was perhaps the most famous woman in the United States—
making a lasting impression on the young Walt Whitman
and many others. Once in Boston she looked out her hotel
room window on the morning of a performance and saw
men fighting one another at the theater box office across the
street, observing how some of the men in the melee, more
uncouth than ordinary theatergoers, had slathered them-
selves in molasses to make the other ticket buyers shy away
so that they could buy up all the tickets and scalp them at a
profit to others. But all this excitement spoke little of her real
powers.

Put simply, the world awakened to her eye. Alert, inquis-
itive, amused and wise, she caused bluebells and strawberries
and waterfalls to spring up around her. Forget the miles of
waste and axle-breaking mud that made up the American
scene; the bone-jarring cruelty of the nation's "corduroy"
roads, comprised of logs laid down like railroad ties next
to one another, the tree roads from which the makers did
not bother to remove branches that scratched, poked, and
speared the unwieldy carriage's battered doors and floor. All
of this went unsaid. What really got observed—awakening
only as Fanny herself awakened to it—was the social scene
of America, the life she saw, in the notation of which she
allowed the pen of herself to begin making its marks, literally
in the form of journals and copious letters but figuratively
in the arabesques she made by being always so *outside* the
scenes that involved her. This was no detachment, no supe-
rior distance from American failings and prejudices, like the
journals of other English visitors to the United States, with
all their scoffing at spittoons, though Fanny's proper accent
and genteel manners made provincial Americans mistake her
for a snob. It was instead her way of cutting to the quick—of
delineating a precise contour, so penetrating and telling—that

soured Americans unaccustomed to having their dullness and rapacity so neatly drawn.

Foremost among the chagrined was Pierce Butler himself. Yes, he had carried off his prize, successfully courting Fanny when so many others had not even had the nerve to try, and the couple were married in Philadelphia in June 1834, the summer after their interlude at Trenton Falls. But with their marriage had come the disclosure of what Fanny—for all her acumen—had never guessed: wealthy Butler owned an island plantation on the Georgia coast, fifty miles south of Savannah, at the mouth of the Altamaha River; his money came from slavery. By then Fanny had befriended abolitionists and fiercely denounced slavery in the most logical terms— wondering, for example, why it was illegal to teach slaves to read when it was said that they could not comprehend it. But somehow she had never inquired about the source of her new husband's wealth, and her husband, for his part, thought that she would give up her social views just as she gave up her career on the stage. But this did not happen.

The real test came when Fanny accompanied Pierce to the plantation and met the slaves. For nine months of the year, they were supervised by one of their own and a white overseer who had returned a handsome profit on the plantation's staple crop of rice. But in December 1838, as that year's malaria season ended, the master and his young wife, together with their infant daughter, arrived for a three-month stay. Fanny noted the slaves' terrible health, their squalid living conditions and self-degradation, and saw their enslavement as the only cause. Who could aspire to anything amid such dehumanizing conditions? She argued with her husband and with the overseer, infuriating them both. She pleaded for more sanitary conditions in the slaves' infirmary, where expectant mothers writhed in agony on beds of

Spanish moss. She secretly taught a teenage boy to read. She wept when another slave named London read from the Bible at the funeral of an elderly slave (London had learned to read and Pierce Butler did not seem to mind in this case), and she pleaded with her husband to let another slave named Psyche keep her husband when Butler had given the man as a gift to the overseer, who was leaving to start a new plantation in the rich cotton lands of Alabama. But amid all this, a line in Fanny's mind drew apart even from the horrifying pictures of slavery it portrayed. It was a line unto itself, a line making a kind of signature—the separate song of a person on her own.

One day she rowed over to the adjacent Georgia town of Darien, hired a carriage, and set forth to visit some of the local gentry who had called upon her and her husband. What she saw, as they rode along, was nothing: "The road was a deep wearisome sandy track, stretching wearisomely into the wearisome pine forest—a species of wilderness more oppressive a thousand times to the senses and imagination than any extent of monotonous prairie, barren steppe, or boundless desert can be." There was no horizon, no heaven, no sun. The pine barrens enclosed them. The resin smelled strongly in the stifling heat, punctuated only by the occasional fragrance of heliotrope. The poor white settlers whom they occasionally saw were unwilling to work, she was told, because they felt that labor was the lot of slaves and that a white person who worked became black, and so these whites were all "immensely proud of the base freedom" of their poverty and dissipation. When Fanny arrived at the plantation in the middle of these woods, she found that it was falling apart.

Yet how delicately she drew it. Drew it in words intended for a close friend, the abolitionist Catherine Sedgwick, living in the Berkshires in Western Massachusetts, for whom Fanny pledged to keep a record even if the letters recording

her time on the Georgia plantation were never sent and, indeed, not published until 1863, long after the dissolution of her marriage, when the Civil War made her account of the antebellum South even more urgent. What she depicted was not so much slender trees reeking of resin, or the sun-canceled gloom of the parched Georgia woods, or the chipped paint and cracked cornice of the shabby plantation. She drew instead the operations of her mind, making shadow and bark into a depiction of her thought, unfurling in real time as the carriage wheels rolled on the forest floor. She made a record not of the world as it was but of the person to whom it appeared; a person for whom the packed house was always less important than the empty stage. For here as elsewhere Fanny ceremonially hollowed out the world around her so that, reduced to a blank, it could impress itself upon her. In such moments the great falls of the loud world—the hue and cry of ordinary satisfaction and complacency—became distilled to the thimble draft of a bluebell, a private sip of personal sensation. There may have been no recompense—no restitution—in any of this. The world remained as it was. But the drink was clear and black as ink.

Harriet of the Stars

Araminta Ross, later known as Harriet Tubman, lay in a cradle carved from a tree. Her father, a timber inspector on the Eastern Shore of Maryland, had selected a sweet gum for the purpose, chopped it down, and made the crib, and now Araminta lay in the wooden basin. In the scented deep of the nest she lay snugly sleeping, waking to stare at the sky, loving it when the young women came down from the big house where her mother worked to lift her out and toss

her in the air. She and her parents were slaves, and though her father was highly skilled, entrusted with marking trees on the master's plantation for transport to the Baltimore shipyards—as skilled as the white ship's carpenters at Fells Point who knew the hewn wood so well that they wrote on each piece "L.F." for larboard forward or "S.A." for starboard aft, as it came through their hands—Benjamin Ross was not free.

The biggest job he ever undertook was one that killed many men. For twenty years, starting a decade before Araminta was born, the slaves on the plantations of master Joseph Stewart and other landowners labored to build a seven-mile canal in the wetlands of the Eastern Shore, connecting the rich forest interior to Madison Bay. By floating logs down the canal to the bay and from there to Baltimore and other ports, the owners aimed to avoid tedious inefficiencies in getting their product to market. But making this passage—or any such canal—was lethal. Dry canal building was bad enough. The hard-core *grubbing* that initiated dryland work—getting rid of all trees and roots and stumps—was wretchedly painful. The dynamite used by the Irish immigrants to create the Erie Canal killed scores of them. Others died of disease or suffered broken bones and disabling injuries that left them bound for the almshouse. But the wet sections of the Erie Canal were worse. The path through the Montezuma marshes at the foot of Cayuga Lake near Syracuse required laborers to stand in knee- or waist-deep water, shoveling muck all day for months, and many contracted diseases—generically called "ague" or "bilious fever." Down at the Stewart Canal, Benjamin Ross and the rest of the work crew endured these hazards, rising stiffly at dawn from their stale shanties, shaking the pain from their limbs, eating a fill of potatoes and mackerel from boiling iron kettles, and setting forth to wield

shovels, slap mosquitoes, and quiver with chills even on the hottest summer day.

A year after the canal was finished, a remarkable event occurred—one that put the waterway in a new light and shaped young Araminta's life. In the early hours of November 13, 1833, at around two in the morning, and continuing until the day dawned, a meteor shower took place the likes of which no one who saw it had ever witnessed. As people rose for the workday at four and five in the morning and looked upward, their exclamations awakened others, and soon village squares and remote habitations up and down the Eastern Seaboard and all the way to Missouri filled with gawking spectators. By some estimates, as many as ten thousand meteors were falling in a single hour. More than that, they all seemed to be falling from the same point in the sky, which some observers noted was in the constellation Leo. The Leonid meteor shower (as it came to be called) was then an astonishing mystery—copious flares falling from a single point covering the sky in an umbrella of streaming lights. The slaves said it was "snowing fire." Ten-year-old Araminta Ross, stealthily making her way to a neighboring plantation to see her mother, huddled with one of her brothers and looked up. They were not the only ones to think it was the end of the world.

Out on the canal, no one saw the meteors. Work had not started for the day. But the canal itself witnessed the event. Reflecting the heavens, it showed streaks of light in the dappled brown and black tide. The perfectly straight trench, so different from the maze of grassy waterways around it, was a righteous sword reflecting the glinting sparks. In that respect, it was no different from other stretches of land that, as it were, rose up to meet what came down. In New England, in New York State, and far to the west, the shooting

stars mixed curiously with the local ambience. The meteors lighting up these places sometimes achieved the brightness of a full moon, casting stark shadows of barns and churches on the ground, and making sleepers blink in their beds as celestial fires traced lines on coverlets and counterpanes. The heavens invaded home and hearth, flaring on the embers of spent fires, shining on cold kettles.

The wind did it—that's what some people said. Up on the Hudson River, a sudden gust had capsized a two-masted ship and killed all on board the afternoon prior to the meteor shower—perhaps a sinister augury of the windblown stars. God had come to earth, blowing death as he did life; He descended his tarantula fingers, hairy with light, bringing them down on ordinary souls. On the Eastern Shore, the wind shifted the canal's brown water to and fro, where it mixed with the tide pulled by the moon, making a lisping and lapping sound amid the blowsy marsh grasses, which waved as if drugged in some hallucination of the stars snagged and floating amid their green blades. But no one saw, the day dawned, and the world went on.

Some days later, Araminta Ross bent before a horse trough her father had carved, looking down into the wooden scoop of water as she readied to wash her face. Seeing herself, she also saw God, with whom she pleaded as she broke her image by dipping her hands in the water. She prayed for Him to cleanse her sin. Then she prayed for her master, to help him see the error of his ways, even as he was trying to sell her and her family to the cotton and rice fields farther south. Then she prayed that if the man's heart was not changed that he be killed. The water in the trough—dark with the reflections of the trees overhead, dark with the wood of its basin, dark with Araminta Ross's face—sparkled in the droplets falling from her hands.

Some miles to the south, on the evening of the shooting stars, Dr. Ashbel Smith set out in his sulky at nightfall. He knew the journey would take until dawn. He was traveling from Salisbury, North Carolina, where he lived and worked, to Charlotte, some forty miles away, on a matter of great urgency. The infant daughter of friends was gravely ill, and the parents had written frantically, imploring him to come. The little girl, Harriet Eliza Bissell, born only the previous December, seemed near death, and Smith doubted if there was anything he could do. But that night at dusk he set out in his sulky, with one of his slaves, the youth Isaac, at the reins.

The two rode silently through the streets of Salisbury. A white house glowed in the clear November evening, its porch and front door just a few feet from the road, and Smith eyed it briefly. An educated bachelor from Connecticut, he had recently returned from medical work in Paris and was a sought-after guest in the small town: twenty-eight years old, a worldly man, shrewd and intelligent, with an eye for young women. He had visited this house a few times. But tonight would be an evening *sub dio*, as he put it—under the open sky—and soon Isaac directed the sulky onto the bone-jangling road out of town.

At about ten Ashbel and Isaac noticed a shooting star or two but thought nothing of it. As the evening went on, they saw a few more. At around midnight, however, they looked up to see something amazing. The sky started raining meteors. They were flaring everywhere, seemingly from all parts of the heavens, and they showed no signs of abating—not for minutes, not for hours. Thousands came down, all in perfect silence, though the jangling sound of the sulky on the bumpy road made it impossible to tell for sure.

About three in the morning, the sky suddenly lit up. A large meteor blazed across the sky, as big as the full moon,

streaking west, a little below the zenith. The others had flared and quickly disappeared, but the tail of this one remained visible for at least twenty minutes, maybe even thirty, transforming from a straight to a wavering line before finally becoming a curved shape and, at last, a luminous cloud. When it burst on the scene, the whole darkened land had suddenly lit up, bathed in a gorgeous glow that sharply portrayed fence posts, tree trunks, and even the individual stalks of roadside bushes. Smith's every sense was aroused, matching, he said, "the violent impression on the sight." After that, the smaller meteors kept falling, more and more, thousands an hour. The streaks of light went away only in the light of dawn, when he and Isaac arrived at the home of Titus Lucretius Bissell, his wife Claudia, and their ailing baby daughter.

Little Harriet Eliza Bissell, the newly married couple's first child, was having trouble breathing. Her phlegm was choking her. Sweat soaked her head and neck, and she was pale and febrile. Her parents had grown hopeful at times over the past few weeks, steadied by improvements in Harriet's health, but these always proved temporary, and she kept sinking before their eyes. The local doctor was at a loss what to do, and now Titus and Claudia feared the worst. They had written to Dr. Smith not even necessarily to save their daughter—although they hoped he could—but so that he could be with them, care for them, in such a terrible and depressing time. As the sulky pulled up before the home, Claudia emerged and said to Smith that he had answered her prayers.

Smith had seen most kinds of illness. A practical man, he was straightforward in his bedside manner, his diagnoses, and his remedies. The previous year in Paris he had treated hundreds of cholera patients, choosing to live in a heavily afflicted quarter of the city and daily visiting the hospital. He recorded case notes, corrected misinformation about the

illness and its treatments, effected cures when he could, and coolly performed autopsies on victims of all ages to study the disease. As the poor of Paris cried of a government plot, claiming a conspiracy to sicken them—as they alleged some kind of poison, and not a disease at all, as the culprit laying them low—as the situation then turned violent, with mobs killing order-keeping soldiers and throwing their bodies into the Seine, Smith kept calm. Entering the Bissells' house, he looked at little Harriet.

He saw there was no hope. On the day the stars had fallen, the girl died. The rain in the heavens preceded her death by only a few hours. Smith did not return to Salisbury at once but remained to console the mourning parents. Titus Lucretius Bissell was a friend of his from Connecticut, three years older than Smith, and Titus's older brother Jonathan Humphrey Bissell, also from Connecticut, lay sick in the same house, feeble from an illness that had kept him mostly bedridden for a month. This, too, kept the doctor busy, and he took pleasure in the task, though not so much as in looking after the departed girl's parents, which he felt was "one of the greatest privileges ever accorded me," to be there "in an hour of affliction when one is needed to soothe the wounded feelings and bind up the broken spirit." There was one other reason for remaining. Staying up late after the parents had gone to their room, the doctor talked with Claudia's pretty sister Caroline until two in the morning. He spent time with her in the day, too, when his duties permitted—walking, talking, reading, admiring her faultless form, her charm.

The return journey to Salisbury was uneventful. Isaac's presence made it more so. The young man was an excellent horseman—too much so, according to Titus Bissell himself, who had written to Smith earlier that year to complain that on some business to the Bissell house Isaac had gotten into

the stable at night, in company with Claudia's and Caroline's younger brother Jack, and had taken the prize horse Cyclops out on a midnight gallop. Bissell had wanted Dr. Smith to discharge Isaac, but he did not, and it was a good thing. That summer the doctor's sulky had overturned while he tried to cross a flooded river, and he narrowly escaped with his life. Now he kept Isaac with him on his rounds, counting on the slave's equestrian skill to keep him from such dangers.

The streaking of the meteors and the relation of the races, the slicing-open of the body and the quickening of the senses—all of it made a perfect order to Smith, a man not easily amazed. As he said in defense of slavery, he was not one to "string together a quantity of flowery nothings gathered in the fields of *belles lettres*." He was simply one who saw how it was. The meteors shone, the girl died, the slave attended. That was all. Under the clear blue sky of a cool November day, Smith and Isaac arrived back in Salisbury.

To Smith, light and dark seemed decreed by God. He thought of his time in Paris, where he attended a glittering ball in company with his friends James Fenimore Cooper and Samuel F. B. Morse. Beneath gaslit chandeliers, all of society was there: beautiful ladies ornamented in gold and diamonds and jewels, dignitaries in "the glowing folds and turban of the Turk and Levantine," even the king and queen of France, everyone "glowing in more than noonday brightness in the floods of light from the huge lustres." He thought of his underground schemes back in the States, of agreeing to supply slaves to an acquaintance in Georgia who needed laborers to dig a mine, slaves Smith agreed to find either by contracting on plantations or by buying at the block, in exchange for a handsome kickback provided for the delivery of each able-bodied worker. So was each man sent down to the mine, sold out of the light, away from the stars and into the earth's night.

Death, Smith reasoned, was a plummeting, a streak across the sky, quick-vanishing, long-lasting. The heavens fell for the person raised, lifting the little girl sent below the ground, inverting the spheres in fevered tears. No calamity could not be explained, no drudgery not ordained: science turned a blind eye as she flew in the sky. Her life was so universal that no part of the heavens did not fall in sympathy with her demise and, in so doing, become the girl fate despised. But on that night little streaks of light had imprinted on another person's eyes. They showed not a heaven, not some kind of grace, nor the solace of the human race, but another face: that of Isaac the horseman, lost in a radiance that shone for him alone.

And north of those eyes was the prism of a canal—a smooth-seeing channel back on the Eastern Shore of Maryland. Soft fires lit the sadness of that place when Benjamin Ross and others built it, but after the meteors there came a new lucidity, a new purpose, upon the place, as if it had awaited a sufficient heavenly event to recognize the latent power of its reflecting surface. For the newly dug waterway made the skies visible on a strip of earth where otherwise the heavens would never have been seen. It turned out that the labor had all been to make this aisle, this slender avenue of transport, less for goods than for visions: for visions not only of special nights but even ordinary days. On a humble autumn afternoon now, the canal still blends clouds and blue sky with the movements of tide and wind. It makes a delicate pattern of vibration, a softly breathing and liquid light, that swims on the eye of a person who, instead of tears, sees the spread of years, the stillness of time, lifted in holy act, the labor having been, against all appearances, a gift to an earth that had forgotten the sky—the sky's lullaby.

The Glitter of the Argand Lamps

The door opened, and the guests walked into a blaze of light. Their shadows flew out behind them on the snow. They had started from Cooperstown, eight miles away at the other end of Otsego Lake, and the sleigh ride had been all forest darkness, scarcely lit by the crescent moon. But when they stepped into the hall of the new stone mansion, where servants began helping them remove their furs and coats, the illumination was so bright they blinked. The wealthy landowner George Clarke, their host, had spent extravagantly in the construction of his neoclassical home, which had been completed earlier in that year of 1834 and which had culminated in the architect Philip Hooker's most lasting achievement—the wing set aside for entertainment that the guests now entered. Clarke had spent lavishly on the interior furnishings, too, including the source of the house's glow. His home shone with the clean-burning light of Argand lamps, designed to run on a mixture of five parts alcohol and one part turpentine—much better than the whale oil typically used for illumination in 1830s America, which no matter what its grade, 1 to 12, smelled fishy. The guests entered that night in a blast of odorless light.

But the light came from more than just the lamps. The walls sparkled, thanks to a plaster mixed with a special mica-flecked sand brought from Long Island. And on those walls hung three lavish full-length mirrors, framed in gold, each taller than a person and two of them five feet wide. Reflecting the glow, the mirrors threw the Argand radiance around the room. The gold frames seemed to burn on their own, while their glass surfaces beamed like quasars where they reflected the lamps back to themselves. The damage to those mirrors now—gray blooms on the glass—makes it seem that it was

the doubled brightness of long ago that burned them out. On the night in question, the very conversation of the guests and their hosts seemed to sparkle.

Strange to say, there was still another form of light in one of those rooms, as if all that blaze had not been enough. This other light was of a darksome kind, coming from a large painting measuring six by nine feet. It did not radiate like everything else, unless from its frame, which was gold like that of the mirrors. Reflected in one of those looking glasses, the painting made a brown pocket, honeycombed like a wine cellar of bottles emitting separate glints of storied vintage. The accents barely brightened the canvas, let alone the room, yet the painting's flickers attracted the curious guests, who drew close to see what it was. Nearing it, they saw it was a painting depicting many other paintings, all small, the size of playing cards, a compendium of great paintings in miniature, works by Leonardo and Raphael, Veronese and Van Dyck, Guido Reni and Claude Lorrain, all in one giant gallery, now transported in miniature to this other room on the shores of a wilderness lake. It was Samuel Morse's *Gallery of the Louvre*, bought by Clarke from the dejected artist after American audiences refused to pay admission to see it on a projected—and quickly abandoned—American tour.

The magic of Morse's tiny paintings was not lost on the guests. Transported from Paris, the pocket-size masterpieces were a fine entertainment to travelers still numb from the cold. Marveling at the tiny sunsets and grimacing sacrifices, the martyrs and madonnas, the revelers clinked their glasses and spoke the flatteries of taste. To know who Raphael was, to know about Rembrandt, too, cozied them up in the limestone bastion of light. As frost clouded the windowpanes, Hyde Hall burned ever more brightly, like a semaphore on the sea, glowing proudly for no one to behold, a light feeding

upon itself. The guests turned to a lavish meal, pies of pigeon, lark, and quail, washed down with oceans of Madeira.

Laughing and conversing, they ate with gusto, the silver striking the china, while French-speaking servants cleared away and replaced the shiny plates. The light in which they dined had room to spare, for so it burst outside, at least for a short distance, illuminating the crusted footprints of guests and grooms on the drive, the bare oak against the frozen lake. After a while it became intoxicating. Warming in the rooms, the guests drank the swirling Madeira, Argand reflections and all, mixing the alcohol-fuel of the lamps with their wine. Drunk on light, they sipped the shining brim of their glasses as much as what the glasses held. Morse's picture, too, getting its own measure of the shine, seemed for a moment to become intoxicated itself. The neat array of paintings became to the drinkers a kaleidoscopic confusion, another form of excess, sating itself in silver knives and pigeon pies: an enormity, a gastronomy, individual delicacies piled sumptuously on a sideboard of vanity, a groaning table of art. But that was only for a moment. Even soaked and stewed in the guests' perception, the painting soon asserted a soberer note, a didactic know-it-all tone. At a dinner of money and power and prestige, Morse's picture could not help but speak like a schoolmaster.

At Hyde Hall, in fact, there was a far better artist than Morse: one who understood the guests' radiant credo. The gorgeous neoclassical mirrors of the frame maker Isaac L. Platt portrayed life as it happened in coruscating detail, honoring its splendor and finery and frippery, the swallowtail coats and nankeen jackets, the silk and grapevine curls. What could one say—Platt *got* the expectant slur of vision, the ribald brightness of colors, the doubling of persons into radiant gods whose power was to *expend* life, to let it go so profusely,

to spend their very reflections, millions of them, by the min-
ute, to toss them out with no concern for their glassy fading,
in defiance of the ever-colder night.

Platt understood, too—so consummate his art—the power
of humility. He knew his part was only to hold his mirrors up
for scenes he would never see; that he was the selfless mae-
stro of others' lives, the conductor of a symphony he did not
write. He understood that the reflections he made possible
would be infinite and random, a scattering so great that even
the trees that the mirrors reflected, as laborers had carried
them sideways from the wagon to the front door, remained a
part of their luster, mixing with the fleshy rouge and missing
teeth of the local lords. The mirrors contained all things, life
exploding in ever-failing warmth.

Outside, the snow drifted across the sleigh's tracks, and
powder fell from the firs. A few withered leaves hung from
the oaks. Ledges of black shale grew darker in ice. *That* world,
the world outside the light, who could portray it? Who would
be the Isaac L. Platt of snow and frost, of forest seclusion and
moonlit trace?

Down at the other end of the lake, the writer James Fen-
imore Cooper sat at his desk. It was one thing for him to
show up in his friend Morse's painting—for there he was in
that canvas, standing proudly with his wife and daughter,
a cultural aristocrat amid the toy treasures of the Louvre.
But now at his desk, away from the glitter, way at the other
end of Otsego Lake, he was picturing a darkened scene:
hemlocks in a forest, a stream glazed in a craquelure of ice.
Pompous man that he was—appalled by the market turn in
America, intoning that the New York fire of 1835 had been a
mammon-wrecking judgment from God—he shed the jingo,
let go the rage, and found, once again, that the forest came
to him in humble pictures. In flashes, he might have said, if

the abundant tone of these mental images were not so dark, not so indebted to the chiaroscuro of the Old Master artists he loved. Rembrandt never etched an American tree, but Cooper did not delay in transposing the tenebrism of an *Ecce Homo*, a *Deposition from the Cross*, and other Rembrandt prints he owned, to the streaming black-on-black of overhanging boughs shading gloomy pools at night. It all came from his pen, such a poor pen, if truth be told, filling up page after page with interminable dialogue, unconvincing narration, the stentorian chatter of warriors, settlers, and generals, all alike expounding their actions as if under penalty of failing to disclose their every aim and desire. But the forest itself in Cooper's writing stays undisclosed, swept back, turned to shade and self-retirement in scenes forever vanishing in a scrim of phrases.

It was a kind of half-wittedness, like that of Hetty Hutter in Cooper's novel *The Deerslayer*. A girl not in her right mind, her dreaming was his: the Hutter family's boat sailing down Lake Glimmerglass one evening, the forests and mountains adding their shadows to the water's gathering darkness, she alive to it all. In the center of the lake a strip of light drops from the sky like an "inverted Milky Way," suggesting that this upside-down heaven is the dim light of Hetty herself, the gospel of her lord abhorred, dream and vision and superstition, locked away, font and key, piracy and virginity, in some sweet spell of danger and security: grace, prayer, feather and fur, a frontier legend of gentle reflection.

Hetty sometimes sets out from the family boat, paddling a canoe alone to the spot where her mother lies buried, to "sing sweet hymns to the evening air," to "hold fancied conversations with the deceased," to repeat the prayers her mother had taught her. The incantation of the child, forsaken and wild, creates the solitude of the spot: inverted and true,

a galaxy of thin air, she dips the paddle in a shattered image, conjuring the dead in a foam of sparks. The novelist, too, is not all there.

Back at Hyde Hall, eight miles away, the guests emerged from the front door. Their sleigh, bright chrome yellow with cattails painted on the side, stood ready to take them home. Better to be seen at night, no worry of summer dust and mud, the sleigh stood a light unto itself, though pale by all that they had seen, the lamps dazzling in their drunken sheen. But the sleigh was bright enough, as the hours grew small, to speed the way from darkness into day. And the ice on the lake, at last, showed their picture as they passed.

A Sight Unseen at New Harmony

A mystery, a clue: on a fall day in 1832, sitting on the banks of the Fox River, the Swiss artist Karl Bodmer made a small picture in watercolor and graphite. It shows a secluded stream with dead trees on either side. Vines hang from dark branches on the near shore. White trees on the far side cast pale reflections in the shallow water. In the picture no one is there, not even the artist himself. In a drawing so finely made, he has left without a trace.

Bodmer made the picture near the failed utopian socialist community of New Harmony, Indiana. He and his companion, the German prince Maximilian of Wied-Neuwied, had landed in New York that April and begun heading west, their aim a journey up the Missouri River and into the Far West. Six months later they had made it to Indiana. Maximilian, fifty years old, was an accomplished naturalist, a veteran explorer of the forests of Brazil, who had hired Bodmer, age twenty-three, to portray the scenery and people along the

way. That fall day they were at the junction of the Fox and
Wabash Rivers, where they had stopped at New Harmony to
stay with a friend, the distinguished naturalist Charles Alex-
andre Lesueur.

Lesueur had moved to New Harmony in 1826 at the
invitation of the founder, the Scottish social reformer Robert
Owen. A prosperous mill owner in his native Scotland, Owen
had envisioned a utopian community based on shared labor
and profits and found seemingly an ideal place for his utopia
in the fertile regions of southern Indiana, at the site of a
vacated Lutheran village called Harmony. Christening his
utopia New Harmony, Owen invited settlers interested in
the principle of equality to move there and hired scientists
and teachers to educate the populace. From Philadelphia he
brought distinguished naturalists and pedagogues, among
them Lesueur, to study the land and teach the residents. The
work of the settlement was hard, however, and those doing
most of the labor grew disillusioned and left—the experiment
was a failure after only two years. Owen returned to Scotland
in 1827, and most of the scientists and teachers left too. But
Lesueur remained. He felt hoodwinked by William Maclure,
an Owenite scientist who had lured him there, calling him a
"Bad Genius," but he stayed because he was fascinated by the
wild surroundings.

Lesueur took solitary excursions on the Wabash and the
Fox, looking for the turtles that sunned on sandbars and hid
under the roots and trunks of dead trees. He found them,
killed them, drew them, gave them scientific names. He dug
up the fossils of prehistoric sea lilies and snails. He unearthed
the throat slitters and arrowheads of ancient Indian tribes—
sharp pieces of flint, jasper, petrosilex, and agate. When the
banks of the rivers silted away in floods, he found Indian
burials half-exposed in the mud, the remains so extensive

that one half-mile stretch of the Wabash was known as the Bone Bank. In a red sandy clay covered by two or three feet of black mold, Lesueur saw rows of bodies buried with heads to the east and feet to the west.

Sitting on the bank of the adjacent Fox River, Bodmer showed none of this. He was making a watercolor destined for scientific libraries—one of many intended as illustrations for the prince's North American travel narrative—but his picture does not lend itself to learned captions and commentary, either those of the prince or Lesueur or anybody else. It seems instead an image of a place *before* it became known, at least to people such as the artist himself—as if the location were somehow drawing itself, picturing itself, without him.

It was a trick, of course. The dead trees on the far bank seem strangely precise, likely because Bodmer drew them with the aid of an optical instrument called a camera lucida, a portable device invented in 1806 that reflected a scene onto a piece of paper, allowing the artist to trace the mirage right on the sheet. With a camera lucida set up on the bank of the Fox, Bodmer could transfer the tree's tracery of fine lines directly into his picture. In a decade in which Louis Daguerre and William Fox Talbot later invented photography, Bodmer's apparently machine-assisted drawing aspires to a magical fidelity.

At New Harmony the term for it was *Anschauung*. The German word meant intuition, sense experience, impression, observation, or sense perception. It was the hallmark of Bodmer's fellow Swiss, the renowned educator Johann Henrich Pestalozzi, who followed Rousseau in developing a nature-based theory of education. Pestalozzi believed that abstractions were lost on children—that they needed to see things directly to learn—and his principle of *Anschauung* was central at New Harmony. William Maclure, Lesueur's

nemesis, introduced Pestalozzian education there as a prelude to establishing it around the world. On board the steamboat *Philanthropist*, which had taken Maclure, Lesueur, and others from Pennsylvania to New Harmony in early 1826, was Madame Marie Duclos Fretageot, a French schoolteacher trained by Maclure, who brought Pestalozzi's faith in the "Sense-impression of Nature" to Indiana, teaching children natural history before they could read. *The Fox River near New Harmony* is likewise a primitive scene, beheld as though by a child, without language.

Maybe that is why a hint of strangeness lurks in Bodmer's picture. Something about it suggests a land lost in time, a land that could have been witnessed by no human being, as in scenes by later artists of Cenozoic swamps showing the habitat of early mammals—humid lowlands with dragonflies the size of crows and centipedes the length of rattlesnakes. In Bodmer's ooze and flow of jungle rot, his Indian summer of florid decay—what the fleeing Maclure, hightailing it out of New Harmony, called the "plagues" of that "sink"—no clocks and watches tick the silent slowness. The trepidation, however, emerges not only because of this feeling of a land that time forgot. It emerges because the artist appears to have vacated the scene, as if abandoning it near completion.

Some of the white branches remain undone, never filled in. Like the ruins of a colony in which scratched initials are left on a tree, like the ruins of New Harmony itself, the watercolor is cryptically deserted, leaving us to guess at clues. In a lonely place exempted from human eyes, Bodmer portrays no burials—he is hardly engaged in exhumations or desecrations of other kinds—but he makes us wonder if picture-making itself were the sacrilege, the grave robbing, the disturbance. If that were the case, the land itself would come to life, in best Romantic fashion, to admonish the interloper with

the temerity to portray it. The trees' warning would be all the sterner for a person of exceptional talent, one with a mechanical drawing aid to help him. See into the secrets of God, would you? The land accuses and the artist departs, his work not only unfinished but even, in those white branches, seemingly "erased"—as if he had thought better of his trespass and were busy retracting the evidence of his deed when he withdrew.

Scornful Diana and her nymphs never bathed in the Fox River. The hunter Actaeon never went there, stumbling upon the forest goddess and her entourage and paying for his clumsy witnessing with his life. But Bodmer was himself a kind of Actaeon who could not unsee what he had observed. His fate was not to be ripped apart by his own dogs on the spot. He completed his two-year journey alongside Maximilian with hundreds more drawings executed after New Harmony, and he lived to a ripe old age, dying in 1893. But he had touched something better left hidden. If the delicacy of the tree's white lines hints of Chopin and Schubert, the sense of guilt recalls the swamps of Poe. In drawing the natural world so well, the artist hit upon a truth too true, that he had stolen what he saw.

A Statue in the Woods

He did not relish the job at all. Emerging from a thick forest a few miles from the rough frontier town of Cincinnati, the fifteen-year-old boy found himself in a clearing near a farmer's log cabin, a half mile off the road. Looking around, he grabbed a stout stick in expectation of the dog that always came running in such places and started plodding across the plowed field. Sure enough, a big hound came bound-

ing toward him, barking and snarling at the rare sight of a stranger. Wielding the stick, the boy threatened the beast long enough to make it back off and kept approaching the cabin from which, just then, a haggard girl emerged, curious to see what all the noise was about. He told her he was the debt collector and could he please come inside.

Reluctantly, she let him in, and there he saw a woman nursing a dying infant on the dirt floor. On a crude shelf in the dimness above her, the boy noted the clock that one of his company's peddlers had persuaded the woman's husband to buy: an unwise purchase, since there was never a way the farmer could pay for it, even in installments. The young debt collector had a poetic turn of mind, and he thought of the clock ticking away the last hours of the sick child, even as he exacted payment from the poor family and left.

That was how he came to the Infernal Regions. There was an entrepreneur in Cincinnati, a Frenchman named Dorfeuille, who ran an establishment at the corner of Columbia and Main Streets called the Western Museum. Monsieur Dorfeuille had ordered some wax figures to fill out his exhibition halls, hoping to entice customers with life-size likenesses of the politician John Quincy Adams, the preacher Lorenzo Dow, and the assassin Charlotte Corday. But when the wax dummies arrived after a long transport on frontier wagons and riverboats, Dorfeuille found them missing limbs and noses. Hearing of the handiness of the young debt collector, whose name was Hiram Powers, Dorfeuille contacted him to make the necessary repairs.

Back home in Woodstock, Vermont, where he was born in 1805, and from which the Powers family had emigrated to southern Ohio in 1819, the young man had been a sculpting prodigy, delighting his friends by making toys out of old hoes, rakes, and forks. Now maybe he could do something similar,

returning the damaged wax politician and preacher and killer to the dignity of their whole bodies. He quickly saw it was hopeless, however, and proposed instead to repurpose the figures into demons and goblins. He took the head of Lorenzo Dow home with some natural history specimens from the museum and gave the preacher a frightful new appearance, inserting two alligator fangs in place of his eyeteeth. He created other figures and posed them on the museum's stage, adding lights, sound effects, and background scenery. The Infernal Regions exhibit on the third floor was soon ready to go.

One of Powers's friends described what it was like: "Hell itself glared with livid light, and fiends dragged in carloads of little souls [made of stiffened muslin] amidst the flashes of lightning, the mutterings of thunder, the clanking of chains, and the low, faint groans of the damned." In a grotto of stalactites and stalagmites, Satan presided—first in the form of a stationary wooden dummy that Powers sculpted using a lathe and circular saw, then in the form of Powers himself, wearing a dark robe and skull mask, a huge pair of spectacles, and a lobster claw for a nose, asking a breathless rustic if he smelled sulphur. When questions like this did not keep curious spectators at bay, Powers bought and repaired an old electrical machine that he connected by a wire to his devil's wand, giving him the power to shock interlopers intent on climbing onto the stage. Eventually tiring of performing as Satan for two hours every night, he devised automata to take his place and keep the show lively. The exhibition was a hit and Dorfeuille gave young Powers the titles of official inventor, wax-figure maker, and "mechanical contriver" at the museum.

But all the time he was overseeing the Infernal Regions— some seven years—he was thinking of something very

different. Chiefly, it was this: how to make something that had *no relation* to the world around it. What would it be like, in this forest, this farmland, this provincial city, to make something that had no use—either as entertainment or practical instrument? If he could devise such a thing, it would be the most splendid invention of all: a device that no one would dare touch because touching it was a violation of the purposelessness that its devoted maker had brought into the world. For once, all a person would be required to do was look. Soon the ingenious Powers had an idea about how to do this.

Back in Vermont, he had a recurrent dream about a woman in the woods. She was naked, marble-white, and stood on a pillar. She was close by and he wanted to get nearer to see her, but he could never get there: the woman was always on the other side of the river—the Quechee River, below his father's farm—and the water was always too swift and deep for him to ford. But what was unconsummated in the dream eventually inspired his idea for an art apart. Leaving Cincinnati in 1834 to go to Washington, DC, and from there to Florence, Italy, to train as a sculptor, Powers conceived what became the most famous American sculpture of the nineteenth century: *The Greek Slave*.

Of course, this life-size marble woman *was* related in all sorts of ways to worlds imaginary and real: to the recent war between the Greeks and the Turks, to stories of young Greek girls being sold as slaves in Turkish markets, and indirectly to the question of slavery in the United States. But in other respects the work was the fruition of Powers's dream of nonrelation. Here was a white figure as incongruous as the lady of the Vermont woods; a lady who, moreover, was equally incongruous in *any* setting in which she might find herself. Lower her marble form into a crate, ship her across

the ocean, and she was more unlike the sea, more unlike the ship, than anything on board. She would always be a rarity, an anomaly, something people were calling, with mixed awe and mockery, *a work of art*. Install her even in an art gallery, of which there were beginning to be a few, whether in Dusseldorf or New York or in 1851 at the Crystal Palace in London, and she had a way of repelling her surroundings, of resisting them like a slicker does rain. The velveteen sofas, the potted plants, the heavy swags of curtain and other arrangements of pomp, the waving fans of the ladies and the cigars of the gents—all of it seemed to back off, curl away, to take on a fusty everydayness, compared to this haloed being who stood on her own, in no ticking time at all, not even measured by the watch of the impresario clocking the next round of spectators, but in a strangely timeless world of pure isolation.

Picture the filthy streets outside—the dust rising from the road, the loafer hitting the spittoon with yet another jet of tobacco saliva, the drover moving his herd—then imagine going farther out to the remote farms and beyond those to the untenanted woods, to the mumbling streams and deer slaking their thirst, and you get an idea all the more that this white girl at the center of it all was an extraordinary invention: an empty center, an empress of absence. *Art*—free of any relation to the world! Before the milky blandness of those eyes, the woods backed away.

The Secret Bias of the Soul

The two men stood in the entryway looking up at the spiral staircase. One was the homeowner, a man in his late thirties named Oliver Bronson, prim and well educated, extremely wealthy, too, the son of one of the founders of the New York

Life Insurance Company. Isaac Bronson, Oliver's father, was a major American financier who liberalized banking practices to keep pace with the country's burgeoning market economy and democratization of business enterprise, while striving to keep control of banking in the hands of wealthy northeastern men such as himself. A flinty Yankee, the elder Bronson lived modestly for his means even as "spent his life pursuing material gain." Now, upon his death at age seventy-eight, his son Oliver had come into his full share of the inheritance and bought this country home in Hudson, several hours north of Manhattan, where he was a doctor and lived in a beautiful townhouse on fashionable Bowling Green.

The other person at the foot of the stairway that day in Hudson was a self-described "architectural composer" named Alexander Jackson Davis. Also from Manhattan, Davis was in his midthirties, dapper, bearded, imaginative, at the start of what would be a long career; Bronson had hired him to make changes to his new country home. They agreed that the staircase was perfect as is. The man who designed it, working when the house was originally built some twenty-five years before, had once made a meticulous drawing of a rattlesnake skeleton, and without knowing of that drawing Bronson and Davis, looking up, sensed a perfection of organic form in the coiling rounds, the toothpick ribs of the bannisters. But elsewhere, inside the house and out, there was much work to be done.

Davis envisioned an exciting transformation. A specialist in "the picturesque," he spoke of harmonizing the house and its grounds, of creating a retreat of exquisite taste in accord with the wishes of his client, who had seen the young architectural composer perform miracles of such natural harmony on the nearby estate of a friend. None of these changes would be easy on the Bronson property. Built in the 1810s, the Federal style mansion sat on the earth like an alien spaceship—a

white, angular structure in stark contrast to the surrounding
meadows, farms, and rugged Catskill trees. But in the coming
months Davis began blending the house into the scenery and
changing the scenery to blend back into the house. He had
the exterior painted "verdure green." He installed organically
patterned vergeboards and brackets at the eaves, softening
the roof's edges in a play of vegetal ornament. He fitted the
brackets with outsized wooden sculptures of acorns, each the
size of an apple, and like all the other decorative work, the
acorns cast pleasant shadows on the facade and even into
the interior of the house, through big windows that received
the warmth and the light and the green. As the year went
on, Davis transformed the vast grounds, ordering new plant-
ings and trees that he picturesquely placed. Eventually, he put
trefoil brackets on the seventeenth-century Dutch barn near
the house, turning the utilitarian building into an aesthetic
object, a play of shadow and light and pleasing contour: a
beautiful red structure against the blue of the Catskill Moun-
tains. Soon every window in the house framed a gentle scene.

There was moral philosophy in this, not just expensive
taste. If nature was benevolent, human nature was too. The
beauty of the world and the splendid innocence of the person
flowed through one another in delicate and forceful harmo-
nies drawn by God. The sight of sky and woods and hills
made the heart beat stronger—an inner goodness revealed
in the sumptuous delight of nature framed, elevated, and
praised. Oliver Bronson had written his medical school thesis
in 1825 on "The Influence of Man's Physical Structure on his
character as an intelligent being and moral agent," anticipat-
ing the premise of his estate. Perhaps it was as Jean-Jacques
Rousseau had written in the eighteenth century: "Climates,
seasons, sounds, colors, darkness, light, the elements, food,
noise, silence, movement, repose . . . all act on our machines

[our bodies], and consequently upon our souls." At Hudson, Bronson hired Davis to create a space of benevolence—soft shapes and sweet smells, delicate sights and sensations, each acting upon the mind receptive to grace and repose.

Of course, the peacefulness was a magic act—a deception. Nearby the town of Hudson teemed in commercial activity. The new Springfield to Hudson Railroad, the clotted wharves of South Bay, the whaling ships, the spermaceti and candle factories, the ropewalk and tanneries, not to mention the town's main commercial street, all had to be hidden for Bronson's retreat to be real. Davis planted screening trees and created a mound of boulders to increase the sequestration. He hid the servants as much as possible, installing dumb-waiters to minimize their presence. He saw to it that the long carriage road onto the grounds made a vast interval between the common road and the sacred space, so that by the time Bronson arrived at the house, chauffeured in his costly new barouche, he had left the noise and ugliness of Hudson well behind. No matter that Bronson's house had originally been built for an entrepreneur who made his fortune tying barges with ropes to the era's brand-new steamboats, taking advantage of this parasitical relationship to the new technology to speed up the delivery of goods and charge a premium for the service; or that the house acknowledged the humble basis of its original owner's fortune with decorative rope patterns on the mantel and staircase; or that the designer of the staircase, the maker of that snake's skeleton of perfect organic beauty, had been a compulsive gambler often in debt. Nor did the furnishings of Bronson's home make a secret of his vast wealth: sofas from the workshop of the gifted cabinetmaker Duncan Phyfe; plush carpets and pier tables imported from Paris. The home and its grounds were a retreat, a salve, a moral center of natural goodness.

It was not Bronson himself who best experienced this delight, however, but his children. At the time they bought the home, Bronson and his wife, the former Joanna Donaldson, had two young sons, ages three and one. Soon the couple added a third son and eventually a fourth. The spiral staircase soon trembled with the steps of brothers racing up and down on their adventures. In Hudson and elsewhere, the age of "natural" childhood had arrived. No painting of children clasping kites or teasing caged finches could give an adequate idea of this newfound spirit of play in nature. Books read in gardens, lessons recited in sunlight beaming through windows, integers and alphabetical letters turning and curving like streams and twigs—if learning was natural, play was even more so. Pulling petals from flowers, planting sticks in the dirt, diverting water from one sapling to another in childhood emulation of the gardeners' irrigation—it was all good clean fun. And if nature was sacred, and childhood were as well, then both were as full of secrets as any holy font, and play itself became a mysterious rite.

The Bronson estate was no exception. As they grew a bit older, the family's little sons found hidden places to explore: the bog by the river, stewing with marsh grasses and black water, where they dipped their feet in the sucking slime; the old boards a few yards away, which they lifted on a dare to reveal a muck of worms wriggling in the sun. The boys' games of hide-and-seek emulated nature's own concealments: the youthful players folded themselves into some rocky crevice, or stood behind a thick tulip tree, or vanished in gullies. The estate was a child's paradise.

The eldest Bronson son was named Oliver after his father. He grew up to be a diligent and honest boy. Letters he wrote home from his boarding school in Northampton reveal him negotiating the politics of that life as best he could.

In a school of some thirty students, a few boys kept setting
off firecrackers—putting the innocent such as Oliver in an
awkward position. Always escaping detection, the scofflaws
drove the factotum of the place, poor Mr. Dudley, teacher,
principal, and constable all in one, nearly mad. Sometimes
he drank, and when he drank he became even angrier as
he helplessly accosted the silent students. Knowing Oliver
Bronson to be a good boy, certainly not one of the perpe-
trators, Mr. Dudley one day took him aside and pointed out
to him all the good he had done for him at school. He had
given him a private room at the boy's request so that he
could study more effectively and in general had tried to make
young Bronson's stay in Northampton as pleasant as possi-
ble. Could the young man therefore tell him which boys had
set off the firecrackers? Yet Oliver would not reveal the cul-
prits. The schoolmaster was exasperated. "This is the way
you repay me," he burst out, "by encouraging the bad boys
by not exposing them." He said he would close the whole
school and that Oliver would be among those to blame. But
Oliver did not tell. Nor did he interfere when, on a climb up
nearby Mount Holyoke, a bunch of boys played a trick on
a hated classmate—another boy from Hudson whose sole
offense was trying too hard to be liked. Eventually the unspec-
ified trick made the young man so miserable that "he now
feels so ashamed of himself that he hardly comes among the
boys at all." Oliver coolly said that no one liked the boy and
that he—though also from Hudson—did not like him either.

Back at the Bronson estate, when Oliver was barely more
than a toddler, then when he got a little older and roved
the grounds with his little brothers, the land was there to
set a moral standard, to be a hallmark of natural kindness,
offering a range of delightful scenes the little boys would
find mirrored in their souls. The sweeping views, the long

lawns, the merry orchards and combustible piles of autumn leaves all made the picture-visions that explained why Oliver's father, like other Hudson River squires, never bothered to own a landscape painting. His whole land was a series of such paintings, a gallery of them, and all—as he would have said—to the greater good. But hidden in that land was a murkier psychology. Concealed in the vistas was a child's clotted experience of what was true, impressions as soft as clay, buried in the light of day. Together they made a version of what Davis, quoting an English poet, called the "the secret bias of the soul."

For young Oliver one of these impressions concerned bees. He spent time with one of the estate's hired hands, a man with some knowledge of beekeeping. One day, in the clover field over by the barn, the man noticed Oliver watching the bees happily at work and saw fit to instruct his young charge, then about five years old, in the arts of locating a hive. Carefully approaching a bee, he covered it in a glass jar, waited until the creature instinctively rose to the top, then placed a paper card beneath, preventing escape. On the card was some honey, which soon the bee had dabbled in. Then to the wonderment of young Bronson, the man let the bee go and, with a well-trained eye, watched it make its "beeline" across the clover field and into the nearby woods. The beekeeper repeated the task with a second bee, observing that when it flew away it went in the same direction as the first one. The man and young Oliver then followed that line into the woods, looking for exactly the kind of tree that was right for a hive: a dead or diseased one amid the live foliage, a tree with a sufficient hollow to make the bees' home. Before long they stood before an aged oak and looked about fifteen feet up the trunk. Thousands of bees were swarming and crawling around a blackened hollow.

It was hard to say what about this black knot was so moving to the boy. He himself did not know, and eventually he forgot the whole episode, or at best intermittently remembered it as an adult, as chance occasions allowed, and never perfectly enough for it to become a part of his philosophy. The experience was rather a gap, a lure, some portal in space, through which life passed and repassed without ever being grasped. Maybe this deeper significance retired at the very moment it appeared, hidden in the much more prevalent sense of the scene: the hired man's moral and practical explanation, offered on the spot; a lesson about the industriousness of the bees; a lesson, too, on a shrewd way of finding honey (a vast amount in this case, as the man discovered when he returned with Oliver a few days later to chop the tree down).

The boy could not say what he felt when he saw the swarm. He could never have put it into words, certainly not then and not as an adult, but if there were a clue to this emotion, it was the feeling that, even as he and the man had come upon the bees, their activity had seemed to take place independent of human presence. Sequestered in the woods, long accustomed to this secret tree, the bees crawled in and out of the hollow—or shot straight out of it on their urgent missions—all in a perfect retirement from the world: a retirement that the boy and the keeper saw but witnessed as if they were not there. They were neither intruders punished for their trespass nor argonauts rewarded for their bravery and cunning (though the boy's parents were delighted to hear of his participation in the discovery). Rather something more hidden had happened. They had come upon a world they were not supposed to see. And once sighted it continued to be unseen.

It was a few months later, or a few months before (time got lost in his memory), that he had another encounter with

this more hidden nature. He was gamboling with his younger brother on the lawn when, all at once, he came upon an eagle feather on the grass. It lay there, suspended on individual blades, as if not yet quite done falling from the sky. Picking up the gray feather by the shaft, he had the feeling of the bird's flight, of gusts and zephyrs and distant promontories, though none of this was manifest in words or even in his comprehension. The feeling of vastness left him speechless. The feather had floated down to earth as if personally for him, to communicate some essence of the unknown, to find the mind whose thought was flown. Against the assurances of faith and declaration, where summit and sky rise to meet the eye, where all existence seems lofty and glad, the feather had a life of its own; it came from nowhere and everywhere. There was no world it had not flown through and in flying had forgotten. Sensing this mystery, the boy was strangely reminded of a fever dream in which he imagined he was an apple—a terrifying dream, since the apple was so much itself, hanging on a bough, that he could hardly breathe for the fullness of the fruit he had become: all flesh and no lungs, so dense and ripe and replete, a dead weight in the morning sun. The feather, by contrast, was a wand of light, so perishable and slight he could hardly grasp its flight—a weird emanation of something likewise gossamer in his own being, as scary as the apple's weight to keep him from knowing his fate. But all this the boy had no way to relate.

A third and last experience, this one of a direr kind, came when he was a little older, maybe seven or eight. He was exploring the wooded edge adjoining the family property and the main road. Slicing through the brambles with a sturdy stick, pretending to be a pirate, he looked up to see, out of nowhere, a dead dog hanging from a tree. A rope had been tied around the dog's neck and the body hung from a lower

branch. The dog was about thirty or forty pounds; its head tilted up, its floppy ears drooped down.

In the interval between main road and private property, in that thick and secret brush between the two, the hanged dog made a cryptic sign. Halfway to public declaration, the sight remained concealed. Neither here nor there, it seemed meant for a wayward person, a brave one, too—perhaps exclusively for a child, someone adventurous and innocent enough to stumble into a profitless zone where adults have little need to go. The sight grooved channels into the boy's brain like the ones he saw gather the rain—lines of muddy reflection, of sorrowful scope, dead ends of doubt and fear. Had the dog barked too much? Had the killer just been mean? Who and what was astray? At home, asked what was wrong, he climbed the stairs and did not say.

Deities of the Boardinghouse

Many who saw her, at one of the rented rooms or boarding-houses where she set up shop on her itinerant travels, had never gazed upon such a person. Martha Ann Honeywell was born with stumps for arms, with no elbows and no hands; her legs were stumps, too, and she had only three toes on one foot and none on the other. Yet as customers and bystand-ers watched, she made intricate miniatures of cut paper and the written word. Holding a pair of scissors in her mouth, guiding the blades with one of her stumps, she grasped the paper with her toes, cutting it in designs as complex as the filaments of a snowflake. Sitting like a Turkish sultan, she embroidered fabric by entering the needle with her toes and pulling it out with her mouth. And she wrote a fine minia-ture script with her toes. It was too much to be believed.

At the center of one of her works, a design of cut papers about three inches in height and width, Honeywell wrote the Lord's Prayer in a circle the size of a modern penny. The outer edges of the papers make a four-pointed star, serrated like a pineapple or saw blade, a compass to the cardinal directions. At each hollow—the points corresponding to NE, NW, SW, and SE—delicate pine branches burst. Within the compass-star, foliate patterns of green and light green teem like the designs on damask. Around the central prayer, a rotary of thistle encircles a garland of delicate vines glowing with a metallic luster. In the innermost circle, the Lord's Prayer appears in a script so slight, so small, though written by dexterous movements of her toes, that reading it requires a magnifying glass. Only about a third of an inch separates the first two lines, "Our Father who art in heaven," from the last: "Written without hands by M. A. Honeywell."

Part of the wonder, the smaller part, was how this woman who might have been only three feet tall made a living. For decades she made her way independently, traveling without accompaniment in the United States and Europe, her appearances noted in newspapers up and down the Eastern Seaboard and elsewhere. Long gone were the days when her mother had accompanied twelve-year-old Martha Ann on her first paper-cutting forays into the marketplace, back at the end of the eighteenth century, when the Honeywell family had sold their 250-acre farm in Westchester County, New York, and moved to Manhattan in part because they could no longer afford to maintain it while caring for their daughter, one of five children. Some thirty years later, about the time she made the Lord's Prayer miniature, Honeywell was not only a solitary world traveler, having journeyed alone from Le Havre to New York in 1827, but a veteran negotiator of the

early republic's economic realities. But the larger part of the miracle remained the work itself.

The Lord's Prayer cutout discerns God in the heart of things. It suggests that if a person presses into the whirrings and untold heart of a pine cone, or a piece of bark, or a blade of grass, they will find—pattern upon pattern—a secret symmetry, an infinite delicacy, beyond what the eye can see. Honeywell revealed—magically, without hands—the unity and diversity, the complex simplicity, that underwrites the cosmos. If a design so small was perfect in every detail, then what were heaven and earth writ large but an exponential version of the same perfection? The Lord's Prayer, pith and heart of the outward flow of forms, generated the gentle fur and serrated feathers of a star's ruffled surface.

Honeywell drew the crowd in, a special saint, goddess of the rendezvous between affliction and revelation. Her birth defects seemed a divine sign, not simply a misfortune she needed to overcome to show her dexterity and Christian good cheer but a blessing whereby the microscopic order of the universe was revealed especially to her, and through her to the people who watched her work and who owned what she made. The natural world in its infinite beauty—a small slice of it sufficing as a sign of the heavens—might not reveal itself to a different kind of soul.

Who was an artist and what did she give? Others reached for Honeywell's formula, sensing it lay in their grasp. Not that they literally studied her and sought to emulate the mystery of her grace. But by themselves they arranged a vision commensurate with hers. William Sidney Mount's *After Dinner* of 1834 shows a handsome Romantic violinist clad in black, his hair tousled and gaze lifted, as if searching for the invisible music he plays, discovering it perhaps in the

quiver of his strings and bow. Two listeners flank him: one, on the right, a working-class man wearing a thick peacoat and jaunty red cap, sporting an insouciant stare; the other, on the left—heavier, more sedate, finely dressed, closer to the liqueurs on the table, in short, a merchant, resting his right arm on a chair and gazing at the musician. The artist plays for these men—accompanying their digestion, appealing to different classes, splitting the difference between mercantile opulence and laboring coarseness, perhaps even bringing them together, effecting a temporary reconciliation among hostile parties, by the performance of his song. Filling the tall hat of the merchant with a rising sound, inflating his head with music, he simultaneously intoxicates the workingman's brain with a fiery glow: the tip of his raking red cap smolders like the tip of his cheroot.

Yet the musician provides the men foremost with another gift. Set off from them, absorbed in his music, he grants them their solitude by seeking his own. Giving to each the dream of a separate being, he explores a state of raw experience as purposeless, as fulfilling, as the warm brown emptiness above the heads of him and his listeners, the common atmosphere of producer and consumer, an indefinite emanation of creaturely well-being, of the body thickly wrapped and full-bellied, of enjoyment without philosophy, without thought, in proud reverie.

The musician's song evokes the lyric Honeywell played, the vibration of her prayerful melody, a small tune cut from the workaday world. She, too, made a momentary community without rancor, in boardinghouses and rented rooms, accompanying people's lives to the point where, if only for a moment, they sensed that this mere diversion *was* their lives: a picture of their prayers, the warmth of their forms, the sensation of budding life, as they watched her work.

In Mount's painting we see only three of a possible six hands. None of these three is very distinct. We do not see any feet, for that matter. Art requires a lack, that much the Romantics knew. Some disablement, some privation, it all came from that, the sweet muse of disablement. The soulful Byronic gaze and handsome features of the violinist, suggesting a great feeling beyond the reach of his sated listeners, beyond even himself (he seems to search for something), is one with the scissor blade of his bow cutting across the strings. A pattern of silence, pared to small notes, his song entered their heads, who knew how.

It is a question of otherworldliness. Mount's musician, chiseled in feature, is a Greek god in black garb, fiddling like Apollo at a sacrificial rite. If no goat hangs from a tree, if the god himself no longer slays a python or chases a nymph, his descent to the same level as his patrons—now allowed a vulgar proximity to the immortal—does not conceal his supernatural origins. The artist is both democrat and deity. Honeywell, for her part, betrayed no less celestial a genesis. Scarred in a cosmic storm, the survivor of a disaster that splintered her at birth, she brought a scissored message from the stars. At her humble craft, she channeled the supernatural powers that struck her down, making her body and her art into twin signs of fate and revelation. In the humble germinations of her art, she ministered to the sources of life, spoke for the stars, pressed them to earth.

The artist was descended from gods, so the times decreed: a sacred stranger, wiser than her customers, who, smitten or embarrassed, incredulous or rude, looked away, looked back, and stared again, trying to solve the riddle of her, and in some distant way of themselves. And if it all was finally only entertaining, just another amusement to pass the day, the gods understood this too. The forms of failure were themselves

divinely ordained, a part of the heavenly prescription, ensuring that the lyric song retained the invisible atmosphere of its parentage—a family likeness, born of the blue, lost to sight and sound, a grand negation, concealing the mystery of how it came to be. Reality, Martha Ann Honeywell might have said, consists of what is not there.

Triptych of the Snuff Takers

This is the story of the Irishman who fell from a tree. He had been pruning an elm, a business he knew little about since his job was in a wagon shop and he had been trimming the tree on the orders of his employer, when he lost his balance, struck the ground, and hit his head. Now he was dying, some of his fellow workers leaning around him, street boys too. His wife was notified and came running. A priest, arriving, sprinkled holy water, used his thumb to trace crosses of oil on the man's eyes, ears, nostrils, lips, hands, and feet, and spoke Latin words in such a liquid way that the sounds were like the oil, like the water.

This was in New York, not far from where distinguished citizen Philip Hone lived at 245 Broadway. Dressed in a blue swallowtail coat, tight gray trousers, and high-collared shirt, round and pink of face, he was writing in his diary of the distresses in Ireland and the serious alarm that the massive waves of cholera-infected immigrants had caused among Americans. "The boast that our country is the asylum for the oppressed in other parts of the world is very philanthropic and sentimental," he wrote, "but I fear that we shall before long derive very little comfort from being made the almshouse and place of refuge for the poor of other countries."

His words, uncharitable to the man who had fallen from the tree, whose fate he did not know, were more than political opinion. The flow of them, issuing in a great range of educated belief, made a more curious effect. Concise unto themselves, punctilious records of given days, Hone's sentences made an oddly immaterial adornment to the city he described. They gave an invaluable picture of life—without Hone's diary, our sense of America in the 1830s would be much diminished—but on this day they also made a net through which the Irishman had fallen to his death. The inadequacy was not chiefly political, despite Hone's anti-Irish sentiment. It consisted in his words—not the choice of them, and not their editorial position, but somehow just in their existence itself: so many of them, so many thousands, telling a story that made a vapor, a blank, through which life, like the man in the tree, uttering an unprintable cry, fell through the leaves.

Down in Tennessee, in Nashville, Peggy Eaton had been invited as the guest of honor to a dinner party at Travellers Rest, the home of John Overton, one of President Jackson's longtime political allies. The event was important, because back in Washington the wives of the cabinet members had snubbed Peggy after her marriage to Secretary of War John Eaton, dismissing her as an upstart—the beautiful, uncouth, flirty daughter of a local Irish tavern keeper. Her step into Washington society had not been easy—in fact, it had been prevented—but that had not kept Judge Overton's wife from hosting Peggy and showing the support of at least the first families of Tennessee on Peggy's visit to the land of her chief defender, Andrew Jackson himself.

That night after dinner the men went to a separate room for wine and cigars, and the ladies climbed the white oak stairs and entered a circular room. In the center stood a table

with boxes arrayed on it, surrounded by chairs. Next to each box was a twig from the althea tree. Next to each chair was a bowl. Peggy, unsure what to do, looked to the other women for an explanation. You have to *dip*, they said, pointing to the snuff in the boxes. You have to take up the althea twig, chew it on one end until it becomes soft, then dip the twig into the snuff and rub it furiously on your teeth. It was a tradition, it was required, it was superstitiously necessary, because the brother of one of the women needed to retain his political position in Tennessee.

Peggy Eaton said she "took a tea-spoon of snuff and rubbed away as if I never had a mop out of my mouth since I was born." She kept doing so, and after a while the walls of the house began to swerve. The fine ash floorboards got wobbly. The circular room started spinning and her head bobbed from side to side. "I—I—I think—it—it is—a—a—a—little—close—here. I—I—I—am—am fraid—I—I—I am—am not—quite—well. I—I—I—feel-f-f-faint." As the last syllable left her mouth so did her dinner. The women screamed with laughter. The hostess, Mrs. Mary Overton, "simply laid down upon the table and roared. A dinner party never ended more informally," Peggy recalled, adding that after a while she was able to laugh about it too.

Peggy's stammering words made a strange chant in the circular room. On a plantation with Overton's fifty slaves, in the house that the Confederate general John Hood, with his missing arm and missing leg, would one day use as his headquarters during the Battle of Franklin—the one time, Hood said, when he saw his soldiers run, pressed upon by black troops as well as white—in that place, the ladies got high, they fell all over themselves. It was delicious, indecent, a private affair of the body and mind, women doing such uncouth manly things, a little comeuppance, too, for the

beautiful upstart. She was one of them, to be sure, but needed to be hazed, the pukey ruin of her dress a sign of her sorority. Let the legend be written, inscribed in the plantation's elms, oaks, and fragrant boxwoods, bedded in its bales of cotton, the story of the night Peggy Eaton took snuff and, safely, securely, protected by her friends, threw up.

Her words, like all the words of that decade for which not a single recording preserves the sound of the voice, evaporated as soon as they were spoken. They made an invisibility, quite a sturdy one, as silent as the air, that constituted a great network tying people to one another by their diction as by their actions. In dialect and deed, they were words to live and die by, as sure as the alleged and certifiable insults that led many men, including Andrew Jackson himself, to fight multiple duels. Yet curiously these substantial words, these avowals of reality, were themselves a mysterious vapor through which the duelists and all else fell, in slow motion, as through a crepe paper powerless to prevent their demise. It was not just a question of sentences failing to outlive a person—a would-be pantheon of immortal utterances becoming a gallery of blank walls. It was that a gray pallor and bluish tremble hung on the lips of the brightest utterance: not the morbidity of gothic observers, not the stuff of Poe and the other poets of portent, but some other transience that kept words from holding true—an acceptance of their disappearance in time and history, even the very history of which they sought to be a record. So it was that the Irishman who fell from the elm had no one to say who he was or what he had done because words alone, true to their nature, could not save him.

In a Catholic church, like the ones that Protestant mobs burned down in the 1840s, a certain triptych stands. In the center panel, the Irishman is shown dropping from the tree.

His body is already an angle of slumped and disjointed limbs, as if the artist had gotten ahead of himself and portrayed him already crumpled on the ground even though he was still falling in air. He looks like Jesus deposed from the Cross (clearly the artist's intention), though without the followers who gently lower the body—their absence not preventing them, however, from having bestowed a certain ghostly caress and softness to the man's body as he descends, as if in his time of solitude and need he were being stroked by invisible, powerless hands. One wing of the triptych shows a learned friar coincidentally looking very much like the anti-Catholic Hone. With his quill and paper, his books and satin slippers, the friar looks upward as if for inspiration to fill a page still blank: making a pact, it seems, with a higher power who will bestow on him the powers of nothingness that his rich range of words will consecrate to a greater spiral of oblivion. So it is that the diarist, keen at work to make sure that nothing is lost, creates a medium of helpless silence that adds to the legend of the saint he could not save.

And Peggy Eaton? On the other wing of the altarpiece, proud in her gown, she holds her twig and box, staring at the viewer with kindness and a parted mouth. If it were not for the fact that paintings cannot speak, it would seem she is saying something. Even in the varnish and grime, we can see her teeth and some of her tongue. Her words are of course lost to history. But it is of this very loss that she wishes to speak, for she is the patron saint of vanished evenings, of levity and laughter, of talk lighter than air. Sower and victim of gossip, deity of powerless power, she lets the gas of truth rise in league with God, her divine sign an unction of snuff. Those who are high, those who are inspired, climb the stairs and sink to your knees, virgins of the word.

The Drug of Distance

Two brothers talked of art in the older one's room. It was late at night and they spoke in hushed tones. The older one was nineteen, the other fifteen. The walls of the older boy's room were lined with prints of Old Master paintings from the National Gallery in London. He had cut them out of a volume their parents had given him. The two young men were standing before one of these pictures—Claude Lorrain's *Italian Seaport*—looking at it by candlelight. In the guttering light they saw another flame—the sunset on the horizon of Claude's picture, or at least the engraver's black-and-white version of the sunset. The rays made a pavement across the water to the near shore, where fishermen, stevedores, and gentlemen stood, beckoned by the sun to faraway places. The finely stroked waves seemed to call to one shore-bound gentleman especially—a man wearing a flowing dark cape and dashing hat, who stood, like the others on the beach, between a temple of crenellated stone and a thicket of cruciform ships' masts.

Voyages made sense to the brothers. They lived in Hudson, New York, that town on the Hudson River founded in 1783 as a whaling port that even then, in the 1830s, still sent oceangoing ships around the globe. By that decade other industries were also thriving in Hudson, not least the iron foundry that the boys' father, Elihu Gifford, had recently bought. The Giffords lived in one of the city's finest homes, an Italianate mansion on Columbia Street, and it was there that the two young men—Charles and Sanford, the artistically inclined among the family's eleven children—talked of art. Their parents' wealth and liberal views meant they could pursue their aesthetic ambitions and travel in their dreams.

In 1846, however, Charles, the older one, then in his midtwenties, made a practical move, settling in the bustling frontier settlement of Milwaukee, Wisconsin, where he hoped to prosper in his chosen profession of landscape gardening. Sanford, meanwhile, had decided to become a landscape painter. He had climbed to the top of a local hill—Mount Merino, named after the sheep that grazed there—and been inspired by seeing the home of Thomas Cole, the founder of the Hudson River school, who lived in the nearby village of Catskill. Sanford's first known work of art is not, however, a landscape but a portrait of Charles, done in black chalk and white highlight, made perhaps as a memento the year he moved to the shores of Lake Michigan. In the drawing Charles is aloof and intimate, sitting at an angle, his thin face pointed down, lifting his gaze to stare directly at his younger brother.

Both Charles and Sanford suffered from depression, especially Charles. He was also afflicted with migraine headaches and began taking a recently invented sedative called chloroform to ease the pain and escape his dejection. The drug had been introduced as an anesthetic at mid-century and quickly became popular as a form of self-medication. Out in the wilds of Milwaukee, Charles found relief in a way that uncannily recalled one of those engravings from the National Gallery in London of which he was so fond, David Lucas's print from John Constable's *The Cornfield*, with its depiction of a boy, mistaken by some viewers as being dead, lying flat on his belly and submerging his face in a stream to slake his thirst. Like that boy, except with chloroform, Charles was a Narcissus plunging past the point of self-regard and into the murky experience of quenching his desire, of "going under." In 1860, Sanford visited him in Milwaukee and found him in a "disordered state of mind and body." The next year Charles killed himself with an overdose of the drug.

Just then Sanford's landscape paintings became beautiful.
What made them so was the artist's solemn and melancholy
portrayal of distance. No one painted distance like Sanford
Gifford, and probably no one ever will. He could not get away
from it; it was the nearest thing to him. A mountain at sun-
set, a crag silhouetted against the dying sun, a lake darkening,
the water deprived of the sun's light as a farmer herds a few
cows. It does not sound like much. But by looking far away,
portraying mountains fused in fading light, sucking invisibil-
ity into their ledges and valleys, he raised an unanswerable
philosophical question. Call it the reality of a place that we
can see—more than that, a place that we can be moved by,
that we can feel inside ourselves—but that we can never
reach. For even if we were to travel to the remote ledge on
which the light glints, when we arrived there the ledge would
be something other than when beheld from afar: a matter of
sticks and stones, some craggy escarpment not without its
own close-up charms, perhaps, but lacking the glitter, the
glint, of the horizon. Sit in a canoe and spot a dark hollow on
the opposite shore of a small lake; paddle resolutely to that
very spot, keeping one's eye on it to make sure that there is
no mistake; disembark there and the spot will be only some
wily proximity, a false hope, no answer at all to what drew
one there but only the gateway to another distance. Gifford's
pictures dwell on this fact: that what we cannot know is a
part of our reality; that what we can never experience *is* a
part of our experience.

Call it a kind of religion—if not the open faith Gifford's
mother wished for her children to profess, then of some silent
devotion manifest in art. His was the feeling of a sustained
vision—a fasting saint staring at a mountain so long it starts
to float, so long the mountain's name drops away, so long that
the proximate world flees and everything starts sweeping

backward in some reverse cosmology of light retracting and channeling—the sun setting, the clouds tinting like the blazons of an empire without a territory, no land at all.

Gifford's local inspiration, Thomas Cole, had populated his vistas with glowing crosses and winged skeletons, the eschatological signs awaiting the world's pilgrims at the end of their journeys. Gifford saw the same, except the mystery of his mountains was not that they divulged cryptic writings and broken tablets, skulls and crucifixes. Instead they questioned the silence until, reticently at first, then with more disclosure, the silence undertook a delicate striptease—an unveiling of soft granite and slow stone, revealing, in the end, not the gleam of seductive life or the grimness of the mortician's rouge, but some guess, some ghost, between. His real-time act of making a painting, with each fleck of the little brush, was a religious conjuration less reliant on Jesus than on perception itself, a ritual attempt to ride on what the world gives—namely, the diminished clarity of faraway things, until this simple law of vision became inseparable from memories and dreams.

Not like a geologist, and still less like an explorer, he dug and dug into the distance until it yielded extracts of pure desire—a mixture of the flame and the moth's wing. The ingestion of a pill, the taking of a tablet, the passage of distance into the blood intoxicated him until he could not fail to see it: it was everywhere, a redemptive dream, a saving grace, a way of not jumping. Yet it was a fall all the same: a fantastic leap, a fluency with limits, down into knowledge and nonexistence, conversant with a land whose language neither he nor anyone else could speak. His pictures say that the line of mountain and sky is the first to go when we die.

Painter and Oak

John Gadsby Chapman had recently come back from Rome, where he had gone to continue his artistic education. Now he was back home in Virginia, just across from Washington, DC, outside Alexandria, strolling through a forest not far from the Potomac on a day when the sky was darkening and a huge electrical storm was rolling in from the west. The woods were no place to be in such a deluge, but the storm was far from the young man's mind. Chapman was conscious of nothing so much as his own walk—the *way* he walked: measured, casual, contemplative—which brought to his mind the relation of great thoughts and solitary journeys, the necessity of one to the other, if he was to go anywhere, achieve anything, or, as the Romantics said in Europe, be inspired. That was why he now stopped and looked up into the crown of an oak.

At first he did not believe it, but he thought he saw something there. After a moment he realized that he had not, but the fact that his imagination had fooled him gave him pause, and he lingered, still craning his neck, no longer anxious to see whatever it was but to ponder the fact that his imagination gave rise to such phantoms. With a deep and joyous breath, as if starting a voyage, he squinted his eyes, looked some more, and thought now that he saw a man up in the tree. The man was not actual but painted, however, standing high above at a split of branches springing from the trunk. A painted figure in a tree? Chapman understood right away that he was transposing the ceiling frescoes he had just studied in Rome onto this Virginia oak, that the matter of staring into the foliage had awakened in him memories of his recent habit in Italy of craning his neck to look up at the painted glories of church and chapel. But not worrying about this vagary, he

continued to stare because he believed his imagination was telling him something he should note.

The man he saw in the tree—the man who was suggesting by his imaginary presence that the whole canopy above him was a kind of painted dome—did not seem especially important in the scene. He was no pope or potentate. He did not have wings or Grecian sandals or a fish tail. He was no allegory, no god, no monster. Instead he seemed to be a subordinate, a servant, a proper inhabitant of the ancillary conjunction of tree and branch, of column and dome. Implicit in the sight of him was that a full glory of pomp, the stuff of striding chariots and flinching demons, must be still out of sight, permeating the full and flourishing summit of the tree. But not seeing the main drama, or choosing not to imagine it just yet, Chapman kept focused on this one figure he thought of as a servant. He appeared, this painted man, in extreme foreshortening. The soles of his shoes loomed largest and nearest to Chapman, as if in league with his own boots firmly on the ground, though the airborne servant stood high above him and on no floor that he could see. Still, he could determine some things. The arching of a branch, mixed with the smooth onward elevation of the trunk, gave the painted man his uprightness and his aspect of servitude. The branch springing out seemed to be an arm that, as Chapman peered into the foliage, might even be holding a platter. Some banquet was taking place above him, it seemed, and lowering his eyes he paused to think.

It was when he looked back up that he saw suddenly, spreading across the flaring canopy of the whole tree, a vast scene of gods and goddesses, ensconced in airborne glades. Scented with his own sweat, and not a little with the cigar smell of his clothes and the damp permeation of spirits in his breath, Chapman thought he beheld radiant goddesses and

churlish, angry giants, massively muscled, twisting to swat buzzing cupids off their shoulders. Drapery-swept women lifted glowing crowns; weird marbleized caryatids strained their shoulders to hold up the foliage of which they themselves were composed. Still other hybrid giants, hanging from the swirl of branches like snakes, coiled their serpentine tails round momentary respites in the tree's bombast of vegetative energy, spaces of calm that seemed to Chapman almost like escutcheons portraying a druidical family crest. The little dabs of gray sky, visible through the gaps, were a crowning piece of the artist's craft: a masterpiece of illusion whereby even the sky itself, visible above the green dome, peeped through the canopy to proclaim that the universe, too, was a fantasy. The whole scene above him, with its vascular contraction of veiny branches, beat like the tree's own heart, like his heart too.

Steamy in the Virginia heat, he looked down. Something too riotous, too sumptuous, threatened him in this pounding uproar above him. He became conscious, too conscious, of his own place. It was not just that he had accomplished nothing yet as a painter. It was not that he could already see, as he contemplated his own career, that the days of gods and goddesses, of flaunted rippling muscle and impossible mythology, were so long past that it was left to him, like his peers, only to pick up the pieces of that grand era and portray, as if with sticks and stones, the comparatively parched and destitute episodes of American history. Even if he already understood that the obvious way forward was to combine, albeit on a minimized and modest scale, the surfeited extravagance of the paintings he had seen in Rome with the responsible and edifying stuff of moralized history, the recognition that this combination was a falling off, a departure from the glory days, was clear enough. Yet, still staring at the ground, he was aware that this was not what had unsettled him.

Chapman thought he had seen, in that swell of gods above him, an orgy of mind and body that might permanently ruin for him his pleasure in the rituals of ordinary life. Perhaps he had read Nathaniel Hawthorne's recent short story, "Young Goodman Brown," which in a setting of Puritan New England had described what he was feeling: namely, that on a journey into the woods, he had seen and experienced something that would forever make him a grave man. If Young Goodman Brown observed the pious worthies of his village cavorting in satanic rituals deep in the woods, if he witnessed them spewing hellish epithets in a forest clearing set with blazing fire, young Chapman had caught a glimpse of some other forest rite, as of secret initiations and forbidden sights, though the very way all of it was hidden, nested in thickly intertwining branches and pelts of patterned leaves, was what paradoxically gave it the feeling of a direct revelation of something he was not supposed to see. For all he tried to get the image out of his mind, he kept likening the underside of the tree to the lifted dress of a woman. And though it was easy, in the cigar-chomping spirit of male bonhomie, to celebrate the vision in those terms, he felt that there had been something illicit and guilty in the sight, like a memory flashing up in a man, as he walked with his fiancée, of a night in a brothel.

Chapman kept studying his boots and thought of a favorite topic: the poor manufacture in America of shoes, the way they crimped the toes, the two smallest ones especially, so that the feet of many adults in America were fused and clumped into misshapen stubs. Not far from Mount Vernon, which Chapman had already painted, the nation of George Washington was composed of hobblers and limpers scratching the ground in ways so different from those God desired. The tracks they made, erratic and skewed, blighted the public paths and roads he, too, was obliged to follow. It was an

indignity. He knew that beneath the fine upper leathers of his boots, purchased in Italy, his own feet were smooth and pink and as flawless as those of a Greek statue come to life. As he wiggled those perfect toes—he knew the gesture was odd—he started noticing the ground, where all around him he observed for the first time the hundreds, maybe thousands, of acorns upon which just then the first rain penetrating the oak's canopy had started pattering. The spread of acorns, a great hail of seed, each one containing an oak as vast as the one above him, struck him as obscene. Not just the crunching underfoot bothered him, which he now recalled as the noise of his approach to this spot beneath the tree, but the smoothness of the acorns' skin and their little crested tops, not to mention the way many of them lay half-buried in the mulchy soil, felt wanton, profligate, like a spewing of waste. As the rain fell, hitting the soil in pendulous drops, bursting on the dirt, he thought of the tree's roots submerged at his feet and envisioned the vast system belowground—a whole second tree, really—inverse to the one above him, a narcissistic reflection of the crown, greedily sucking the rain.

Chapman had a sense that the tree was not only sustaining itself but creating itself as he stood there, even *because* he was there. The oak seemed to flourish its powers of germination, flaunting its power to grow versions of itself everywhere he looked, though only raindrops and not acorns were falling around him. It was an experience that no one would believe, and even he doubted that he would credit the sensation once the sunlight of daily life—its rhythms and rituals, its pieties and small talk—closed back over it. It would seem too strange to be true, as if he had looked in the mirror one day to find that he had grown the ears of an elf or the goatee of a satyr. He half hoped that tomorrow he would be as good as new, splendid and youthful and handsome, as cherubic as the

young Virginia gentleman he felt himself to be, that he would have no recollection of his time beneath the oak, but right now he acknowledged he was in the grip of a terrible fancy.

Not the least of it was that the tree seemed to control his thoughts. Leaning his back against the sturdy trunk, he felt the plates of bark rub against his shoulders and considered that he was not only in the midst of a swarming propagation—a kind of pollen storm of drenching rain that might in reality happen a few times a year but felt just now like a once-in-a-lifetime miracle—but that the tree looming over him was causing him to believe in this fantasy in the first place. High above him, the canopy was a kind of brain, a circuitry of designs shaping his thoughts. Obscuring all else, even the tops of the neighboring trees, the oak's crown made the center and circumference of his philosophy. It determined all he could know. And just then what he knew was that there was no world but the one that made itself, in self-satisfying rituals of fertility, soaked in rain that fell not from the heavens but seemingly from the tree's own cosmos. There it was above him, behind him—*everywhere*, it seemed—entirely bound up in its own ecology, down to the parasites chewing the leaves, the grubs ingesting the bark, and the tree's chemical combat of those miniature enemies. Though the oak swayed elegantly in the storm, though nothing about it particularly "menaced" him, as Chapman's friend Poe might have put it, he felt that the branches clutched at his hair, and that the roots rustled his toes.

Maybe it was for this reason—in the last few seconds before he passed out—that he thought the turf began stirring with growths that, most strangely, resembled the crew of gods he had first seen in the leafy scaffolding high above him. Angels, cherubs, scrawny old men holding scythes and hourglasses, little licking flames of light and goddesses

brandishing torches and wreaths and bright phalanxes of subsidiary maidens sweeping their pink and orange gowns around their shapely thighs—none of it was "real," none of it could be credited (because, after all, wouldn't all these figures be wet with the rain and dirt if they were so?), but it did seem that the ceiling had fallen to earth, that the fresco was on the floor, that some natural disaster had caved in the painted gods, who now lay all around him in bright chunks of plaster, and that he was ankle-deep in the heavenly illusions that led him to lose his mind.

The next year, when Chapman got the most important commission of his life, to paint a large canvas called *The Baptism of Pocahontas* for the Capitol Rotunda in Washington, he had mostly repressed this strange and solitary episode. Perhaps it was something in the experience itself that induced him to draw a blank, as if part of the tree's chemistry were the secretion of an enzyme ensuring that its momentary control over the man would cease to be a fact in that man's mind. But this could not have been quite right, because somewhere in Chapman's brain, as he set about his masterwork, the memory of the oak worked its spell.

Not that you could see that pagan encounter anywhere in what was shaping up to be a fine and proper portrayal on canvas, as anodyne and celebratory as one would expect for a piece of national propaganda. But somewhere in the smooth flow of kneeling Pocahontas's chaste white gown, in the preacher's solemn oratorical stance, in the manly ardor of John Smith, and even in the shadowed group of incredulous Indians baffled and discomfited by the girl's conversion, some weird recollection of Chapman's sylvan tryst made itself known. The spread of the figures on the eighteen-foot-wide canvas was so insistent, so declarative that *width* and width alone was what governed the picture. But one could not help but think that *height* was what it really dreamed

of—for example, the height of the dome above the rotunda where the painting would hang near the floor. It was as if everyone in Chapman's latitude, saved and sinners alike, had fallen from above, and that the painting, sensing this fallenness, had converted a vertical format proper to the gods into a horizontal one suitable to adjudication, bureaucracy, and ground-level ideological self-congratulation.

Yet the rub of this conversion was that the figures, having undergone their fall from grace, seemed to regret it. It was not just because of the pains, as though of the rack, that contorted their limbs from the foreshortened glories of the heavens into the extenuations of earthbound gestures. It was because their actions, no longer requiring us to crane our necks to see them, now savored too much of the ordinary registers of birth and death, weddings and communions: a secularization of which they wanted no part but had to perform, like actors accustomed to playing Jupiter and Juno adjusting themselves to the roles of husband and wife in a domestic melodrama.

It was Chapman's Pocahontas, of all these figures, who seemed most to lament her new place. Kneeling on a homespun pine altar, she resembled some windswept sister of the stars, trailing the comet of her white gown, now laid low. Bending meekly, her hands folded at her breast, she had become defeat, surrender, obeisance, a queen of vanquished heaven. Baptized in fallen rain pooled in a sacred font, she was more akin to the rain's twisting skeins, self-distorting as they spun from the clouds, the rains that made a mist diffusing everywhere and not just in a sacred chalice or cup, and it was this recollection of herself as the rain that Chapman's Pocahontas seemed to mourn.

In her reduction, spread across the stage, she seemed to yearn for something else too. It was for another zone of

painting, that of the dome above, the sphere most proper to unreachable things. She missed the freedom of this elevated place, a realm congenial to hallucination, in which the very figures themselves forget their roles and become something lawless and self-generating. In those moldy Italian domes dim with centuries of smoke, rotating in funnels of air and light, their legs and arms morphing into vapors of colored breath, the celestial beings spin in astrological fantasies so outlandish that they experience their own vanishing as an erotic caress. Only gods could fashion a language, there in the moment, that evaporated its own meanings in league with the drying of the paint on plaster. Only gods could float high above decrees and treaties, even those they allegorized, in an abandon that stood for nothing except the power to defy gravity.

That is why, having fallen to earth, Chapman's Pocahontas retains the aura of a deity. She was envisioned—created—by the fantasy of a painter who, alone beneath the oak, let fall the dreams the tree had of him, the sylvan fantasy that made him, just for that moment, a creative force. If he wasted no time in forgetting that this brief access to the immortal gods had ever happened—if he made even his swirling goddess kneel chastely on the floor—he remained haunted by the one moment in his life when the heavens turned green.

PART EIGHT

Four Greens

The Gasbag of Louis Anselm Lauriat

The balloon of the aeronaut ascended from Boston Common on the Fourth of July, 1835. From ample seating in the shade of the common's elm trees, the Independence Day crowd saw Louis Anselm Lauriat's craft rise from the earth, treetops and gasbag momentarily appearing together, astral and terrestrial spheres in relation. Just for a second the trees' intricate twirl of limbs, backlit against the sun, made an arboreal echo of the ropes connecting basket to balloon, so that it seemed that the trees themselves might ascend. But the elms kept their place, and the crowd followed the brightly painted gasbag as it climbed several hundred feet, then higher, and started blowing north. The aeronaut waved frantically, glad or terrified, it was not clear.

The trees, stuck on the ground, nonetheless rose and fell at each moment. They sucked soil up to their crowns. They brought the sky down to the earth in a million splinters, a sparkle of shattered patterns. Each tree was a cosmos, a womb below and a phallus above, generating a silent conversation between stars and stones, grass and clouds. Each brokered the introduction of sod and sun as though they were new to each other at every second yet also ancient friends, druidical counterparts in an elemental ritual of life and death. Down beneath the ground, it was said, the roots of these trees grew with such muscular tenacity that coffins, when opened, revealed these roots clasping the skulls of casketed worthies, their heads held like white balls in barky fingers. Back up in the trees' crowns (a mirror of those roots, some said), the elms were busy making a pact with the sky, letting the same breeze that shook their branches vibrate in little shudders of the soil.

The trees were so complete that it seemed no human being need ever look anywhere than to them for a view of life. Independent and full, organically connected in every part, they idealized the existence of those who looked on them. Strange, then, that they lacked something, that avenue of the elms on Boston Common. Their pagan perfection was the same as always—they were like orators soundlessly repeating their own maxims to audiences of no one but themselves. But a gap was there all the same—some hollowing of their fullness and completeness. They needed paltry human beings—needed these little people to live their lives, enact their dramas, for leaves and bark and roots to be real.

On that Fourth of July in Boston in 1835, several hours after Lauriat had risen, a man and woman promenaded beneath the elms. She wore a lilac silk dress with a plain front and ample billowing sleeves, a shawl of red Indian muslin attached at the waist with a ribbon of Pomona green taffeta, a rice straw hat with a sprig of flowers at the crown. The attentive gentleman at her side—dressed in dark coat and light trousers—noticed none of this, however, so much as her hair. Hanging in brown ringlets on either side of her head, it struck him as like the leaves of the elms above them. The effect was stronger when, irritated by some insect that had crawled into her hat, she took it off for a moment to reveal more curls on her head's own crown. The relation between hair and trees was not a simile, the kind that might strike a poet. Nor was it a bawdy analogy like the lyrics of the popular song "Katy Mory," about a man who climbs a tree at his lover's request only to find that she mocks him and leaves him there—a sorry state he overcomes by winning her over, so that, as he sings, "now I climb as fair a tree as ever bore a pear." It was a mystery, the musk of shade and sun, when the beauty of a person seemed part of something beyond herself,

a compound of breeze and leaves and drooping branches and bark, all of it acting as a tincture, a perfume, making her skin, her smile, and her ringleted hair more sensuous, more present, than it would have been otherwise. It was as if the woman had become a sylvan sister, a dazzling mythological being grown into life, sprouted from the ground, by virtue of the trees that let her be.

It was all a fantasy, of course, gone before the attentive man could say what it was. But what it brought up was the difference, if there was one, between what Ralph Waldo Emerson would call the "over-soul" and the feeling of the man on the ground. Emerson had been to Rome in 1833 and gone straight to Raphael's *Transfiguration*, marveling at the Savior floating in the sky, raised in a blinding light, his face the simple and "home-speaking countenance" of a friend. Soon Emerson like Jesus would lift from a bare common, perhaps the same one as Lauriat, rising into infinite space, his head "bathed by blithe air" as he became a "transparent eye-ball." It was all so different from the ground-bound amours of the man courting his lady on the promenade. But the trees lifted his courtship up, made his partner a person of the skies, gathering her in the leafy canopies before returning her, refreshed, to earth. If there were no trees, would there be no chaste desire—the desire of the man who saw stars as he shifted the gravel with his boots? With no connection of up and down, no ladder such as the trees provided, perhaps the world would have long since separated into incommensurable realms of glittering constellations and trampled turf. The tree was the model of love.

And love was in the air. The aeronaut Louis Anselm Lauriat had distributed leaflets bearing a romantic poem he had composed for the occasion—a lover's lament written to the earth he was forsaking: "Adieu of Monsieur Lauriat on

an Excursion through the Upper Regions, to the Inhabitants of the Mundane Sphere." He said he was seeking the "soft-kissing Zephyrs," the rarified air of the bodiless firmament, where, doomed to sight and a dot in the light, he could experience the erotic freedom of a life whose only connection to the ground below was the ever-garish fabric of his omnipresent balloon. But love was more sacred than that, and the trees soon conspired to rend this Icarus from his embrace of the skies.

On a day later in the 1830s, lifting off from the garden of the Chelsea House in Boston, Lauriat and his balloon immediately got blown sideways and snagged on a tree. The tree cut five of the cords suspending his basket and tilted it dangerously, threatening to spill him out. Before he could do anything, the balloon began wafting laterally at low altitude, heading toward Shirley Point. Seeing the open ocean loom, Lauriat desperately tried to land the damaged craft, but as he let out the gas, a gust of wind blew him along the ground until the balloon struck another tree that cut two more of the cords. When the balloon disentangled itself, it started blowing across the bay, alternately skipping the aeronaut's basket on the waves, submerging it, and then suddenly lifting it a hundred feet in the air. As the balloon kept drifting, now some ten miles from shore, heading north toward Cape Ann, Lauriat grew faint and sad, wearied by his helplessness, salted, soaked, and chilled, until the captain of a schooner dispatched a boat and rescued him just as the balloon, in its death throes, wriggled from its netting, flew free, and quickly became a speck on the zenith. Back at the Chelsea House, where Lauriat's handbill farewells littered the ground, the trees did not exchange smiles of knowing complicity with the wind gods that blew the balloon into their grasp. They stood there as always, bereft of agency and mood, indifferent as aliens.

Yet they held a clue. Somewhere someplace was a country swain, way away from the city green, who stood on the branches of a tree, courting a girl with a milk pail standing in a field. His love for her was so complete, so otherworldly, that it made it seem for a moment, as he stood on those branches, that no tree was really there, that he perched on air, a creature of pure elevation for a moment lifted, as no other state and no other thing on earth could do, by her and the tree, their matching bonnets of green having driven him to this bravado of grace. Jesus in Raphael's painting elevates at treetop height on a painting made of trees—a giant panel gnawed by termites for centuries; the country boy's act is lost to time. But it was a moment of transfiguration, of life lifted, that but for the tree could not be.

Ship of Elms

The books were beautiful, bound in calf, perfect to hold, as thick as loaves of bread, with color illustrations throughout—a two-volume set of François André Michaux's *North American Sylva*, books that were to trees as Audubon's folios were to birds. On a certain day—August 5, 1837, in Philadelphia—one R. K. Richards presented the volumes to his friend, Lieutenant James F. Glynn of the US Navy, a bon voyage gift prior to Glynn's departure as commander of the bark *Consort* on a mapping expedition along the southeast coast of the United States. In a fit dedication on the flyleaf to his departing friend, Richards transcribed fifteen lines from another adieu—the poet Nathaniel Parker Willis's valedictory address to the Yale Class of 1826, exhorting his classmates and now Glynn himself—"To see, and hear, and breathe the evidence / Of God's deep wisdom in the natural

world!" Gratefully, Glynn brought Michaux's volumes to his
snug stateroom on the *Consort.*

Mariners and foresters navigated the same domains, the
worlds of ocean and woods coming together, long before this
bibliographic occasion. Since the first Europeans en route to
North America smelled pine a hundred miles from shore,
settlers thought of trees at sea. James Fenimore Cooper, a
midshipman in his youth, called the ocean a wilderness and
let his maritime heroes roam upon it like the woodland pio-
neers of his most famous tales. Painters showed Daniel Boone
as a Columbus of the woods surveying Kentucky vistas like
the Italian explorer setting eyes on a distant shore. Himself
a Columbus of the coast, Glynn made maps of Beaufort and
Cape Fear and other places, sounding the depth, noting the
sand and mudbanks, the breakers, tides, and zigzagging ship-
ping lanes, captaining his ship made of trees.

Willis, whose poem made the inscription, thought often
of the elms of New Haven. Back when he lived there, the
poet was a wild undergraduate like all the Yale boys of the
era, just another walking lesson in "human depravity," in
the words of one beleaguered minister-tutor. By graduation,
however, he had begun reconciling faith and pleasure, and it
was trees—especially the city's elms—that for him combined
God's wisdom with worldly delight.

He wrote in his poetry how the moon and stars that
looked so stark and distant in other places seemed at home
when nestled in New Haven's elms. He said that the crowns of
the elms upheld birds and angels and prayers; that they shook
with the sound of church bells and the rustling of the breeze;
that they gathered all creation in visions of self-sufficient
truth. Not for Willis the stream splashing in a remote glade,
the fallen oak blocking a traveler's path. Poetry was an organ-
ism of the arboreal city, a refinement as pretty and dignified

as the streets it shaded, a polite enjoyment never deviating from narrow lanes of grace, emerging in interwoven patterns, vaulted like a church, in wreaths from his head.

In the stateroom Michaux's book with Willis's poem lay in Glynn's hands, as intimate as the inscription, the elm just one tree at his fingertips. Prohibited from fraternizing with the men, socializing only with his two fellow officers at meals, the lieutenant was often by himself. His aloneness was not eloquent; his thoughts in his cabin were not those of a desert hermit addressing the heavens. It was a different solitude—civic and proper, right and true, the kind in which aloneness checks itself by imagining an audience constantly judging its deeds and thoughts: a very elmy eloquence, groomed and self-contained, civic order in the shade it made.

In this captaincy of himself, his ship bobbing on the tides he mapped, Glynn had a strange thought about his relation to trees. It was all a fantasy, of course. He found himself thinking that if once upon a time a person had barely been separated from the shaggy bark of the woods, if once his very language—such a natural language—had barely been separated from the arboreal rustle of the forest, it was now true, by this age of the 1830s, that such a person had gradually shed this sylvan grossness, this uncouth hirsute aspect of a man of Pan, and become a pruned and trimmed specimen, a person such as he now was, beneath the canopy of his big black hat, resplendent in his slim white trousers, the jacket with its lapels looped and braided in gold. The illusion was so intense—"I once had been a wild tree"—that involuntarily he wanted to look aft as if expecting to see, toying in the waves, the forest nymphs and other sisters of Syrinx left behind, like all legend, in the wake of progress. The forest was succumbing, the ocean was known, and the elms of New Haven, right there at sea, remarked the beauty of bonnet and summit, of

freedom and lyric, sheared and clipped into decor. Horticul-
turist, captain, and poet joined hands to sing the national
strains of peace and reassurance: of narrative, outline, and
map; spit, polish, and rule, the very sweep of his ship. The
shade and silence of verse was a command, a navigation of
the nation.

When Glynn came to reside in New Haven later in
life—he died there in 1871—he arrived at a destination Wil-
lis's poetry had prepared him for: a place, keyed to the elms,
where the silence of solitude was the sermon of public duty.
Strolling on the green, he savored the civility of nation and
town, the order of avenues and flowerbeds. It all made a per-
fect peace, the same moon shining through the elms having
controlled the tides that had stirred his ship. Nature dena-
tured, made more perfect, the words of the manual and the
textbook, the poet's exhortation—all made a plaintive order,
compass and verse comprising a single map, a charted path, a
hymn of national greatness.

Yet one day on the green Glynn stood beneath the pos-
itivistic elms, remembered the lines of Willis, and glimpsed
something else. He saw the trees not as guides, not as trea-
tises, but as hidden sets of circles. The circles were the trees'
rings, yes, concealed within their trunks. But they were also
circles of water, the concentric radiance of stones dropped
to depths unknown, of messages spread far and wide that
returned upon the tide, of sounds unsung, their manner
undone.

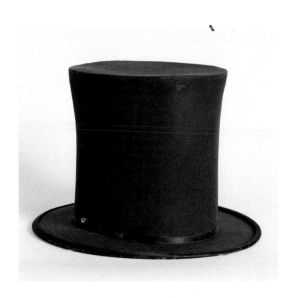

Thomas Cole's Hat (Hat and Tornado). "Inside that hat was his childhood."

Thomas Cole, *Tornado in an American Forest*, 1831 (Hat and Tornado). "What unholy energy, what resinous storm of turpentine, blew the hat from his head?"

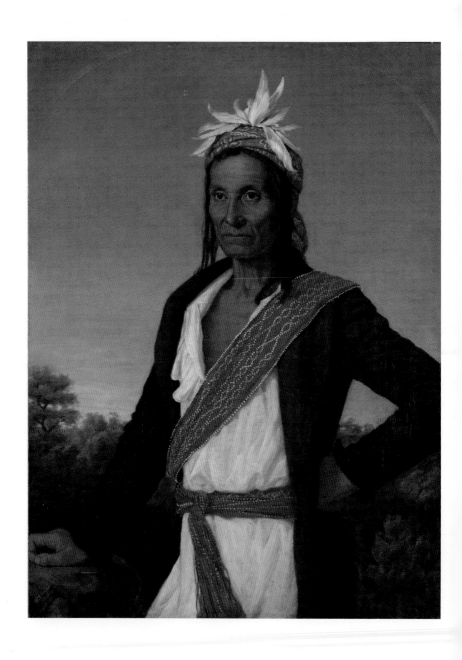

William John Wilgus, *Ut-ha-wah (Captain Cold)*, 1838 (Grand Central).
"Call it historical consciousness."

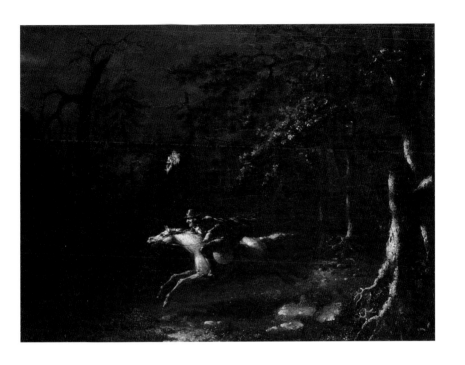

John Quidor, *Ichabod Crane Flying from the Headless Horseman*, ca. 1828
(The Sleep of John Quidor). "Moonlight stuck like sugar to rocks and roots."

Laura Bridgman, ca. 1845 (A Land of One's Own). "The light stung like a wasp."

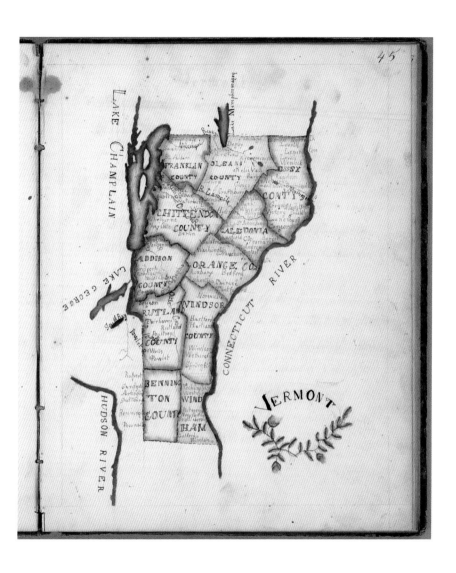

Frances Henshaw, *Vermont*, 1828 (A Land of One's Own).
"A corneal vibration, a delicate touch."

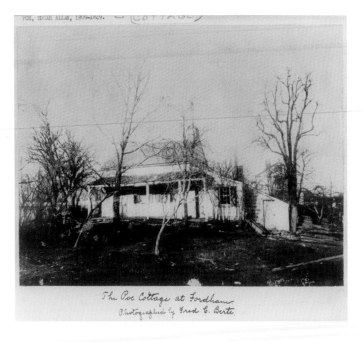

Undercliff, Home of George Pope Morris, Cold Spring, New York (photograph, ca. late nineteenth century) (The Song of Cold Spring). A "mystic atmosphere."

The Poe Cottage at Fordham, New York, 1846–49 (photograph, ca. 1900) (The Song of Cold Spring). "Look up over your head into the trees."

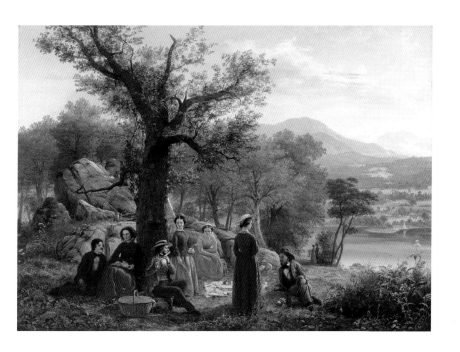

Jerome Thompson, *Recreation*, 1857 (The Branches Played the Man).
"His song spread above the party, an otherness rooted in his being."

FIG. 3. COMMON METHOD OF ESTABLISHING TRAIL TREE MARKERS
a. SAPLING, YOUNG ENOUGH TO WITHSTAND ACUTE BENDING NEAR BASE. *b*. TREE BENT AND HELD
IN POSITION BY HITCHING WITH RAWHIDE. *c*. LATER, SECONDARY STEMS APPEAR ALONG THE BENT
TRUNK, REPLACING THE ORIGINAL BRANCHING STRUCTURE. *d*. SEVERAL SEASONS LATER, THE NEW
BRANCHING STRUCTURE HAS MADE CONSIDERABLE PROGRESS, WHILE THE ORIGINAL, PROSTRATED
BRANCHES HAVE DISINTEGRATED. *e*. YEARS LATER, THAT PORTION OF THE TREE BEYOND THE POINTS
OF EMERGENCE OF THE SECONDARY STEMS HAS ENTIRELY ATROPHIED AND DECAYED AWAY.

Marker Tree (White Oak), Georgia (An Oak Bent Sideways).
"The direction has become lost in the woods."

"Common Method of Establishing Trail Tree Markers," 1941
(An Oak Bent Sideways). "A scattered alphabet."

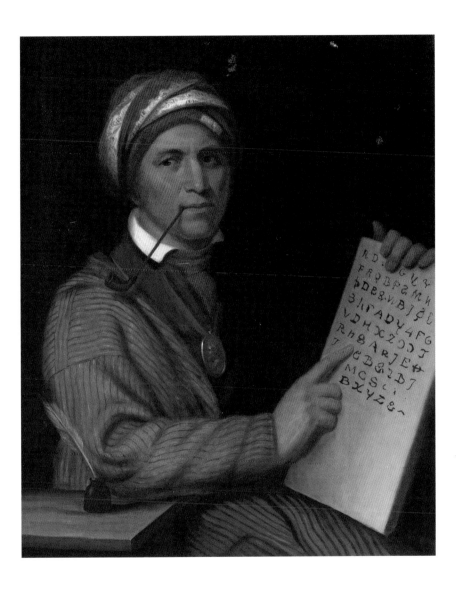

Henry Inman (after Charles Bird King), *Sequoyah*, ca. 1830 (An Oak Bent Sideways).
"The saint of an unknown legibility."

Bible belonging to Nat Turner, 1831 (Smoke and Burnt Pine). "The truth resided in unlikely places, concealed in plain sight, not far from the events it ordained."

John Henri Isaac Browere, *Thomas Jefferson*, 1825
(Sculpting Thomas Jefferson's Face). "At Monticello it did not go well."

William Sidney Mount, *Dregs in the Cup*, 1838 (Reading the Leaves).
"The tablecloth is their charmed circle, a cauldron swirling with leaves."

Caravaggio, *The Incredulity of Thomas*, 1601–2 (Reading the Leaves).
"The doubter's finger has become the fortune-teller's."

John Gadsby Chapman, *The Lake of the Dismal Swamp*, 1825 (A Meeting in the Great Dismal Swamp). "Many things . . . would present themselves to my imagination."

R. P. ROBINSON,

The "Innocent Boy"

Alfred M. Hoffy and John T. Bowen, *R. P. Robinson, The "Innocent Boy,"* 1836
(Ere You Drive Me to Madness). "A total want of moral perception."

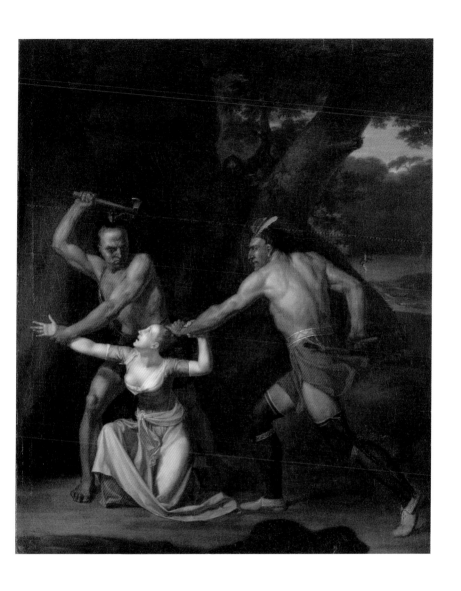

John Vanderlyn, *The Death of Jane McCrea*, 1804 (Ere You Drive Me to Madness).
"Her grave had become a shrine."

The Jane McCrea Tree, from Benson J. Lossing, *A Pictorial Field Book of the American Revolution*, 1852 (Ere You Drive Me to Madness). "When the tree was cut down in 1849, an entrepreneur fashioned canes and boxes from the wood."

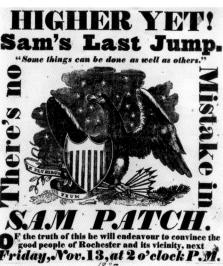

Temple Stream, Temple, Maine, 2022 (Ere You Drive Me to Madness).
"A halo of the unseen."

Higher Yet! Sam's Last Jump.... November 13, 1829, in *Rochester Daily Advertiser and
Telegraph*, October 29, 1829 (Lifesaver). "Turning his rage and sorrow into a
perishable creation that no marble statue could rival."

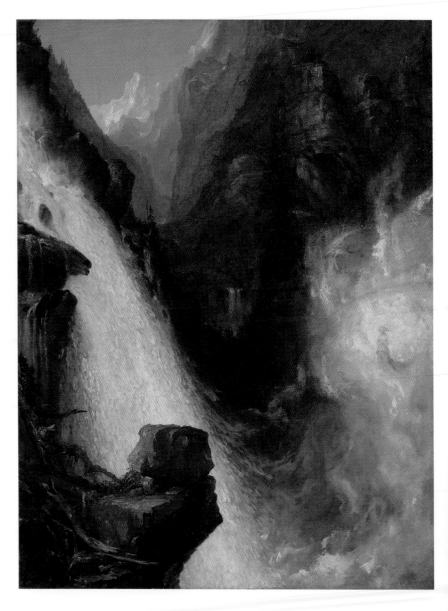

Thomas Cole, *Scene from Byron's "Manfred,"* 1833 (Lifesaver).
"A nobleman's incest and suicidal guilt."

Henry Lewis, *Piasa Rock*, 1847 (Sayings of the Piasa Bird). "A kind of phoenix—painted on the bluffs at Alton above where Lovejoy was killed."

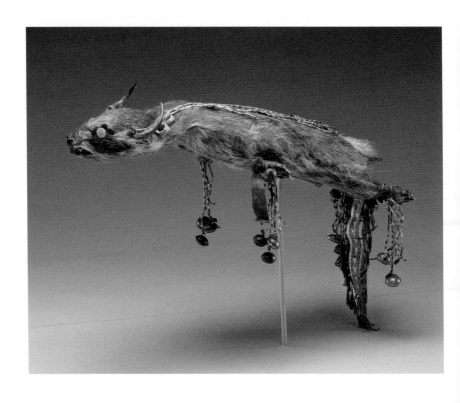

Animal Skin Tobacco Bag, Eastern Plains, ca. 1840 (Lord of the Sod). "Though now a flying deity of horns, it lets us see the ordinary elements of what it was."

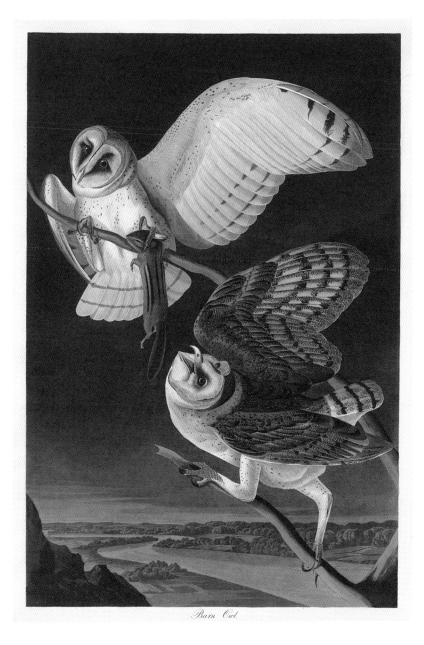

John James Audubon and Robert Havell Jr., *Barn Owl*, 1833 (Night Vision).
"The one-for-one world—where art becomes life—requires that we not be there."

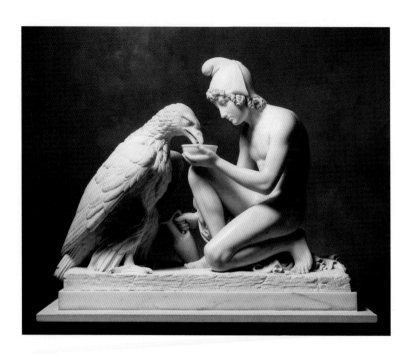

Bertel Thorvaldsen, *Ganymede and the Eagle*, 1817 (The Cup of Life). "An incarnation, holy wine and blood, some substance lethal to the rest but indifferent to him."

Townsend's Bunting, May 11, 1833 (Calamity at New Garden). "On May 11, out in the Atlantic, not far from where the *Titanic* would sink nearly seventy-nine years later."

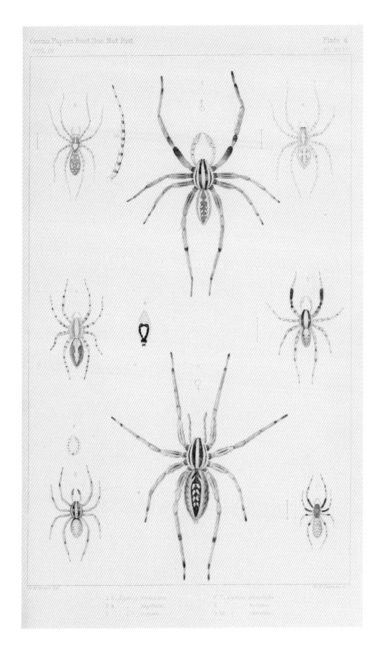

Nicholas Marcellus Hentz, *Spiders of the United States*, 1875 (Spiders at the Altar). "I could not turn without seeing myself reflected on every side, and not only myself, but an eye that watched my every movement, and an ear that drank in my every word."

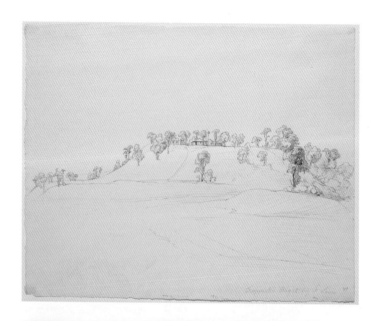

Karl Bodmer, *Trappists Hill Opposite St. Louis*, 1834 (Daybreak on Monks Mound).
"He did not know it, but his home sat on the tallest human-made structure in
North America."

Silas Hoadley's Clock Shop, Greystone, Connecticut, ca. 1850 (The Clocks of Forestville).
"Like the men at the clockmaking factories, whose ranks he had recently joined,
he would stand tall in proud self-assertion."

Thomas Sully, *Frances Kemble as Beatrice*, 1833 (The Actress at the Waterfall).
"A sense that one's life was not one's own, that life in the round was compassed
by an intelligence far greater than her own, however wise she was."

Joseph Stewart's Canal, Taylors Island, Maryland, 2021 (Harriet of the Stars). "For twenty years, starting a decade before Araminta was born, the slaves on the plantations of master Joseph Stewart and other landowners labored to build a seven-mile canal in the wetlands of the Eastern Shore, connecting the rich forest interior to Madison Bay."

THE NOVEMBER METEORS.

Étienne Léopold Trouvelot, *The November Meteors*, 1882 (Harriet of the Stars).
"The heavens fell for the person raised."

Reflections, Joseph Stewart's Canal, Taylors Island, Maryland, 2021 (Harriet of the Stars).
"A gift to an earth that had forgotten the sky."

Isaac L. Platt, *Mirror*, showing Argand lamp and copy of Samuel F. B. Morse's *Gallery of the Louvre*. Hyde Hall, Cooperstown, New York, 1832–34 (The Glitter of the Argand Lamps). "The damage to those mirrors now—gray blooms on the glass—makes it seem that it was the doubled brightness of long ago that burned them out."

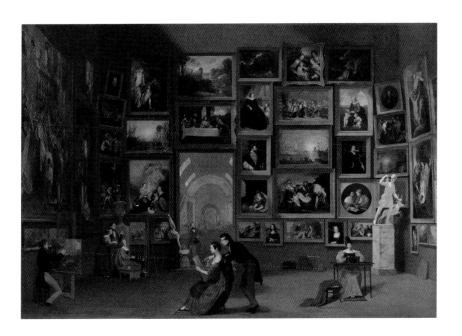

Samuel F. B. Morse, *The Gallery of the Louvre*, ca. 1831–33 (The Glitter of the Argand Lamps). "The painting made a brown pocket, honeycombed like a wine cellar of bottles emitting separate glints of storied vintage."

Philip Hooker, *Hyde Hall*, Cooperstown, New York, 1832–34 (The Glitter of the Argand Lamps). "The door opened, and the guests walked into a blaze of light."

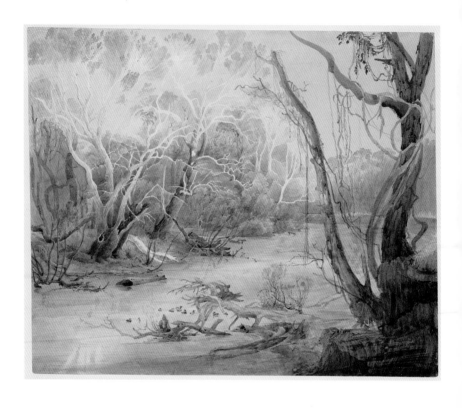

Karl Bodmer, *The Fox River near New Harmony*, 1832 (A Sight Unseen at New Harmony). "In the picture no one is there, not even the artist himself."

Infernal Regions Broadside (detail), ca. 1832 (A Statue in the Woods).
"In a grotto of stalactites and stalagmites, Satan presided."

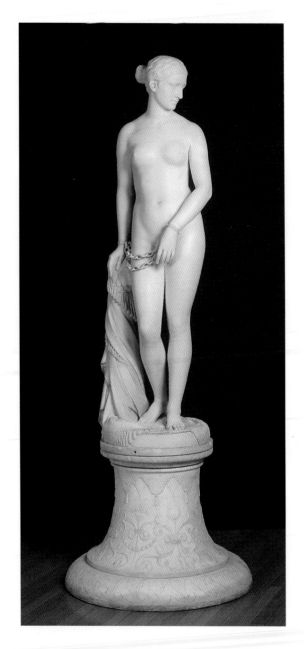

Hiram Powers, *The Greek Slave*, 1850 (after original of 1844) (A Statue in the Woods).
"How to make something that had *no relation* to the world around it."

Benjamin Henry Latrobe (?), *Rattlesnake Skeleton* (detail), ca. 1805
(The Secret Bias of the Soul). "A perfection of organic form in
the coiling rounds, the toothpick ribs."

Benjamin Henry Latrobe (?), *Spiral Staircase*, Oliver Bronson House, 1811–12,
Hudson, New York (The Secret Bias of the Soul). "The spiral staircase soon trembled
with the steps of brothers racing up and down on their adventures."

Martha Ann Honeywell, *Cut-paper Card with the Lord's Prayer*, ca. 1830 (Deities of the Boardinghouse). "Holding a pair of scissors in her mouth, guiding the blades with one of her stumps, she grasped the paper with her toes."

Honeywell, *The Lord's Prayer* (detail) (Deities of the Boardinghouse). "If a design so small was perfect in every detail, then what were heaven and earth writ large but an exponential version of the same perfection?"

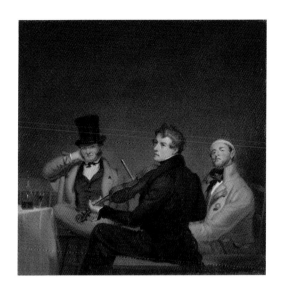

William Sidney Mount, *After Dinner*, 1834 (Deities of the Boardinghouse).
Oil on wood, 10⅞ × 10 15/16 in. Yale University Art Gallery.
"A small tune cut from the workaday world."

Anonymous photographer, *Peggy Eaton in Later Life*, ca. 1870s (Triptych of
the Snuff Takers). "The ladies got high, they fell all over themselves."

John Pye, after Claude Lorrain, *Italian Seaport*, 1840 (The Drug of Distance).
"In the guttering light they saw another flame."

David Lucas, after John Constable, *The Cornfield*, 1834 (The Drug of Distance).
"A Narcissus plunging past the point of self-regard."

Sanford Gifford, *A Gorge in the Mountains (Kauterskill Clove)*, 1862
(The Drug of Distance). "A redemptive dream, a saving grace, a way of not jumping."

John Gadsby Chapman, *The Baptism of Pocahontas* (detail of Pocahontas), 1837–40
(Painter and Oak). "Some windswept sister of the stars, trailing the comet
of her white gown, now laid low."

THIS DAY. *1836*

GRAND BALLOON ASCENSION.

MR. LAURIAT

will make a splendid ascension with his Balloon, THIS DAY, July 21, in Portland—all the necessary arrangements being previously made. Mr. L. will commence inflating his Balloon, by the decomposition of water, with the agency of sulphuric acid and iron, and producing, at once, upwards of 15,000 cubic feet of Hydrogen Gas.

The door of the Amphitheatre (which has been made substantial) will be thrown open at 1 o'-clock, P. M.

The Balloon and Car will then be brought into the arena, and commence the operation precisely at half past one o'clock.

During the process of inflation, small pioneer or miniature Balloons will be let out to ascertain the various currents of air above, and enable the Aeronaut to ascertain the most proper altitude to range himself in.

At 3 o'clock, Mr. L. will commence attaching the Car to the cords of the Balloon, place his instruments within, and at half past 3, will enter his car, bid adieu to his friends and patrons, cut the cords which hold him to the earth, and depart with perfect *sang froid*, on this, his third aerial expedition this season.

At the elevation of 2000 feet, Mr. Lauriat will send with safety to the earth a small quadruped, attached to a parachute, in full view of his patrons in the amphitheatre—and at the same time give to the winds his humble address, prepared for the occasion; and then pursuing his course above the clouds, will gradually lose sight of his beholders.

This Day. Grand Balloon Ascension. Mr. Lauriat, 1836 (The Gasbag of Louis Anselm Lauriat). "When the balloon disentangled itself, it started blowing across the bay."

Raphael, *Transfiguration*, 1516–20 (The Gasbag of Louis Anselm Lauriat). "It was a moment of transfiguration, of life lifted, that but for the tree could not be."

To | Lieut James Glynn. U. S. N.
from his friend
R. K. Richards
phil: aug: 5" 1837.

" + & + And this is human happiness!
Its secret & its evidence are writ
In the broad book of Nature. 'Tis to have
attentive & believing faculties;
To go abroad rejoicing in the joy
of beautiful & well created things.
To love the voice of waters, & the sheen
of silver fountains leaping to the sea;
To thrill with the rich melody of birds,
Living their life of music; to be glad
In the gay sunshine, reverent in the storm;
To see a beauty in the stirring leaf,
And find calm thoughts beneath the whispering tree
To see & hear & breathe the evidence
Of God's deep wisdom in the natural world! "

Inscription from R. K. Richards to Lieutenant James Glynn, August 5, 1837, flyleaf in François André Michaux, *The North American Sylva* (Paris: D'Hautel, 1819), vol. 1 (Ship of Elms). "Michaux's book with Willis's poem lay in Glynn's hands, as intimate as the inscription, the elm just one tree at his fingertips."

François André Michaux, *Dutch Elm and Common European Elm*, 1819 (Ship of Elms).
"The crowns of the elms upheld birds and angels and prayers."

John Warner Barber, *Tontine Hotel, New Haven, CT*, ca. 1840 (Pray with Me).
"His room looking out on the elms, Jackson dined that evening on turtle soup
and thought of the celebration that afternoon."

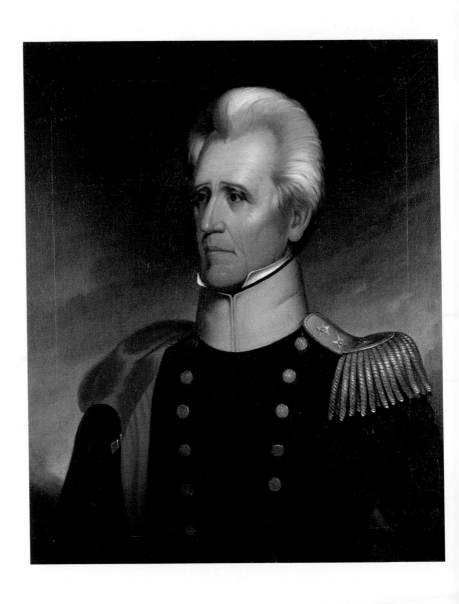

Ralph Eleaser Whiteside Earl, *Andrew Jackson*, 1 8 3 7 (Pray with Me). "Whatever its public face, history was becoming pathology, a revelation of damaged interior being."

Lam Qua, *Patient of Dr. Peter Parker (Leäng Yen)*, ca. 1838 (Pray with Me).
"A person bore the weight of fate as others had held scepter and crown."

Grabeau, from John Warner Barber, *A History of the Amistad Captives*
(New Haven: E. L. and J. W. Barber, 1840) (Backflip and Sky). "He flipped
the elms and New Haven's three churches upside down."

Robert Montgomery Bird, *Untitled [Rooftop]*, ca. 1852–53 (The Many Skulls of Robert Montgomery Bird). "If Edgar Allan Poe had been named mayor of an American city."

Robert Montgomery Bird, *Untitled [Girl Swinging on a Branch]*, ca. 1852–53 (The Many Skulls of Robert Montgomery Bird). "A levitating specter, a private siren."

Robert Montgomery Bird, *Untitled [The Mountain Spring]*, ca. 1852–53
(The Many Skulls of Robert Montgomery Bird). "The soldier's kneeling posture
and the girl's delight having grown lewd in the haze."

Robert Montgomery Bird, *Untitled [Ten-Dollar Bill]*, ca. 1852–53 (The Many Skulls of
Robert Montgomery Bird). "When had the artist not been a counterfeiter, a thief?"

Robert Montgomery Bird, *Untitled [Fence Gate]*, ca. 1852–53 (The Many Skulls of Robert Montgomery Bird). "A clouded recollection of dangerous childhood games."

Robert Montgomery Bird, *Untitled [Rooftop]*, ca. 1852–53 (The Many Skulls of Robert Montgomery Bird). "A mental wilderness."

Pray with Me

The crown of the elm and the crown of the man—President Andrew Jackson visited New Haven in June 1833, on his first-ever trip to New England. Beneath his shock of white hair was a long scar, an indentation of the skull, the slash of a British officer's saber made when a defiant Jackson, then fourteen, refused to shine the officer's boots. Now, fifty years later, a friend reported that he could lay a finger entirely in the groove made by the blade. Jackson's body was scored with wounds—dueling injuries to the ribs, breastbone, shoulder, and arm—plus the effects of illnesses and chronic conditions such as smallpox, tuberculosis, and hemorrhages. Sometimes, intent on relieving the pain, he drained his veins of many ounces of blood.

Now Jackson was in New Haven, all six-foot-one and 140 pounds of him, his face lathered in milk to cure a bad case of sunburn, his nose still smarting from the punch six weeks earlier of disgruntled former Navy lieutenant Robert Randolph, the first act of violence committed against a US president. But the pomp of the day might have made up for that. Greeted by a crowd at the wharf, stepping off the steamboat *Splendid* and mounting a white horse, Jackson rode at the head of a procession of soldiers and citizenry while the town's church bells rang and cannon fired on the green. Taking a circuitous route along College, York, Elm, State, Chapel, and Church Streets, he stopped at the statehouse to watch militia pass in review and to meet the governor of Connecticut, the mayor of New Haven, the faculty of Yale College, and local veterans of the American Revolution. The procession ended at the Tontine Hotel, where Jackson stayed, a fancy new place overlooking the green, named in honor of Lorenzo Tonti, a failed seventeenth-century Neapolitan insurrectionist who

invented the investment scheme called the "tontine royale," which the citizens of New Haven used to finance their splendid hotel. His room looking out on the elms, Jackson dined that evening on turtle soup and thought of the celebration that afternoon.

That same night, elsewhere in town, a man wrote in his diary, appalled at what he had witnessed that day. Peter Parker, a recent Yale undergraduate then still in New Haven while obtaining dual advanced degrees in theology and medicine, had watched the presidential procession aghast. All the pomp made him think of its opposite: a selfless life of anonymous public service, committed to God. He wrote that night that he would rather "be a humble missionary in China, though unknown but to the heathen, than to be President of the United States of America with all the attention bestowed by men whose breath is in their nostrils, and who are alike frail and perishable." Already deeply interested in Chinese culture, and soon ordained a Presbyterian minister in addition to having earned his Yale MD, Parker set forth for Canton the following year, becoming the first Protestant medical missionary in China.

There he met Lam Qua, a Western-trained Chinese painter of great talent, whom he commissioned to make portraits of some of his patients. Parker had opened the Ophthalmic Hospital in Canton, where in addition to treating diseases of the eye he also began seeing patients afflicted with large external tumors. It was a select few of these patients—of the more than five thousand that traveled from far away seeking cures at Dr. Parker's newly named Hospital of Universal Love in just its first three years of operation—that Lam Qua began painting. In more than a hundred such portraits, they appear without sentiment, without sympathy, yet in dignity, impassive, alone, in aspects of their own, martyrs of a cruel torture

inflicted by the body upon itself. Without executioners gathered around with pliers and whips, they suffer growths and lumps, an elephantiasis of ballooning necks and breasts, as patiently as Jesus beneath his crown of thorns.

In one, a reluctant young woman named Leäng Yen hides her face with her left hand while displaying a huge growth on the right. The tumor is so large that it seems like a second head, as if—in the Christian terms underwriting Parker's hospital—we were seeing both Salome and the head of John the Baptist. Direly needing help but mistrustful of Parker and loath to lose her right arm, Yen peeks from behind her good hand. Eventually Parker returned to New Haven with many of Lam Qua's portraits, including this one, with which he lectured on Christian and medical topics.

Back in 1833 the man who inspired Parker's departure for China rose early on the last morning of his three-day visit to New Haven. Jackson's itinerary that day called on him first to tour an axe factory in a developing part of the city called New Township, a few blocks from the green. The factory was a large one-story stone building, ventilated at the roof, reverberating with the noise of a twenty-horsepower steam engine blowing forge fires, a trip-hammer banging metal, and leather-aproned men hammering on anvils, scraping axes on grindstones and polishing them on emery wheels. At the president's arrival, the noise stopped, the workers cheered, and the proprietor, Alexander Harrison, presented Jackson with a dozen axes in a velvet-lined box of old hickory wood. Jackson directed that the box of axes be sent to his home in Tennessee, the Hermitage, where he said he would be "proud to have them used."

Later that morning, Jackson and his entourage rode out of town. For a few minutes inside his carriage, away from the public eye, he contemplated the Lombardy poplars lining

each side of Whitney Avenue and took internal stock. His sunburn itched. The scar on his head throbbed. Whether from pride, pain, or both, it was difficult to say. His nose smarted from that young jackass officer's fist six weeks before. His body ached as it always did from the old dueling wounds. The official portraits showed Jackson as he outwardly appeared now: bright blue officer's tunic, shiny gold buttons, crest of white hair, eagle face. But his epaulettes were protrusions of his broken shoulders, and all his regalia was an outer casing of pain. Whatever its public face, history was becoming pathology, a revelation of damaged interior being, manifesting without one's wish by some horrible process of its own. A person bore the weight of fate as others had held scepter and crown.

If Leäng Yen saw the change—if she recognized it with her nearly closed eyes—she kept her knowledge concealed. There was no choice. Her affliction was an unknowable inwardness, a secret scripture, a history of the hidden. In Lam Qua's painting she is a saint, a martyr of her own fate. In souvenirs, stages, and shrill decrees, the annals got written, the fanfare proclaimed. Universal Love kept moving down the avenue. But a hiddenness was appearing, laying by the way, in retirements and shadows. It could be chopped down, beaten back, amputated. But it kept emerging—a forest instead of a green was only one of its names. Behold then a new heroine of history, the woman of the concealed face: not some splendid goddess glowing in the sun but a person in darkness, a life alone.

Backflip and Sky

A few doors from the Tontine Hotel stood the New Haven Prison. In early September 1839 the prisoners from the *Amistad*, placed in cells there, described for visitors the cotton tree they worshipped back home among their Mendi tribespeople in Sierra Leone. They said there was a spirit in the cotton tree and that they would leave a chicken hanging from one of its branches, or place one at its roots, so that "they might be well." It was a question of whether this tree was with them in New Haven. Led by a man named Cinque, the prisoners had revolted on board the Spanish slave ship *Amistad* as it transported them from one part of Cuba to another, killing the captain and cook and compelling two other crew members to steer the ship to Africa. When the Spanish secretly thwarted these plans—sailing the ship east during the day but back west during the night— the *Amistad* ended up off Montauk, where the United States Coast Guard seized it and all those on board. Cinque and fifty-three other black men, women, and children—all of them claimed as slaves by the surviving Spaniards and by the Spanish government—were brought first to New London, Connecticut, and then to New Haven to await a ruling on their fate.

No cotton trees like the ones back home grew in the United States, but by naming it—by describing it—the prisoners made the magical tree appear, if only for a moment, in their own minds and in those who listened: the Yale theological students who, via translators, were asking the Mendi questions about their religious beliefs. The cotton tree was far too large to emerge in one of the four large rooms where the captives were confined. And it could not flower across the street on the elm-dense green, which in any case

the prisoners could not see from within the stone, dirt, and iron of their cells. But they made the invisible tree appear, hanging suspended and bright, before the mirage faded without necessarily becoming lost. The translators acting as go-betweens—especially a Mendi adolescent named Edward Covey, brought up from New York for the purpose—helped the cotton tree emerge slowly then suddenly from nonexistence into a brief but enduring clarity for all concerned.

Thousands of visitors went to the New Haven Prison to stare at the men, women, and children confined there. The culture of celebrity—the same spirit that gave rise, in a different sphere, to the Broadway showman P. T. Barnum's exhibits of novelty and strangeness—required that the *Amistad* prisoners be verified, be witnessed. And if the witnessing was a kind of violence—if the sharpened teeth of the Mendi struck some of the spectators as proof of cannibalism—then it was really the mouths of the hungry visitors themselves that were adorned with fangs. It was as though the comestibles in the hold of the *Amistad*—all the raisins, bread, rice, and olives the Coast Guard had found there—were now a human food on which the jail's visitors glutted themselves.

Photography—patented earlier that year of 1839—would be the logical result of this wish-to-see with one's own eyes. The medium soon started determining, bit by bit, that only that which had been *recorded*, documented, could truly be known. Never mind that the new medium would come blurred and disturbed with the shadows and reflections and other supernatural appearances it seemingly dispelled. It promised a verifiable correspondence between image and world, language and reality. The jailors and visitors in New Haven, without access to the new medium, contrived crude approximations. The famous phrenologist Orson Squire Fowler measured the head of Cinque to determine his intelligence, while showmen

used calipers to measure the skulls and faces of all the captives as sources for the wax dummies that would be made and toured as the spitting images of the slave celebrities.

Against all this, the invisible cotton tree was another language, another deity, seemingly alone but possessed of an unlikely ally. This was the green across the street. True, the opposite appeared to be the case. The polite art of poetry sought refinement in the avenue of elms, consorting with the prettiness of the day in the burbled intoxication of delicate phrases and suppressed sighs, the no-account opposite of the prisoners' sorrow and fervent conjurations. For those who strolled beneath them, the elms made only a prim heaven of self-sufficiency, a cosmos of cultivation, strung with the mesh that trapped songbirds so that their feathers would adorn ladies' hats. So many necks wrung, so many songs sung, the bird and beauty of a given day depended so much on an idle cruelty, and the elms, silent structures of the diurnal round, facilitated the commerce of earth and stars. The cotton tree, by contrast, came out of nowhere and seemed poised forever in the lisp of nonexistence. Splayed with a brightness that burned, it seemed always in danger of disappearing, like a sun perpetually eclipsed by the moon—but still there, in fact truly noticeable, because it could not be seen.

Yet the green itself radiated with certain signs of invisibility. In those last years before photography gradually rendered obsolete all that could not be seen, just prior to the impending new medium's glacial fossilization of all phenomena, invisibility retained a little credibility. Vestiges of a hidden world still appeared in half signs and intimations, little glimmers and shocks, a world appearing to itself—imagining itself—in a silent conversation of elements. Although these intimations were sensible anywhere—even in the flaking rust upon the prison's locks—they gathered especially in the

green, an open space built as if to receive them. After a day of rain, for instance, they manifested as the sky-blue reflections of puddles on paths. On any day of sun, they shone as the shadows of the elms—mysterious secondary trees, growing along the ground and made of grass and gravel, minutely laced with branches just like the elms above, but in silent secondary mystery, truer trees than the actual ones. Like the puddle reflections, these shadows retained an aura of luxurious indifference to human spectatorship—of appearing for themselves and to themselves, as nature's own picture gallery, a private realm on a public green.

For those strollers who happened to see them, the way these emanations split the difference between being discovered and being invented added to their charm. For it was only by noticing that they hardly cared to be noticed at all—that they existed independent of noticing—that a person could appreciate their mystery. Like the snow gathering on the bare branches of the elms in winter—so *much* snow, the Mendi had marveled, so much greater than the dustings of the stuff they knew from higher elevations back home—the natural world had a way of portraying itself, lavishly and thickly, without a thought of ever being seen, of treating the green as some great receptacle, a tapestry to be seen from the sky, meant to display whatever fell there, in patterns of change and permanence. This fleeting record of shadow cloud was not the historical palimpsest beloved of melancholic historians, the ones who relish the accretion of eras upon a single place, but instead—all at once—a pictured evaporation of rain and sky, of sodden mud and frozen puddle, a hallucination like the cotton tree, deity of the day, land of faraway, on the bare common.

The Mendi went out onto the green every day to exercise, given this temporary freedom by their jailors. During these

airings one of the prisoners, a man named Grabeau, four feet eleven inches tall, astonished the local citizens by turning somersaults. Since no one documented these pirouettes and inversions, since it would have been impossible in any case for the medium as it then existed to record them, they existed—and still exist—like the green's puddles and shadows, just on the far side of photography's permanent arrest of the world. By turns gratuitous and free, Grabeau made a pause between heaven and earth. And in that pause he flipped the elms and New Haven's three churches upside down—a single act, a new scene, inverted on the green.

Three
Levitations

The Architect's Escape

The mansion framed life, from the sweat and strength of the mud-caked slaves who built it to the ingenuity of the architect overseeing the design. It gave shape and duration to hard work and ephemeral dreams, to all that had turned the timber of the surrounding Mississippi woods into a genteel grandeur of parlors and porches. The house bestowed a permanence so severe that even when years later nothing remained of it, the blank forest still exuded the presence of what was no longer there.

That presence, in addition to all the other things, consisted of the rage and resentment of the house's owner, the master of the slaves. The feelings went back to the man's youth in mountainous Western Virginia, where everyone was white. His family had moved to the tidewater part of the state when he was a boy, and there he noted a hierarchy not only between whites and blacks but among whites themselves. He noted, too, architecture's role in these divisions, a matter of back doors and front doors. Sent on an errand to a rich planter's house, he went unthinkingly to the front door, only to be told by a liveried slave that barefooted whites go to the back door, not the front. Right there he grasped the role of buildings in the inequalities and violence of the world and dreamed of a mansion of his own, of starting a dynasty with this mansion at the center of it, of walking in the front door when he pleased. And so, some years later, his slave-begotten wealth secured, he hired an architect to build a mansion deep in the Mississippi woods. This was in 1833.

The architect whom the master had found to build his mansion did not want to be there. Hired in New Orleans, he came to Mississippi and stood there day after day, overseeing the work of the master and his twenty West Indian

slaves, watching with grim satisfaction and despair as for two full years they built the house. Fearing the maniac who hired him, surrounded by a trackless forest of cedar and oak, the architect was a prisoner of the project. Nonetheless he patiently looked for a way to flee. One day, wearing his coat and tie and flowered vest and Paris hat, he took advantage of a moment when the master was not paying attention and ran into the woods. The master did not miss him until that evening. The architect knew they would soon set dogs on him and had thought ahead how best to make his escape. Out in the woods, he grabbed a sapling pole, "calculated stress and distance and trajectory," and vaulted himself into one of the trees, hauling the pole up with him. Then he began vaulting from tree to tree, traveling distances like a flying squirrel except better. For a full half mile he skipped across the treetops before coming back to earth, having left no track, no scent, and thinking he might well get away. But the mansion's owner and his slaves were hunting for him, and soon a slave found the place where he had alighted. They tracked him down and found him gasping, wet, and injured, after he had attempted and failed to vault across a river. Brought back to the mansion to complete the task, the architect resumed his work like a true artist, admiring the building's sturdy and beautiful proportions even though he still hated being there, still feared the master and his slaves, and wished never to see his creation as soon as it was finished and he was allowed to leave.

Yet the architect's greatest art was not the mansion but his attempt not to make it. His failed escape was his true achievement. He may have planed the raw forest into edifice, to sash and window and stoop, to pediment and corner, but his real deed was his feat of desperation, his science of flight from the appointed task of making art. In his sapling pole

and vaulting plan, he departed his given job and found a truer realization of his skills. His capacities for problem-solving and lyrical design came most to bear not in the project of empire but in a desperate and compromised attempt to save himself. The abortive intricacies, the laced mathematics of torque and stress, intertwined his thought to an utmost strength. Art was not the building but the impossible fiction of *not* making art, of escaping it, of fashioning—in the very escape itself—a *new* art, another art, whose failure would make an ephemeral thing for the ages.

Being a buffoon was part of it. Helpless, vain, having performed his circus tricks, the architect was brought back in disgrace to the beautiful ugliness of the slave-owner's mansion. Complicit in another's fantasy, caring for nothing but his escape, he cut a degraded figure, a lackey dragooned in others' plots and schemes. But in his brief freedom—a crescendo of his foolishness—he had found a more glorious futility. Against the laws of probability, in a grand self-conceived fiction, he had done something so absurd, so beyond belief, that he had secured the legitimacy of a separate vision. And what he made appear, there in that desperation and fear, were the woods themselves, back before they were a house: the lush fragrance of needles and springing branches, of bark and loam and cone. Never more an architect than in his flight from being an architect, he turned the mansion momentarily back into trees, into a solemnity of leaves.

The Many Skulls of Robert Montgomery Bird

A man emerged on the roof of his house in Philadelphia, carrying a camera. A writer by trade, he had recently taught himself photography, using the method of paper negatives

refined by Gustave Le Gray. The man's name was Robert
Montgomery Bird. Fifteen years before, he had published a
novel called *Nick of the Woods*, the most bloodthirsty of the
frontier novels of the 1830s, but now he had become fas-
cinated by the views from the roof of his home on Filbert
Street in Philadelphia: fascinated, more precisely, by what
the views looked like when turned into photographs.

The pictures Bird took from his roof, which like so
many of his photographs exist only as paper negatives,
show curiously x-rayed scenes of beams, chimneys, and
adjacent buildings. Close-packed, the architectonics of a
Philadelphia neighborhood appear in cubistic density: lay-
ers of slats, windows, and tiles crowd upon one another. As
in a civic allegory—the Siena of Ambrogio Lorenzetti's *Good
Government*, for example—Bird shows the geometric patterns
of an orderly town. But the scenes also suggest a nightmarish
fairy tale, a dream of hooded unreality, bricks and wood fried
in darkened light, the glint of day a darkness at noon, the
roof a sacred mount for a wizard's reversals of evening and
afternoon. That wizard, however, was far from omnipotent,
since standing on a wooden deck, with just four naked slats
separating him from a three-story fall to the pavement below,
his brilliance was precarious, his skull (in advance of the fall)
a little cracked.

Bird's novel *Nick of the Woods*, published in 1837, tells the
story of Nathan Slaughter, a pious Quaker living in appar-
ent peace in the Kentucky forest. True to his name, however,
Slaughter is a psychopath, a serial murderer of Indians,
his rampage having started years earlier when maraud-
ing Shawnees killed his family in their frontier cabin. He
becomes a vengeful spirit, the "Jibbenainesay," as the sur-
rounding tribes call him, a killer who descends on his victims
without warning, then mysteriously vanishes back into the

woods. Slaughter was Robert Montgomery Bird's brainchild, and he, too, was up there on the roof with the author-photographer of Filbert Street, turning civic order eerie and insane.

The roof was the novelist's head, his skull, his mind. Bird's photographs show the architecture of thought, the topmost part of his mental house, teeming with designs. An attic of recollections, they make his upper story, like the brim of the hat in which he placed scraps of paper on which he would scribble ideas during the day. The paper photographs were scraps as well, records less of the neighborhood than of the district of his mind, the off-kilter clarities of a man finding his balance in the giddy heights of a vision. When he was a boy Bird took a fall, not from a roof but while ice-skating, and it was then he discovered the beauties of art made by agony. He had tumbled "head foremost on the glassy surface of a frozen pond," so that "his half-cracked skull impressed a star of such beauty and regularity as set him half wild with delight; spite of the heavy pain." The head hammered the ice with a heavenly radiance, and even many years later the pains of creation brought joy to the maker of a frozen art.

Slaughter, in *Nick of the Woods*, takes his vengeance by caving in his victims' skulls. One warrior is left glued to the roots of a tree in a mass of congealed blood and brains. Another's skull and brain are "crushed like a gourd." Slaughter kills a chief by burying an iron tomahawk "in the Indian's brain." The teeming activity of the novelist's own "exulting consciousness," as Bird put it, which "produced such a fever of delight in his brain as was only to be allayed by the most extravagant expressions and actions," seemed one and the same with his homicidal hero's rage. The architectonics of destruction mirrored the mind's darkened designs: Bird's rooftop images are the first crime-scene photographs ever

made. Warily turning the clarity of city streets into a jigsaw of private motivations, they show what it would be like if Edgar Allan Poe had been named mayor of an American city. In his den on Filbert Street, Bird slowly turned the pages of *Crania Americana*, marveling at the plates. Samuel Morton's tract of scientific racism, published in Philadelphia in 1839, showed seventy-eight Indian skulls, in detailed illustrations, each depicting human remains the scientist procured from far-ranging correspondents despoiling midwestern mounds and riverbank burials. From Steubenville and Marietta, from other places, too, a grinning chorus of skulls spoke Morton's hypothesis: that brain capacity dictated civilization, that Indians could not think as well as whites. On the rooftop, manipulating his camera, Bird made his own cranium, a white man's skull brimming with dormered eyes and phrenological ornaments, the fissures and bricks of civilized cogitation: the mind enlarged in patterns and long views, capacious but thick, polymathic and perverse.

The palisade of the man's mind was a marvel, a constant theater of operations. The roof was a new venue for the "dark and rugged walls on either side, the ramparts of timber of every shape and size," that Bird had envisioned in *Nick of the Woods*. Philadelphia was an urban forest, trees and cliffs transformed into bricks and boards—a citified version of the sylvan traveler's view of "the full-grown sycamore, piled high above the rocks." And in those visionary lands Bird flew: "he perceived himself flying, as it almost seemed . . . borne aloft by a curious current betwixt what appeared to him two lofty walls of crag and forest." Making pictures, the author lifted himself to the topmost place where he lived.

But Bird saw it was trickier than that. The mind was its own home, yes, but souls transmigrated; they flew from roof to roof. One was not oneself but a composite of other

beings. Poe called this "metempsychosis," praising Bird's novel *Sheppard Lee*, published in 1836, the story of the eponymous hero, who witnesses the death of a wealthy landowner and finds that his consciousness has moved inside the dead man, who then revives with all his privilege and personality intact, except now with Lee himself in the driver's seat of the man's being. From there, Lee ends up transmigrating into the bodies of five other social types—a dim-witted dandy, a skinflint moneylender, a naive and high-minded Quaker minister, a slave, and a Virginia planter—before landing back in his own body and life. Forget Emerson's praise of the individual's original relation to the universe. Bird saw the incestuousness of 1830s America, the jumbled proximity whereby, donning different guises, people changed identities, taking on different roles as chance and personal need required. It was all a counterfeit, like Bird's photographs of a ten-dollar bill—one negative and one positive, both on photographic paper like that of currency itself—that show him experimenting with photography's deceptions literally to make money. When had the artist not been a counterfeiter, a thief? Stumbling in the cracking of his star, the man on the roof saw it all.

Sometimes he took photographs of sentimental engravings by setting these modest prints before his camera. It was deceptively simple, nothing to it, but his photographs rearrange values, turning pictures of peaceable innocence into something skeletal and remote, laying bare the charm of human kindness in a constant X-ray of ulterior motivation and craven purpose. In one of the original prints, a child exultantly swings on a wooden gate like a rider upon a bucking horse, pushed back and forth by his cherubic friends. But in Bird's photograph the boy appears overtaken by a thunderstorm of darkening sky, the scene becoming a clouded

recollection of dangerous childhood games. Waggling the gate in the gloom, the little swinger's helpmates appear to shake him into taking a fall such as the one Bird once took. Envisioned by a bespectacled sleuth of human deviance, ordinary bonhomie becomes a dark vision of depraved souls. By a magic wand he summoned murky desires. A girl in another print grasps the branches of a tree, her robes fluttering as she swings back and forth, her floating body descended from the angels hovering in holy scenes. In Bird's negative she becomes a levitating specter, a private siren, her innocence revamped. In another print, a rustic maiden watching a soldier slaking his thirst at a mountain stream becomes, x-rayed, a blushing fantasy of the boudoir—the soldier's kneeling posture and the girl's delight having grown lewd in the haze. The civic sphere was just here—in private dreams of guilt and shame, of desire and crime, stacked in city blocks. "He had the greatest aversion to a crowd," Bird's wife Mary remembered. "Essentially a man of the closet, he avoided all public assemblies, and took no pleasure in spectacles of any sort. . . . It seemed to be not only the choice, but the necessity of his nature to live in retirement." And in that aloneness the pictures got dark.

Occasionally, a great destructive energy blew through Bird's upper stories, disarranging his mentality. On a June day at his modest country house in New Castle, Delaware, he saw storm clouds. Within minutes hail, rain, and wind pounded the house—a hurricane was sweeping the Atlantic coast. The winds shattered the windowpanes and blew through Bird's home while the deluge crashed on the roof and eventually poured onto the floors. "How did the house withstand the tremendous forces that waged war upon it?" Mary Bird asked. "Probably its non-resistance saved it. The tempest swept unbridled through its upper chambers, and

was satisfied." Her husband's mental hurricane, like the storm itself, was a dispensation of providence, a decree of the Almighty, a heaven-sent blast so much stronger than himself that it was better simply to accept it than resist.

Back on Filbert Street, ensconced in the urban maze, the bard was no less swept away. Hemmed in on all sides, he mixed the chemicals of a private storm. Portraying the architecture of his thought, he was always at home, always alone, until sometimes he imagined he became the slope, the slat, the tiles of the roof. Down that descent, slipping from the edge, he spoke a personal address, a mental wilderness.

Two Sisters at the Mountain House

The sisters sat together in their room at night. A candle burned to one side, casting the profiled shadow of one sister on the wall while her sibling carefully traced it on a sheet of paper affixed there. They were enacting the story of "The Corinthian Maid," the young Greek woman who invented drawing by outlining the shadow-cast profile of her sleeping lover on the wall prior to his departure for battle. That was a story of mourning, loss, and love, but the sisters were not saying goodbye. They had just arrived the previous morning at this place—the Catskill Mountain House, a new hotel situated on a bluff in the Catskill Mountains looking down 2,500 feet into the Hudson Valley. Although the Mountain House would become much grander in the following decade, it was already a uniquely luxurious place in the 1830s, a "Yankee Palace," as the Dutch locals scornfully called it, located ten hours by steamboat up the Hudson from Manhattan, plus a rugged four-hour carriage ride from the river landing to the hotel's front door.

The sisters came there with their banker father, a widower who had gone blind a few years earlier. In the last steep mile before the party arrived at the hotel, while the exhausted horses strained to pull the heavy carriage, it had been their father, alone among the male travelers, who had not gotten out to walk alongside and save the animals some of their burden. Instead his daughters had alighted in his place, thinking nothing of strolling side by side next to the jouncing high-sprung vehicle. Excited by the nearness of the destination, which at one bend in the road dramatically appeared above them like a celestial aerie of white-painted wood, they twirled their parasols and spoke in tones a bit like the stream (swelled by a recent rain) that flowed down one side of the road. At the hotel early the next morning, the sisters rose and went to their father's adjacent room to watch the sun rise above the clouds that floated like an ocean up to the very escarpment on which the hotel stood. For this man who could not see, woken from the blindness of sleep but not from his constant affliction, they described the radiance of the dawn, the feeling of Genesis, the eagle alighting on a pine tree like the dove let loose by Noah. That evening, they invented drawing.

The next morning, long after the sun rose, the sisters guided their father down the hotel's wooden steps to a bench on a granite ledge overlooking the valley. By then the day's fog and clouds had cleared, and the sisters told him what they saw: the filigreed line of the Hudson, the patterns of farmland, the smoke of Albany to the north, the Berkshire Mountains of Western Massachusetts on the blue horizon to the east. At their feet, previous visitors had carved crude initials and whole names into the granite, and the sisters amused themselves and their father by noting that one of the names—a common one, one that many men doubtless

shared—was coincidentally that of a financier friend of his. They laughed at the thought of that portly capitalist stooping on his hands and knees, his expensive black coat thrust out behind him, top hat about to fall from his head, scraping his name into stone with a jackknife. One of the sisters, the more mischievous one, even asked her father to lean down from the bench and place his finger in the grooves of the capital T that began this carved name, which was directly at his feet. But when he did so, something strange happened. The sisters had the weird sensation that, in tracing the T, he was seeing—perhaps even drawing—the valley, making a record of farm and stream and cow, of big and small and all between in the panoramic sweep made visible in the blunted arrow of that initial T, the carved name of another man, predesigned, not even that of the blind father's friend but a perfect stranger who bore that man's name and had been there before.

That afternoon, the sisters left their father to rest in his room and took the hotel's carriage with a few other guests on a sightseeing tour to the mountain scenery that lay behind the hotel. They rode around two small lakes, North and South Lake—in reality, just one lake narrowed by a jutting peninsula that seemed to split it into two bodies. The two pools nearly disjoined by the peninsula resembled eyes bridged by a nose, and at night, like true eyes, they reflected the stars on their irises. As the carriage rode around them, the lakes gave back bits of the afternoon sky, displaying ruffled clouds that seemed to float in the breeze-driven furls of water, while the sisters looked at these lakes so like their own eyes.

The main destination of the carriage was a waterfall a mile away that the lakes fed. As the sisters stepped from the carriage a quarter mile from Kaaterskill Falls, they heard the roar and saw the mist rising through the forest of pines and hemlocks. Their faces dampened by the spray as they came

near, they saw that the falls descended in two stages, like a strip of white silk gliding down a flight of stairs, and that a deep cavern behind the top fall allowed braver souls to view the crashing water from behind, from within the earth itself, a primal place reminiscent of the eyes' placement in the skull, so that the cataract fell before them like an endless tear.

But the sisters did not go in, their attention drawn to something else. Walking around, they saw that it was wrong to think of the falls as a single entity, viewable—graspable— from one point of view. There was the lip of the top fall, with its rock islands of scraggy vegetation at the verge; the plateau between the upper and lower falls, a respite of pools and eddies; the bottom, where the water crashed and mist soaked the broken trees; and, most alluring, the rushing flow of the stream beyond, putting itself back together after the swift descent. For all the stream's difference from the fall, they saw that the river was still the cascade in the way that a person switching from one mood to another is the same person whether in rage or peace.

The sisters saw in this changeability of the waterfall the limitations of art, of portraiture in particular: how it was impossible for even the most accomplished portraitist to cap- ture the fluid effects of a person as a single scenic attraction. And so the sisters reboarded the carriage with a new sense of what a portrait might be, whether of themselves, their father, or anyone else: that it needed to be a dislocation, a composite of falls and pools and plateaus, of rushing ener- gies and invisible calms, all breaking away from one another yet recognizably of the same stream. Heredity, the descent of lineages—theirs from their father, for example—was part of this broken pattern, this glittering rush, whose most beau- tiful force was the way it spent its energies in self-escape, becoming itself by fleeing what it was.

When they returned to the hotel from the falls, the sisters saw an artist with a sketchbook on the clearing before the verandah. The artist sat on a chair at an angle to the valley, his gaze focused not on the panoramic view but on several pine trees at the clearing's edge. The sisters' father, who had met the artist the day before and introduced him then to his daughters, sat on a bench near the man as he drew. Money had become friendlier to art in America by then, and the blind banker had taken an active interest in the artist's company, delighting in his description of what he sketched, and of much else, too: for the artist was keen and yet as delicate as the pale swaths of graphite he made bloom in his little book.

Approaching, the sisters saw that the artist had just finished drawing the second of two prominent white pine trees in a stand of three (the third tree, apparently lifeless, stood back a little and to the right in the drawing). On the sheet the two prominent trees rose a little apart from each other as, looking up, the girls saw the originals did: for there, about twenty yards away, the distinctive forms of the actual pines made a match, at least in their eyes, for what the imitator—the magician, they called him—had managed to portray on the page. But the artist was thinking something different. In the presence of the sisters, he saw that his pines looked humanlike, even feminine. They were hardly "portraits" of these two women who now stood near him, but his sketch seemed invested with their charm, as if the twenty-four hours he had known the sisters had guided his hand. He saw how the tree on the left side of the drawing slightly bent toward the one on the right. And he noticed how the pine on the right seemed aware of the other's presence across the small blank of cream-colored paper separating the two. It was as if, without knowing it, he had made a closeness, an

affinity, between these straining arboreal beings. Pondering this as he looked at his drawing, the artist imagined that the two emphatic trees he had drawn actually were the young women now looking admiringly over his shoulder, as if he had unwittingly envisioned their metamorphosis into lithe evergreen forms, sinew and stalk, leaf and branch, set amid a paper blankness like strands of graphite hair.

But then he realized that the opposite was true. It was the sisters themselves who were trees, for so the young women standing above him did so in a distinctly treelike way. Tall and thin, remote and intimate, they examined the drawing like persons studying their own likenesses. The artist's reveries along these lines might have continued, but the sisters bid goodbye and strolled away, strangely ambulatory for trees, and walked back to the white wooden steps of the hotel.

Left alone with the blind banker, the artist gazed down into the valley and envisioned how the white hotel at his back appeared to those in the valley below. He knew from his own experience that from down there the Mountain House looked like a toy castle, a blanched hallmark set against green summits, as small as a thumbnail to the hardened farmers and enterprising shopkeepers setting about their daily tasks. They could not know the delicacy of the feelings, the little strides and gestures, the comportments of grace and flirtation, bought by blind money and sanctioned in cautious cliffside freedoms, that took place invisibly in the sky. He understood that reciprocally he could not see the anvil and forge, the spark and bellows, the filth, oath, and sweetness of verdant grass and choked flume, in all that looked so lovely down below. But then he thought that he had it all wrong. The hotel was made of the same pine that comprised the valley towns and farmhouses. The water they drank down there came from the lakes at his back. And for all he knew, the

stars reflected in those lakes had slid down the cascades and mountain streams along with the water to give the townsfolk their own sips of the universe.

This made him think again of the sisters. Looking over his shoulder at the verandah, where they now stood, he saw that they, too, had been gazing down at the valley. Suddenly he saw them as goddesses, the sisters of Space and Time, born of Darkness, surveying their domains. He wondered if these lovely beings would eventually turn into haggard crones, toothless and stooped, cackling at the misfortunes they would toss like nails at the feet of the blessed. He asked himself if one day they would glide as ghosts at treetop height along the corridors of a hotel that no longer stood. But no sooner did he have these thoughts than he ceased to think this way. Maybe it was the sunlight tipping the trees he had just drawn, or the soughing of the breeze-blown needles in the mountain air. Maybe it was nothing so exalted—no zephyr or other supernatural sign—but just the dirt at his feet, smudging his boots, that made him feel glad and whole.

He felt that the sisters were like him. They, too, stared at the world below, at the white spire in the sun, the flint-specked green of the cemetery, the tiny lanes of gentility and poverty. They noted the paths of cruelty, resentment, and love, as small to them as their grand elevation was to those below. They knew that all they surveyed, no matter how clear, still bore traces of the clouds that hid the view at dawn—as on a first day of creation when not even the air-mounted gods knew yet the world they made; when lucidity itself was a fog. They saw that life is veiled; that life is lost. They knew that the mother they mourned lay clear as day in the light that made visible the strangeness of the world that took her place. Yet there was no sorrow, no shame. Arm in arm, the sisters laughed that the silhouette they had made

the previous evening was a faithful picture of how their father saw their souls. The candle had thrown the light of a double darkness, the blind paper of their being, as seen by the blind. Just then the afternoon sun stretched shadows on the ledge. They smiled, and the man on the chair closed his book of trees.

The Shield

The wooden box lay buried partly in the wet ground. A little girl noticed it sticking out of the stream bank, where the spring rains had sluiced away some of the mud. Nine years old, bored with her chores, the girl had wandered a little from her family's farm, knowing the penalty for dereliction but feeling that the spring day called her in some way. Now the object in the mud appeared as if it had been her destination all along. Cautiously edging down the slope, careful not to slip into the water, she began pulling it out.

It was stuck in the bank, weighted with mud and caught in fibrous roots that made a ripping sound as she tried to wriggle it free. It was wider than the space between her little arms and felt too big and heavy for her strength, but at the same time delicate—as though it might break apart in her hands. Eventually she wriggled the box free and observed a rusted metal latch. Flipping it open, she opened the box and beheld a polished wooden shield in a bed of moldy velvet. Bending close, the burnished wood shining in the sun, she observed concentric circles of incised figures radiating in widening bands around the shield's center. She saw that the marks depicted figures in various actions that looked like rites or incantations. Even though some mud and wetness had gotten into the box, staining and warping the wooden shield, the detailing of the characters was so minute that she could see the eyes on individual faces, the fur on a dog, the split seam on a running man's pants. Whoever the carver was, he was a person whose work did not deserve to be lost, though she reflected that perhaps it was the woodsmith himself who had left the shield by the wayside, consigning it to the oblivion she had disturbed.

She ran back to the farm and told her father about her find. On the way she decided to lie about her reason for wandering but tell the truth about where she had made her

discovery. Skeptical about her excitement, her father and fifteen-year-old brother came back with her and skidded down the bank, finding the box with its shield where she had left it. Bending down to look more closely, they saw that the bands of figures covered the whole surface except at the center, where a stand of trees stood like a sacred grove, and at the edges, where a pattern of serrated leaves, as finely wrought as veins, encompassed the outer circle. Lifting it out, they saw that nothing was on the back, no markings or names of any kind. They placed it back in the box and carried it up the bank. The girl stood above and stared at the impression the box had left in the mud. A few feet below, the stream rushed along in a spring torrent of silver, white, and pale blue.

When the antiquarian came a week later, he asked the farmer to carry the shield from the house into the yard so he could see it better. He leaned it against the barn, where the polished shield, despite its intermittent decay, glowed in the sun. Standing there, the girl looked especially at the raised nobs encircling the shield, seeing how these protuberances that she had hardly noticed when she first saw the shield on the stream bank now made a special concentrated glow, brighter than the wood's general shine, how they caught the light like the radiance of a holy crown or (this was the way her mind worked) like the mortal wounds of a man whose pain went in circles. The wind blew so blustery on that April day that the girl wondered if the tiny figures on the shield would lift off the surface, born away like the ones she had noticed nearest the sacred central grove who appeared to float on tiny waves of chiseled lines, ecstasy in their outflung arms.

Using his handkerchief to wipe it down, the antiquarian swept his fingers across the shield and studied it closely. The tiny figures performed recognizable actions—there was one of a man reading a book, for example—but he could ascertain

no story that brought each figure or group of figures together. He felt, too, not just because of the age and burial of the shield in its box but because of something indescribably outdated about the figures on it, that it came from some other time: not a remote era but from a past sufficiently bygone that everything looked quaint by the standards of his own day. He began thinking of the shield as a chronicle—a series of episodes, each happening in isolation, moving around the object and encompassing, so it seemed, a whole age. That time, insofar as he could tell by running a magnifying glass across it, looked to be the America of several decades before his own moment: certain customs, styles of dress, even the number of stars on a miniature American flag—the tiny quasars in their field double-magnified beneath his glass by a stray drop of spring rain that glistened on that portion of the shield—all pointed to a time a few decades before the war.

Leaning his head back, the antiquarian felt that each figure, no matter how small, was circled by the whole, was an expression of the object's own planetary roundness. Here was a theory of time and space as cosmic as a clock, an object that was apparently the workings of a necromancer as well as a woodcarver, someone intent upon inscribing the doings of a day, a year, an era, in relation to more eternal circuits of space and time—those of the planets and stars, one of which just then, emerging from behind a springtime cloud, beamed on the little figures as if burning them into their wooden grooves. Drawing on the money he had inherited from his well-to-do father, the antiquarian paid the farmer a decent sum and took the wooden shield and its box back to the town, where for the next several decades he displayed it in his little museum until it gathered dust and became nearly as obscured in cobwebs as its box once was in mud.

The antiquarian neglected the shield because he came to think it was likely a hoax—an elaborate object with no pedigree, found under odd circumstances, that came from another time, out of nowhere. A friend of his kept using the word *apocryphal*—not only a fancy word for "fake" but a word that implied something dangerous in the way the illegitimate object was made: as if its skillful intricacy was not to be trusted; as if the shield would transfer by magic, by beguilement, a feeling of disbelief into anyone who touched or even observed it—a disbelief that this person, cursed from then on, would take down the street and into the next town, finally even on an ocean voyage, so that the whole world would appear, because of the shield, finally as a make-believe, a dream, a mirage. At last the cursed observer himself would look down at his arm and see his flesh start to fuzz, grow amorphous, and become thin as air. The object unnerved him.

Dubious, the antiquarian also worried that the farmer had taken him for a ride. He imagined the rustic man laughing as his scholar-visitor drove his little buggy back to town, the shield in the seat next to him all but winking back at the con man standing in the chicken-scratched yard counting his coins. A person of some pride, the antiquarian worried that his collection of true artifacts would be mentioned in the same breath as carnival freaks and fakes—as just another Cardiff giant or Fiji mermaid. Yet for all that, he was not quite willing to discard the thing. He had an idea about it—though really it would be wrong to credit him with an idea: it was more a feeling that he could not articulate. It was that any onlooker who presumed to study the bands of figures looking for the single one that would magically "turn the lock," that would reveal the meaning of the whole mute amplitude, was thinking incorrectly. The most important event on the shield was the one it did not show. This event was the making of

the shield. Why had it been made? What purpose did this object serve? He dimly sensed (this was as far-ranging as his half-formed idea went) that all the figures did nothing but cryptically portray, again and again, the carver's own meditations on his enterprise: the maker's thoughts having gone round and round, circulating in exponential array, the question of what he was doing and why; in short, what it was to have made, in his own day and age, such a pointless and mysterious thing.

The antiquarian's intuition was wise, but so was his wariness about pursuing it further. Asking questions of an unanswerable object seemed to him not just a height of stupidity but even possibly a way that the object had of *making* him look stupid, of enticing him into demonstrations of foolishness. So he kept the shield in the back of his museum and tried not to think about it. And mostly he succeeded, except in those moments when he would open the top drawer of his desk and peek at his handkerchief, where the portion of the shield along which he had dusted the white fabric on that first day on the farm had left a strangely printed impression.

If now only that handkerchief remains—itself a chance find, located among the antiquarian's effects—that has not stopped me from basing the preceding manuscript on it. That trace of smudged hieroglyphs, mixed with the effluvium of a forgotten local historian, suggested to me as soon as I saw it a whole world I wanted to reconceive. I did not care that about twenty-five years after the antiquarian purchased the shield, a wealthy man came from a big city, paid good money, and took the charismatic object off the antiquarian's hands; or that the wealthy man, enamored not of the object itself but of the effects it produced, loved to display it to those of

both sexes with whom he sought assignations, so that the luster of the shield must have been reflected in bottles of bourbon and lovers' eyes; or that the wealthy man, his yacht having sunk in the year 1900 in a gale off the Carolinas, had gathered the shield and himself to darkness. The handkerchief imprint called to me, marking the presence of the actual object I believe it had grazed, and that object portrayed the lived experience of a forgotten time with a truth comparable to the handkerchief's own. The improbable survival of a wooden shield on a stream bank, a survival made still more unlikely by the shield's subsequent disappearance—a disappearance making the existence of the object permanently unverifiable—did not deter me. A life world was there—rituals of daily existence, lit by the orbs of noon and night, a surface scratched by roots and stars—and it seemed a shame not to dig for it anew, though what I sought could never be found. Reading books, filling in the blanks with my imagination, I sought to restore the stories of the figures in the original I had not seen, which itself was a record of what the chronicler-carver perhaps only dreamed when he invented the life of his times.

I have spoken with the descendants of the girl who found the shield. They have pointed me to the typewritten transcript of an interview she gave as an elderly woman to a town librarian some seventy years ago. What I know of the shield and the circumstances of its discovery owes to these sources. Beyond that there has been little for me to do except imagine the era the shield might have portrayed, learn as much as I can about that time, and step along the bank where the girl said the shield was found. Gazing now on the much-altered stream, I would never think of edging down those shifting slopes. She was much braver and more curious than me. But

in one respect I was like her that day. I, too, would have walked away from my chores to that stream glinting in the sun, loving what flowed away and the strange record of what did not.

Acknowledgments

Many people have made this book possible. First, I am grateful to Elizabeth Cropper, Peter Lukehart, and Therese O'Malley, at the Center for Advanced Study in the Visual Arts at the National Gallery of Art, for inviting me to give the sixty-sixth annual Andrew W. Mellon Lectures at the Gallery in 2017. Those lectures are the basis for this book.

For my research, I have benefited from the expertise of so many scholars and archivists, among them Alan Neumann, for a tour of the Bronson House in Hudson, New York; Travis Brock Kennedy, for research conducted in New York on the Bronson family; Peter Jung, for taking me to the grave of Sanford Gifford; Patricia Cline Cohen, for her gracious answers to my different questions about Helen Jewett and Richard P. Robinson; Shawon Kinew, for recommending reading about animal skin medicine bags; Thavolia Glymph and Kevin Quashie, for inspiring me to keep thinking about Nat Turner's Bible with their eloquent meditations on that object; and Ben Stone and Matt Marostica, for their expertise on American history, including, in Matt's case, on the Collinsville Axe Factory.

I learned a great deal from the two anonymous readers of the manuscript, also from a close reading given it by my friend Ruey Timberg. All three readers gave me much to think about, and the book is better for their comments.

To Michelle Komie, of Princeton University Press, I am indebted for her ongoing faith in my work. At the Press, I am also grateful to Kenneth Guay for his assistance in preparing the manuscript and gathering many of the illustrations, and to Cathy Slovensky for her careful copyediting.

To my family—wife Mary, daughters Lucy and Anna—I say thank you, again, for all that you give me.

Notes

Part One: Herodotus among the Trees

A Lone Pine in Maine

For lumbering in Maine, I have learned from James Elliott Defebaugh, *The History of the Lumber Industry of America*, vol. 2 (Chicago: American Lumberman, 1907), 1–125. For the uses of wood in the early republic, see François André Michaux, *The North American Sylva, or A Description of the Forest Trees of the United States, Canada and Nova Scotia* (Paris: C. D'Hautel, 1819). For the Kennebec and the sawmills between Winslow, Maine, and the sea, see Michaux, 299. For Hawthorne watching the log floating downstream, and for his various observations on trees, see Nathaniel Hawthorne, *Passages from the American Note-Books* (Boston: Houghton Mifflin, 1883), 48 (July 5, 1837), 69–70 (July 24, 1837), 135 (July 26, 1838), 52 (July 8, 1837), 25 (October 17, 1835).

The Town the Axes Made

For the rising productivity of the firm of Samuel and David Collins, and the story of Charles Morgan, see Janet Siskind, *Rum and Axes: The Rise of a Connecticut Merchant Family, 1795–1850* (Ithaca: Cornell University Press, 2001), 91–94. For the story of the Liberty Men in Maine, see Alan Taylor, *Liberty Men and Great Proprietors: The Revolutionary Settlement on the Maine Frontier,* 1760–1820 (Chapel Hill: University of North Carolina Press, 1990), 184, 206. For statistics about lumber shipments in Maine, see *History of the Maine Lumber Industry*, vol. 2, 23.

Hat and Tornado

Alexander Nemerov, "Thomas Cole's Hat," *Magazine Antiques* (December 22, 2014): https://www.themagazineantiques.com/article/thomas-coles-hat/. For Cole's early years in England and the United States, see Louis Legrand Noble, *The Life and Works of Thomas Cole* (Cambridge: Belknap Press of Harvard University Press, 1964 [1853]), 3, 7, 9. For Cole's *Course of Empire* and for his trip to Rome, including his experience outside the Colosseum, see Noble, 129, 115.

rush, *rush*, RUSH

The detailed reporting of one of Jedediah Burchard's sermons is in Russell Streeter, *Mirror of Calvinistic Fanaticism; or, Jedediah Burchard & Co. during a Protracted Meeting of Twenty-six Days in Woodstock, Vermont* (Woodstock, VT: N. Haskell, 1835). Specific quotations are from 15, 43–44. For the bodies lying on the forest floor, see Francis Lieber, *The Stranger in America; or Letters to a Gentleman in Germany: Comprising Sketches of the Manners, Society, and National Peculiarities of the United States* (Philadelphia: Carey, Lea & Blanchard, 1835), especially 305, 312–13.

History without a Sound

For episodes and experiences on the journey to the Flint River, see *Alexis de Tocqueville and Gustave de Beaumont in America: Their Friendship and Their Travels* (Charlottesville, VA: University of Virginia Press, 2010), 422–23, 407, 412, 410, 425, 436; also George Wilson Pierson, *Tocqueville and Beaumont in America* (New York: Oxford University Press, 1938), 307–8, 313–14. For Tocqueville's experience in Sicily in 1827 and his admiration of the Michigan woods "in haste," see *Alexis de Tocqueville and Gustave de Beaumont in America*, 436–37. For the experience in the one-room inn across the Tennessee River—including a fragmentary letter from this time from Beaumont to his mother ("Man is not made for slavery," "not a white man exists in America who is not a barbarous, iniquitous persecutor of the black race"), see Sara M. Benson, "Democracy and Unfreedom: Revisiting Tocqueville and Beaumont in America," *Political Theory* 45 (August 2017): 466–94, esp. 483–84.

The Sacred Woods of Francis Parkman

For Francis Parkman's childhood in the 1830s, see George E. Ellis and O. B. Frothingham, "March Meeting, 1894. Rev. John Wheelwright; Memoir of Francis Parkman," *Proceedings of the Massachusetts Historical Society*, 1892–94, 2nd series, vol. 8 (Boston: Massachusetts Historical Society, 1894), 503–62, esp. 524–25; and George E. Ellis, Francis Parkman, Oliver Wendell Holmes, Robert C. Winthrop, George S. Hale, John Lowell, and Leverett Saltonstall, "Special Meeting, November 1893. Autobiography of Francis Parkman; Poem by Dr. O. W.

Holmes; Letter of Mr. Saltonstall; Minute on the Death of Mr. Parkman," *Proceedings of the Massachusetts Historical Society*, 1892–94, 2nd series, vol. 8 (Boston: Massachusetts Historical Society, 1894), 349–69, esp. 351. For the account of Holy Week in Rome, see Parkman, letter to his mother, April 5, 1844, in *Letters of Francis Parkman*, ed. Wilbur R. Jacobs, vol. 1 (Norman: University of Oklahoma Press, 1960), 16–17. Parkman's Commencement Address, entitled "Romance in America," is reprinted with commentary in Wilbur R. Jacobs, *Francis Parkman, Historian as Hero: The Formative Years* (Austin: University of Texas Press, 1991), 169–73. The "decoction of forest leaves" and "their rough, gaunt stems" are in Parkman, *Montcalm and Wolfe*, vol. 2 (New York: Charles Scribner's Sons, 1915), 7; "in glimpses only" is in *Montcalm and Wolfe*, vol. 1, 213. Parkman's account of Father Isaac Jogues is in Parkman, *The Jesuits in North America in the Seventeenth Century*, vol. 2 (New York: Charles Scribner's Sons, 1915), 43; his account of the photograph of the bust of Jean de Brébeuf is in *The Jesuits in North America*, vol. 2, 215–17n1; of the large cross of the first Jesuits of Montreal, *The Jesuits in North America*, vol. 2, 81. For a notable account of the relation between Parkman's physical ailments and his visualizations of the past—an account that has stayed with me ever since it appeared and no doubt informs my thinking here—see Simon Schama, *Dead Certainties* (New York: Knopf, 1991).

A Shallow Pool of Amber

Margaret Fuller, letter to Charles K. Newcomb, March 4, 1839, in *The Letters of Margaret Fuller*, vol. 2, 1839–41, ed. Robert N. Hudspeth (Ithaca: Cornell

University Press, 1983), 55–57. "A
shallow pool of the clearest amber,"
"the most *impetuous force* with the most
irresistible subtlety" are in Fuller, letter
to Samuel G. Ward, April 20, 1836, *The
Letters of Margaret Fuller*, vol. 1 (Ithaca:
Cornell University Press, 1983), 249–
50; "elemental manifestations" is in
Fuller, letter to Jane F. Tuckerman, June
1839, *The Letters of Margaret Fuller*, vol. 2,
77; and Thomas Wentworth Higginson,
Margaret Fuller Ossoli (Boston: Houghton
Mifflin, 1887), 57.

Grand Central

For Ut-ha-wah's role in the War of
1812, see Laurence M. Hauptman,
*Seven Generations of Iroquois Leadership:
The Six Nations since 1800* (Syracuse,
NY: Syracuse University Press, 2008),
53. For the biography of William John
Wilgus, and various anecdotes about
the Indian response to his art, see Lars
Gustaf Sellstedt, *Life of William John
Wilgus* (Buffalo, NY: Matthews-Northrup,
1912). On the portability of images
in nineteenth-century America, see
Jennifer Roberts, *Transporting Visions:
The Movement of Images in Early America*
(Berkeley: University of California Press,
2014). For the second William John
Wilgus, the painter's nephew, see Kurt
C. Schlichting, *Grand Central Terminal:
Railroads, Engineering, and Architecture in
New York City* (Baltimore: Johns Hopkins
University Press, 2001). For the his-
tory and ecology of chestnut trees on
Onondaga land, including the attitudes
of contemporary Seneca to the newly
introduced genetically modified chestnut
tree, see S. Kathleen Barnhill-Dilling
and Jason A. Delborne, "The genetically
engineered American chestnut tree as
opportunity for reciprocal restoration in

Haudenosaunee communities," *Biological
Conservation* 232 (2019): 1–7; and
Barnill-Dilling and Delborne, "Rooted in
Recognition: Indigenous Environmental
Justice and the Genetically Engineered
American Chestnut Tree," *Society and
Natural Resources* 33 (2020): 83–100.

Part Two: The Tavern
to the Traveler

The Sleep of John Quidor

For the condition of Quidor's studio
and the behavior of Quidor, see the
account of his two students, Thomas
Bangs Thorpe and Charles Loring Elliott,
in Col. T. B. Thorpe, *Reminiscences of C.
L. Elliott* (reprinted in pamphlet form
from the *New York Evening Post*, ca. 1868),
in John I. H. Baur, *John Quidor, 1801–
1881* (Brooklyn Institute of Arts and
Sciences, Brooklyn Museum, 1942),
9–10. For Quidor's suit against his
art teacher, see Ernest Rohdenburg,
"The Misreported Quidor Court Case,"
American Art Journal 2 (Spring 1970): 74–
80, esp. 76. For the sugar manufactory
of Robert and Alexander Stuart, see Paul
Spencer Sternberg, "'Wealth Judiciously
Expended': Robert Leighton Stuart
as Collector and Patron," *Journal of the
History of Collections* 15 (2003): 229–40,
esp. 229. For the two students' response
to *Ichabod Crane Flying from the Headless
Horseman*, see *Reminiscences of
C. L. Elliott*, quoted in Baur, 9.

The Dancing Figures of the
Mountain Pass

This story is based on Hawthorne,
Passages from the American Note-Books
(Boston: Houghton Mifflin, 1883),
172–74 (August 22–23, 1838).

The Dutchman's Diorama

This story is based on Hawthorne, *Passages from the American Note-Books* (Boston: Houghton Mifflin, 1883), 178–83 (August 31, 1838).

Menagerie

This story is based on Hawthorne, *Passages from the American Note-Books* (Boston: Houghton Mifflin, 1883), 191–93 (September 4, 1838).

The Man with the Amputated Arm

This story is based on Hawthorne, *Passages from the American Note-Books* (Boston: Houghton Mifflin, 1883), 137–49 (July 29, 1838).

A Land of One's Own

For the light stinging like a wasp and other sensations of Bridgman's childhood, as she herself recollected them, see Edmund Clark Sanford, *The Writings of Laura Bridgman* (San Francisco: Overland Monthly, 1887), 9–10. For descriptions of Bridgman under Howe's care in Boston, see Charles Dickens, *American Notes* (Floating Press, 2009), 62ff; G. Stanley Hall, "Laura Bridgman," *Mind* 4 (April 1879): 149–72. For the life of Frances Henshaw, see Bethany Nowviskie, "'Inventing the Map' in the Digital Humanities: A Young Lady's Primer," *paj: The Journal of the Initiative for Digital Humanities, Media, and Culture* 2 (2010): 1–44. For the teaching of Ida Strong and Emma Willard, and Noah Webster's views on the recitation of place-names as a "catechism to the nation state," see Susan Schulten, "Emma Willard and the Graphic Foundations of American History," *Journal of Historical*

Geography 33 (July 2007): 542–64. Henshaw's schoolbook is in the collections of the David Rumsey Map Center, Stanford University Libraries. Bridgman's poem is in Sanford, *The Writings of Laura Bridgman*, 24.

Down the Well

Taken from three sources: the description of the burial of a young boy in Hawthorne, *Passages from the American Note-Books* (Boston: Houghton Mifflin, 1883), 176–77 (August 26, 1838); a posthumous portrait of fifteen-year-old Jedediah Williamson, of Long Island, painted in 1837 by William Sidney Mount; and the story of a get-rich-quick scheme in "Ten Days in Ohio; from the diary of a Naturalist," *American Journal of Science & Arts* 25 (April 1834): 217–58, esp. 224–27 ("Muskingum Mining Company—Fruitless Exploration for Silver").

The Song of Cold Spring

For the story and poem inspiring the song, see Morris, "A Letter and a Poem, February 1, 1837," in *The Little Frenchman and His Water Lots, with Other Sketches of the Times* (Philadelphia: Lea & Blanchard, 1839), 87–96. For a brief history of Undercliff, and a recollection of her own girlhood exploring the ruins and grounds, see Dorothy Giles, "Marshmoor and Undercliff: Two Houses on the Hudson and the Life that Filled Them for Half a Century—1825–1875," unpublished manuscript, 1955, Putnam History Museum, Cold Spring, New York. For Morris's songs as flowers floating on the stream, and for his instinctive avoidance of turbulent emotion, see Nathaniel P. Willis, "A Memoir of the Author," in *Poems of George P. Morris*, 17th

ed. (New York: Charles Scribner, 1860),
21–25. For the adjacency of Morris's
"The Oak" and John Gadsby Chapman's
The Landing of Columbus, see their publica-
tion on pages 217 and 220, respectively,
of *The New York Mirror: A Weekly Gazette
of Literature and the Fine Arts* 14 (January
7, 1837). For the "indefinitiveness" of
music, and of Morris's songs in partic-
ular, see Edgar Allan Poe, "Review of
New Books," *Burton's Gentleman's Magazine*
(December 1839): 332; and "George P.
Morris," in *The Works of the Late Edgar Allan
Poe*, vol. 3 (1850): 253–56. For the story
of Poe and the girl, the young Elma Mary
Gove (1832–1921), including a reprint
of her own account, see Christopher P.
Semtner, "A Young Girl's Recollections
of Edgar Allan Poe," *Resources for American
Literary Study* 36 (2016): 53–64. My
thanks to Patricia Cline Cohen for
calling my attention to this account.

The Branches Played the Man

Jerome Thompson (1814–86), the
painter of this scene, began as a sign
painter in his native Massachusetts in
the 1830s, his ambition to become a
portraitist. His father Cephas was an
itinerant painter who went as far as
New Orleans to make portraits of
wealthy sitters, and though Cephas did
not want Jerome, the seventh of his
eight children, to do anything other
than work on the family farm, the young
man was not to be dissuaded. In 1831
he had set up a studio in Barnstable, on
Cape Cod. Hustling for business, he bet
a group of men at the Globe Hotel that
he could paint a portrait of any one of
them (their choice) in five minutes, with
the likeness good enough that an outside
party could recognize the sitter. He
took up a piece of smooth pine board,

executed the portrait, hung it outside
the hotel, and sure enough a passerby
recognized the man, a marvel. See Lee
M. Edwards, "The Life and Career of
Jerome Thompson," *American Art Journal*
14 (Autumn 1982): 4–30, esp. 6.

Without a sky to see, without a God
to acknowledge: On early humans as
giants living in forests, unaware of the
sky until a few of them dwelling on
mountains saw it, heard the thunder,
and saw this realm above as the body of
a god, in this case Jove, see Giambattista
Vico, *The New Science of Giambattista
Vico* (Ithaca, NY: Cornell University
Press, 1984), 117–18. The basis for
Thompson's scene might be more
benign, more the woods of Jean-Jacques
Rousseau in his *Discourse on Inequality: On
the Origin and Basis of Inequality Among Men*
(early humans being, in Rousseau's view,
neither vicious nor fearful among "the
other wild inhabitants of the forest"),
than of Vico. Likewise, Thompson's
picture might be more in line with
Ralph Waldo Emerson's view in his essay
"Nature" ("In the woods, we return to
reason and faith") than that of English
settlers in the 1630s, who feared the
woods' darkness, silence, and vastness.
But the twisting tree in Thompson's
painting finally calls to mind such dark
conceptions of the forest rather than
the optimistic views of Rousseau and
Emerson. See Jean-Jacques Rousseau,
*Discourse on Inequality: On the Origin and
Basis of Inequality Among Men* (Auckland,
NZ: Floating Press, 2009), 15ff; Ralph
Waldo Emerson, "Nature" (1836), in
Essays & Lectures (New York: Library of
America, 1983), 10; Charles Carroll,
The Timber Economy of Puritan New England
(Providence, RI: Brown University
Press, 1973), 59–60. For an illumi
nating account of the forests of many

thinkers, including Vico, Rousseau, and Boccaccio (from whose story of the adolescent lovers Pietro and Agnolella in the *Decameron*, as analyzed by Harrison, I draw my mention of the young lovers lost in the woods), see Robert Harrison, *Forests: The Shadow of Civilization* (Chicago: University of Chicago Press, 1992), esp. 3–13, 125–33, 87–91.

An Oak Bent Sideways

For Sequoyah teaching Ahyokeh how to read his alphabet, see Willard Walker, "The Design of Native Literacy Programs and How Literacy Came to the Cherokees," *Anthropological Linguistics* 26 (Summer 1984): 161–69, esp. 165–66, 163. See also Ellen Cushman, " 'We're Taking the Genius of Sequoyah into This Century': The Cherokee Syllabary, Peoplehood, and Perseverance," *Wicazo Sa Review* 26 (Spring 2011): 67–83, esp. 74. For Sequoyah's early life, see, for example, Marel Brown, "Sequoyah," *Georgia Review* 1 (Winter 1947): 490–91. For Inman's copy of King's portrait of Sequoyah, and Sequoyah's sovereignty therein, see Elizabeth Hutchinson, "From Pantheon to Indian Gallery: Art and Sovereignty on the Early Nineteenth-Century Cultural Frontier," *Journal of American Studies* 47 (May 2013): 313–37, esp. 325–30. For "culturally modified trees," see Dana R. Elliott, "Thong Trees: Living Indian Relics," *Central States Archaeological Journal* 40 (January 1993): 16–19. For the site in the Tennessee woods, see Marion Blackburn, "Return to the Trail of Tears," *Archaeology* 65 (March/April 2012): 56–58, 64.

Part Three: Come, Thick Night

Smoke and Burnt Pine

Nat Turner, "Confession," in Thomas R. Gray, *The Confessions of Nat Turner* (Baltimore: Thomas R. Gray, 1831), 10–11. "Wrapped . . . in mystery": "Confession," 9. "Mossy knoll . . . shelter of pine boughs": William Styron, *The Confessions of Nat Turner* (New York: Random House, 1967), 275.

Sculpting Thomas Jefferson's Face

For the story of Browere going to Monticello and the making of the plaster cast of Jefferson's face, see Henry C. Randall, *The Life of Thomas Jefferson*, vol. 3 (New York: Derby & Jackson, 1858), 538–40. For initial reporting on the taking of the cast, see, for example, *Aurora and Franklin Gazette*, Nov. 21, 1825. "A perfect *facsimile*": Charles Henry Hart, *Browere's Life Masks of Great Americans* (New York: Doubleday and McClure, 1899), 26. "Plaster factory," "not above exhumation," "giant strength," "terrible imprecations": Thomas Bangs Thorpe and Charles Loring Elliott, in Col. T. B. Thorpe, *Reminiscences of C. L. Elliott* (reprinted in pamphlet form from the *New York Evening Post*, ca. 1868), in John I. H. Baur, *John Quidor, 1801–1881* (Brooklyn Institute of Arts and Sciences, Brooklyn Museum, 1942), 11. The request to saw off the heads of the most important busts is in Hart, 25. "Contempt for all moral systems compared with that of Christ": Randall, *The Life of Thomas Jefferson*, vol. 3, 539. "Faithful record": Gray, *The Confessions of Nat Turner*, 4.

Reading the Leaves

For "*blood—your life depends upon lying close*": Edgar Allan Poe, *The Narrative of*

Arthur Gordon Pym of Nantucket, in Poe, *Selected Tales* (New York: Library of America, 1984), 271. For the stance of the *Southern Literary Messenger* on slavery during Poe's editorship, see Nathaniel B. Tucker, "Slavery," review of J. K. Paulding, in *Slavery in the United States* (New York: Harper and Brothers, 1836), *Southern Literary Messenger* (April 1836): 336–39; see also Poe's letter to Tucker, May 2, 1836, mentioning that he cut some passages from the article, though it is not known which ones: https://www .eapoe.org/works/letters/p3605020.htm. My thanks to Chris Semtner of the Poe Museum for this information. For the "Tsalians," "Ethiopian characters," and the illusion of writing, see *The Narrative of Arthur Gordon Pym*, 372, 414, 403.

A Meeting in the Great Dismal Swamp

On conjecture about Turner hiding in the Great Dismal Swamp, see Daniel O. Sayers, *A Desolate Place for a Defiant People: The Archaeology of Maroons, Indigenous Americans, and Enslaved Laborers in the Great Dismal Swamp* (Gainesville: University of Florida Press, 2014), 104. On the swamp as a geological freak, see Sharon Pettie, "Preserving the Dismal Swamp," *Journal of Forest History* 20 (January 1976): 29. On snakes in the Great Dismal, see C. R. Mason, "Mapping in Dismal Swamp," *Military Engineer* 44 (March–April 1952): 125. "Great Bigness" and "Genial Beams of the sun": William Byrd II, report of March 23, 1728, quoted in Mason, "Mapping in Dismal Swamp," 120. On the opening of the canal system in the Great Dismal in 1829, see Burton R. Pollin, "Edgar Allan Poe and John G. Chapman: Their Treatment of the Dismal Swamp and the Wissahickon," *Studies*

in the American Renaissance (1983): 248. "Many things that the fertility of my own imagination had depicted to me before": Turner, "Confession," 8. "Sunk slowly," "the waters of this lake grow blacker with age," "darkness fell over all things": Poe, quoted in Pollin, 256. On the Halfway House, see Pettie, 32. "Casting different things in moulds made of earth": Turner, "Confession," 8.

Part Four: Panic

Ere You Drive Me to Madness

On Helen Jewett, Richard Robinson, the location of the murder, and the growth of Manhattan in the 1830s, see Patricia Cline Cohen's authoritative history, *The Murder of Helen Jewett: The Life and Death of a Prostitute in Nineteenth-Century New York* (New York: Alfred A. Knopf, 1998), 141, 28, 10, 70–71. Cony Female Academy: Cohen, *The Murder of Helen Jewett*, 49–50. Impressed by her manners and intelligence: Cohen, 152. The wallpaper and its possible impression on Dorcas Doyen: Cohen, 181–83, 442n71. "Monstrous tide of depravity and dissipation," quoted in Cohen, 230–31. "The sensualities of that great metropolis": *Robinson Down Stream: Conversations with the "Great Unhung," since his Acquittal; and an account, by Robinson himself, of his travels from Connecticut to New-Orleans on his way to Texas* (New York, 1836), 11. My thanks to Patricia Cline Cohen for sending me an electronic copy of this rare pamphlet. For Dorcas Doyen at the Westons' home in Augusta, Maine, and Dorcas's departure from Maine and her change of name, see Cohen, 42, 40. "Pause, Frank, pause": quoted in Cohen, 285–86. "A crusty brown"; "good spirits": quoted in Cohen, 7, 386. "Total want of moral

perception": *Robinson Down Stream*, 13. On Crockett's exploits in the *Crockett Almanacks*, see Carroll Smith-Rosenberg, *Disorderly Conduct: Visions of Gender in Victorian America* (New York: Alfred A. Knopf, 1985), 96–97, 106. "I can dance the tiger waltz, as well as the bloodiest": *Robinson Down Stream*, 11. For James Gordon Bennett's description of the painting in the front room of the brothel on Thomas Street, and for the story of Jane McCrea, see Cohen, *The Murder of Helen Jewett*, 118, 123, 125. For "intaglioed": Benson J. Lossing, *Pictorial Field Book of the Revolution*, vol. 1 (New York: Harper & Brothers, 1852), 97. On the fashioning of souvenirs from the tree, see Samuel Y. Edgerton Jr., "The Murder of Jane McCrea: The Tragedy of an American Tableau d'Histoire," *Art Bulletin* 47 (December 1965): 481–92. On Jewett's reading and the decor of her room on Thomas Street, see Cohen, *The Murder of Helen Jewett*, 17. "With the apathy of despair"; "cast a mournful glance"; looters: Hone, *The Diary of Philip Hone*, 187, 187, 193. "Call it a land of visibility": for an account of the visible world before the invention of photography, see Hagi Kenaan, *Photography and Its Shadow* (Stanford, CA: Stanford University Press, 2020). For an evocative description of Temple, Maine, as it was in the 1970s, see George Dennison, *Temple: From a Writer's Notebook* (South Royalton, VT: Steerforth Press, 1994).

Lifesaver

The discovery of Sam Patch's body: Paul E. Johnson, *Sam Patch: The Famous Jumper* (New York: Hill & Wang, 2003), 162. See Johnson's entire book for a full account of Patch's life and an interpretation of the cultural significance of his feats. For Byron's *Manfred*, see Peter Cochran, *Manfred: An Edition of Byron's Manuscripts and a Collection of Essays* (Cambridge: Cambridge Scholars Publishing, 2015).

Sayings of the Piasa Bird

For Elijah Lovejoy's life and last night, see John Gill, *Tide without Turning: Elijah P. Lovejoy and the Freedom of the Press* (Boston: Starr King, 1958). For Gill's account of Lovejoy's boyhood and his recollections of that time on November 7, 1837, see Gill, *Tide without Turning*, 12–13, 200. For the discovery of Lovejoy's printing press in 1915, see Kelsey Landis, "100 Years since Lovejoy Press Lifted from River," *Telegraph*, July 24, 2015: https://www.thetelegraph.com/news/article/100-years-since-Lovejoy-press-lifted-from-river-12702995.php. "Our feet are upon the necks of nearly three millions of our fellow men!": Lovejoy, quoted in David Blight, "The Martyrdom of Elijah P. Lovejoy," *American History Illustrated* 12 (November 1977): 24. "Nations and individuals": Lovejoy, quoted in Gill, *Tide without Turning*, 17–18. For the murder of Francis McIntosh, see Gill, *Tide without Turning*, 60–70. "[Ten thousand] bullet holes": A. D. Jones, *Illinois and the West* (Boston: Weeks, Jordan, and W. Marshall, 1838), 60. "A mulatto man, by the name of McIntosh"; "a forest of giant oaks": Abraham Lincoln, "The Perpetuation of Our Political Institutions," Address to the Springfield Young Men's Lyceum, January 27, 1838, in Abraham Lincoln, *Political Writings and Speeches* (Cambridge: Cambridge University Press, 2015), 13, 18–19. On Thomas Hope in Alton, see John Hogan, *Fifty Years Ago: A Memoir* (Kansas City, MO: Franklin Hudson, 1907), 103.

The Death of David Douglas

For the death of David Douglas and the
ongoing mystery of how he died, see
Jean Greenwell, "Kaluakauka Revisited:
The Death of David Douglas in Hawai'i,"
Hawaiian Journey of History 22 (1988):
147–69. On the Romantic praise of
organic creation, see, for example, M. H.
Abrams, "Coleridge and the Aesthetics
of Organism," in *The Mirror and the Lamp:
Romantic Theory and the Critical Tradition*
(New York: Oxford University Press,
1953), 218–25. For Ned Gurney's
appearance and background, see
Greenwell, "Kaluakauka Revisited,"
161. For Gurney's account of discov-
ering Douglas's body, see Greenwell,
"Kaluakauka Revisited," 155–56.

Part Five: Animals Are Where They Are

Lord of the Sod

For the identification of the animal as
a raccoon, I rely on Gaylord Torrence,
former curator of Native American art at
the Nelson-Atkins Museum of Art (email
to author, April 21, 2017). For the use
of tobacco bags in Ojibwe culture, I have
learned from Walter James Hoffman, *The
Mide'wiwin or "Grand Medicine Society" of
the Ojibwe*, Seventh Annual Report of the
Bureau of Ethnology to the Secretary of
the Smithsonian Institution, 1885–
1886 (Washington, DC: Government
Printing Office, 1891), 220–21.

Night Vision

"Near-living doubles": Jennifer Roberts,
*Transporting Visions: The Movement of Images
in Early America* (Berkeley: University
of California Press, 2014), 108–9. The
Voyageur and the cholera epidemic; the

disease quickly spreading six hundred
to seven hundred miles; "avoid all
exaggerations": *Report of the Commission
appointed by the Sanitary Board of the City
Councils, to visit Canada, for the investigation
of the epidemic cholera, prevailing in Montreal
and Quebec* (Philadelphia: Mifflin & Parry,
1832), 2, 4, 12. "The original referent
itself": Roberts, *Transporting Visions*, 112.

The Cup of Life

"With perfect indifference": Richard
Harlan, *Medical and Physical Researches*
(Philadelphia: Lydia R. Bailey, 1835),
445. "The most notable, and certainly
the most interesting, character in the
history of fire-eating, fire-resistance, and
poison-eating": Harry Houdini, *Miracle
Mongers and Their Methods* (New York: E. P.
Dutton, 1920), 54. "By having a hidden
pouch into which the poison fell when
he seemed to place it in his mouth";
"arrant": Richard M. Swiderski, *Poison
Eaters: Snakes, Opium, Arsenic, and the
Lethal Show* (New York: Universal, 2010),
142, 147.

Calamity at New Garden

On Townsend's killing of the bird, see
Barbara Mearns, *John Kirk Townsend: A
Collector of Audubon's Western Birds and
Mammals* (Kirkton, Dumfries, Scotland:
Barbara and Richard Mearns, 2007), 20–
22. For the fate of the *Lady of the Lake*,
see "*Lady of the Lake*, Departed Belfast,
Ireland for Quebec, Sank May 11, 1833,
265 Lost": http://ngb.chebucto.org
/Articles/dis-lady-of-the-lake-1833.shtml.

Spiders at the Altar

"Repressed the natural frankness," "I
could not turn": Caroline Hentz, *Ernest
Linwood* (1856), 244. For the social

life of Nicholas and Caroline Hentz in Florence, Alabama, see Jamie Stenesa, "Caroline Lee Whiting Hentz (1800–1856)," *Legacy* 13 (1996): 130–41, esp. 132; "endless search for spiders": Stenesa, 131. For the story of *Mimetus interfector* and *Theridion vulgare*, see Nicholas Marcellus Hentz, *The Spiders of the United States: A Collection of the Arachnological Writings of Nicholas Marcellus Hentz, M.D.*, ed. Edward Burgess (Boston: Boston Society of Natural History, 1875), 138, 142. Caroline Lee Hentz, "The Fatal Cosmetic," *Godey's Lady's Book* 18 (June 1839): 265–74.

Moose and Stencil

The submersion of the moose is in "Sagacity and Cautiousness of the Moose," *Davy Crockett's Almanack*, 1837, 34. At the Shelburne Museum in Shelburne, Vermont, is the so-called Stencil House—so named because of its elaborate preserved stencil decorations made by an unknown itinerant artist—a house originally located in Columbus, New York. The art historian Ann Eckert Brown believes that the painter at the Stencil House may have been Stephen Clark (1810–90), who made similar designs in homes in South Bay, Ontario; Farmersville, New York; and Naples, New York (Allison Harig, Archives & Library Manager and Assistant Registrar, Shelburne Museum, email to author, December 7, 2020). "In one minute, in this talkative age": *Davy Crockett's Almanack*, 1838, 40. For the habits of moose in the wild, I have learned from Donna Naughton, *The Natural History of Canadian Mammals* (Toronto: University of Toronto Press, 2012), 545. The story of the porcupine and Crockett's speech in Congress—"Who—Who—Whoop—Bow—Wow—Wow—Yough"—are in the *Davy Crockett's Almanack*, 1837, 7–8, 40.

Encounter in a Black Locust Grove

On Constantine Rafinesque's appearance and habits, see Leonard Warren, *Constantine Samuel Rafinesque: A Voice in the American Wilderness* (Lexington: University of Kentucky Press, 2015), 85; John Jeremiah Sullivan, "La·Hwi·Ne·Ski: Career of an Eccentric Naturalist," in *Pulphead* (New York: Farrar, Straus and Giroux, 2011), 192, 206. On the remnants of the old frontier station at Lexington, see Timothy Flint, *Biographical Memoir of Daniel Boone* (Schenectady, NY: New College and University Press, 1967), 89–93. On Rafinesque's schemes and demands at Transylvania, and his teaching about the ants, see Warren, *Rafinesque*, 83, 87. Among the last aspiring to know the whole universe: Sullivan, "La·Hwi·Ne·Ski: Career of an Eccentric Naturalist," in *Pulphead*, 204. Rafinesque's expertise in so many fields: Charles Boewe, introduction to Rafinesque, *The World; or, Instability* (Gainesville, FL: Scholars' Facsimiles & Reprints, 1956 [1836]), vi. On Rafinesque's shipwreck, see Warren, *Rafinesque*, 56–57. Identifying species as he swam away; attacking bats with Audubon's violin, Sullivan, "La·Hwi·Ne·Ski: Career of an Eccentric Naturalist," 192, 200. As Sullivan puts it, "He became the real Rafinesque only after the wreck" (194). "Endless shapes, mutations quick or slow"; "the great universal law": Boewe, introduction to *The World; or, Instability*, xiii, xii. "The Lord and Leader": *The World*, 9. "We see the world piece by piece":

Ralph Waldo Emerson, "The Over-Soul," *Essays* (Boston: James Munroe, 1841), 223. *"Only as the several parts of an immense Being"*: Tocqueville, quoted in Richard Hardack, *"Not Altogether Human": Pantheism and the Dark Nature of the American Renaissance* (Amherst: University of Massachusetts Press, 2012), 20. "The admission of everything and the denial of nothing": quoted in Hardack, *"Not Altogether Human,"* 18. The description of the picnickers sitting on the rotten log—adapted to my story—is in Frances Trollope, *Domestic Manners of the Americans* (New York: Dover, 2003 [1832]), 57–58. For Pan as the American "Over-Soul," see D. H. Lawrence, "Pan in America," in *Phoenix: The Posthumous Papers of D. H. Lawrence*, ed. Edward D. McDonald (New York: Viking Press, 1936), 22–31. "An earnest, articulate advocate of nonsense": Warren, *Rafinesque*, 92–93.

Part Six: The Clocks of Forestville

The Time the Peddler Fell

"Time is money," "arrange the hours": Michael O'Malley, *Keeping Watch: A History of American Time* (New York: Viking, 1990), 42, 50. *Station*: James Fenimore Cooper, "On Station," in *The American Democrat; or, Hints on the Social and Civic Relations of the United States of America* (Cooperstown, NY: H. & E. Phinney, 1838), 77–83. "Little white marble palaces . . . built of whitewashed brick and . . . painted wood": Alexis de Tocqueville, *Democracy in America*, part 2, ed. J. P. Mayer, trans. George Lawrence (New York: Perennial Classics, 1966), 468. A German prince, towers of sandstone, and castles on the

Rhine: the prince was Maximilian of Wied-Neuwied, on his exploration of North America from 1832 to 1834, in company with the painter Karl Bodmer. In late July and early August 1833, on the Missouri River near the mouth of the Musselshell River, he remarked the castle-like rock formations, of which Bodmer made a number of drawings and watercolors. See William H. Goetzmann, David C. Hunt, Marsha V. Gallagher, and William J. Orr, *Karl Bodmer's America* (Omaha: Joslyn Art Museum and University of Nebraska Press, 1984), 213ff. "In some places," Maximilian wrote in his journal on August 6, "one was sure he was seeing old mountain castles" (231). On peddlers, see David Jaffee, "Peddling Clocks," in *A New Nation of Goods: The Material Culture of Early America* (Philadelphia: University of Pennsylvania Press, 2010), 181–87. See also, for example, Priscilla Carrington Kline, "New Light on the Yankee Peddler," *New England Quarterly* 12 (March 1939): 80–98. Kline focuses on a cache of fifty-seven letters written by her great-grandfather, George Rensselaer Upson, of Bristol, Connecticut, who sometimes worked as an agent for a Yankee peddler from Bristol.

Daybreak on Monks Mound

For a description of the prairie around Monks Mound, see *North American Journals of Prince Maximilian of Wied*, vol. 3 (Norman: University of Oklahoma Press, in cooperation with the Durham Center for Western Studies, Joslyn Art Museum, 2012), 330. For a description of Amos Hill's farm, including the location of the farmhouse, his archaeological excavations, and the crops he cultivated, see George William Featherstonhaugh,

Excursion through the Slave States: From Washington on the Potomac, to the Frontier of Mexico; with Sketches of Popular Manners and Geological Notices (New York: Harper & Brothers, 1844), 66. Other details about Hill and his farm appear in Nelson A. Reed, "Excavations on the Third Terrace and Front Ramp of Monks Mound, Cahokia: A Personal Narrative," Illinois Archaeology: Journal of the Illinois Archaeological Society 21 (2009): 8–9, 31, 61, 75. The conjecture about the priest, warrior, and sunlighting ritual is from John Pfeiffer, "Indian City on the Mississippi," in Nature/Science Annual (New York: Time-Life, 1974), 125–27; quoted in Sally A. Kitt Chappell, Cahokia: Mirror of the Cosmos (Chicago: University of Chicago Press, 2002), 54. The descriptions of bilious fevers and abundant game are in Hall, letter to Ashbel Smith, December 12, 1833, Ashbel Smith Papers, Dolph Briscoe Center for American History, University of Texas at Austin. For the Trappist monks at Cahokia, including their watchmaking, see "The Trappists of Monks Mound," Illinois Catholic Historical Review 8 (October 1925): 106–36. The first written description of the mounds at Cahokia is Henry Marie Brackenridge, Views of Louisiana (Chicago: Quadrangle, 1962 [1814]), 187–90; he gives an account of the Trappists, who were there when Brackenridge visited Cahokia in 1811, on 287–91.

The Clocks of Forestville

Some 280 separate firms and five hundred thousand clocks a year: Donald Muller, "Everyman's Time: The Rise and Fall of Connecticut Clockmaking," Connecticut Explored (Fall 2007): https://www.ctexplored.org

/everymans-time-the-rise-and-fall-of -connecticut-clockmaking/. See also Carl W. Drepperd, American Clocks and Clockmakers (Boston: Charles T. Branford, 1958). For the solitary geriatric trees in New England towns—in this case elms around the year 1900—see Thomas J. Campanella, "Boulevard of Broken Trees," in Republic of Shade: New England and the American Elm (New Haven: Yale University Press, 2003), 141–69.

Longleaf Pine and a Length of Time

Oil rendered from the fat of raccoons: William Physick Zuber, My Eighty Years in Texas (Austin: University of Texas Press, 1971), 38. For 262,000 employed in the Texas lumber industry: Vernon H. Jensen, Lumber and Labor (New York: Farrar & Rinehart, 1945), 76. For child labor in the Texas sawmills, see the photographs Lewis Hine made in November 1913: https://www.loc.gov/pictures /search/?q=Lewis%20Hine%20texas%20 lumber. "Bray's Bayou": Zuber, My Eighty Years in Texas, 26. Shay engines; bundling fatty pine: Thad Sitton, Nameless Towns: Texas Sawmill Communities, 1880–1942 (Austin: University of Texas Press, 1998), 15. The Homestead Act of 1866, the purchase of the woods at $1.25 an acre, and the black workforce, see William Powell Jones, The Tribe of Black Ulysses: African American Lumber Workers in the Jim Crow South (Urbana: University of Illinois Press, 2005). "Deep Ecology": Luc Ferry, The New Ecological Order, trans. Carol Volk (Chicago: University of Chicago Press, 1995), ix–xv. The story of the march to the Alamo is in Zuber, My Eighty Years in Texas, 47–50.

Shades of Noon

For an introduction to hemlock tanning
in the nineteenth century, see John
Bates, "Hemlock Bark and Wisconsin's
Tanning Industry: The World Walked on
Milwaukee Leather," lecture, October
20, 2020, YouTube: https://www
.youtube.com/watch?v=CtXrwwkGXo
-c&t=222s. For hemlock tanning in the
Catskills, see Alf Evers, "Tanners Versus
Hemlocks" and "Tanlords, Turnpikes,
and Railroads," in *The Catskills: From
Wilderness to Woodstock* (Woodstock, NY:
Overlook Press, 1972), 332–40, 384–
93. For the founding of Hudson as a
whaling port, and for the revival of the
whaling and sealing industry there in
the 1830s (it had begun disappearing in
the previous two decades), see Margaret
B. Schram, *Hudson's Merchants and Whalers:
The Rise and Fall of a River Port, 1783–1850*
(Hensonville, NY: Black Dome Press,
2004), esp. 37 and 135–47. For the
experience of American sealing ships
in the Falklands and elsewhere near
Antarctica, see the account of Captain
Christopher Burdick of Nantucket in
1820 in Edouard A. Stackpole, *The Sea-
Hunters: The New England Whalemen during
Two Centuries, 1635–1835* (Philadelphia:
J. B. Lippincott, 1953), 357–66. For the
decrepitude of hemlocks—their eerie
way of seeming both dead and alive—
see François André Michaux, *The North
American Sylva*, vol. 2 (Paris: C. D'Hautel,
1819), 318–19.

A Trip to Bloomingdale Asylum

For the visit of William Dunlap (1766–
1839), the art historian, and Gulian
Verplanck (1786–1870), the mayoral
candidate, to the Bloomingdale Asylum
for the Insane, see Dunlap, *Diary of
William Dunlap: The Memoirs of a Dramatist,*
Theatrical Manager, Novelist, and Historian,
vol. 3 (New York: New-York Historical
Society, 1930), 796–98. For the violence
around the New York City mayoral
election of April 1834, see "The Riots
of 1834: New York City's First Direct
Election for Mayor," *The Bowery Boys:
New York City History*, November 2,
2021: https://www.boweryboyshistory
.com/2021/11/new-yorks-first-mayoral
-election-in.html. For lists of the goods
and services paid for by the asylum,
see *Bloomingdale Asylum Report, 1832*
(New York: Mahlon Day, 1833), 3; for
statistics on patient admissions, as well
as a description of the grounds and the
building itself, see Pliny Earle, *History,
Description and Statistics for the Bloomingdale
Asylum for the Insane* (New York: Egbert,
Hovey and King, 1848), 18, 23–24.
For Dunlap's kidney stones and bladder
operation, see, for example, 780; for his
use of laudanum, for example, 771; for
his temporary shift in diet, 793. "If I say
shoot that man": Dunlap, 797. On the
encouragement of patients to take the
airs and pitch quoits, and on the "cam-
isole" as a means of restricting bodily
movement, see Earle, 29, 34, 36.

The Lost Child

Filley's story, and that of Mary Mount, is
in *Life and Adventures of William Filley Who
Was Stolen from His Home in Jackson, Mich.,
by the Indians, August 3d, 1837, and His Safe
Return from Captivity after an Absence of 29
Years* (Chicago: Filley & Ballard, 1867).
The story of Filley riding the railroad for
free and regaling the local children with
Indian lore is in Leanne Smith, "Peek
through Time: In 1837, a 5-Year-Old
Jackson-Area Boy Was Kidnapped by
Indians," *Michigan Live: Jackson*, January
21, 2019: https://www.mlive.com/news

/jackson/2011/02/peek_through_time_in_1837_a_5-.html.

Part Seven: Supernatural

The Actress at the Waterfall

The story of the day at Trenton Falls, New York, on July 12, 1833, is in Fanny Kemble, *Fanny Kemble's Journals*, ed. Catherine Clinton (Cambridge, MA: Harvard University Press, 2000), 73–74. The audience failing to applaud Kemble's balcony scene in *Romeo and Juliet* is described in Robert Rushmore, *Fanny Kemble* (London: Crowell-Collier Press, 1970), 70. Kemble's view of the actor as only "the filler up of the outline designed by another" is in *Fanny Kemble's Journals*, 58 (December 29, 1832). "Immediate presence of God": Kemble, quoted in Rushmore, *Fanny Kemble*, 79. For Kemble's experiences in Butler's Georgia plantation, see Kemble, *Journal of a Residence on a Georgia Plantation in 1838–1839* (London: Longman, Green, Longman, Roberts & Green, 1863), for example, 182–83.

Harriet of the Stars

The story of Araminta Ross (Harriet Tubman) and the cradle is from Emma Paddock Telford, *Harriet: The Modern Moses of Heroism and Visions* (typescript, ca. 1905), 3–4, reprinted in Jean M. Humez, *Harriet Tubman: The Life and the Life Stories* (Madison: University of Wisconsin Press, 2003), 205. "L.F." and "S.A." is from Frederick Douglass, *Narrative of the Life of Frederick Douglass, an American Slave, Written by Himself* (New York: Signet, 1968), 57. On the hazards of dry and wet canal building, and on a typical day—and a typical meal—for canal builders, see Peter Way, *Common Labour: Workers and the Digging of North American Canals, 1780–1860* (Cambridge: Cambridge University Press, 1993), 134–36, 147–48. On the Leonid meteor shower of November 12–13, 1833, see Mark Littmann, *The Heavens on Fire: The Great Leonid Meteor Storms* (Cambridge: Cambridge University Press, 1998), 1–12. Harriet Tubman's recollection of the meteor shower of 1833 is from "Aunt Harriet Was Very Old," *Auburn (NY) Daily Advertiser*, March 13, 1913, 6, in Humez, *Harriet Tubman: The Life and Life Stories*, 212. The story of the capsized ship on the Hudson River is from Alexander C. Twining, quoted in Denison Olmsted, "Observations on the Meteors of November 13th, 1833," *American Journal of Science and Arts* 25 (April 1834): 371. Tubman and the trough are in Sarah H. Bradford, *Scenes in the Life of Harriet Tubman* (Auburn, NY: W. J. Moses, 1869), 14–15.

Ashbel Smith's observations of the meteor shower are from Ashbel Smith, quoted in Olmsted, "Observations on the Meteors of November 13th, 1833," 378–79. Smith describes the especially bright and long-lasting meteor of three in the morning, the one making a "violent impression on the sight," on 379. Smith uses the phrase "sub dio" in an original facsimile of his letter to Denison Olmsted, November 29, 1833, Ashbel Smith Papers, Dolph Briscoe Center for American History, University of Texas at Austin. For the illness of Harriet Eliza Bissell, see Titus Lucretius Bissell to Ashbel Smith, [Nov. 9,] 1833. For Smith in Paris, and the accusatory and violent reactions of the poor to the cholera epidemic there, see Ashbel Smith, *The Cholera Spasmodica, as*

Observed in Paris in 1832, Comprising Its Symptoms, Pathology, and Treatment (New York: Peter Hill, 1832), 9–10. "In an hour of affliction when one is needed to soothe the wounded feelings and bind up the broken spirit"; the condition of Harriet Eliza Bissell when he arrived; and the flirtation with Caroline Bissell, see Smith, letter to Henry Barnard, November 17, 1833, Ashbel Smith Papers. Isaac's prowess as a horseman and the story of Cyclops is in Titus Lucretius Bissell, letter to Ashbel Smith, April 1833, Ashbel Smith Papers; the flooded river and Isaac accompanying Smith in the sulky are in Smith, letter to Henry Barnard, August 23, 1833, Ashbel Smith Papers. "Flowery nothings": Smith, draft of a speech about slavery, n.d., Ashbel Smith Papers. The glittering ball in Paris is in Smith, letter to Caroline A. Smith [his sister], January 31, 1832, Ashbel Smith Papers. The scheme about the mine in Georgia is first described in Robert Folger, letter to Ashbel Smith, October 27, 1834, and in subsequent letters such as those of December 12 and 28, 1834; for Smith's replies, see, for example, his letter to Folger of November 8, 1834; all Ashbel Smith Papers. For an overview of Smith's career beyond his North Carolina years—he moved to Texas in 1837—see Elizabeth Silverthorne, *Ashbel Smith of Texas: Pioneer, Patriot, Statesman, 1805-1886* (College Station: Texas A & M University Press, 1982).

The Glitter of the Argand Lamps

I owe my knowledge of Hyde Hall, its lighting, walls, and mirrors, among other things, to a visit to the historic house in April 2017, when I spoke with the curators. Appalled by the market turn

in America; reaction to the New York fire of 1835: James Fenimore Cooper, *Home as Found* (New York: Capricorn Books, 1961 [1838]), 109. For Cooper, Rembrandt, and the American forest, see Alexander Nemerov, "The Forest of the Old Masters: The Chiaroscuro of American Places," in Samuel F. B. Morse's *Gallery of the Louvre*, ed. Peter J. Brownlee (Chicago: Terra Foundation for Art, 2014), 168–83. "Inverted Milky Way": Cooper, *The Deerslayer* (New York: Signet, 1963), 151. A bright chrome yellow sleigh with cattails painted on the side: I base this description on a sleigh in the collection of the Shelburne Museum. My thanks to Kory Rogers, curator of design arts at the museum, for alerting me to the object and describing the reason for the bright paint (Rogers, email to the author, December 18, 2020).

A Sight Unseen at New Harmony

The authoritative book of Bodmer's work on the journey with Maximilian is *Karl Bodmer's America* (Lincoln: Joslyn Art Museum and University of Nebraska Press, 1984). "Bad genius": *Partnership for Posterity; The Correspondence of William Maclure and Marie Duclos Fretageot, 1820-1833,* ed. Josephine Mirabella Elliott (Indianapolis: Indiana Historical Society, 1994), 1,092. *Anschauung: Partnership for Posterity,* 138. "Sense-impression of Nature": Sarah Anne Carter, *Object Lessons: How Nineteenth-Century Americans Learned to Make Sense of the Material World* (New York: Oxford University Press, 2018), 12; Paul R. Bernard, "Irreconcilable Opinions: The Social and Educational Theories of Robert Owen and William Maclure," *Journal of the Early Republic* 8 (Spring 1988): 37. "Plagues," "sink": *Partnership for Posterity,* 662.

A Statue in the Woods

Powers's work as a debt collector: Donald Martin Reynolds, "Hiram Powers and His Ideal Sculpture," PhD dissertation, Columbia University, 1975, 39; the Infernal Regions: Reynolds, 49; a sculpting prodigy: Reynolds, 23; official inventor, wax-figure maker, and "mechanical contriver" at Dorfeuille's museum: Reynolds, 49; "if he smelled sulphur": Reynolds, 51; devised automata: Reynolds, 55. For another eyewitness account of visiting the Infernal Regions, see the reminiscence of a visitor who saw the exhibit in Powers's company when she was a little girl, quoted in Dennis Looney, "Flame-Coloured Letters and Bugaboo Phraseology: Hiram Powers, Frances Trollope and Dante in Frontier Cincinnati," in Caterina Del Vovo, *Hiram Powers a Firenze: Atti del convegno di studi nel bicentenario della nascita (1805–2005)* (Firenze: L. S. Olschki, 2007), 144–45.

The Secret Bias of the Soul

"Spent his life pursuing material gain": Grant Morrison, "Isaac Bronson and the Search for System in American Capitalism, 1789–1838," PhD dissertation, City University of New York, 1973, 47. For a thorough introduction to the Oliver Bronson House, conducted on-site on October 28, 2021, I am indebted to Alan Neumann, president of Historic Hudson. The designer of the staircase may well have been Benjamin Henry Latrobe, to whom the exquisite drawing of a rattlesnake skeleton has been attributed. For an essay on the drawing and on Latrobe's aesthetic philosophy and life, including his gambling addiction, see Alexander Nemerov, "The Rattlesnake: Benjamin Henry Latrobe

and the Place of Art in America," in *Knowing Nature: Art and Science in Philadelphia, 1740–1840*, ed. Amy Meyers (New Haven, CT: Yale University Press, 2011), 226–53. The original owner of the house, the entrepreneur Samuel Plumb, relied perhaps on the local builder Barnabas Waterman, who in turn may have consulted Latrobe, who was in the Hudson Valley in the early 1810s.

For the title of Oliver Bronson's medical school thesis, see *The New-York Monthly Chronicle of Medicine and Surgery* 1 (1825), 351. Unfortunately, a copy of the thesis has not surfaced. "Climates, seasons, sounds": Rousseau, *The Confessions* (Harmondsworth, Middlesex, England: Penguin, 1953 [1781]), 381.

The title "Architectural Composer" is on the business card of Alexander Jackson Davis (1803–91) in the Alexander Jackson Davis Papers, Avery Library, Columbia University. "Secret bias of the soul": Davis's quotation of "Taste," a poem by Mark Akenside (1721–70), is in the manuscript for his essay "Taste," Alexander Jackson Davis Papers, Avery Library, Columbia University. For Oliver Bronson's purchase of a barouche in 1839, see Oliver Bronson Papers, New York Public Library. The letters of Oliver Bronson Jr. to his mother and father in summer 1854, detailing the story of the misbehaving boys, the firecrackers, and Mr. Dudley, are also in the Oliver Bronson Papers. My thanks to Travis Brock Kennedy for conducting research on my behalf in the Bronson Papers at the New York Public Library and the Alexander Jackson Davis Papers at Avery Library, Columbia.

For Oliver Bronson Jr.'s childhood experiences on the family's Hudson

estate, I have drawn on, for the bees, the opening of James Fenimore Cooper's *The Oak Openings; or, The Bee-Hunter* (Boston: Houghton Mifflin, 1903), 1–18; for the eagle feather, Robert Browning's poem "Memorabilia," *Robert Browning's Poetry*, eds. James F. Loucks and Andrew M. Stauffer (New York: W.W. Norton, 2007), 235; for the dog hanging from the tree, Frederic Church's drawing of such a dog, made in 1845 (Gerald Carr, *Frederic Edwin Church: Catalogue Raisonné of Works of Art of Olana State Historic Site* (Cambridge: Cambridge University Press, 1994), vol. 1, 83; vol. 2, plate 110v.

Deities of the Boardinghouse

For Honeywell's life and art, see Laurel Daen, "Martha Ann Honeywell: Art, Performance, and Disability in the Early Republic," *Journal of the Early Republic* 37 (Summer 2017): 225–50; and Alexander Nemerov, "Without a Trace: The Art and Life of Martha Ann Honeywell," in Asma Naeem, ed., *Black Out: Silhouettes Then and Now* (Washington, DC: National Portrait Gallery, 2018), 46–57. For a different account of Mount's *After Dinner*, see Bruce Robertson, "Who's Sitting at the Table? William Sidney Mount's *After Dinner* 1834," *Yale Journal of Criticism* 11 (Spring 1998): 103–9.

Triptych of the Snuff Takers

The story of the Irishman who fell from the tree is lifted from Harold Frederic's *The Damnation of Theron Ware* (New York: Hurst, 1896), 61–68. Frederic's novel is one of many showing the long effects in American literature of that great writer of the 1830s, Nathaniel Hawthorne; see Richard Brodhead, *The School of Hawthorne* (New York: Oxford University Press, 1989). For Philip Hone's concerns

about Irish immigration, see Allan Nevins, "Introduction: Philip Hone, The Man and Diarist," in *The Diary of Philip Hone, 1828–1851*, ed. Allan Nevins (New York: Dodd, Mead, 1936), viii; also Hone, *The Diary of Philip Hone*, 78 (September 20, 1832). For the story of taking snuff, see Peggy Eaton, *The Autobiography of Peggy Eaton* (New York: C. Scribner's Sons, 1932), 152–53.

The Drug of Distance

For Charles and Sanford's growing up in Hudson and Charles's early death, see Ila Weiss, *Poetic Landscape: The Art and Experience of Sanford R. Gifford* (Cranbury, NJ: Associated University Presses, 1987), 46–53. "Disordered state of mind and body": Weiss, *Poetic Landscape*, 90.

Painter and Oak

The poor manufacture of shoes: John Gadsby Chapman, *The American Drawing-book: A Manual for the Amateur* (New York: Barnes, 1870), 71. For Chapman's *Baptism of Pocahontas*, see William H. Truettner, "The Art of History: American Exploration and Discovery Scenes, 1840–1860," *American Art Journal* 14 (Winter 1982): 4–31.

Part Eight: Four Greens

The Gasbag of Louis Anselm Lauriat

A sample of Lauriat's promotional broadsides is *This day. Grand balloon ascension: Mr. Lauriat will make a splendid ascension with his balloon, this day, July 21, in Portland* [1836]. *Katy Mory*, broadside, ca. 1830–40. "Home-speaking countenance" of a friend: Ralph Waldo Emerson, "Art," in *Essays* (Boston: James Munroe, 1841),

298. "Blithe air," "transparent eye-ball": Emerson, "Nature" (Boston: James Munroe, 1836), 13. "Adieu": *Adieu of Monsieur Lauriat: On an excursion through the upper regions, to the inhabitants of the mundane sphere* (Portland, 1836). The details of Anselm's perilous flight from the Chelsea House are in "Chelsea, MA—June 17, 1839," *New England Aviation*, posted March 17, 2017: https://www.newenglandaviationhistory.com/tag/louis-a-lauriat-aeronaut/. On the termite damage to Raphael's *Transfiguration*, see Martin Rosenberg, "Raphael's *Transfiguration* and Napoleon's Cultural Politics," *Eighteenth-Century Studies* 19 (Winter 1985–86): 193.

Ship of Elms

Glynn's two-volume set of Michaux's *North American Sylva*, in the Paris D'Hautel edition of 1819, with Richards's inscriptions, is in a private collection. "The Elms of New Haven": *Poems of Nathaniel Parker Willis* (New York: Hurst, 1882), 127–36. Cooper as midshipman, calling the ocean a wilderness: H. Daniel Peck, *A World by Itself: The Pastoral Moment in Cooper's Fiction* (New Haven: Yale University Press, 1977), 39. Henry Tuckerman [1852], J. Gray Sweeney, *The Columbus of the Woods: Daniel Boone and the Typology of Manifest Destiny* (St. Louis, MO: Washington University Art Gallery, 1992), foreword, n.p. "Human depravity": quoted in Thomas N. Baker, *Sentiment and Celebrity: Nathaniel Parker Willis and the Trials of Literary Fame* (New York: Oxford University Press, 1999), 27.

Pray with Me

On Jackson's injuries and afflictions, see Reda C. Goff, "A Physical Profile of Andrew Jackson," *Tennessee Historical Quarterly* 28 (Fall 1969): 297–309; also Robert V. Remini, *Andrew Jackson and the Course of American Freedom* (New York: Harper & Row, 1981), xv. Milk and sunburn: "The Tontine Hotel, 1825–1913," unpublished manuscript, 8; given by the Committee on Historical Buildings of the Connecticut Colonial Dames, undated, New Haven Historical Society. Jackson's procession through New Haven: undated and unidentified newspaper clipping [June 1833], Dana, vol. 125, New Haven Historical Society. Tontine and the New Haven Green: "The Tontine Hotel," 1–12. Peter Parker, diary entry of June 14, 1833, quoted in Michael J. Green, *By More than Providence: Grand Strategy and American Power in the Asia Pacific since 1783* (New York: Columbia University Press, 2017), 43. For a superb account of Lam Qua, Peter Parker, and especially the portrait of Leäng Yen—formative to me in my conception of this scene—see Stephen Rachman, "Memento Morbi: Lam Qua's Paintings, Peter Parker's Patients," *Literature and Medicine* 23 (Spring 2004): 134–59. See also "Peter Parker's Lam Qua Paintings Collection," Harvey Cushing/John Jay Whitney Medical Library: https://library.medicine.yale.edu/find/peter-parker. Jackson's visit to the axe factory: "The Tontine Hotel," 8; undated and unidentified newspaper clipping [June 1833], Dana, vol. 125, New Haven Historical Society; "Proud to have them used": *Columbian Register*, June 22, 1834.

Backflip and Sky

"They might be well": John Warner Barber, *A History of the Amistad Captives* (New Haven, CT: E. L. and J. W. Barber, 1840), 29; "cannibal"; food on the

Amistad: Barber, 10, 4; Grabeau: Barber, 10. "Vestiges of a hidden world": for an account of what such a world might have been, see Kenaan, *Photography and Its Shadow*.

Part Nine: Three Levitations

The Architect's Escape

The plot, action, and characters are from William Faulkner, *Absalom, Absalom!* (New York: Vintage, 1990 [1936]), esp. 177–78, 193, 196–97, 206–7, 28–29.

The Many Skulls of Robert Montgomery Bird

Robert Montgomery Bird, *Nick of the Woods* (New Haven, CT: College and University Press, 1967 [1837]), 234. "His half-cracked skull impressed a star of such beauty": Mary Mayer Bird, *Life of Robert Montgomery Bird* (Philadelphia: University of Pennsylvania Library, 1945), 14. Bird, *Nick of the Woods*, 254, 323. *Crania Americana*: Samuel George Morton, *Crania Americana: or,*

A comparative view of the skulls of various aboriginal nations of North and South America (Philadelphia: J. Dobson, 1839). The copy I consulted is in the collections of the Library Company of Philadelphia. "Dark and rugged walls on either side," "the full-grown sycamore," "And in those visionary lands": Bird, *Nick of the Woods*, 183. Metempsychosis: Bird, *Sheppard Lee, Written by Himself* (New York: New York Review Books Classics, 2008 [1836]). "He had the greatest aversion to a crowd": Bird, *Life of Robert Montgomery Bird*, 124; Storm at New Castle, Delaware: Bird, *Life of Robert Montgomery Bird*, 105.

Two Sisters at the Mountain House

For a thorough history of the Catskill Mountain House, see Roland Van Zandt, *The Catskill Mountain House* (New Brunswick, NJ: Rutgers University Press, 1966). See also Kenneth Myers, *The Catskills: Painters, Writers, and Tourists in the Mountains, 1820–1895* (Yonkers, NY: Hudson River Museum of Westchester, 1988).

Credits

P. 1 top. *Thomas Cole's Hat.* Greene County Historical Society, on loan to the Thomas Cole National Historic Site, Catskill, New York. Courtesy of the Bronck Museum of the Greene County Historical Society, Coxsackie, NY. Photography courtesy of the Thomas Cole National Historic Site.

P. 1 bottom. Thomas Cole, *Tornado in an American Forest*, 1831. Oil on canvas, 46⅜ × 64⅝ in. National Gallery of Art, Washington, DC, Corcoran Collection (Museum Purchase, Gallery Fund), 2014.136.117.

P. 2. William John Wilgus, *Ut-ha-wah (Captain Cold)*, 1838. Oil on canvas, 40 × 30 in. Yale University Art Gallery, de Lancey Kountze Collection, Gift of de Lancey Kountze, B.A. 1899, 1939.39. Photo: Yale University Art Gallery.

P. 3. John Quidor, *Ichabod Crane Flying from the Headless Horseman*, ca. 1828. Oil on canvas, 22⅝ × 30 1/16 in. Yale University Art Gallery, Mabel Brady Garvan Collection, 1948.68. Photo: Yale University Art Gallery.

P. 4. *Portrait of Laura Bridgman*, ca. 1845. Daguerreotype, 3¼ × 2¾ in. Courtesy of Perkins School for the Blind Archives, Watertown, Massachusetts.

P. 5. Frances Henshaw, *Vermont*, from *Frances H. Henshaw's Book of Penmanship Executed at Middlebury Female Academy*,

April 29, 1828. David Rumsey Map Center, Stanford University Libraries, Stanford University.

P. 6 top. Unknown photographer, *Undercliff, Home of George Pope Morris, Cold Spring, New York*, ca. late nineteenth century. Putnam History Museum, Cold Spring, New York.

P. 6 bottom. Fred C. Berte, *The Poe Cottage at Fordham*, ca. 1900. Library of Congress, Prints and Photographs Division, LC-USZ62–62309.

P. 7. Jerome Thompson, *Recreation*, 1857. Oil on canvas, 40½ × 56 in. Museum purchase, M. H. de Young Memorial Museum, Fine Arts Museums of San Francisco, 47.13.

P. 8 top. *Marker Tree* (White Oak), Georgia. Photo courtesy of Don Wells, Mountain Stewards, Jasper, Georgia.

P. 8 bottom. "Common Method of Establishing Trail Tree Markers," from Raymond E. Janssen, "Living Guide-Posts of the Past," *Scientific Monthly* 53 (July 1941): 24.

P. 9. Henry Inman (after Charles Bird King), *Sequoyah*, ca. 1830. Oil on canvas, 30¼ × 25¼ in. National Portrait Gallery, Smithsonian Institution, NPG.79.174.

P. 10. *Bible belonging to Nat Turner*, 1831. Ink on paper, 4 15/16 × 3½ in. Collection of the Smithsonian National Museum of

African American History and Culture, Gift of Maurice A. Person and Noah and Brooke Porter, 2011.28.

P. 11. John Henri Isaac Browere, *Thomas Jefferson*, ca. 1825. Plaster, height 26¼ in. Fenimore Art Museum, Cooperstown, New York, Gift of Stephen C. Clark. N0241.1940. Photograph by Richard Walker.

P. 12 top. William Sidney Mount, *Dregs in the Cup*, 1838. Oil on canvas, 42 × 52 in. New-York Historical Society.

P. 12 bottom. Caravaggio, *The Incredulity of Thomas*, 1601–2. Oil on canvas, 42 × 57 in. Potsdam, SPSG, Sanssouci Picture Gallery, GK I 5438. Wikimedia.

P. 13. John Gadsby Chapman, *The Lake of the Great Dismal Swamp*, 1825. Oil on fireboard, 36 × 40 in. Virginia Museum of History and Culture, purchased with funds provided by Lora M. Robins, 1995.120.

P. 14. Alfred M. Hoffy and John T. Bowen, *R. P. Robinson, The "Innocent Boy*," 1836. Lithograph, 16½ × 10½ in. Museum of the City of New York, 95.54.15.

P. 15. John Vanderlyn, *The Death of Jane McCrea*, 1804. Oil on canvas, 32½ × 26½ in. Wadsworth Atheneum.

P. 16. *The Jane McCrea Tree*, from Benson J. Lossing, *A Pictorial Field Book of the Revolution*, vol. 1 (New York: Harper & Brothers, 1852), 97.

P. 17 top. *Temple Stream, Temple, Maine*, 2022. Photo by author.

P. 17 bottom. *Higher Yet! Sam's Last Jump. . . . November 13, 1829*, in *Rochester Daily Advertiser and Telegraph*, October 29, 1829. From the collection of the

Rochester Public Library Local History & Genealogy Division.

P. 18. Thomas Cole, *Scene from Byron's "Manfred"*, 1833. Oil on canvas, 50 × 38 in. Yale University Art Gallery, John Hill Morgan, B.A. 1893, LL.B. 1896, M.A. (Hon.) 1929, Fund, 1968.102. Photo: Yale University Art Gallery.

P. 19. Henry Lewis, *Piasa Rock*, 1847, from *The Valley of the Mississippi Illustrated* (Düsseldorf: Arnz & comp., 1857). Library of Congress, Rare Book and Special Collections Division.

P. 20. *Animal Skin Tobacco Bag*, Eastern Plains, ca. 1840. Raccoon skin and skull, native tanned leather, natural and dyed porcupine quills, wool cloth, silk ribbon, bird claws, brass bells and buttons, glass beads, metal cones, feather, and animal hair, 26 × 5 × 2¾ in. The Nelson-Atkins Museum of Art, Kansas City, Missouri. Anonymous gift, 2002.24. Photo: The Nelson Gallery Foundation, Jamison Miller.

P. 21. Robert Havell Jr. after John James Audubon, *Barn Owl*, 1833. Engraving and aquatint on paper, 38⅜ × 25¹³⁄₁₆ in. National Gallery of Art, Washington, DC, Gift of Mrs. Walter B. James, 1945.8.171.

P. 22 top. Bertel Thorvaldsen, *Ganymede and the Eagle*, 1817. Marble, 36¾ × 46⁹⁄₁₆ in. Thorvaldsen Museum, Copenhagen, A44. Photo: Jakob Faurvig © Thorvaldsen Museum.

P. 22 bottom. *Townsend's Bunting*, May 11, 1833. National Museum of Natural History, Smithsonian Institution, Washington, DC, USNM A10282.

P. 23. Nicholas Marcellus Hentz, *Spiders of the United States* (Boston: Boston

Society of Natural History, 1875), plate 4. Smithsonian Libraries.

P. 24 top. Karl Bodmer, *Trappists Hill Opposite St. Louis*, 1834. Graphite and ink on paper, 10 × 12½ in. Joslyn Art Museum, Omaha, Nebraska, Gift of the Enron Art Foundation, 1986.49.226. Photograph © Bruce M. White, 2019.

P. 24 bottom. *Silas Hoadley's Clock Shop, Greystone, Connecticut*, ca. 1850. Daguerreotype. Mattatuck Museum, Waterbury, Connecticut.

P. 25. Thomas Sully, *Frances Kemble as Beatrice*, 1833. Oil on canvas, 30 × 25 in. Courtesy of the Pennsylvania Academy of the Fine Arts, Philadelphia. Bequest of Henry C. Carey (The Carey Collection), 1879.8.24.

P. 26. *Joseph Stewart's Canal, Taylors Island, Maryland*, 2021. Photo by author.

P. 27 top. Étienne Léopold Trouvelot, *The November Meteors*, 1882, lithograph, from *The Trouvelot Astronomical Drawings Manual* (New York: Charles Scribner's Sons, 1882).

P. 27 bottom. *Reflections, Joseph Stewart's Canal, Taylors Island, Maryland*, 2021. Photo by author.

P. 28. *Mirror*, Isaac L. Platt designer. Hyde Hall, Cooperstown, New York, 1832–34. Photo by author, 2017.

P. 29 top. Samuel F. B. Morse, *The Gallery of the Louvre*, 1831–33. Oil on canvas, 73¾ × 108 in. Terra Foundation for American Art, Daniel J. Terra Collection, 1992.51. Photography © Terra Foundation for American Art, Chicago.

P. 29 bottom. Philip Hooker, *Hyde Hall,*

Cooperstown, New York, 1832–34. Photo courtesy of Hyde Hall.

P. 30. Karl Bodmer, *The Fox River near New Harmony*, 1832. Watercolor and graphite on paper, 11⅔ × 14¼ in. Joslyn Art Museum, Omaha, Nebraska, Gift of the Enron Art Foundation, 1986.49.64. Photograph © Bruce M. White, 2019.

P. 31. *Infernal Regions Broadside* (detail), ca. 1832. Cincinnati Museum Center.

P. 32. *The Greek Slave*, 1850 (after original of 1844). Marble, 65¼ × 21 × 18¼ in. Yale University Art Gallery. Olive Louise Dann Fund, 1962.43. Photo: Yale University Art Gallery.

P. 33 top. Benjamin Henry Latrobe (?), *Rattlesnake Skeleton* (detail), ca. 1805. American Philosophical Society, Philadelphia.

P. 33 bottom. Benjamin Henry Latrobe (?), *Spiral Staircase*, Oliver Bronson House, 1811–12, Hudson, New York, 2021. Photo by author.

P. 34 top. Martha Ann Honeywell, *Cut-paper Card with the Lord's Prayer*, ca. 1830. Cut-paper and pen, framed: 8¼ × 7⅝ in. Metropolitan Museum of Art, New York, Gift of Mrs. Richard Riddell, 1984, 1984.1164.21.

P. 34 bottom. Honeywell, *The Lord's Prayer* (detail). Photo by author, 2017.

P. 35 top. William Sidney Mount, *After Dinner*, 1834. Oil on wood, 10⅞ × 10¹⁵⁄₁₆ in. Yale University Art Gallery, Stanley B. Resor, B.A. 1901, Christian A. Zabriskie, and John Hill Morgan, B.A. 1893, LL.B. 1896, M.A. (Hon.) 1929, Funds, 1972.33. Photo: Yale University Art Gallery.

P. 35 bottom. Anonymous photographer, *Peggy Eaton in Later Life*, ca. 1870s. Library of Congress, Prints and Photographs Division, Brady-Handy photograph collection, LC-BH826–2696.

P. 36. John Pye, after Claude Lorrain, *Italian Seaport*, in Pye, *Engravings from the Pictures of the National Gallery* (London: Associated Engravers, 1840). Image © Victoria and Albert Museum, London.

P. 37. David Lucas, after John Constable, *The Cornfield*, 1834. Mezzotint on paper, 28½ × 23½ in. Tate Britain. Photo: Tate.

P. 38. Sanford Gifford, *A Gorge in the Mountains (Kauterskill Clove)*, 1862. Oil on canvas, 48 × 39⅞ in. Metropolitan Museum of Art, New York, Bequest of Maria DeWitt Jesup, from the collection of her husband, Morris K. Jesup, 1914, 15.30.62.

P. 39. John Gadsby Chapman, *The Baptism of Pocahontas* (detail of Pocahontas), 1837–40. Oil on canvas, 12 × 18 feet. Capitol Rotunda. Office of the Architect of the Capitol, Washington, DC.

P. 40. *This Day. Grand Balloon Ascension. Mr. Lauriat*, 1836. Broadside. American Antiquarian Society, cat. #242939.

P. 41. Raphael, *The Transfiguration*, ca. 1516–20. Tempera grassa on wood, 161⁷⁄₁₆ × 109¹³⁄₁₆ in. The Vatican, cat. 40333.

P. 42. *Inscription from R. K. Richards to Lieutenant James Glynn*, August 5, 1837, flyleaf in François André Michaux, *The North American Sylva*, vol. 1 (Paris: D'Hautel, 1819). Private collection.

P. 43 top. François André Michaux, *Dutch Elm and Common European Elm*, in *The North American Sylva*, vol. 2 (Paris: D'Hautel, 1819). Image from the Biodiversity Heritage Library. Contributed by the University of Pittsburgh Library System.

P. 43 bottom. John Warner Barber, *Tontine Hotel, New Haven, CT*, ca. 1840. Wood engraving, tinted, 11¹³⁄₁₆ × 19¹¹⁄₁₆ in. Yale University Art Gallery, Mabel Brady Garvan Collection, 1946.9.1773. Photo: Yale University Art Gallery.

P. 44. Ralph Eleaser Whiteside Earl, *Andrew Jackson*, 1837. Andrew Jackson's Hermitage, Nashville, Tennessee.

P. 45 top. Lam Qua, *Patient of Dr. Peter Parker (Leäng Yen)*, ca. 1838. Oil on canvas, 24 × 18 in. Medical Historical Library, Harvey Cushing / John Hay Whitney Medical Library, Yale University.

P. 45 bottom. *Grabeau*, from John Warner Barber, *A History of the Amistad Captives* (New Haven: E. L. and J. W. Barber, 1840), 9.

P. 46 top. Robert Montgomery Bird, *Untitled [Rooftop]*, ca. 1852–53. The Library Company, Philadelphia.

P. 46 bottom. Robert Montgomery Bird, *Untitled [Girl Swinging on a Branch]*, ca. 1852–53. The Library Company, Philadelphia.

P. 47 top. Robert Montgomery Bird, *Untitled [The Mountain Spring]*, ca. 1852–53. The Library Company, Philadelphia.

P. 47 bottom. Robert Montgomery Bird, *Untitled [Ten-Dollar Bill]*, ca. 1852–53. The Library Company, Philadelphia.

P. 48 top. Robert Montgomery Bird, *Untitled [Fence Gate]*, ca. 1852–53. The Library Company, Philadelphia.

P. 48 bottom. Robert Montgomery Bird, *Untitled [Rooftop]*, ca. 1852–53. The Library Company, Philadelphia.

A. W. Mellon Lectures in the Fine Arts, 1952–2022

1952 Jacques Maritain, *Creative Intuition in Art and Poetry* (published 1953)

1953 Sir Kenneth Clark, *The Nude: A Study of Ideal Art* (published as *The Nude: A Study in Ideal Form*, 1956)

1954 Sir Herbert Read, *The Art of Sculpture* (published 1956)

1955 Étienne Gilson, *Art and Reality* (published as *Painting and Reality*, 1957)

1956 E. H. Gombrich, *The Visible World and the Language of Art* (published as *Art and Illusion: A Study in the Psychology of Pictorial Representation*, 1960)

1957 Sigfried Giedion, *Constancy and Change in Art and Architecture* (published as *The Eternal Present: A Contribution on Constancy and Change*, 1962–64)

1958 Sir Anthony Blunt, *Nicolas Poussin and French Classicism* (published as *Nicolas Poussin*, 1967)

1959 Naum Gabo, *A Sculptor's View of the Fine Arts* (published as *Of Divers Arts*, 1962)

1960 Wilmarth Sheldon Lewis, *Horace Walpole* (published 1960)

1961 André Grabar, *Christian Iconography and the Christian Religion in Antiquity* (published as *Christian Iconography: A Study of Its Origins*, 1968)

1962 Kathleen Raine, *William Blake and Traditional Mythology* (published as *Blake and Tradition*, 1968)

1963 Sir John Pope-Hennessy, *Artist and Individual: Some Aspects of the Renaissance Portrait* (published as *The Portrait in the Renaissance*, 1966)

1964 Jakob Rosenberg, *On Quality in Art: Criteria of Excellence, Past and Present* (published 1967)

1965 Sir Isaiah Berlin, *Sources of Romantic Thought* (published as *The Roots of Romanticism*, 1999)

1966 Lord David Cecil, *Dreamer or Visionary: A Study of English Romantic Painting* (published as *Visionary and Dreamer: Two Poetic Painters, Samuel Palmer and Edward Burne-Jones*, 1969)

1967 Mario Praz, *On the Parallel of Literature and the Visual Arts* (published as *Mnemosyne: The Parallel between Literature and the Visual Arts*, 1970)

1968 Stephen Spender, *Imaginative Literature and Painting*

1969 Jacob Bronowski, *Art as a Mode of Knowledge* (published as *The Visionary Eye: Essays in the Arts, Literature, and Science*, 1978)

1970 Sir Nikolaus Pevsner, *Some Aspects of Nineteenth-Century Architecture* (published as *A History of Building Types*, 1976)

1971 T.S.R. Boase, *Vasari: The Man and the Book* (published as *Giorgio Vasari: The Man and the Book*, 1979)

1972 Ludwig H. Heydenreich, *Leonardo da Vinci*

1973 Jacques Barzun, *The Use and Abuse of Art* (published 1974)

1974 H. W. Janson, *Nineteenth-Century Sculpture Reconsidered* (published as *The Rise and Fall of the Public Monument*)

1975 H. C. Robbins Landon, *Music in Europe in the Year 1776*

1976 Peter von Blanckenhagen, *Aspects of Classical Art*

1977 André Chastel, *The Sack of Rome: 1527* (published 1982)

1978 Joseph W. Alsop, *The History of Art Collecting* (published as *The Rare Art Traditions: The History of Art Collecting and Its Linked Phenomena Wherever These Have Appeared*, 1982)

1979 John Rewald, *Cézanne and America* (published as *Cézanne and America: Dealers, Collectors, Artists, and Critics, 1891–1921*, 1989)

1980 Peter Kidson, *Principles of Design in Ancient and Medieval Architecture*

1981 John Harris, *Palladian Architecture in England, 1615–1760*

1982 Leo Steinberg, *The Burden of Michelangelo's Painting*

1983 Vincent Scully, *The Shape of France* (published as *Architecture: The Natural and the Manmade*)

1984 Richard Wollheim, *Painting as an Art* (published 1987)

1985 James S. Ackerman, *The Villa in History* (published as *The Villa: Form and Ideology of Country Houses*, 1990)

1986 Lukas Foss, *Confessions of a Twentieth-Century Composer*

1987 Jaroslav Pelikan, *Imago Dei: The Byzantine Apologia for Icons* (published 1990)

1988 John Shearman, *Art and the Spectator in the Italian Renaissance* (published as *Only Connect: Art and the Spectator in the Italian Renaissance*, 1992)

1989 Oleg Grabar, *Intermediary Demons: Toward a Theory of Ornament* (published as *The Mediation of Ornament*, 1992)

1990 Jennifer Montagu, *Gold, Silver, and Bronze: Metal Sculpture of the Roman Baroque* (published 1996)

1991 Willibald Sauerländer, *Changing Faces: Art and Physiognomy through the Ages*

1992 Anthony Hecht, *The Laws of the Poetic Art* (published as *On the Laws of the Poetic Art*, 1995)

1993 John Boardman, *The Diffusion of Classical Art in Antiquity* (published 1994)

1994 Jonathan Brown, *Kings and Connoisseurs: Collecting Art in Seventeenth-Century Europe* (published 1995)

1995 Arthur C. Danto, *Contemporary Art and the Pale of History* (published as *After the End of Art: Contemporary Art and the Pale of History*, 1997)

1996 Pierre M. Rosenberg, *From Drawing to Painting: Poussin, Watteau, Fragonard, David, Ingres* (published as *From Drawing to Painting: Poussin, Watteau, Fragonard, David, and Ingres*, 2000)

1997 John Golding, *Paths to the Absolute* (published as *Paths to the Absolute: Mondrian, Malevich, Kandinsky, Pollock, Newman, Rothko, and Still*, 2000)

1998 Lothar Ledderose, *Ten Thousand Things: Module and Mass Production in Chinese Art* (published 2000)

1999 Carlo Bertelli, *Transitions*

2000 Marc Fumaroli, *The Quarrel between the Ancients and the Moderns in the Arts, 1600–1715*

2001 Salvatore Settis, *Giorgione and Caravaggio: Art as Revolution*

2002 Michael Fried, *The Moment of Caravaggio* (published 2010)

2003 Kirk Varnedoe, *Pictures of Nothing: Abstract Art since Pollock* (published 2006)

2004 Irving Lavin, *More than Meets the Eye*

2005 Irene J. Winter, *"Great Work": Terms of Aesthetic Experience in Ancient Mesopotamia*

2006 Simon Schama, *Really Old Masters: Age, Infirmity, and Reinvention*

2007 Helen Vendler, *Last Looks, Last Books: The Binocular Poetry of Death* (published as *Last Looks, Last Books: Stevens, Plath, Lowell, Bishop, Merrill*, 2010)

2008 Joseph Leo Koerner, *Bosch and Bruegel: Parallel Worlds* (published as *Bosch and Bruegel: From Enemy Painting to Everyday Life*, 2016)

2009 T. J. Clark, *Picasso and Truth* (published as *Picasso and Truth: From Cubism to Guernica*, 2013)

2010 Mary Miller, *Art and Representation in the Ancient New World*

2011 Mary Beard, *The Twelve Caesars: Images of Power from Ancient Rome to Salvador Dalí* (published as *Twelve Caesars: Images of Power from the Ancient World to the Modern*, 2021)

2012 Craig Clunas, *Chinese Painting and Its Audiences* (published 2017)

2013 Barry Bergdoll, *Out of Site in Plain View: A History of Exhibiting Architecture since 1750*

2014 Anthony Grafton, *Past Belief: Visions of Early Christianity in Renaissance and Reformation Europe*

2015 Thomas Crow, *Restoration as Event and Idea: Art in Europe, 1814–1820* (published as *Restoration: The Fall of Napoleon in the Course of European Art, 1812–1820*, 2018)

2016 Vidya Dehejia, *The Thief Who Stole My Heart: The Material Life of Chola Bronzes from South India, c. 855–1280* (published as *The Thief Who Stole My Heart: The Material Life of Sacred Bronzes from Chola India, 855–1280*, 2021)

2017 Alexander Nemerov, *The Forest: America in the 1830s* (published as *The Forest: A Fable of America in the 1830s*, 2023)

2018 Hal Foster, *Positive Barbarism: Brutal Aesthetics in the Postwar Period* (published as *Brutal Aesthetics: Dubuffet, Bataille, Jorn, Paolozzi, Oldenburg*, 2020)

2019 Wu Hung, *End as Beginning: Chinese Art and Dynastic Time* (published as *Chinese Art and Dynastic Time*, 2022)

2021 Jennifer L. Roberts, *Contact: Art and the Pull of Print*

2022 Richard J. Powell, *Colorstruck! Painting, Pigment, Affect*

Princeton University Press is committed to the protection of copyright and the intellectual property our authors entrust to us. Copyright promotes the progress and integrity of knowledge. Thank you for supporting free speech and the global exchange of ideas by purchasing an authorized edition of this book. If you wish to reproduce or distribute any part of it in any form, please obtain permission.

Requests for permission to reproduce material from this work should be sent to permissions@press.princeton.edu

Published by Princeton University Press, 41 William Street, Princeton, New Jersey 08540
In the United Kingdom: Princeton University Press, 99 Banbury Road, Oxford OX2 6JX

press.princeton.edu

Jacket illustration by Julie Orpen

Library of Congress Cataloging-in-Publication Data

Names: Nemerov, Alexander, author.
Title: The forest : a fable of America in the 1830s / Alexander Nemerov.
Description: Princeton : Princeton University Press, [2023] | Series: The A. W. Mellon Lectures in the Fine Arts, National Gallery of Art, Washington, Center for Advanced Study in the Visual Arts. Bollingen Series XXXV: Volume 66 | Includes bibliographical references and index.
Identifiers: LCCN 2022030130 (print) | LCCN 2022030131 (ebook) | ISBN 9780691244280 (hardback) | ISBN 9780691244273 (ebook)
Subjects: LCSH: Art and society—United States—History—19th century.
Classification: LCC NX180.S6 N46 2023 (print) | LCC NX180.S6 (ebook) |
DDC 701/.03097309034--dc23/eng/20220811
LC record available at https://lccn.loc.gov/2022030130

LC ebook record available at https://lccn.loc.gov/2022030131

British Library Cataloging-in-Publication Data is available

This is the sixty-sixth volume of the A. W. Mellon Lectures in the Fine Arts, which are delivered annually at the National Gallery of Art, Washington, and organized by the Center for Advanced Study in the Visual Arts. This volume is based on lectures delivered in 2017. The volumes of lectures constitute Number XXXV in the Bollingen Series, supported by the Bollingen Foundation.

Designed by Jeff Wincapaw

This book has been composed in Livory and Chronicle Display

Printed on acid-free paper. ∞

Printed in the United States of America

10 9 8 7 6 5 4 3 2 1